ART DECO

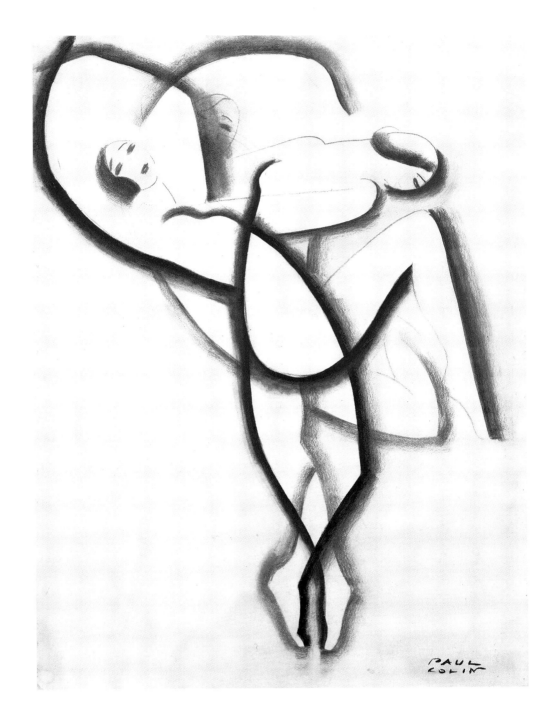

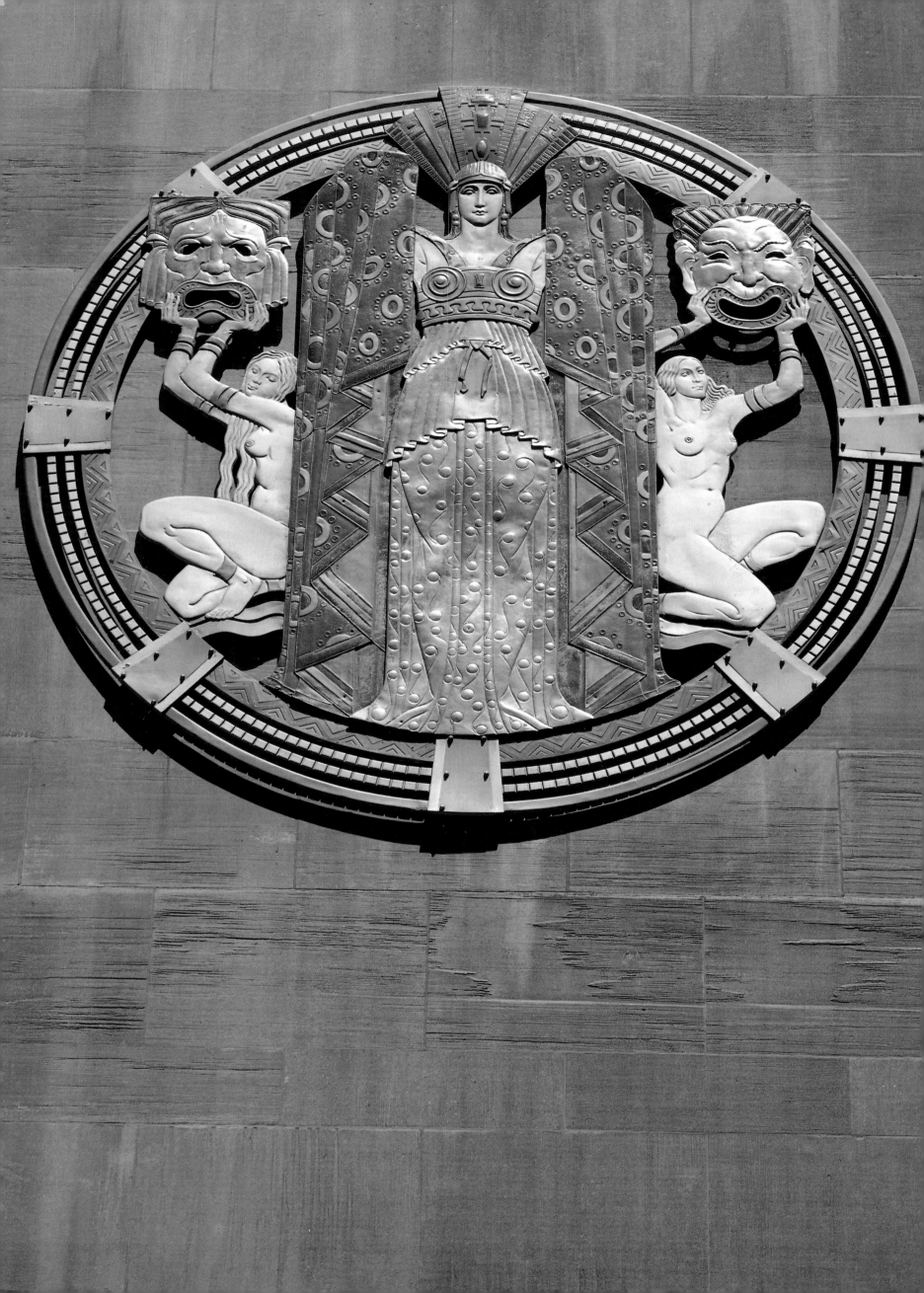

ART DECO

EVA WEBER

GALLERY BOOKS
An imprint of W.H. Smith Publishers Inc.
112 Madison Avenue
New York, New York 10016

Published by Gallery Books
A Division of W H Smith Publishers Inc.
112 Madison Avenue
New York, New York 10016

Produced by
Brompton Books Corp.
15 Sherwood Place
Greenwich, CT 06830

ISBN 0-8317-0455-1

2 3 4 5 6 7 8 9 10

Printed and bound in Spain by Gráficas Estella, S.A. Navarra.

PAGE 1: *Sketch by French designer
Paul Colin, who specialized in
dance and entertainment posters.*

PAGE 2: *Hildreth Meiere,* Drama
*plaque (c 1932) at Rockefeller
Center's Radio City Music Hall in
New York.*

ENDPAPERS: *Design from a wood-
engraved lithograph by Paul Nash.*

Contents

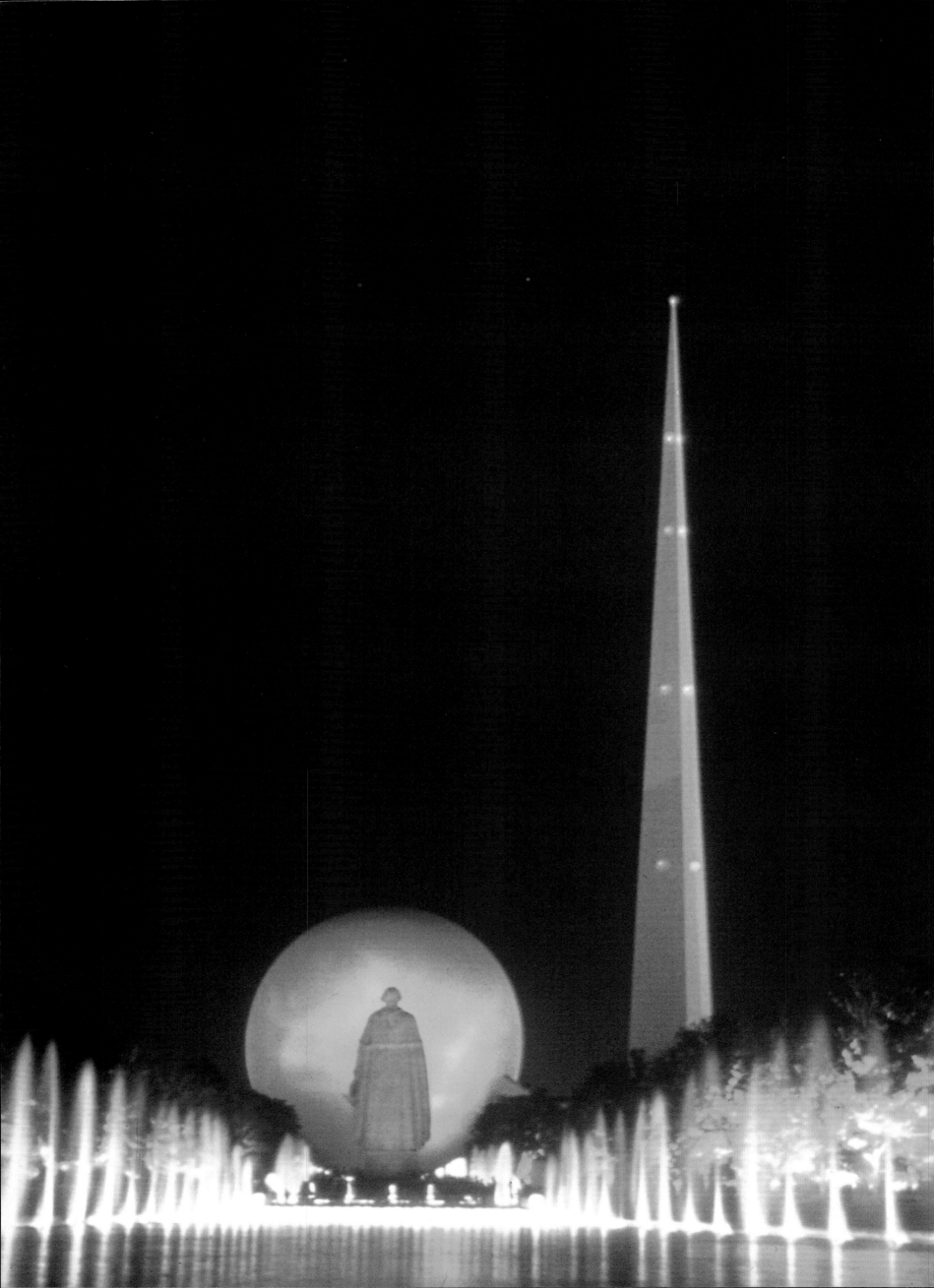

Art Deco Style on Show

Art Deco was a decorative arts style that held a mirror to its times. Its distinctive stylistic characteristics and imagery reflected a complex era of rapid artistic, social and technological change. Although its climax came in 1925 with the Paris *Exposition Internationale des Arts Décoratifs et Industriels*, Art Deco essentially spanned the first four decades of the twentieth century. The style began to evolve shortly after 1900 as a reaction to Art Nouveau, gathered speed with an infusion from the avant-garde art movements of Cubism and Futurism, drew renewed inspiration from ancient and primitive art, was purified and streamlined by the ideas of the functionalists and sought a return to traditional values during the political and economic turmoil of the 1930s.

During the 1920s and 1930s, international expositions provided a major showcase for the Art Deco style. Although they were primarily vehicles of nationalism and commercialism, the fairs also stimulated experiment in the arts and design. Most major architects, artists and designers – many of them important to Art Deco – were involved in the planning and execution of projects for these extravaganzas. Smaller exhibitions organized within the context of these expositions brought together the latest decorative arts, painting and sculpture, much of which also had close affinities with Art Deco. In addition, the expositions disseminated posters, written and pictorial materials and other souvenirs that required the services of graphic artists and others to create designs that reflected the particular style and content of each exposition. These expositions not only summed up current artistic trends but, in a broader sense, expressed, both overtly and implicitly, the concerns and aspirations of the times.

Now hailed as the climax of the Art Deco style, the 1925 Paris *Exposition des Arts Décoratifs et Industriels* had originally been proposed in 1912 for 1915 in order to inspire French designers to develop work equal to that produced by their German contemporaries. Around the turn of the century, while French design languished in the waning years of Art Nouveau, the Germans had started to produce refreshingly modern stylizations based on neoclassicism. An added impetus had been the establishment in 1907 of the German *Werkbund*, an association of designers and manufacturers. Participants in the 1909 Munich *Werkbund* exhibition were invited to show at the 1910 Paris *Salon d'Automne*, where they caused a sensation with their elegant, modernistic well-made pieces. While outwardly critical, the French went on to adapt and combine the new German ideas with motifs from Cubism and the Russian Ballet, and to produce abstract versions of floral ornament derived from Art Nouveau. In the years before World War I, German designers led the way, as demonstrated by the 1913 Leipzig and the 1914 Cologne *Werkbund* exhibitions. There, Bruno Taut's steel and glass pavilions were prototypes for the later experimental exposition architecture of the 1920s and 1930s. Equally important were the works of Josef Hoffmann and his Vienna *Werkstätte* colleagues.

When the 1925 Paris exposition finally took place after a ten-year delay caused by World War I and its aftermath, the Germans were not represented and the United States declined to participate because it had no appropriate work. Twenty-one nations and the French colonies erected pavilions and displays on a 55-acre cruciform site on both sides of the Seine in central Paris. Even the connecting Alexandre III Bridge was lined with the specially built shops of René Lalique, Sonia Delaunay and others. A light and water show below the bridge provided spectacular effects, while moored barges were transformed into floating restaurants and theaters, and Paul Poiret displayed colorful Atelier Martine interiors on his three boats. The Eiffel Tower was the site of the Citroën company's dramatic light shows which alternated shimmering geometric arcs and circles, comet and star extravaganzas and an animated zodiac, with automotive advertising.

The specially designed gateways to the exposition grounds set a mood of fantasy. The modernistically monumental main entrance, the *Porte d'Honneur,* was framed by fluted columns topped with frozen fountains. Architecturally most characteristic of the opulent 1920s style were the design pavilions of the four great Parisian department stores – Galeries Lafayette's *La Maîtrise,* Au Bon Marché's *Pomone,* Louvre's *Studium,* and Printemps' *Primavera.* The characteristic features of these pavilions included zigzag architectural setbacks, the use of unusual materials, the incorporation of decorative wall paintings, and ornate metal and glass worked in geometric and floral patterns. Exquisite metalwork by Edgar Brandt and decorative glass by Lalique were to be found all around the fair.

The displays by French interior decorators, or *ensembliers,* were among the most admired at the exhibition. Foremost was Jacques-Emile Ruhlmann's elegant *Pavillon d'un Collectionneur,* though

LEFT: *Bruno Taut's glass pavilion at the 1914 Cologne* Werkbund *exhibition was to inspire the designers of 1920s and 1930s Art Deco exhibition structures.*

RIGHT: *Louis Boileau's richly embellished design for the* Pomone *pavilion at the 1925 Paris exposition epitomized French Art Deco. The design studio's director, Paul Follot, assembled the stylish interiors.*

BELOW: *Topped by the characteristic frozen fountain motif, the Porte d'Honneur by Henri Favier and André Ventre was the Paris exposition's main ceremonial entrance. The metalwork was by Edgar Brandt and René Lalique provided the molded-glass reliefs.*

equally luxurious and impressive was the collaborative *L'Ambassade Française* with 25 rooms by such top Art Deco designers as Jean Dunand, André Groult, Pierre Chareau, Paul Follot, Maurice Dufrêne and others. In such modernist settings, French virtuosity in furniture design, lacquerwork, ceramics, glass, textiles, metalwork and decorative painting and sculpture dazzled fairgoers. The pavilions of leading manufacturers such as Baccarat, Christofle, Luce and Sèvres also displayed the latest in modern design. Art Deco and related design were also on view in some foreign displays, among the most notable being the influential Scandinavian wares of Sweden's Orrefors glass and Denmark's Jensen silver, Austrian *Wiener Werkstätte* wares and Italian works by Gio Ponti.

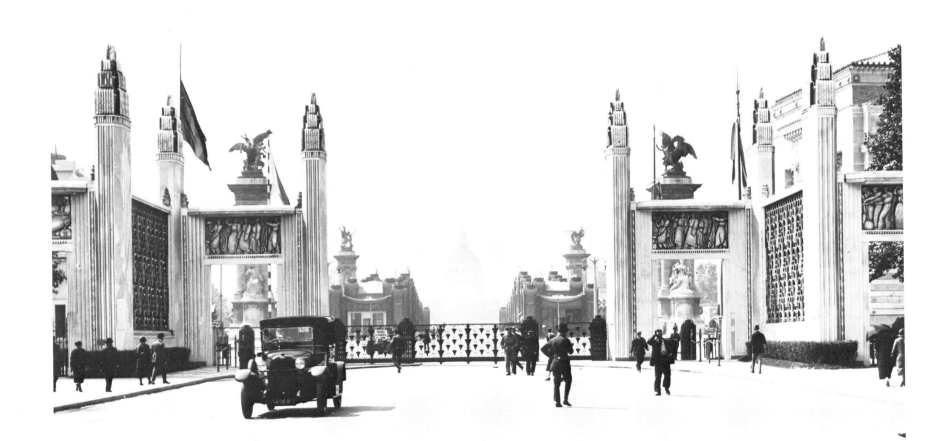

RIGHT: *Robots, seen here as sculpture at the 1925 Paris exposition, were introduced in Kapek's 1923 play* RUR. *Man as machine was to recur as a persistent motif throughout the Art Deco decades.*

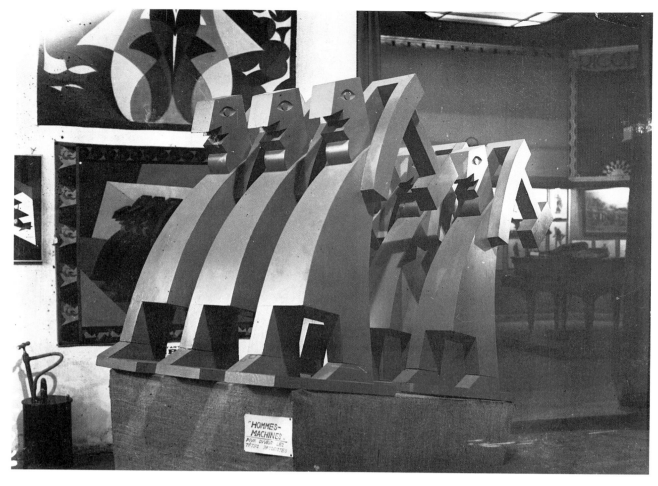

BELOW: *The elegance of Joseph Czarkowski's 1925 Polish pavilion demonstrated the international scope of Art Deco. The architect also designed a number of the tapestries and rugs displayed within, along with the work of other Polish decorative artists.*

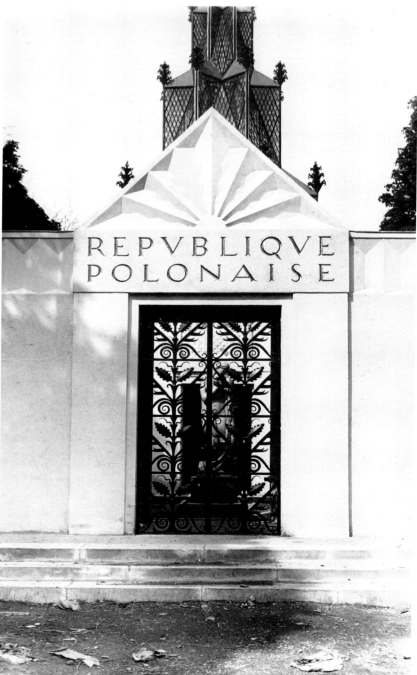

Opposed to all this dazzling opulence created for the monied elite was Le Corbusier's 'machine for living in,' the concrete, glass and steel *L'Esprit Nouveau* pavilion, constructed despite the vehement protests of the fair committee. The exposition administration concealed this stark villa behind fencing that was reluctantly removed only minutes before the fair's opening.

Also in the functionalist mode was Robert Mallet-Stevens's tourism pavilion with a cruciform clock tower. Here, though, ornament was permissible, and included stylized sculptural relief panels by the Martels and a continuous clerestory window glazed with a Cubist representation of a view seen from a speeding car. Painter Robert Delaunay expressed the exaltation of many when he heralded the Paris exposition as the triumph of Cubism. The fair demonstrated how much the decorative arts had been energized by this iconoclastic art movement.

Though the opulent French Art Deco style did not appeal to everyone, the influence of the Paris exposition was far reaching. Numerous articles and reports by observers, along with a 1926 traveling exhibition of the exposition highlights, fueled competition among leading department stores to introduce the style to the United States. Over the next years, dozens of displays inspired by the exposition circulated nationwide and sold items by Chareau, Leleu, Ruhlmann, Hoffmann, Puiforcat and others. In a relatively short time, the exposition led to the transformation of the fashionable domestic and commercial environment.

In the following decade, two subsequent international Paris expositions highlighted the work of Art Deco designers. The first was the 1931 *Exposition Coloniale Internationale* which showcased the cultures and artifacts of the French colonial empire. The displays ranged from reconstructions of monuments such as Angkor Wat to mud huts and native costumes, juxtaposed with primitivistically styled modern pavilions and the usual extravagant illuminations and colored fountains. Primitivism (a European response to the arts of Africa, the South Pacific, Far East and the Americas), had been a source of inspiration for Cubist artists and avant-garde designers since the beginning of the twentieth century.

Designers such as Marcel Coard, Pierre Legrain, Pierre Chareau and Jean Dunand had produced primitivistic Art Deco variations during the 1920s. The furniture specifically designed for this exposition incorporated a variety of exotic woods imported from the colonies – amaranth, bilinga, bubinga, Macassar ebony, palissander,

LEFT: *The 1925* Pavilion d'un Riche Collectionneur *designed by Pierre Patout served as a sumptuous setting for Ruhlmann's luxurious furniture. The relief panels were by Joseph Bernard and Jules Jeanniot executed the stone sculptural group.*

BELOW: *Paul Follot's display cabinet was exhibited at the 1925 Paris exposition. The use of stylized floral motifs on furniture and in other media reflected the origins of Follot and other French Art Deco designers in the Art Nouveau tradition.*

red padouk and wacapo, as well as mother of pearl and ivory set into lacquer. Appropriate interiors were designed by Ruhlmann, Leleu, Cheuret, Groult and Djo Bourgeois among others. René Lalique again designed lighting and fountains, and Dunand showed inlaid metal and lacquer screens, while Edgar Brandt, Claudius Linossier and Raymond Subes were among the metalworkers represented. A wide range of ceramics, glassware and textiles by leading Art Deco designers was also on exhibit. Despite the recent stock-market crash, the luxurious French Art Deco of the 1920s was still much in evidence at the *Exposition Coloniale Internationale.*

Nor had it become obsolete by the time of the 1937 *Exposition Internationale des Arts et Techniques,* which sought to foster the manufacture of attractive, useful mass-produced goods through the collaboration of art and technology. This functionalist emphasis was allied to an idealistic desire to counter the widespread negative effect of the economic Depression.

In architecture, the classical moderne variant of Art Deco had become prominent, not only in the newly built *Palais de Chaillot* and the Museum of Modern Art, but also in the monumental classicist pavilions of Germany and the Soviet Union, which confronted each other threateningly across the Champs de Mars. These pavilions were about the only ones ready on time. The contemporary joke that at least the Eiffel Tower was ready underlined the delays caused by the labor unrest typical of these years. Though some of the fair's planners had seen the exposition as a tribute to socialism and radicalism, the labor unions did not co-operate.

Architectural surfaces were once again enlivened with stylized reliefs and sculptures, and many of the interiors still featured elegant veneers, stylized murals, exotic materials and other Art Deco ornament, although a more somber note was introduced by the display of Picasso's *Guernica.*

Graphics and publicity were provided by Cassandre and Carlu, and among the well-known 1920s designers participating were Dunand, Groult, Süe, Follot and Leleu. Ruhlmann's successor André Arbus designed an elegant music room furnished with Art Deco interpretations of neoclassicism. A functionalist antidote was provided by Mallet-Stevens who designed the *Pavillon de l'Hygiène,* the *Palais de l'Electricité* and the *Pavillon de la Solidarité.* One of the most popular buildings was the immense *Palais de l'Air,* where contemporary and futuristic planes simulated flight above appropriate paintings by Robert Delaunay.

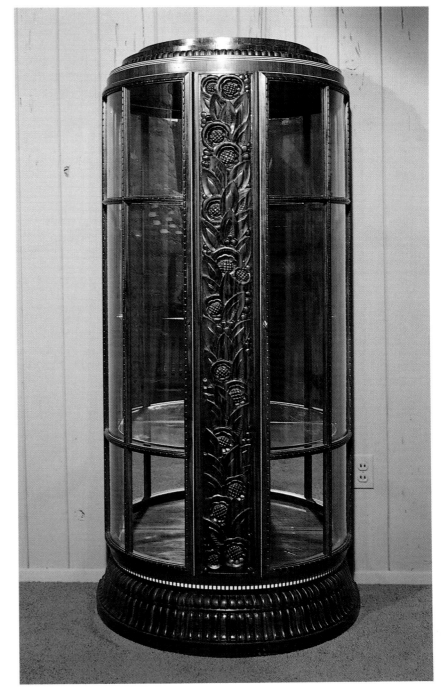

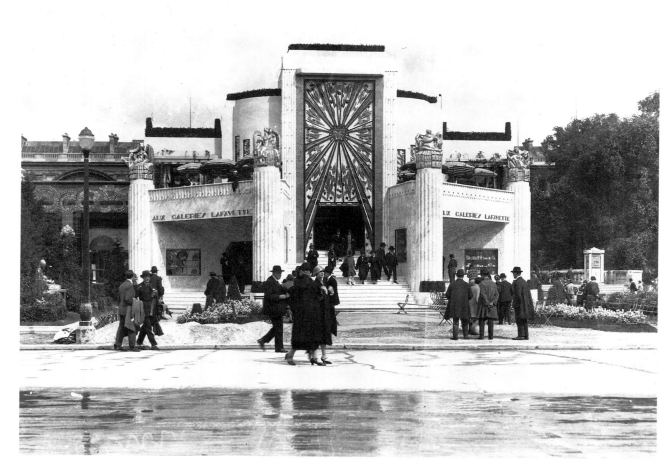

The alliance between French art and industry heralded by the 1937 fair still lay in the future; in the exhibits and the pavilions, the decorative and the functional did not so much interact as merely coexist. This underlying conservatism undoubtedly reflected the political uncertainties of the decade, which was to end in another world war.

During the 1930s, the Americans sought to equal and even surpass the Parisian expositions, beginning with the 1933 Chicago Century of Progress exposition and ending with the 1939 New York World of Tomorrow fair. The Chicago exposition was first proposed in 1927, when the prosperity of the 1920s was still at its height. Intended to commemorate a century of Chicago's existence as a city, the fair also was an opportunity to demonstrate the lessons American architects and designers had learned from the 1925 Paris exposition.

Architect Raymond Hood was selected to head a design board to plan the exposition layout and structures. Hood, himself the designer of several monuments of Art Deco architecture, was assisted by other Art Deco designers including Harvey Wiley Corbett, Paul Philippe Cret, John Wellborn Root, Hubert Burnham, Lee Lawrie and Ralph T Walker. The arrival of the Depression led to the abandonment of the more costly proposals; Norman Bel Geddes, for example, had several

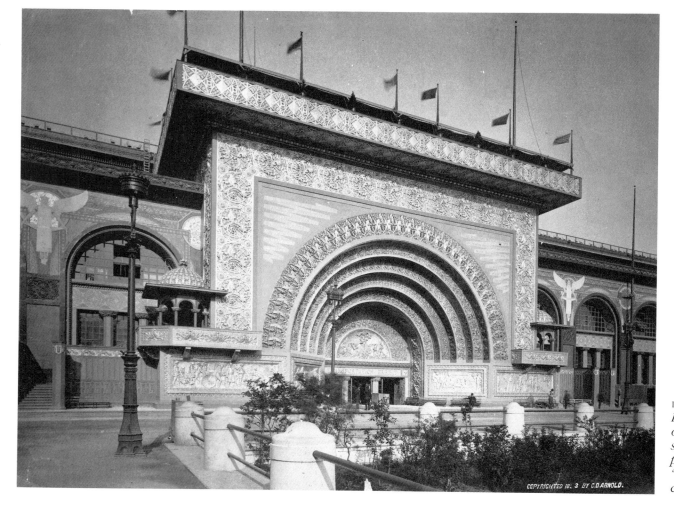

LEFT: *An architectural highlight of Chicago's 1933 Century of Progress exposition was the Travel and Transport Building by Bennett, Burnham and Holabird. The economic restraints imposed by the Depression led to experimentation with new construction materials and techniques.*

BELOW: *In Chicago, the imposing pylon gateway embellished with stylized heroic figures and sphinxes led into Raymond Hood's waterfront Electric Building.*

projects rejected, including one for a dance restaurant built on four islands interconnected by bridges and illuminated by tubular neon arches, and another for an underwater aquarium restaurant.

According to all accounts, the design commission achieved its goal of creating an exposition 'radically different' from earlier fairs, especially the Chicago 1893 World's Columbian Exposition where the Beaux-Arts-style 'White City' was relieved only by Louis Sullivan's orientalist Transportation Building. The 1933 buildings incorporated a variety of Art Deco motifs including skyscraper-style setbacks, Cubist-influenced volumes and cylindrical shapes, decorative geometric surface patterning, stylized relief sculpture, an innovative use of glass and other machine-age materials, and modernist interiors. The diversity of architectural forms was unified by the use of brilliant coloristic effects. Joseph Urban, the fair's director of color, and Walter D'Arcy Ryan, its director of illumination, arranged a sequence of 23 vivid hues painted on the pavilions, which were illuminated at night by an elaborate choreography of floodlights and neon, transforming the fair into a magical spectacle – the Rainbow City.

Among the fair's notable architectural designs were Cret's Hall of Science, Albert Kahn's General Motors building (which contained a complete automobile assembly plant), Holabird & Root's Chrysler building, Nicolai Faro's *Time, Fortune and Architectural Forum* building , which was surmounted with colossal photomurals, Kahn's cylindrical Ford Motor building symbolically designed to resemble an automobile gear, and George Fred Keck's 12-sided House of Tomorrow. Elroy's Ruiz's Owens-Illinois Glass Company building, with its setback skyscraper-style tower was appropriately constructed of multicolored glass blocks.

The Travel and Transport Building (by Bennett, Burnham and Holabird) mounted a green body on a yellow base, and steel trusses painted blue supported the building's suspended dome by means of cables linked to 12 towers, in much the same way as suspension bridges were erected. The walls were of sheet metal bolted and clipped together. The Travel and Transport Building was enlivened by the characteristic Art Deco rising sun motif, along with a band of geometric patterning. Among Raymond Hood's designs was the Electric Building, with its great curved court that resembled a dam with water flowing over it, an effect enhanced by the use of blue neon light. The dam was flanked by sculptural relief panels of gigantic stylized Art Deco figures representing atomic energy and stellar energy.

On the lagoon side of the court, a pylon gateway was decorated with Aztec-style geometric patterns and sculptural relief figures representing light and sound. The participating companies frequently used architecture as a symbolic and often not very subtle way of promoting their product and services to potential customers among the fair-going audience.

At the time, the Chicago fair buildings were hailed as the ultimate in modernism. Only in retrospect did it become apparent that the exposition's architecture was fundamentally backward-looking. It was

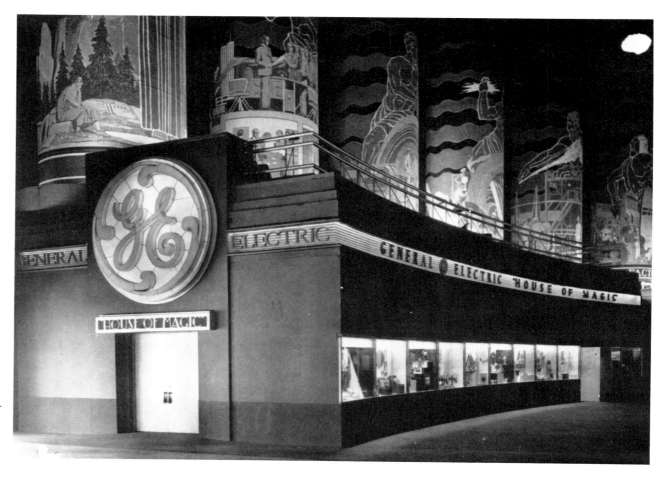

RIGHT: *In Chicago, General Electric's 'House of Magic' exhibit was accompanied by the monumental didactic murals typical of 1930s Art Deco.*

BELOW: *At the Chicago fair, atomic energy was allegorically idealized as a beneficial force. Admiration of technology and the machine was a strong current of the era's visual arts.*

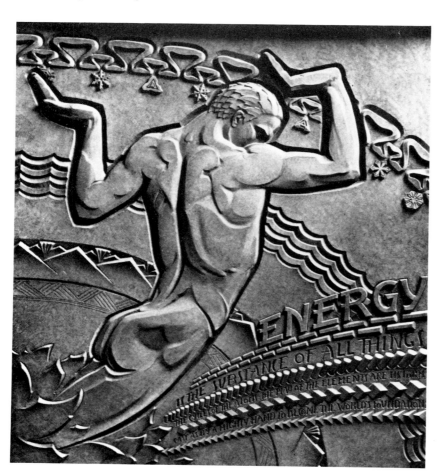

closely tied to the polychromatic Parisian-influenced zigzag deco style of the 1920s, at a time when the streamline style had already become the trend of the future. Indeed, the streamline style was introduced to the public at the Chicago fair in its original industrial context as a feature of aerodynamic transportation vehicles. The experimental version of the Burlington Zephyr – a high-speed, diesel-powered train of lightweight stainless steel construction, designed to travel at up to 100 miles per hour – made its debut in the fair's second season. Public interest was overwhelming; over 700,000 visitors waited in line to tour the Zephyr. Another high point was Buckminster Fuller's teardrop-shaped airflow three-wheeled Dymaxion car (the name derived from the words 'dynamism,' 'maximum' and 'ions'), which appeared in 'Wings of a Century,' a pageant recounting the history of transportation.

Financially the fair was a resounding success, although it received mixed reviews. Many architects who did not participate, including Frank Lloyd Wright, were severely critical. Ralph Adams Cram saw the fair as incorrigibly ugly, 'a casual association of the gasometer, the freight-yard and the grain elevator.' More charitable observers saw the vividly hued, bustling exposition as optimistically symbolizing a way out of the Depression. Despite the differing aesthetic judgments on the fair's architecture, the Chicago exhibition did offer a valuable opportunity to test new engineering and industrial building methods and to experiment with new construction materials. Thus the economic restraints imposed on the fair by the Depression led to advances in building technique that ordinarily would have taken decades to evolve.

The two American expositions that took place at the end of the decade in San Francisco and New York were quite different from one another in intent and outward appearance, though both granted a prominent place to Art Deco architecture, sculpture and related design. Located on the man-made Treasure Island in San Francisco Bay, the 1939 Golden Gate International Exposition's exotic fantasy architecture focused on the cultures of the Pacific, for which San Francisco was the major embarkation port and air terminal. The California fair was, in part, a celebration of the completion in 1937 of the Golden Gate Bridge, which surpassed by 700 feet New York's 1931 George Washington Bridge, capturing the record for the world's longest suspension bridge.

The architecture of the San Francisco fair was more closely allied to the tradition of ephemeral exposition architecture, which in earlier fairs had often sought to re-create past utopias. It was reminiscent of the 1931 Paris colonial exposition structures. The Golden Gate Exposition evoked some vanished pre-Columbian paradise or Oceanic Shangri-la, an effect achieved through the combination of stylized, primitivistic sculptures of monolithic figures with architecture related to the Mayan style, an Art Deco variant popular in California. Characteristic of the exposition structures were Blackwell and Weihe's sculpturally adorned Elephant Towers. These stepped, ziggurat-shaped towers were reminiscent of the skyscraper-style setbacks of the late 1920s while also suggesting the architecture of Southeast Asian temples.

Streamline-style Art Deco made a low-key appearance in the commercial exhibits, which generally were grouped together in larger, shared pavilions. Among the most striking of these were the United States Steel Corporation display designed by Walter Dorwin Teague

RIGHT: *A climax of the Chicago fair's second season was the introduction of the Burlington Zephyr, the nation's first diesel-powered streamlined passenger train.*

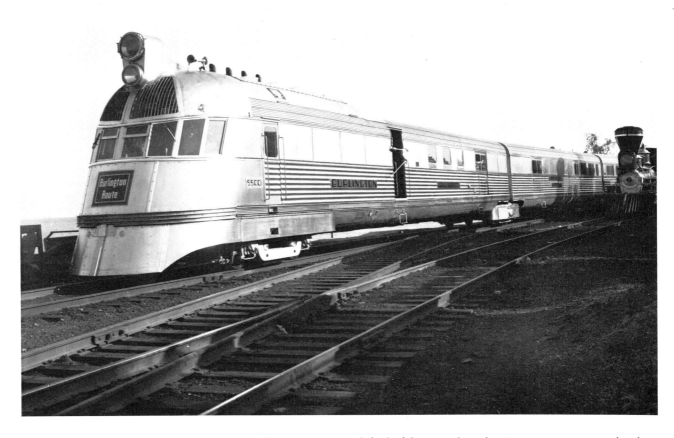

BELOW: *The 1939 New York World of Tomorrow fair featured futuristic streamline-style architecture, as seen in the Helicline ramp leading to the Perisphere.*

and the Dow Chemical Company exhibit by Alden Dow, which made extensive use of glass-block construction with dramatic illumination. Other pavilion ensembles were designed by Gilbert Rohde, Kem Weber, Rena Rosenthal and Paul Frankl. And the true architecture of the future – the austere and ideologically functional International Style – was present in Timothy Pflueger's federal complex of box-shaped, glass-walled buildings.

There was a widely held view that the San Francisco and other 1930s expositions were escapist fantasies which insensitively ignored the harsh social realities of the Depression era. Escapist they were, and as such they played an essential role in raising morale and offering hope for the future. Like the Hollywood comedies and Busby Berkeley dance extravaganzas of the 1930s, the expositions help to relieve the pervasive gloom.

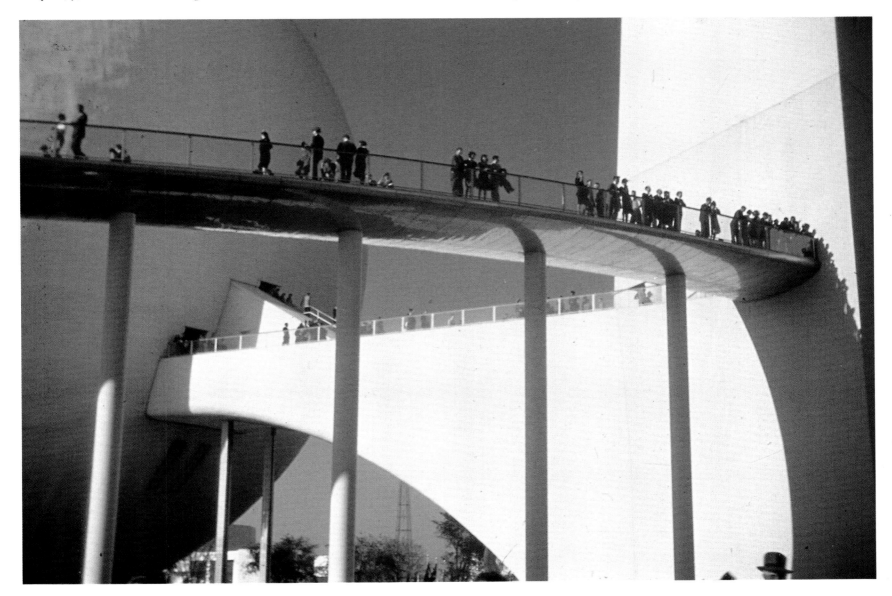

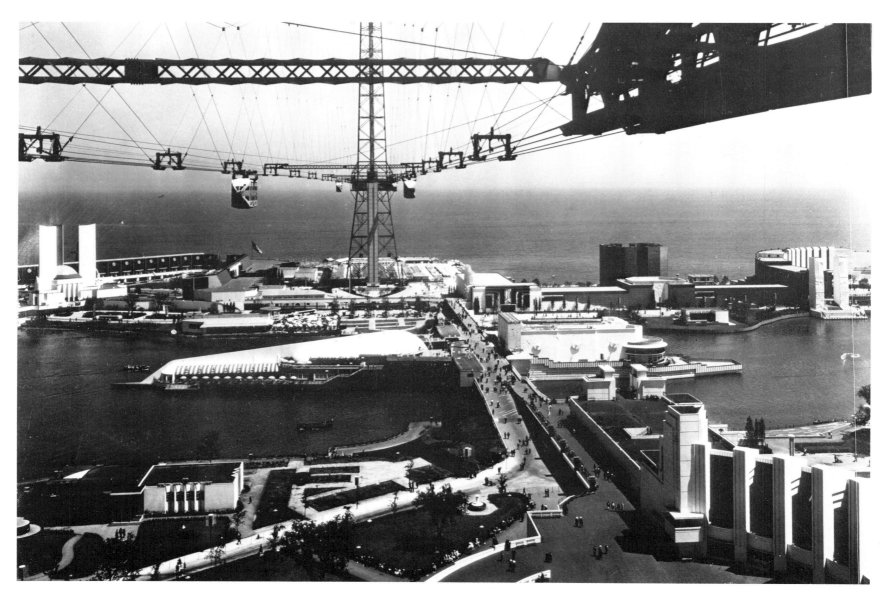

ABOVE: *The Skyride offered a dramatic view of the Chicago's fair's spectacular Lake Michigan setting.*

LEFT: *Ephemera and other fair souvenirs left a vivid record of the New York exposition.*

RIGHT: *The actual Trylon and Perisphere, at fair's end, were dismantled to provide 4000 tons of scrap metal for the war effort.*

The 1939 New York World's Fair, which showcased the streamline style, was far more ambitious in its physical expanse and thematic intent. Its chosen theme was the 'World of Tomorrow,' and it attempted to investigate the idea of a totally planned social environment. This futuristic industrial utopia was facilitated by machines and symbolically realized through the use of streamline-style architecture and design. Among the fair's planners and executors were the nation's leading architects and interior designers, including Norman Bel Geddes, Henry Dreyfuss, Raymond Loewy, Walter Dorwin Teague, Egmont Arens, George Sakier, Gilbert Rohde, Donald Deskey, Russel Wright, Albert Kahn, Harvey Wiley Corbett and Ely Jacques Kahn. Hugh Ferriss, highly regarded for his romantic renderings of Art Deco skyscrapers, was appointed official architectural delineator, while graphic designer Joseph Binder was commissioned to create a now classic Art Deco design that became one of the most widely displayed posters of modern times. And the roster of participating painters and sculptors was a most impressive one, including most of the leading practitioners of Art Deco, as well as many who were to become famous in the postwar years.

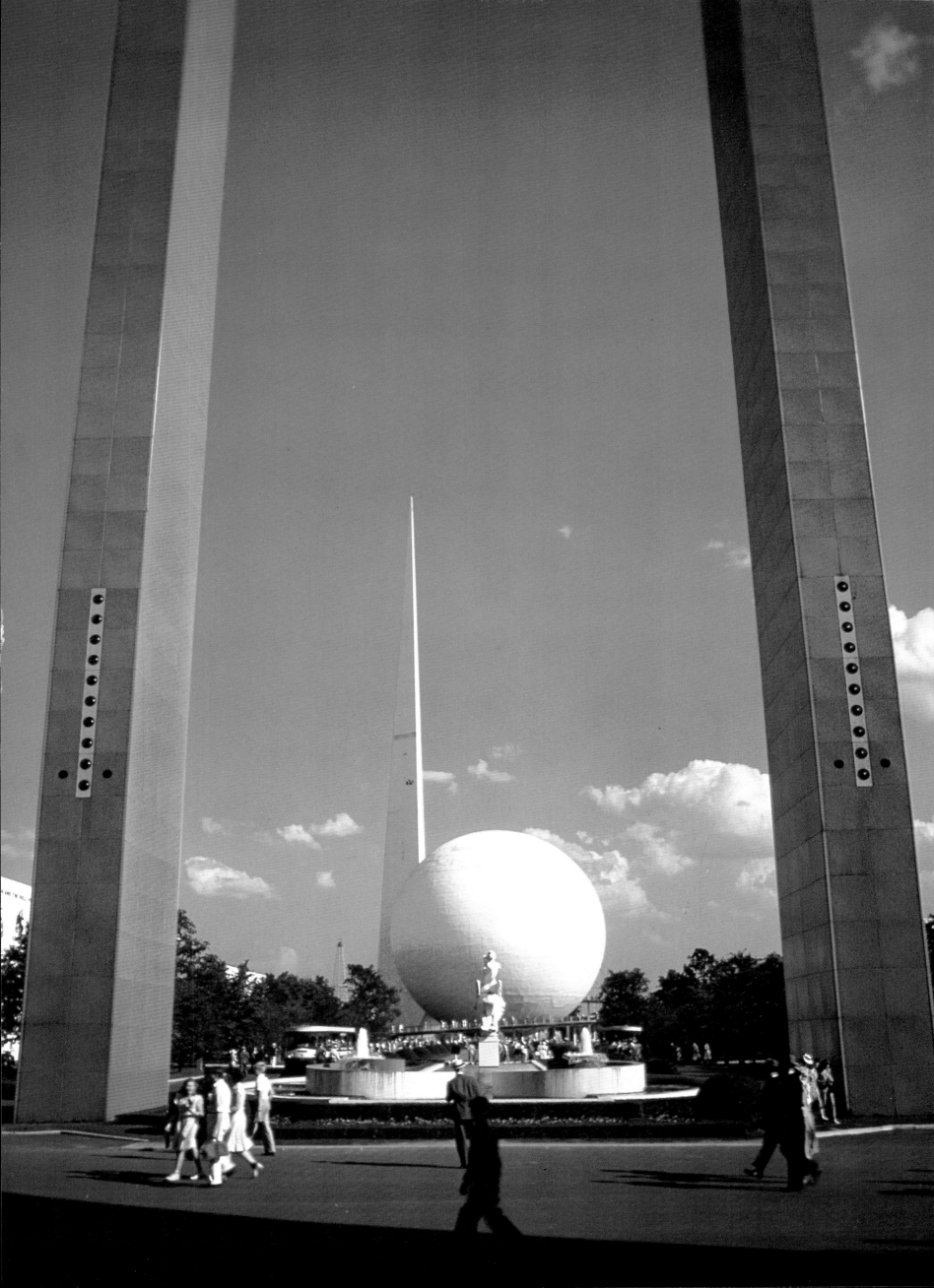

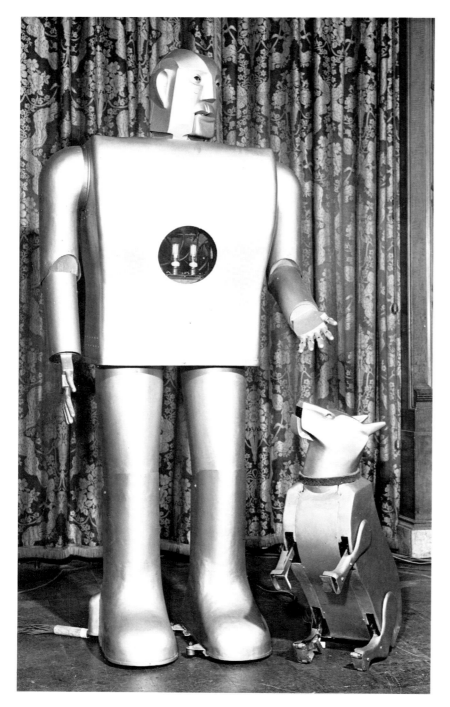

By far the most imposing structures of the fair were the stark white 610-foot tall Trylon (triangular pylon) and the 180-foot wide globe known as the Perisphere, along with its 950-foot long spiral ramp, or Helicline. The symbol of the fair, this colossal Cubist grouping designed by Wallace Harrison and J André Fouilhoux, owed much to Boullée's late eighteenth-century neoclassical fantasies. Visitors rode what was then the world's longest escalator part way up the Trylon and entered the Perisphere where they viewed Democracity, an enormous futuristic multimedia diorama. At night the exterior of the Perisphere served as a gigantic screen for multiple projections of changing colors and moving clouds, as well as of representational images tied to such special events as Thomas Edison's birthday. Architectural historian Lewis Mumford quipped at the time that the Perisphere was a 'great egg out of which civilization is to be born.'

The most impressive aspect of the fair was its streamline style architecture, which evoked a science fiction film set. The most dramatic examples of streamlining were to be found in the Transportation sector: Albert Kahn's sculptural General Motors pavilion, the site of Bel Geddes's Futurama exhibit; William Lescaze's Aviation Building; the Chrysler pavilion framed by twin finned towers; and Ely Jacques Kahn's Marine building, from which jutted two looming ocean liner prows so that it resembled a three-dimensional Cassandre poster. Art Deco styling was also adapted for many smaller commercial structures, which were frequently emblematic of their product. The Schaefer Center, for example, sported horizontal streamline-style banding and was topped by a tower in the form of a stylized frozen fountain reminiscent of the 1925 Paris exposition, here, however, it referred to the beverages offered within. Classical

moderne architecture was seen in the Theme Building and the monumental Soviet pavilion. Its tower, surmounted by the statue of a heroic worker, soared almost as high as the Trylon. Totalitarian monumentalism in the classical moderne style was also offered by the monolithic Italian pavilion.

Much thought by the participating industrial designers had gone into planning the logical sequence and organization of the buildings, effective pedestrian traffic flows and psychologically compelling multimedia display techniques to promote the utopian ideals, technological advances and new consumer products that were the core of the exposition. Ironically, the totalitarian rulers of the era were using related techniques of psychological control and behavioral conditioning to achieve their political aims.

Visitors to the exposition were predominantly enthusiastic. The 'World of Tomorrow' theme provided an alluring fantasy at the end of a dreary Depression decade; the new consumer products and technological marvels on display – including robots, a speech synthesizer, the superhighways of the Futurama exhibit, television and labor-saving household appliances – appeared accessible to many and seemed to promise a brighter future.

The new ideas in architecture and design introduced at the fair were actually quite limited in scope. As most of the temporary futuristic buildings were made of traditional exposition plaster and stucco, there was little opportunity to investigate new materials and construction techniques. Of the 15 model homes on display in the Town of Tomorrow, two-thirds were in traditional styles, with colonial revival a favorite. What imaginative design solutions there were had been applied to the exposition's accessory structures such as the Aqualon fountains, which resembled outsized radio vacuum tubes filled with swimming goldfish. As at earlier fairs, one of the most exciting aspects of the New York fair was the lighting design, this time featuring fluorescent tubing in an innovative variety of machine aesthetic fixtures. The lights were not restricted to interiors but were also incorporated into exterior building walls to achieve dramatic night-time effects.

The New York World's Fair was not just the grand finale of the streamline style; it also provided a final public forum for the imagery and themes of Art Deco in general. The exposition was the result of architects, designers and artists working in collaboration as they had done on so many earlier Art Deco projects. Once again the artists and designers expressed America's love affair with the technology of the modern age in allegorical representations and stylized versions of airplanes, locomotives, ocean liners, automobiles, bridges, radios, electrical power networks and factories. Present too were those mythologized images of man confidently occupying his niche in the cosmos and, more mundanely though still heroically, in the workplace. It was quite possibly the last time that man would be seen as so at home in the technological age, so optimistic about his future and so certain of his place in the universe.

The architectural critics of the period found little to admire in the exposition's futuristic architecture. They condemned its crass commercialism, its hybrid nature, its superficial modernity and its decorative touches. The foreign pavilions, however, many of which were executed in the austere International Style, received their wholehearted approval. This attitude was to become the status quo for the academic and critical architectural establishment over succeeding decades. In the aftermath of the Museum of Modern Art's 1932 International Style exhibition, functionalist proponents of the style were able to suppress to a remarkable degree most divergent and pluralistic tendencies in modern design. It is only in recent years that 1930s exposition architecture, and Art Deco architecture in general, has become a subject of professional appreciation; serious study now focuses on its complex symbolic implications and on its reflection of the historical milieu and cultural values of the decades between the two world wars.

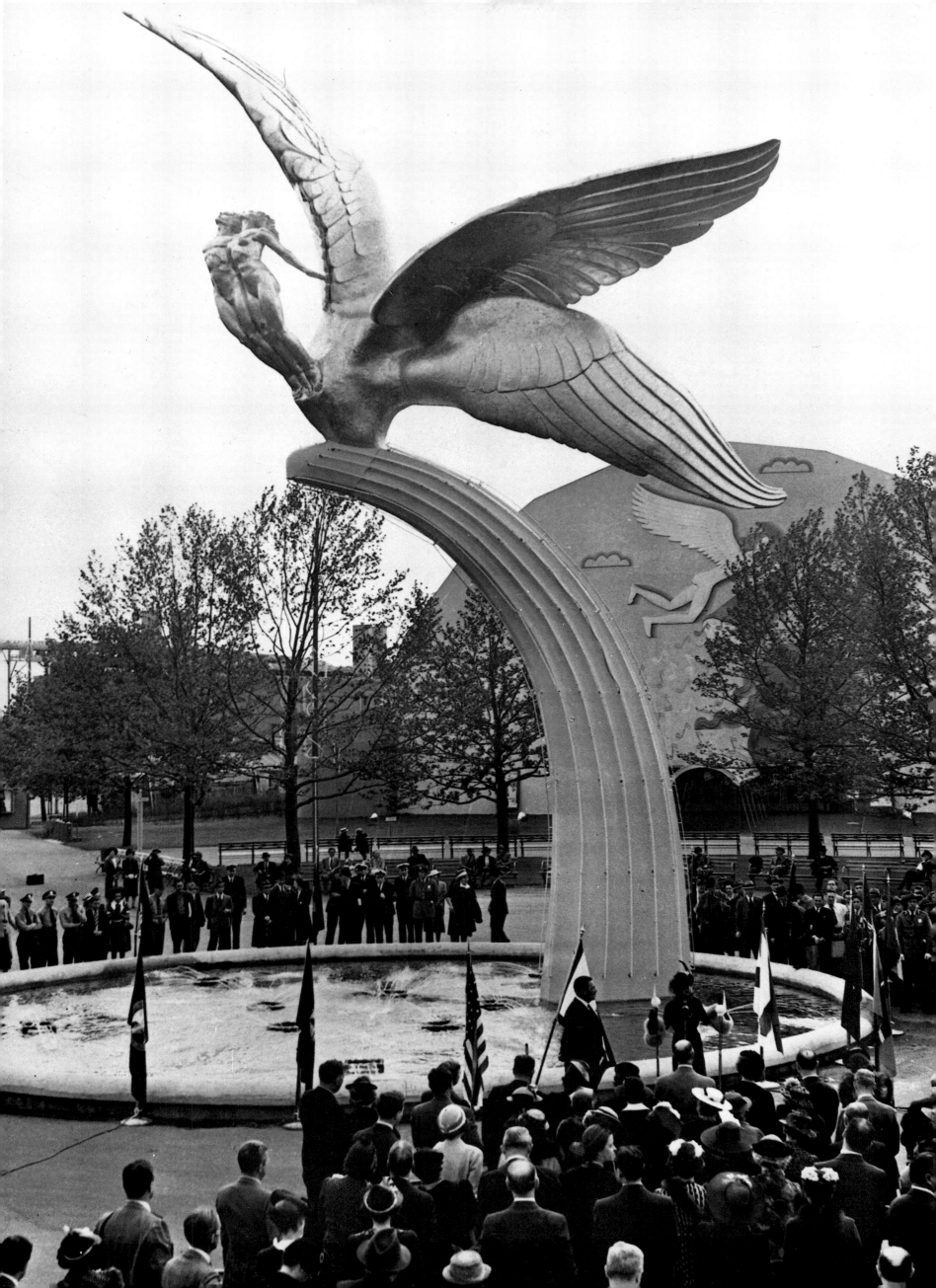

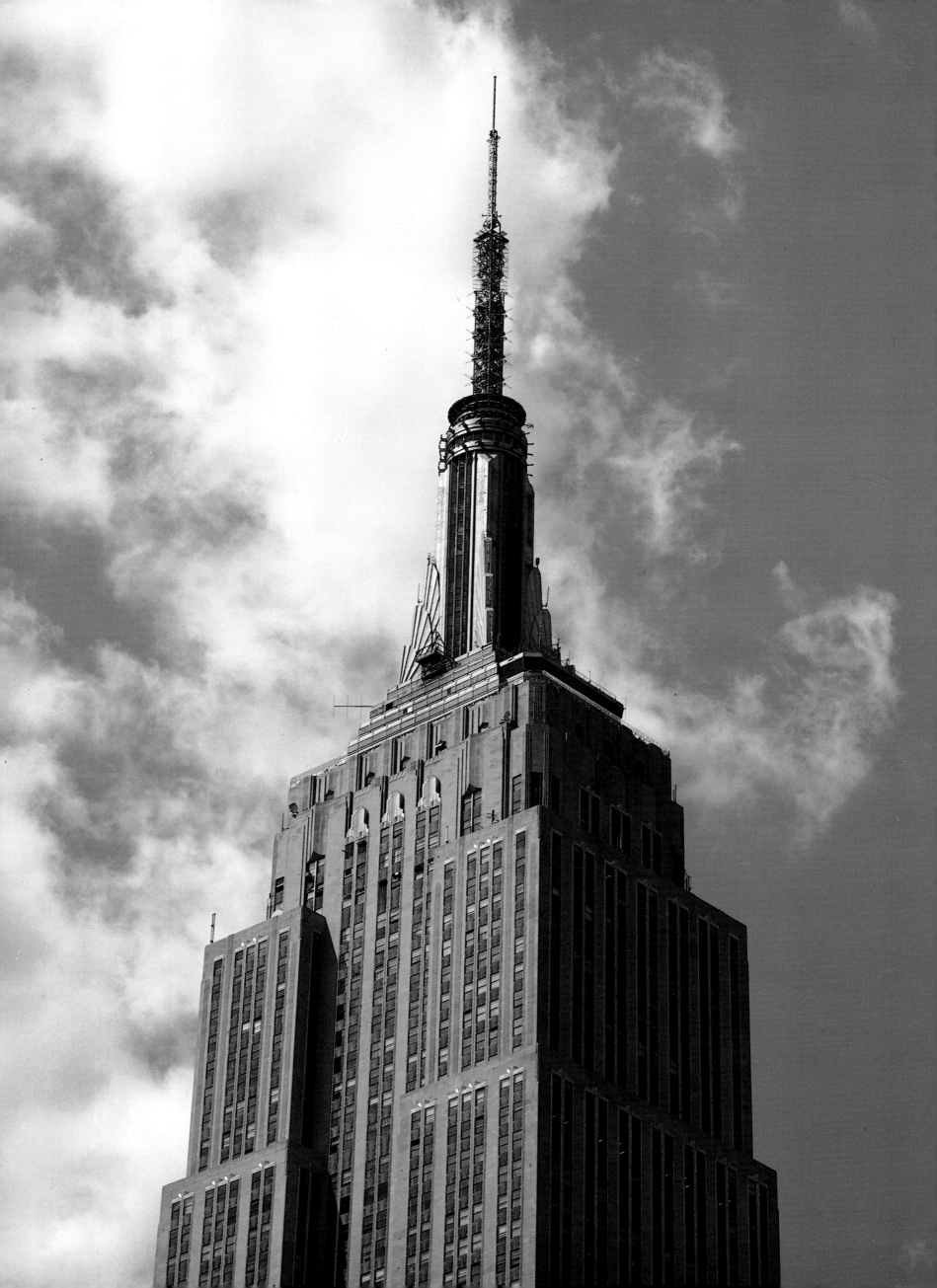

Exuberant Architecture

A true flowering of Art Deco architecture took place in the United States; America led the way in the large number of monumental and secondary buildings erected, in the sheer exuberance of their ornament, in the number of architects successfully working in this style and in the range of regional and stylistic variants explored. Impressive Art Deco buildings were also erected in Canada, Mexico, South American countries, Australia and even in Shanghai, China. In Europe, apart from the use of the style in exposition and theater buildings and shop fronts, a much smaller and more conservative group of Art Deco buildings was produced. On the continent, modern architecture soon came to be dominated by the anti-decorative functionalists led by Le Corbusier, Walter Gropius, Ludwig Mies Van der Rohe and the Dutch practitioners of *De Stijl*. Britain built a somewhat larger number of Art Deco structures, some influenced by American developments, others by those in Scandinavia. It should be noted that the Art Deco architectural style, whether in its classical moderne, zigzag, skyscraper style or streamlined manifestations, was not the only style of the decades between the wars. Although popular, it co-existed during these years with various historical revival styles, as well as with the austere International Style of the functionalists.

Apart from the obvious precedents set by experimental exposition pavilions, the roots of Art Deco architecture – with its characteristic use of abstraction and stylization, rich ornamentation, coloristic effects and dramatic massing of simplified geometric forms – were multiple. In the later eighteenth century, neoclassicism as practiced by such revolutionary architects as Claude Ledoux and Emile Boullée of France and Karl Schinkel and Friedrich Gilly in the Germanic states began a radical abstraction and stylization of the forms and motifs of classical architecture.

Various buildings following this trend were produced throughout the nineteenth century by architects from the Beaux-Arts tradition. Exotic ornament combined with flat surfaces and dramatic masses were seen in Egyptian revival buildings from the 1820s, especially in England and the United States, where the style was often used in cemetery gates and prisons. The use of color and ornament promoted by John Ruskin was exploited in buildings in Gothic Revival and orientalist styles in the later nineteenth century. In England architects of the Arts and Crafts movement began to produce modernized, abstracted renditions of medieval styles.

Art Nouveau, around the turn of the century, was the direct modern antecedent of Art Deco. In the late 1880s Antonio Gaudí produced a few geometrically abstracted buildings in Barcelona – in particular, the *Colegio de Santa Teresa* (1889-94) – that preceded his more famous sinuously organic buildings. Art Nouveau, like Art Deco, sought to base ornament on other than historical sources. A reaction to the opulent decadence of French and Belgian Art Nouveau arose with the rectilinear stylization of Charles Rennie Mackintosh in his 1897-99 Glasgow Art School and in Vienna with Josef Olbrich's 1898 Sezession Gallery, followed by Otto Wagner's Steinhof Church and Post Office bank, and Josef Hoffmann's 1905-11 *Palais Stoclet* in Brussels. These architects based their pioneering modernism on a stylization of classical forms. In Amsterdam, Hendrik Berlage's Exchange building (1898-1901) and Kromhout's American Hotel (1898-1901) were massive picturesque buildings with stylized sculpture and decorative brickwork. And in Finland Eliel Saarinen designed the Helsinki railroad station (1904-16). With origins in romantic nationalism, the Scandinavian version of Art Nouveau, and with its stylized sculpture and its unique tower, Saarinen's design was to inspire numerous Art Deco buildings.

RIGHT: *Saarinen's Helsinki station (1904-16) included Emil Wikstrom's* Guardians of Transportation.

BELOW: *Hoffmann's 1905-11* Palais Stoclet *in Brussels was an important Art Deco forerunner.*

FAR RIGHT: *Bertram Goodhue's design for the Nebraska State Capitol (1922-32) reflected Saarinen's innovations.*

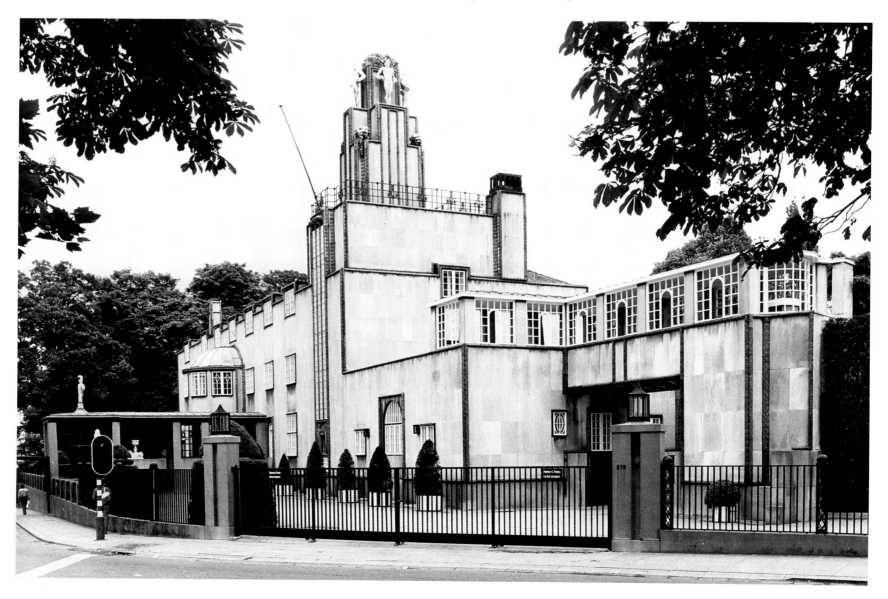

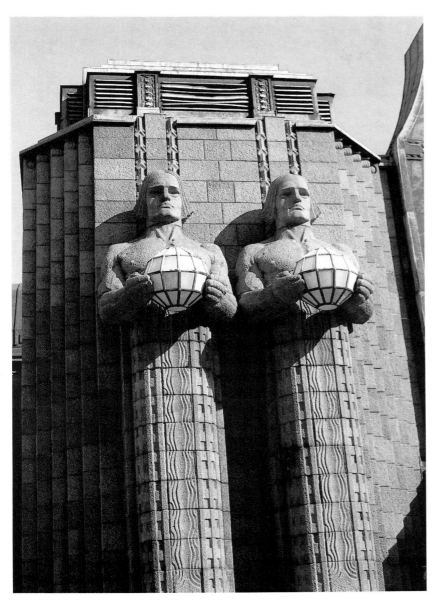

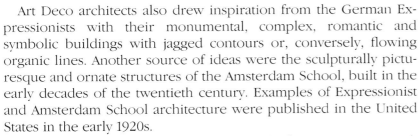

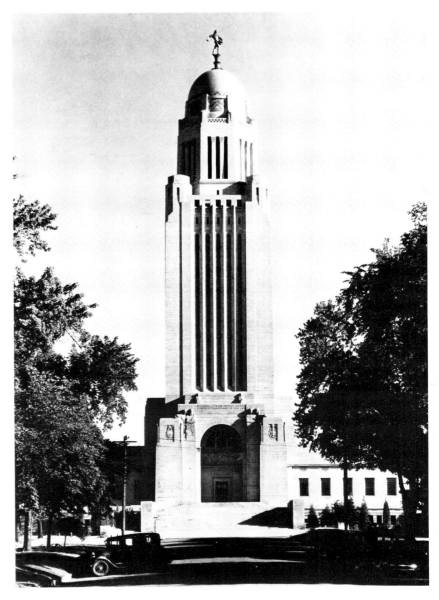

Art Deco architects also drew inspiration from the German Expressionists with their monumental, complex, romantic and symbolic buildings with jagged contours or, conversely, flowing organic lines. Another source of ideas were the sculpturally picturesque and ornate structures of the Amsterdam School, built in the early decades of the twentieth century. Examples of Expressionist and Amsterdam School architecture were published in the United States in the early 1920s.

But not all the modernist innovations took place in Europe. Frank Lloyd Wright, that great original of American twentieth-century architecture, designed the remarkable proto-Art Deco Fricke and Willitts houses (1902), the Larkin Building (1903-06), and the Unity Temple (1906). Quite unlike anything seen before, his designs and photographs of his buildings were published in Europe in 1910-11, astonishing the architectural avant-garde there. Wright, deeply interested in symbolic architecture, integrated ornament and total design of interiors, was a student of that pioneer and theorist of modern architecture, Louis Sullivan. Sullivan's inventive uses of architectural ornament were a significant precedent for Art Deco architects. In addition, Wright came from the Midwest, where the innovative architects of the Prairie School flourished during the early decades of the twentieth century. They also placed a high value on inventive ornament combined with abstraction of form.

The crowning achievement of American Art Deco, the zigzag skyscraper style, did not evolve until the mid-1920s. Earlier examples of American Art Deco architecture appeared in the form of classical moderne buildings. Classical moderne is also known as neoclassical moderne, stripped classicism, PWA (Public Works Administration) Art Deco, PWA moderne, and even Greco Deco. It was a style often used for civic buildings and banks, though it was used in other contexts as well. In the 1930s it became the official style of European totalitarian rulers, and was also used in many American New Deal buildings, and as such is discussed in the later chapter, 'Totalitarianism and the New Deal.' With its familiar monumental forms, classical

moderne represented permanence, solidity and dignity – particularly desirable qualities in times of social, political and economic turbulence. Of the Art Deco architectural variants, classical moderne was the most popular.

Representing a synthesis of the traditional and modern, the classical moderne style was characterized by classically balanced masses with an emphasis on symmetry and horizontality. The exterior columns customary to historical classical styles were replaced by flattened piers which were sometimes fluted, but usually lacked capitals or bases. The monumentality of the buildings was enhanced by flat, simplified wall surfaces, usually executed in or faced with stone, granite, marble or terrazzo. Stylized relief and freestanding sculpture frequently adorned the exterior, although to a more limited degree than in the zigzag style; usually the entrance areas were embellished while the other wall surfaces remained unadorned. At times the classical moderne interiors were surprisingly flamboyant, with a profusion of murals, relief sculpture, mosaics, ornate metalwork, attractive modernistic lighting fixtures, and with the walls and floors executed in a variety of unusual materials including marble and exotic, often contrasting, wood veneers. The imagery of the artwork was usually symbolic of the function of the building or of its region and the local history of the area.

Early examples of classical moderne buildings were found among the designs of architects of the Beaux-Arts tradition. Notable were McKim, Mead & White's Whittemore Library and Bowery Savings Bank of the early 1890s; Albert Kahn's Detroit Hudson Motor Car Company office building (1910), his orientalist National Theater (1910) and his Detroit News Building (1915); and Burnham & Root's 1911 Columbus Memorial and Rock Island Savings Bank. (The style was seen as appropriate for banks because its monumentality symbolically suggested a decorated strongbox.) The eclectic Kahn, who came to be known as the giant of American industrial architecture, later provided skyscraper deco buildings for Detroit, as well as streamline-style pavilions for the expositions of the 1930s.

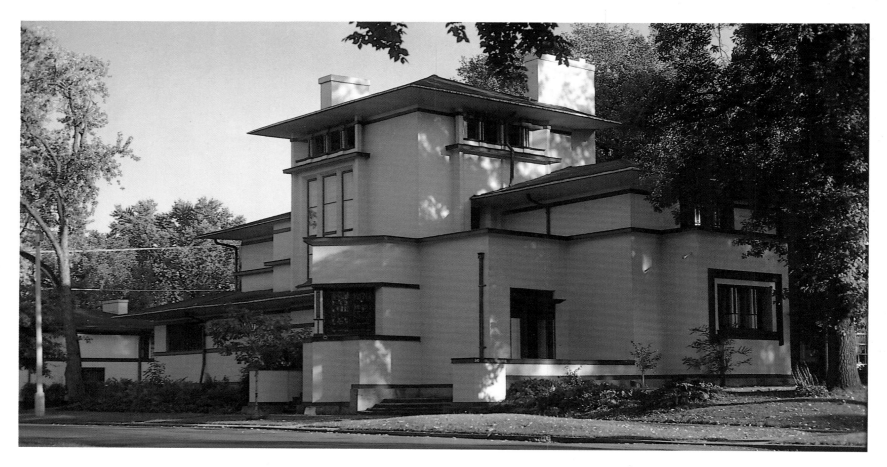

But it was Bertram Goodhue's bold design for the Nebraska State Capitol in Lincoln (1922-32) that fundamentally established the prototype for governmental construction in the classical moderne style. The Capitol building was an innovative amalgam of modernistic and classical, of skyscraper and temple, with a stable, simplified mass, an arched entrance and a dramatic, soaring golden-domed tower. Goodhue's design, which won the 1920 competition, was tied to modernist architecture in the Scandinavian and Germanic countries, and was therefore an appropriate choice for Nebraska, where so many immigrants from northern Europe had settled. Influenced by

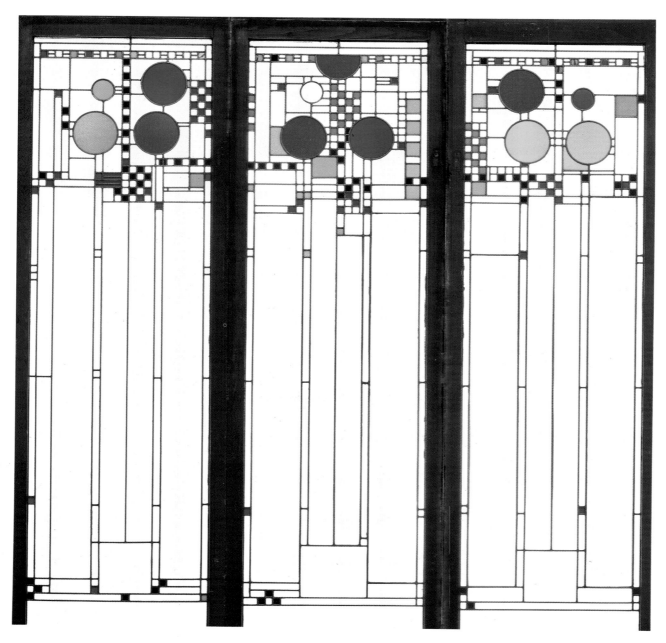

ABOVE: *Frank Lloyd Wright's Fricke residence was another important prototype of the Art Deco architectural style.*

LEFT: *Wright's concern with the unity of architectural and decorative design led to such masterpieces as his 1912 stained-glass windows for the Avery Coonley Playhouse.*

RIGHT: *In New York City, William Van Alen's 1930 Chrysler Building is the archetypal Art Deco skyscraper of the zigzag era.*

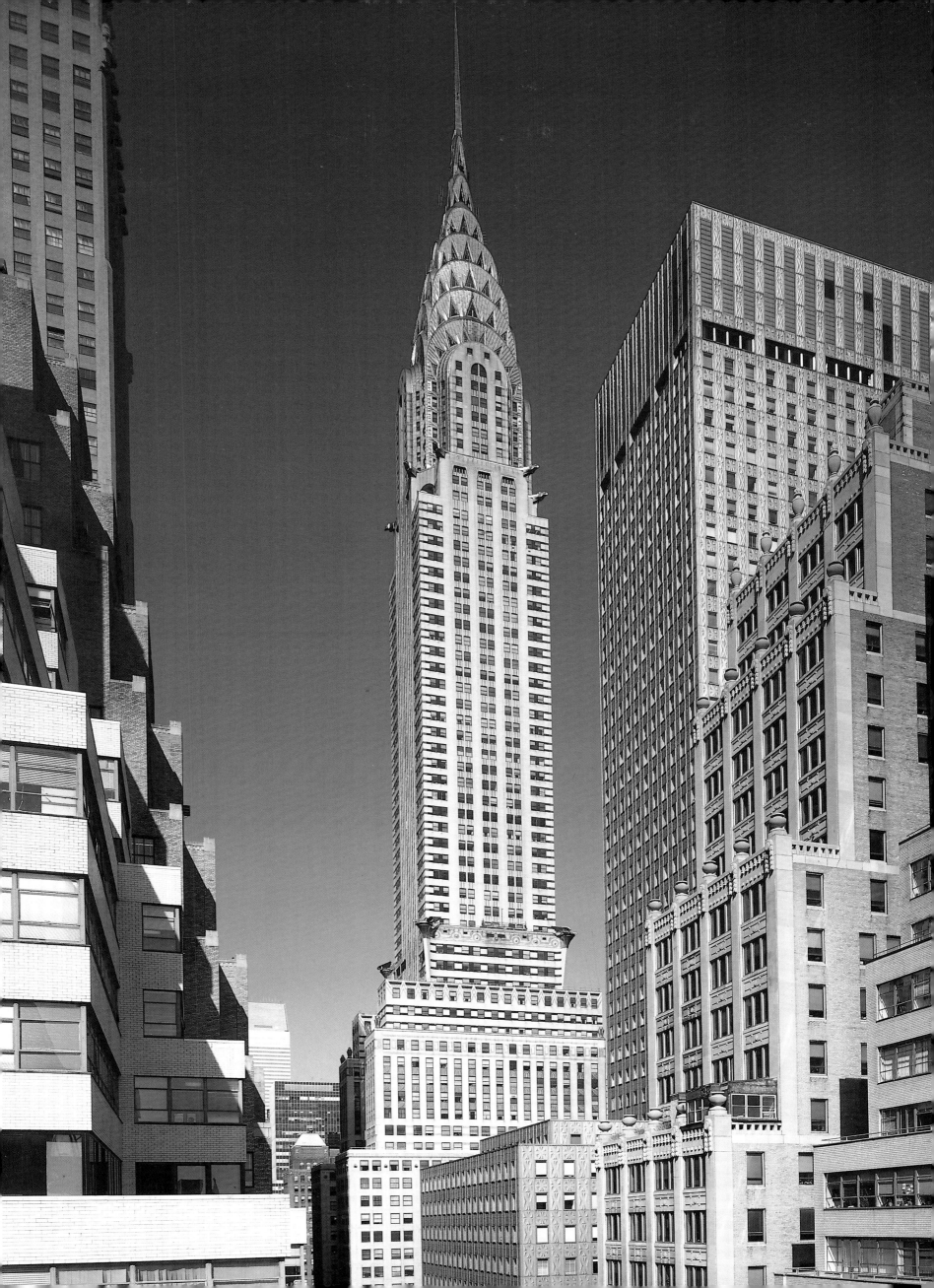

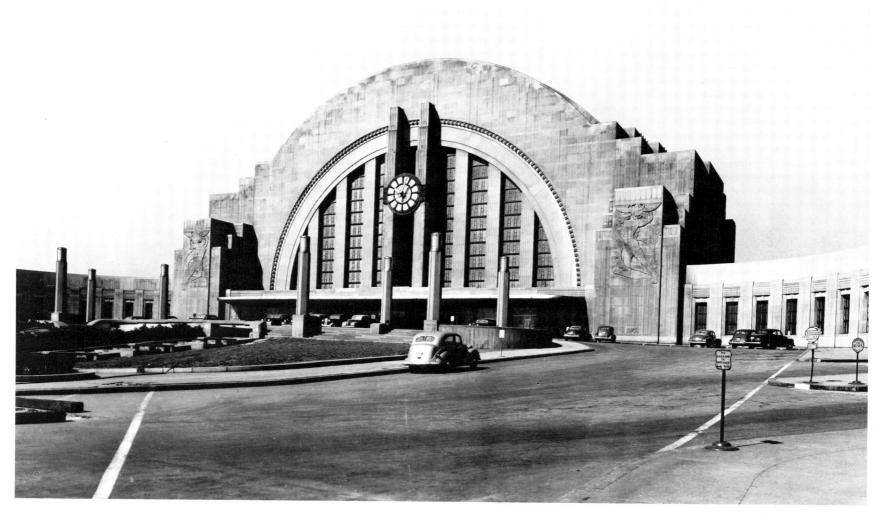

Eliel Saarinen's Helsinki station, the exterior of the Nebraska Capitol incorporated stylized stone carvings and low reliefs. This ornament was restricted to the four entrances and contrasted with the plain wall surfaces. Goodhue personally supervised the artistic program of the building, choosing not only sculptor Lee Lawrie, but also Augustus Vincent Tack to paint murals and Hildreth Meiere to design colorful mosaic ornamentation for the ceiling vaults. Following Goodhue's death – reportedly hastened by aggravations associated with the Nebraska project – the work on the illustrative murals, mosaics and friezes adorning the ceremonial chambers went on for 40 years.

Government buildings influenced by Goodhue's Nebraska design included the 1933 Louisiana State Capitol in Baton Rouge, Los Angeles City Hall, and the North Dakota Capitol in Bismarck. Other important civic structures in the classical moderne style included the Oregon State Capitol and the city halls of Buffalo, St Paul, Kansas City, Nashville, Houston and Oklahoma City. And with the public works programs of the Depression years, the style came to be represented in hundreds of post offices, libraries, schools, courthouses, museums and other civic structures across the United States.

Among the leading classical moderne architects was Paul Philippe Cret. His most important commissions, many of them completed in collaboration with other architects, included the Detroit Institute of Arts (1922), the Philadelphia Rodin Museum (1929), the Folger Shakespeare Library in Washington (1932), the dramatic Hall of Science at the 1933 Chicago Century of Progress exposition and the Federal Reserve Building, also in Washington (1937). Classical moderne was appropriate for war memorials, and Cret designed a number of such monuments including those at Providence, Rhode Island (1927), Cheateau Thierry, France (1928) and Gettysburg, Pennsylvania (1937).

When his firm was hired to tackle problems of interior design, Cret became quite ornate in his use of Art Deco detailing. A prime example was Cincinnati's classical moderne Union Terminal, designed by Roland Anthony Wank of Felheimer & Wagner in 1933. Brought in as a consultant to the railroad, Cret was responsible for enriching the interior with such modernist accoutrements as mosaic

murals and a glittering rotunda ceiling by Winold Reiss, tooled leather jungle motif murals by Pierre Bourdelle, a tearoom decorated with Rookwood tiles and, by Cret himself, specially designed aluminum and leather furniture, ornate metalwork and elegantly streamlined elevator interiors. In his work for the railroad from 1933 to 1945, Cret's firm designed the interiors of 64 different railroad cars for Philadelphia's Edward G Budd Company.

Characteristic of the roaring twenties, the flamboyant, jazzy version of Art Deco known as the skyscraper or zigzag style was comparatively short-lived compared to classical moderne; most zigzag style buildings were completed between 1925 and 1931, though its typical ornament lingered on in classical moderne and streamline-style settings throughout the 1930s. Though zigzag geometric stylization had isolated pre-World War I American precursors – in Frederick Scheibler's Pittsburgh apartment houses and in Chicago's Franklin Building by George Nimmons – the leading impetus came from abroad. The ideas of German architect Gottfried Semper were influential; he advocated the ornamental symbolic stressing of building entryways, roof lines and 'curtain walls' with patterns resembling woven textiles. These concepts came to life in the opulently embellished entrances, luxurious elevator lobbies and decorated pinnacles of Art Deco skyscrapers, and made the buildings visually attractive to the public at street level as well as from a distance.

Key European modernistic influences came from the French Art Deco designers influenced by Cubism and the Russian Ballet, the elegant abstractions of the *Wiener Werkstätte* and from German Expressionist architecture and set design. More indigenous contributions came from pre-Columbian architecture and from the imagery of the machine age. An eclectic recombination and stylization of these diverse motifs achieved a look that was not only aggressively modernistic but also symbolically futuristic.

The actual form the skyscraper took in the late 1920s was determined by two earlier developments. The first was a 1916 New York City zoning ordinance that mandated building setbacks, to be determined by the width of the street. This kind of stepped-back contour resembled a ziggurat topped by a tower. The second decisive event

was the 1922 international architectural competition to design a new building for the Chicago Tribune newspaper company. The winning design by Americans John Mead Howells and Raymond Hood was for a Gothic Revival skyscraper, complete with flying buttresses at the summit. Chosen from 263 submissions, this design reflected the then-current trend for skyscrapers in gothic and classical styles. But it was the design that won second place, by Eliel Saarinen, that attracted the most interest. Though also gothic in conception, the Saarinen design, which was praised by Louis Sullivan, liberated the skyscraper from strict reliance on historical styles and pointed the way towards a modernistic abstraction that adapted and combined a variety of decorative motifs. In 1923 Saarinen traveled to the United States to accept his prize, and decided to remain. Beginning in 1926, he designed the buildings and other facilities for Cranbrook Academy near Detroit and went on to produce some of American Art Deco's finest furniture and household accessories.

A good deal of credit for popularizing the skyscraper style must go to Hugh Ferriss, whose romantically abstracted and visionary renderings of Art Deco buildings were persuasive in selling new design concepts to clients, as well as in generally influencing public acceptance of modern architectural trends. Though trained as an architect, Ferriss never had any actual buildings constructed to his design.

In 1923 construction began on New York's first zigzag-style building, the New York Telephone Building, also known as the Barclay-Vesey Building, designed by Ralph T Walker. Work did not begin on the city's second such structure until 1926. This, the Insurance Center Building, was designed by Ely Jacques Kahn. One of the most talented and productive of Manhattan's Art Deco architects, Kahn designed over 30 such commercial structures before 1931, including such outstanding examples as the Park Avenue Building, the Film Center Building, the Squibb Building and the Casino Building. Because two real estate developers commissioned most of his buildings, Kahn was able to develop a recognizably individual interpretation of Art Deco.

The first true skyscraper in the zigzag style was Sloan & Robertson's luxurious Chanin Building, started in 1927. The archetypal Art Deco skyscraper was William Van Alen's flamboyant Chrysler Building, with an ornamental frieze of automobile hub caps and mudguards, and accents of winged radiator caps at the base of its fantastic soaring spire. And the Empire State Building, topped with a machine-age mooring mast for dirigibles, provided a fitting end to the heroic era of the Art Deco skyscraper.

Raymond Hood was of great importance to Art Deco despite his relatively small architectural output, which included the American Radiator Building and its counterpart in London, the *Daily News*

LEFT: *Fellheimer & Wagner's Cincinnati Union Station (1929-33) is among the many Art Deco monuments unfortunately demolished during the postwar decades.*

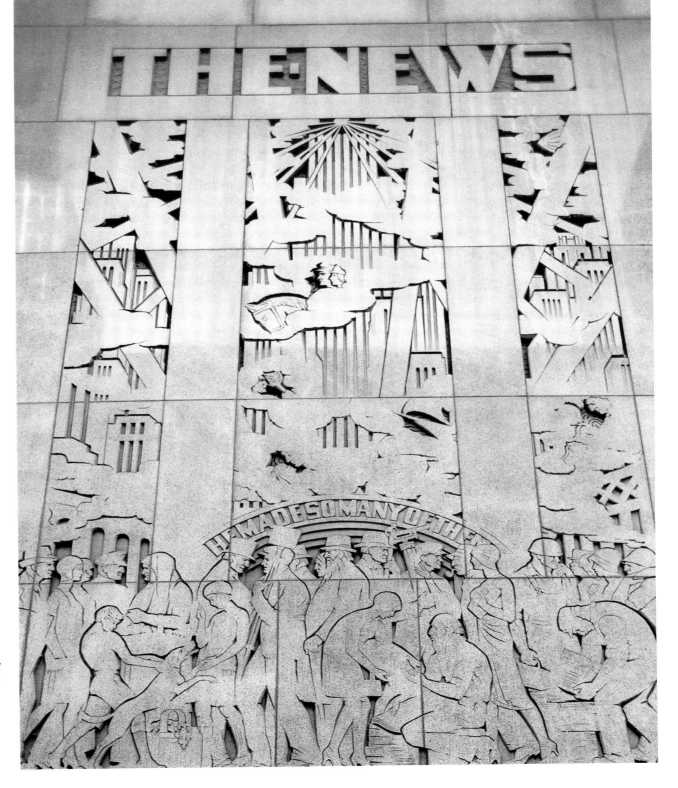

RIGHT: *While the asymmetrically setback tower of Raymond Hood's* Daily News *Building (1929-31) in New York suggested the International Style, at street level the building was pure Art Deco. This incised granite relief depicting the skyscraper city surmounted the entrance, while in the jazzy black glass-walled lobby, a colossal recessed revolving globe dramatically illuminated from beneath attracted hordes of tourists.*

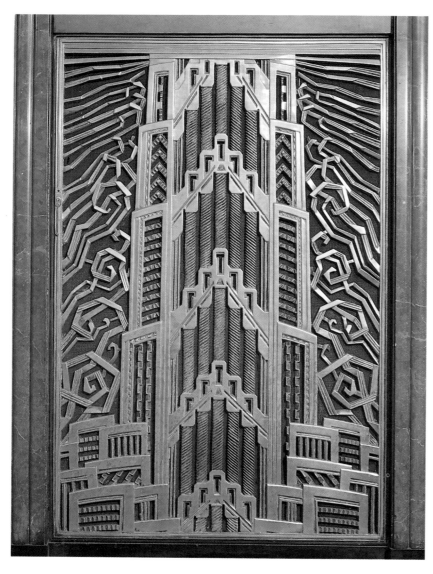

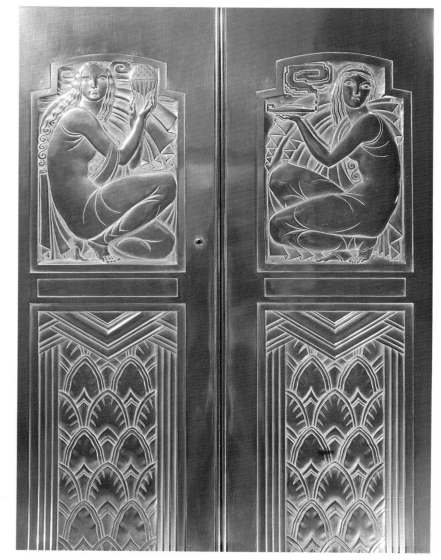

Building with its theatrical black glass lobby surrounding a colossal globe, and the McGraw Hill Building. He collaborated with a large group of architects on the design of Rockefeller Center, now considered as one of the greatest achievements of American Art Deco. The accessible complex of office buildings, theaters, restaurants, shops and an outdoor pedestrian mall was not so important for its monolithic towers as for its success as a planning concept. Its Art Deco highlights include exterior sculptural ornament by leading sculptors, as well as modernistic interiors by top Art Deco designers and artists in a variety of media.

ABOVE LEFT: *These grilles in Sloan & Robertson's 1926-29 Chanin Building typify the taste of the flamboyant zig-zag era. The lobby design was by Jacques Delamarre and the architectural sculpture by René Chambellan.*

ABOVE: *Elevator doors of the Farmer's Trust Building in New York City.*

BELOW LEFT: *Ventilator grilles in Radio City Music Hall at Rockefeller Center in New York.*

BELOW: *Spectacular lobbies, as seen in New York's 275 Madison Avenue, were an Art Deco speciality.*

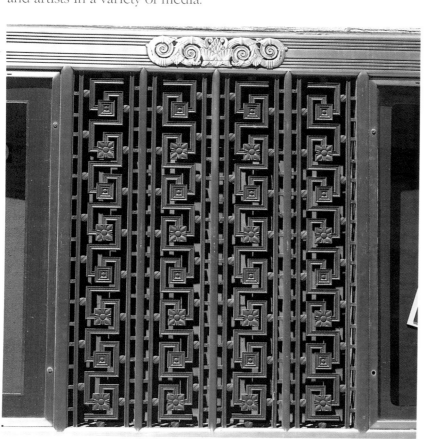

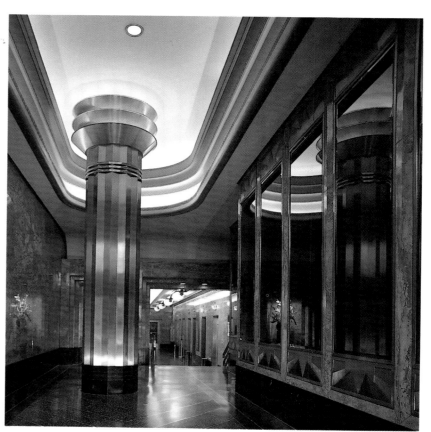

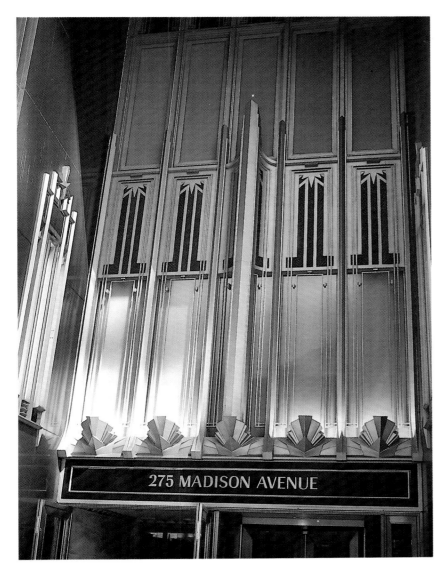

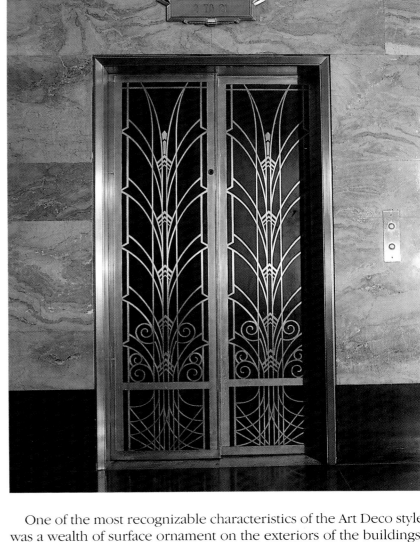

ABOVE: *Theatrical lighting effects were frequently exploited by Art Deco designers.*

ABOVE RIGHT: *The elevator doors at 275 Madison Avenue were part of the integrated lobby design.*

One of the most recognizable characteristics of the Art Deco style was a wealth of surface ornament on the exteriors of the buildings, echoed in their interior fittings. The crisply patterned motifs included zigzags, triangles, stripes, segmented circles and spirals, while among the stylized naturalistic motifs were flowers, trees, fronds, fountains, gazelles, birds, clouds and sunrises. Astrological imagery, along with idealized personifications of natural and technological forces, was also popular. Expressive of the machine age and its dynamism were lightning bolts, airplanes, locomotives, ocean liners, automobiles, skyscrapers and bridges. The machine-age

BELOW AND BELOW RIGHT: *Symbolic and cosmic imagery was a typical feature of Art Deco. The star motif on the lobby floor of 275 Madison Avenue is echoed on the entrance lobby mail box.*

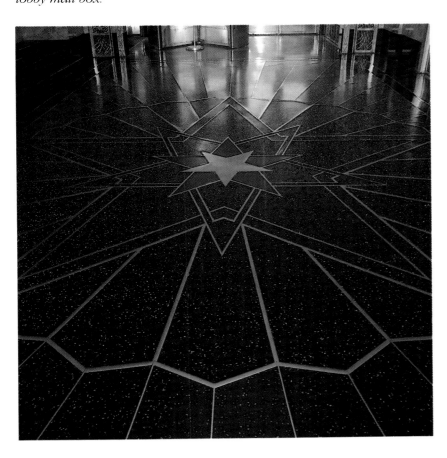

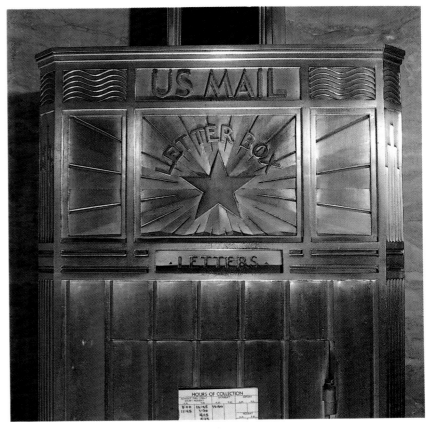

imagery also extended to the building summits, which were frequently surmounted by futuristic masts or finned parapets. Full of aspiration and optimism, the Art Deco imagery depicted man's place in the cosmos and his confident control of the machine, which was to usher in the dawn of a new era.

Often striking in its color, the Art Deco ornament was executed in a rich variety of media, including marble, terracotta, cast plaster, tile, mosaic, metal, etched or stained glass, stencil, paint and contrasting wood veneers. The use of metal and glass became more widespread in the 1930s. Theatrically illuminated, the exquisitely crafted tapestry-like wall ornamentation was part of a total co-ordinated design – which extended from the entrance doors through the vestibules, lobbies and elevators to the carpets, furniture and even the mail boxes – frequently realized through the collaboration of designers, artists, and craftspeople commissioned by the architects. Among the architects who designed their own ornament were Ely Jacques Kahn, Stiles Clements, Ralph Walker and Frank Lloyd Wright.

Zigzag deco was not just a Manhattan phenomenon; buildings in the style were soon erected nationwide. Art Deco, in all its variants, was a frequent choice for the technological and commercial firms that came of age in the 1920s and 1930s: radio broadcasting facilities, telephone companies, newspapers, cinemas, nightclubs, resorts, restaurants, hotels, department stores and especially the transport-related industries such as aviation, bus travel and the automobile. It

was the style for clients who wanted to project an updated, progressive image. Some of the more ambitious buildings were commissioned by utility companies. A picturesque example was Niagara Mohawk's building in Syracuse, New York. Conceived as a temple of electricity, the building's façade displayed bands of glass panels covering helium tubes and incandescent bulbs in a dramatic night-time illumination system. A colossal stainless steel sculpture of the winged *Spirit of Light* was mounted above the entrance. Theatrical lighting effects were soon recognized as a useful form of self-promotion by utility companies such as Tulsa's Public Service Company and Kansas City's Power & Light, whose building was topped with a flame-red beacon.

Indeed, theatrical architectural illumination – by floodlighting, from within through translucent glass or structural glass blocks, or with colored neon tubing as on cinema marquees – became a quintessential Art Deco feature. Effects such as coloring, silhouetting, contrasting of light and shadow to emphasize masses and highlight compositional features, and toplighting of building summits were explored at the expositions of the period, and soon became characteristic adjuncts to zigzag-style skyscrapers.

Important groups of zigzag and other Art Deco buildings were erected in Washington, Baltimore, Pittsburgh, Kansas City, Seattle and elsewhere. In San Francisco, James Miller and Timothy Pflueger were the leading Art Deco architects; Holabird & Roche also

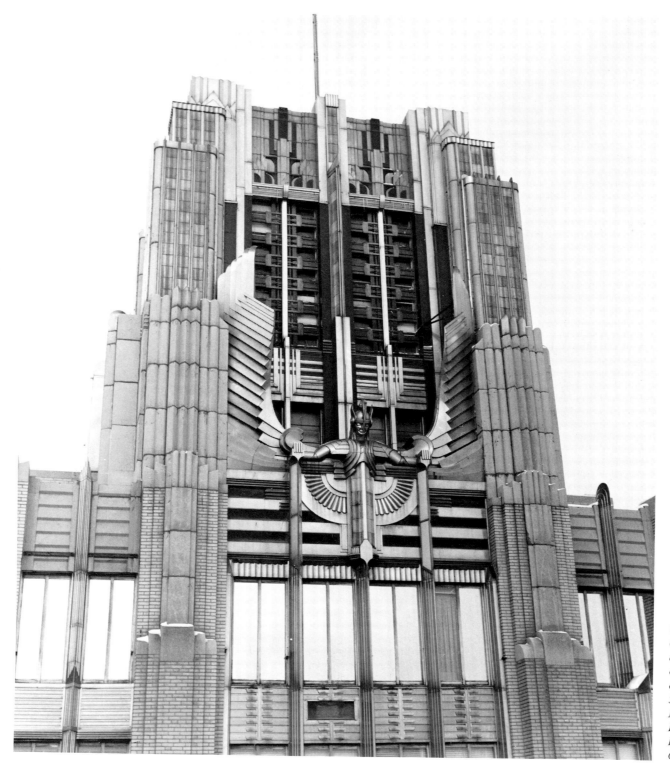

LEFT: *Among the more picturesque examples of American Art Deco architecture were the buildings commissioned by public utility companies. A prime example in Syracuse, New York, was the 1932 Niagara Hudson Building by Bley & Lyman, consultants to King &King, with sculpture by Clayton Frye.*

RIGHT: *As seen in this nighttime view of George Winkler's Public Service Company Building (1917-23) in Tulsa, Oklahoma, utility companies often made dramatic aesthetic and promotional use of one of their chief products – electric power.*

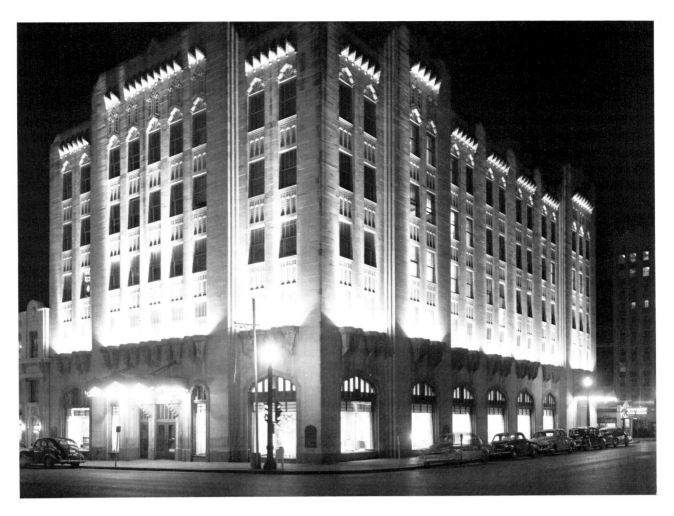

produced a number of important buildings in Chicago. Detroit, in addition to Albert Kahn's works, boasted the richly ornamented Union Trust Building by Wirt Rowland.

One of the most remarkable enclaves of Art Deco architecture was assembled in the oil boom town of Tulsa, Oklahoma, during the 1920s and 1930s. Outstanding here were the buildings of Bruce Goff. Like Barry Byrne and Frank Lloyd Wright, who also designed Tulsa buildings in those years, the individualistic, informally-trained Goff defied categorization. Among his inventive designs were the Tulsa Club, the Page Warehouse, the Guaranty Laundry and the Midwest Equitable Meter Company (which owed a debt to German Expressionism). But it was Goff's dynamic Boston Avenue Methodist Church that earned widest recognition with its stylized sculpture, geometric ornament and Cubist-inspired stained glass, suggested by ideas in Claude Bragdon's *Projective Ornament* and *Architecture and Democracy*. As a means for spreading the latest architectural trends to the Midwest and other culturally isolated areas, architectural publications were essential to Goff and others.

Goff's Tulsa church exemplified a stylized gothic variant of zigzag Art Deco that can be seen in other religious structures of the era. It was used by Adrian Gilbert Scott for the St James Church in Vancouver, and by Barry Byrne in American churches as well as his Church of Christ the King in Cork, Ireland (1928). The sole ornament of the diamond-plan Cork church was a stylized relief of Christ between the portals by John Storrs. Medievalist Art Deco was also seen as appropriate for Detroit's Masonic Temple (1928).

RIGHT: *A gothic variant of Art Deco is seen in Vancouver's St James Church (1935-37) by Adrian Gilbert Scott.*

During the 1920s Frank Lloyd Wright completed a number of innovative commissions allied to zigzag Art Deco. They were executed in poured concrete and geometrically patterned textile block, a technique pioneered in the Unity Temple and the A D German Warehouse (1915). Unfortunately, like his Larkin Building, Wright's Midway Gardens pleasure palace (1913), which was adorned with Alfonso Iannelli's modernistic sculpture, was later demolished. Still extant, however, are a group of Mayan- or Aztec-style California residences. They are the Barnsdall (Hollyhock) house, with its recurrent plant motifs, the Millard residence, the Storer residence, the Freeman residence and the monumental Ennis residence.

Wright's oldest son, Lloyd Wright, supervised the construction of these houses, and went on himself to design other California edifices inspired by pre-Columbian forms, notably the John Sowden house (1926), a futuristic Mayan Hollywood-style fantasy, with appropriate furniture by Lloyd Wright. Lloyd Wright also designed the first angular Hollywood Bowl, as well as the second elliptical version, modernistically more stylish but acoustically less effective.

The Mayan revival style, based on Meso-American architecture and the decorative arts of pre-Columbian times, centered in southern California. There the ebullient Robert Stacey-Judd, designer of the Monrovia Aztec Hotel, was its ardent publicist. Stacey-Judd went on to produce the Ventura First Baptist Church (1928-1930), an unusual amalgam of gothic deco and Mayan, and the Masonic Temple in North Hollywood (1951). The Mayan style's primitivistic stepped-back massive forms also inspired Prairie School architect Walter Burley Griffin, who left in 1914 to design Canberra, the new Australian capital. There he later designed a Mayan-style municipal incinerator

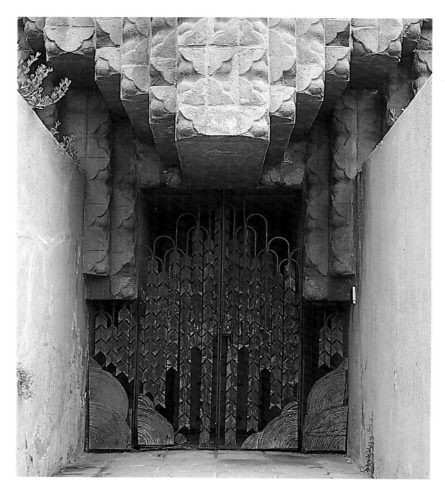

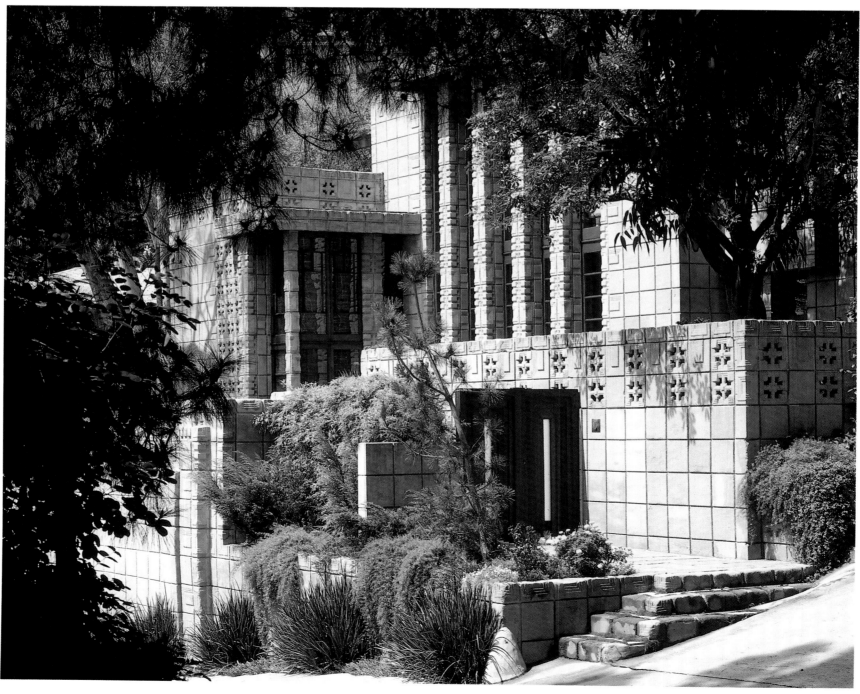

LEFT AND RIGHT: *After supervising the construction of his father's California textile block houses, Lloyd Wright designed the exotic John Sowden house (1926) in Los Angeles.*

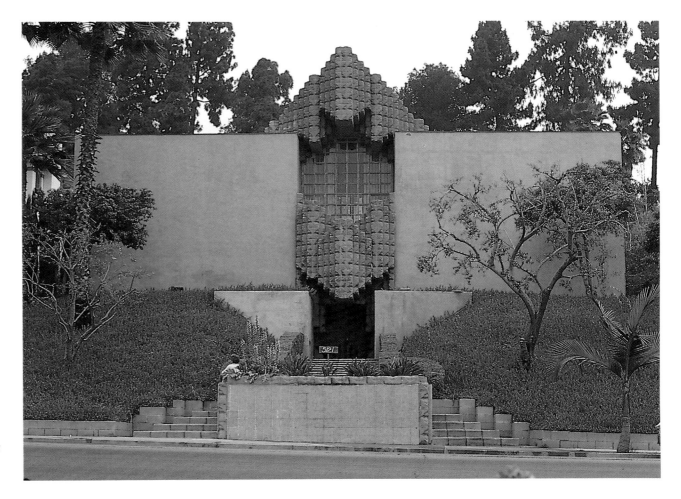

BELOW LEFT: *The 1923 Storer house was the second of Frank Lloyd Wright's innovative textile block houses in the Los Angeles area.*

BELOW RIGHT: *The Ennis house was the last of Wright's residential designs reflecting the Mayan style.*

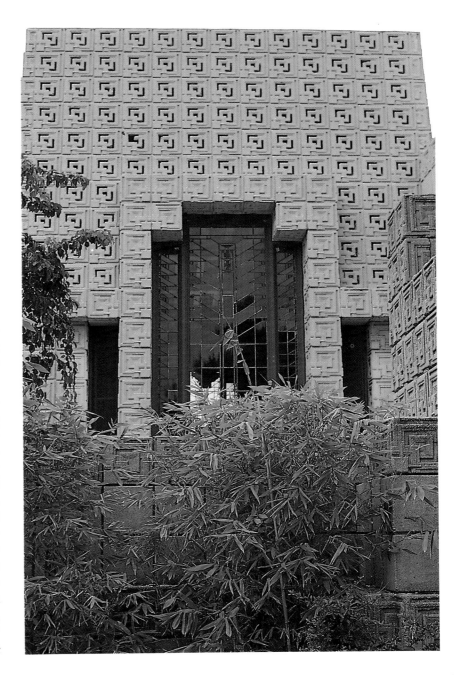

for Sydney. The University of New Mexico commissioned a Mayan-style Chemistry Building, now the Art Annex, by Barry Byrne. The 1915 Aztec Theater in Eagle Pass, Texas, unique for its time, was followed by one in San Antonio, now home to the city symphony, and others in Los Angeles, Denver, Detroit and New York. In New York, Mayan style was also seen in the Bloomingdales store, the Kress building and the designs of Ely Jacques Kahn.

Southern California, which underwent a period of remarkable growth and prosperity during the 1920s, was the site of a number of exotic variations on zigzag deco, as well as of related revival styles. Bertram Goodhue adapted Egyptian ornament for his Los Angeles Public Library and Assyrian motifs were adapted for the Samson Tyre and Rubber Company, later the Uniroyal Tire Factory, by Morgan, Walls, and Clements. These architects also produced such other western zigzag Art Deco treasures as the black and gold Atlantic Richfield Building, the Dominiguez-Wilshire Building, the Security Pacific Bank Building, the Warner Brothers Western Theater/Pellissier Building, the Leimert Theater and the garish, flamboyant Mayan Theater in Los Angeles.

New heights of ostentatious luxury, probably reflecting the Hollywood ambience, were achieved by Claude Beelman's Eastern Columbia Building, which was clad entirely in glazed aquamarine and gold terracotta tile, and by the Bullocks Wilshire department store (1928), with consummate French-style interior detailing by René Lalique and other collaborating artists.

Another regional Art Deco variant, Pueblo deco – based on a fusion of Pueblo Indian, Spanish colonial and California mission revival architecture – arose in the Southwest (west Texas, New Mexico and Arizona). It was an architecture of massive forms, flat-topped arches, and primitivistic columns primarily derived from vernacular white-walled adobe buildings. The ornament was based on symbolic and ceremonial Navaho, Hopi and Pueblo Indian motifs from pottery, basketwork, jewelry and textiles. Related motifs were cacti, cowboys and sun symbols. The characteristic abstraction, angularity and repetitiveness of the Indian artwork were closely allied to Art Deco stylization. A number of Pueblo deco courthouses and theaters were erected, as well as at least one hospital and a railroad station. Quintessential was Albuquerque's Ki Mo Theater (1926-27) with its terracotta buffalo-skull light fixtures, stylized Kachina masks, Navaho rugs, Pueblo pottery and its mural on the theme of 'Seven Cities of Cibola.' Growing tourism made the style attractive for hotels, including those

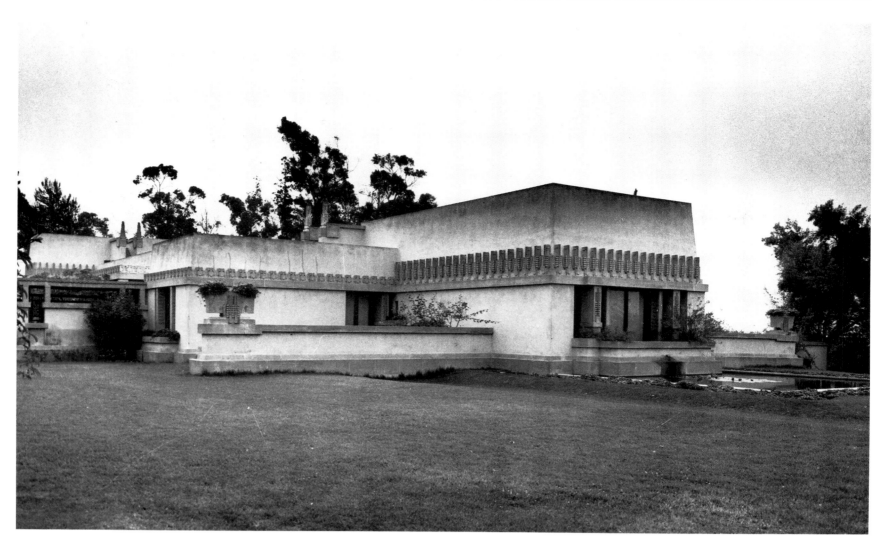

of the Harvey chain. Frank Lloyd Wright's ideas were included in the Arizona Biltmore, while the prolific Henry Trost produced Albuquerque's remarkable Franciscan Hotel (1923), a colossal Pueblo pile with a stepped-back silhouette, and with interior ornament of abstracted Indian motifs and wall plaques by noted Pueblo potter Nampeyo. Trost's Caverna Hotel in Carlsbad (1928) was a variation on this theme. Unfortunately demolished in 1972, the Franciscan was widely published in the 1920s and attracted international interest. Trost also produced skyscraper deco buildings for El Paso and Phoenix. Edward Sibbert, chief architect for the Kress stores chain, produced Pueblo deco designs for stores in El Paso and Phoenix. The

University of New Mexico's active encouragement of indigenous architecture influenced the development and production of Pueblo deco buildings for civic and commercial as well as domestic purposes throughout the Southwest.

The 1929 stock market crash abruptly ended the era of the ostentatious, ultra-expensive zigzag-style architecture. Most of the surplus profits parked in grandiose speculative real estate by the commercially-minded capitalists of the roaring twenties had now vanished. Indeed a number of buildings which began construction before the crash were not finished until after it, remaining alarmingly empty for years. From now on, the key was to be austerity.

ABOVE: *Frank Lloyd Wright's earliest textile block house in California was the Barnsdall (Hollyhock) house of Los Angeles (1917-20).*

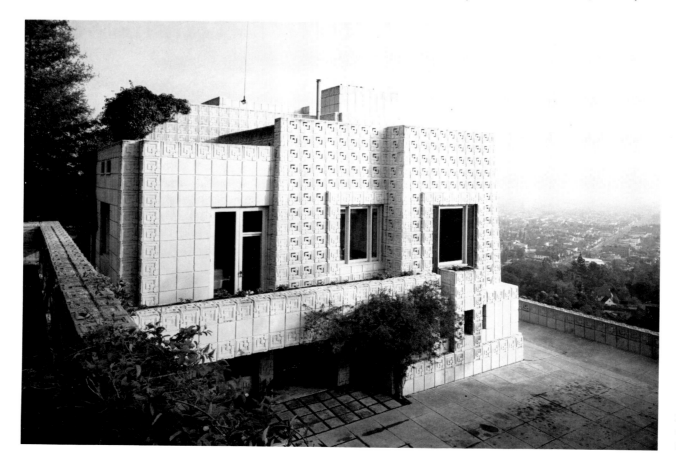

LEFT: *Wright's monumental Ennis residence offered a spectacular view of the Los Angeles metropolitan area.*

The third distinctive manifestation of Art Deco was known as the streamline style, or streamlined moderne. A horizontally oriented style of aerodynamic curves, flat roofs, glass brick, banded windows, tubular steel railings, speed stripes, mechanistically smooth wall surfaces and implications of mass production, the streamline style in architecture paralleled that used by the industrial designers of airplanes, locomotives, automobiles and household appliances. It was a romantic adaptation of the white, flat-roofed cubes of European functionalist architects like Adolf Loos, Le Corbusier and others. In France, *le style paquebot* or steamship style was based on the glamorous ocean liners of the era. With its horizontally banded tubular railings, elegant curves, porthole windows and modernistic decorative detailing, the style was frequently used for resorts or for the villas of the rich, avant-garde, or intellectual. Streamlining's futuristic resonances of machine-like efficiency and decisive forward movement continued the optimistic symbolism of the zigzag era.

The first suggestions of the streamline style appeared in Eric Mendelsohn's Einstein Observatory (1919-24) and the designs of other German Expressionists. The Futurist drawings of Italian visionary architect Antonio Sant'Elia also prefigured the streamlined style, which first appeared on the American scene in two transitional skyscrapers. Raymond Hood's zigzag style McGraw Hill building (1931) was placed on a colorful horizontally banded base curving in to enclose a streamlined lobby. And the design by William Lescaze and George Howe for the Philadelphia Savings Fund Society building (1932) mounted a functionalist International Style office tower on a streamlined base with a curved façade of glass and polished charcoal granite. The streamline style was never widely favored for domestic housing in the United States, although there were a limited number of such curvilinear, flat-roofed, horizontal, white stucco residences commissioned by consciously avant-garde and financially well off clients, particularly on the west coast.

Now widely acknowledged as a masterpiece of the streamline style, the Johnson Wax complex in Racine, Wisconsin was Frank Lloyd Wright's largest corporate commission. Here the disciplined curves of the exterior were echoed in the luminous banded ceiling of the reception area and the monumental columns of the clerical hall. Wright's decorative use of glass tubing for innovative lighting effects, his co-ordinating curvilinear office furniture and sleekly finished exterior walls expressed the machine aesthetic and modern corporate efficiency. Wright's investigation of curved forms culminated in his 1943 design for the Guggenheim Museum, which was finally erected in the late 1950s.

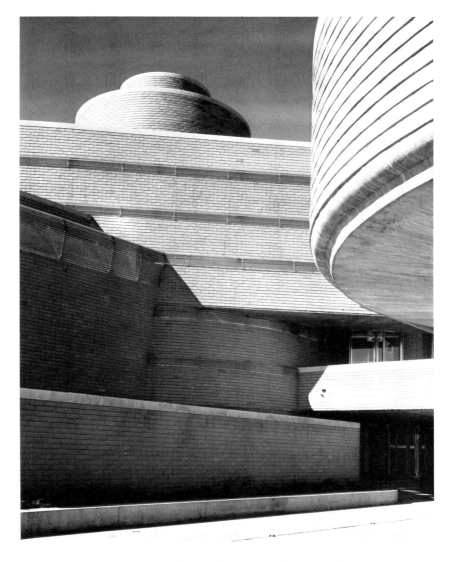

In its more picturesque form, the streamline style became a popular choice for numerous commercial clients across the United States. California boasted many notable examples, including the Winnie and Sutch Company building in Huntington Park and the Los Angeles Coca Cola Bottling Plant, both by Robert Derrah. In the remodeling of an older building, Derrah carried the steamship style to an extreme by including promenade decks, a ship's bridge, portholes and other nautical details. The streamline style, with its futuristic implications, climaxed at the end of the decade in the 1939 New York World's Fair.

ABOVE RIGHT: *Frank Lloyd Wright's 1936-39 Johnson Wax building in Racine, Wisconsin, was a streamline-style masterpiece.*

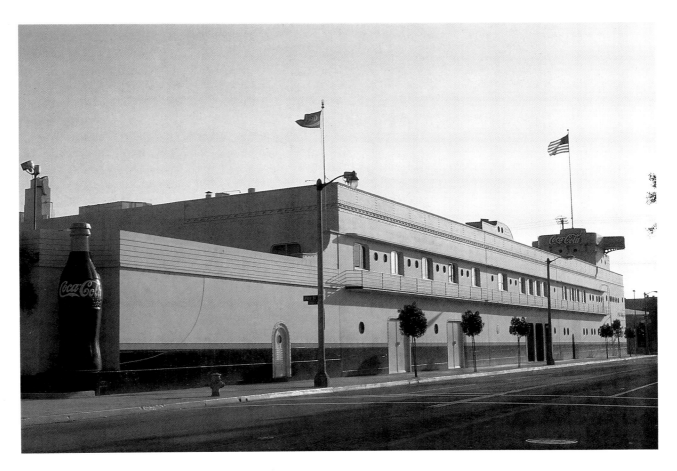

RIGHT: *By remodeling and adding to several older buildings, Robert Derrah concocted a nautically streamlined Coca Cola Bottling Plant for Los Angeles.*

The streamline style was also deemed appropriate by smaller commercial clients. Not only was it used for a whole range of new, modest, sometimes prefabricated roadside structures such as gas stations, diners, bus terminals and stores but, from 1936, it was heavily utilized in the context of the 'modernize Main Street' movement. This resulted in the renovation of countless traditionally styled commercial structures, which were given modernistic façades using such machine-age materials as vitrolite, black glass, backed enamel panels, aluminum and plastic, along with neon tube lighting. Not only the streamline, but also the zigzag style were used in such relatively inexpensive image transformations in the attempt to attract new customers. Eventually the streamline style became accepted as a well established commercial style favored by many business outlets throughout the 1940s and 1950s.

Tropical deco, a regional offshoot of the streamline style, was evidence of the breadth of influences at work on Art Deco. Tropical deco took its name from its Florida locale, although similar buildings were frequently erected in resort areas in California and elsewhere. As a rule, tropical deco buildings were constructed inexpensively of stuccoed concrete. They tempered the aerodynamic efficiency of the streamline style with zigzag-style setbacks, polychromy and stylized organic and abstract ornament. The functionalist white of streamline-style wall surfaces was often painted over with such sensuous pastel hues as flamingo pink, sea green and yellow. And when the curved walls of streamlining were supplanted by the Cubist boxiness of the International Style, their austere linearity was softened by the curves of the applied ornament. Frequently the horizontal structures were topped with the futuristic machine-age masts previously seen on New York's zigzag style skyscrapers. Sometimes these masts were finned, or displayed jazzy neon signs.

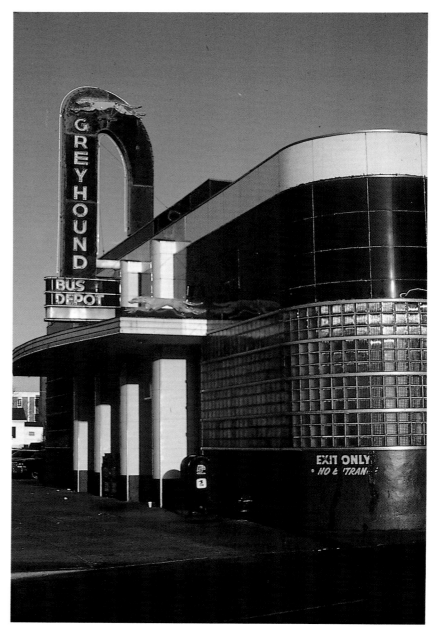

RIGHT AND BELOW: *Streamlining became a popular commercial style for such roadside structures as bus stations and diners.*

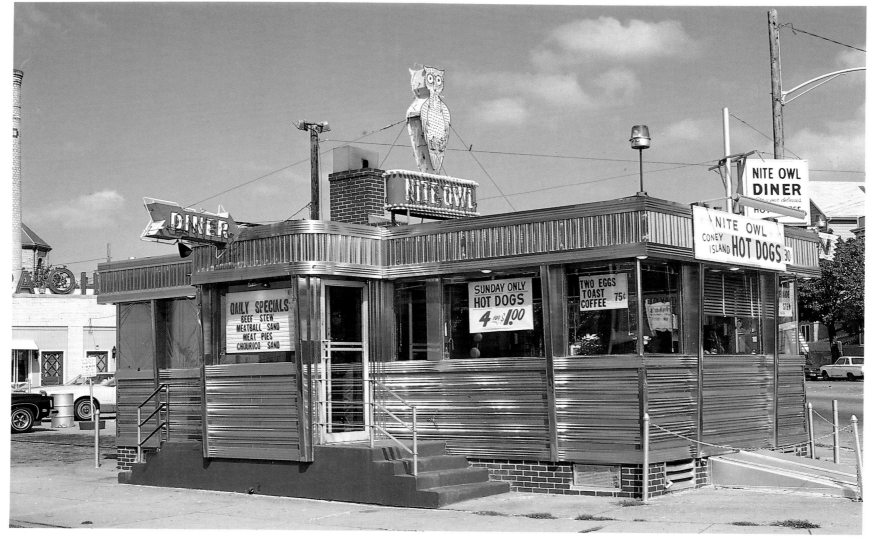

The concentration of tropical deco architecture – some 400 buildings in all – in the square mile of the historical district now known as Old Miami Beach was the result of an intense southern Florida building boom that ran from the late 1920s through the 1930s. Miami's tropical deco hotels, apartment buildings and houses confirm the essentially vernacular nature of art deco architecture – not only in the frequent anonymity of its designers, but also in its idiosyncratic combination of decorative motifs and architectural devices from the zigzag, classical moderne and streamline styles, as well as from the International Style.

The distinctive features of tropical deco included cantilevered sunshades over windows, octagonal and porthole windows, flagstaff parapets and deck-like balconies. These features were part of the regional marine imagery of tropical deco, as were such motifs as dolphins, herons, mermaids, sea shells, alligators, flamingos, palm trees and stylized waves and clouds. The Art Deco sunrise and fountain motifs had special meaning here – after all Florida, the sun worshipper's mecca, was the site of Ponce de Leon's fabled fountain of youth. The opulent, seductive quality of the interior and exterior ornament of tropical deco reiterated the theme of a glamorous vacation paradise, a welcome escape into fantasy.

Art Deco also gained a foothold elsewhere on the North American continent. In Mexico, during the height of the post-revolutionary artistic renaissance of the 1920s and 1930s, a series of splendid schools, hospitals, offices and apartment buildings were designed by Juan O'Gorman, Jose Villagran Garcia, Enrico de la Mora, Luis Ruiz, Antonio Munoz Garcia and others. Farther south, Bogota's Biblioteca Nacional by Alberto Wills Ferro (1938) was representative of Art Deco architecture in other South American cities.

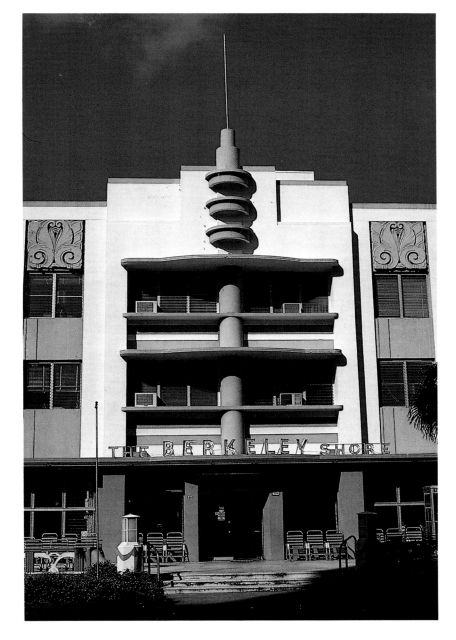

BELOW: *This diner in St Paul, Minnesota, was one among many across the USA to sport the new streamline style.*

RIGHT: *The tropical deco style that developed in Florida's Miami Beach was to spread to other resort areas as well.*

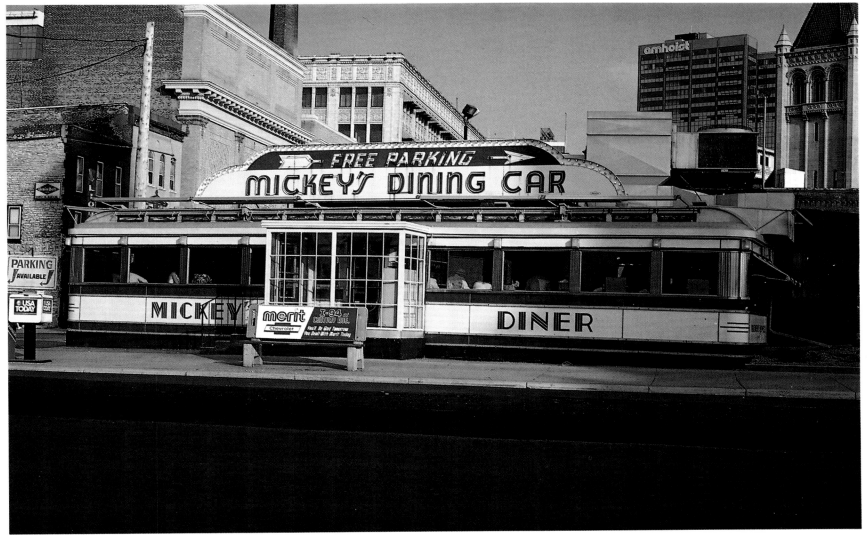

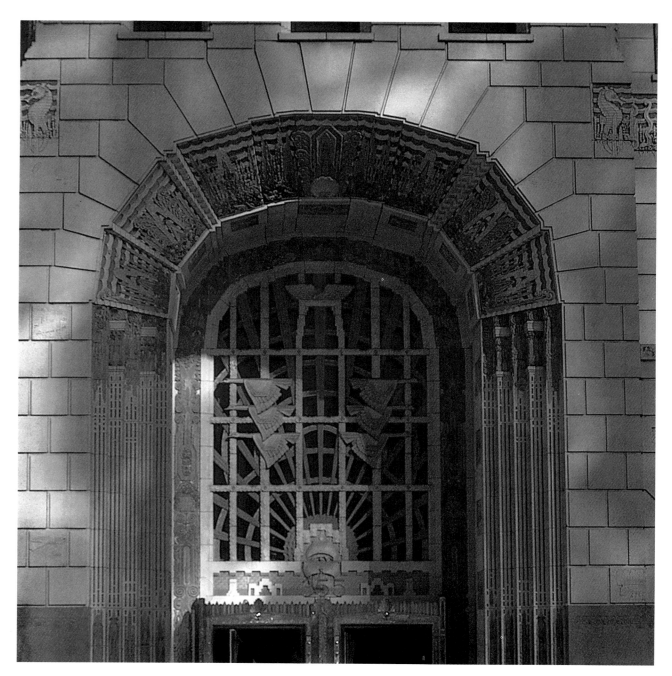

To the north, Canada also built an impressive number of Art Deco structures in the form of civic, office and apartment buildings, as well as department stores and movie theaters. Although many were, unfortunately, demolished in the years after World War II, others survive as splendid reminders of the Art Deco era. Among the monuments erected were Vancouver City Hall; Toronto's skyscraper-style Permanent Trust Company building, Maple Leaf Gardens and Eglinton Theatre, still in continuous use; and in Montreal, the *Maison Cormier* and the University of Montreal designed by the Québecois architect Ernest Cormier.

In an era of unprecedented prosperity and intense nationalism, Canada's determination to forge a unique identity was reflected in the architectural ornament of such buildings as Vancouver's magnificent zigzag-style Marine Building with its terracotta panels illustrating the discovery of the Pacific coast, and Toronto's Concourse Building, with its stylized decoration of Indian and nature motifs by J E H McDonald of the avant-garde Group of Seven. Classical moderne was a frequent choice for the expanding banking industry in Canada as elsewhere, and regional and national motifs played a prominent role in their buildings. This development was exemplified by the Ottawa headquarters of the Bank of Montreal by Ernest Barott, and particularly by the buildings of John Lyle. Working mainly for the Bank of Nova Scotia, Lyle designed numerous banks in Toronto and in the provinces. The Calgary office was appropriately ornamented with imagery depicting the regional oil, grain and cattle industries, along with its characteristic cowboys and buffalo; while the truly opulent headquarters in Halifax featured some 86 different motifs based on the flora, fauna, industry and history of the maritime provinces and of the nation as a whole. Lyle, who also designed metalwork and furniture, deliberately set out to create a distinctively Canadian style.

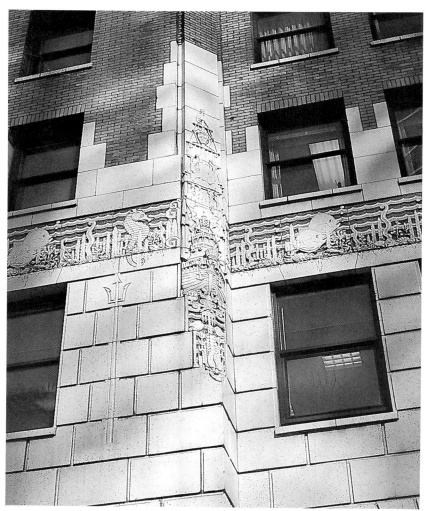

RIGHT: *The Expressionists were not only a source of ideas for Art Deco architecture, but they shared as well an interest in cosmic imagery, as seen here in Taut's vista from Alpine Architektur (1919).*

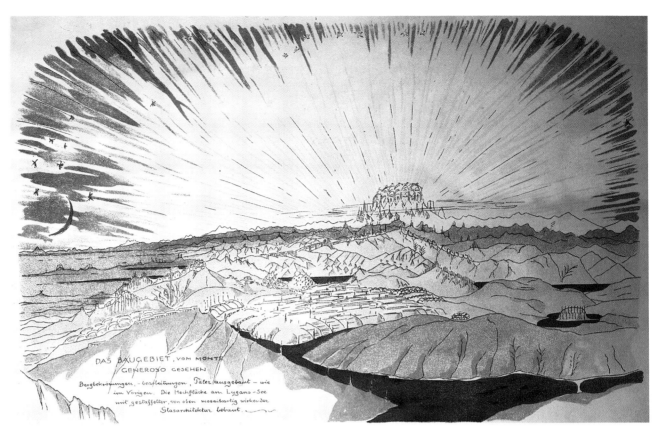

BELOW RIGHT: *In Paris, Auguste Perret's* Théâtre des Champs Elysées *(1911-14) is an Art Deco monument, as are Bourdelle's influential sculptural relief panels.*

Continental Europe produced little to compare with the glamorous jazz-age architecture of the prosperous Americas. Germany, in the throes of an economic collapse in the aftermath of World War I, found that the austere designs of the functionalist Bauhaus designers provided a low-cost solution to the country's acute housing and industrial needs. The modernistically decorated cinemas of Otto Kaufmann, Fritz Wilms, Hugo Pal, Friedrich Lipp and others were a rare exception to the prevailing austerity. Isolated examples of Art Deco could also be seen in Berlin in Philip Schaefer's Karstadt department store (1929) with its twin setback towers and in Hans Scharoun's streamlined wing, complete with porthole windows, for his Breslau hostel (1929). Classical moderne was still a choice for civic structures such as Wilhelm Kreis's art gallery and planetarium in Dusseldorf and Paul Bonatz's Stuttgart railroad station. A more ornate classical moderne railroad station was designed for Basel, Switzerland, by Karl Moser.

By the early 1920s, the sculptural and picturesque Expressionist architecture of Hans Poelzig, Bruno Taut and Peter Behrens had run its course. It remained a source of ideas for Art Deco architects, however, and to the exponents of Czechoslovakian Rondo-Cubism, a modernistic, sculptural and folkloric style pioneered by Josef Chocol and Josef Gocar. Jiri Kroha's interior for Prague's Montmartre Club (1918) might, in its extravagant modernist decor, be considered almost Art Deco. Also related to Expressionism were the unusual buildings of the Amsterdam School, adorned with stylized sculpture and decorative brickwork. Cross influences with Art Deco could be seen in the interior of the Tuschinski Theater (1920-21) where, in the midst of the characteristic jagged and organic Expressionist motifs was a leaping gazelle. American Art Deco was suggested in G W Van Henkelholm's 1920-22 Utrecht office block with skyscraper-style setbacks. Classical moderne was still a popular style for Dutch public projects such as H G J Schelling's Bussum railway station and Willem Dudok's series of buildings in Hilversum. Dudok's austere reworking of classical forms is exemplified by his 1928-31 clock-towered town hall, an asymmetrical grouping of cubic forms abstracted from classicism. Dudok's town hall proved influential both on the continent and in England, appealing to architects who sought a conservative modernism.

In France too, despite the exotic pavilions at the Paris expositions, classical moderne remained the primary expression of Art Deco. The first important design of Auguste Perret, noted for his pioneering innovations in reinforced concrete, was his transitional Paris Rue Franklin apartment building (1902), which was clad in stylized floral tiles between rectilinear structural members. Subsequent Perret projects included the *Théâtre des Champs Elysées* (1911-14), with sculptural ornament and interior murals by Emile-Antoine Bourdelle; his 1925 Paris exposition theater; his revolutionary Le Raincy church of Notre Dame (1922-24) with its geometric concrete grillework; and his monumental Paris Museum of Public Works (1937).

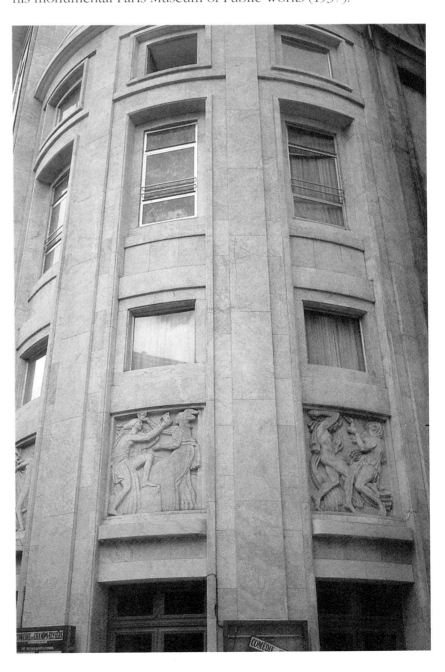

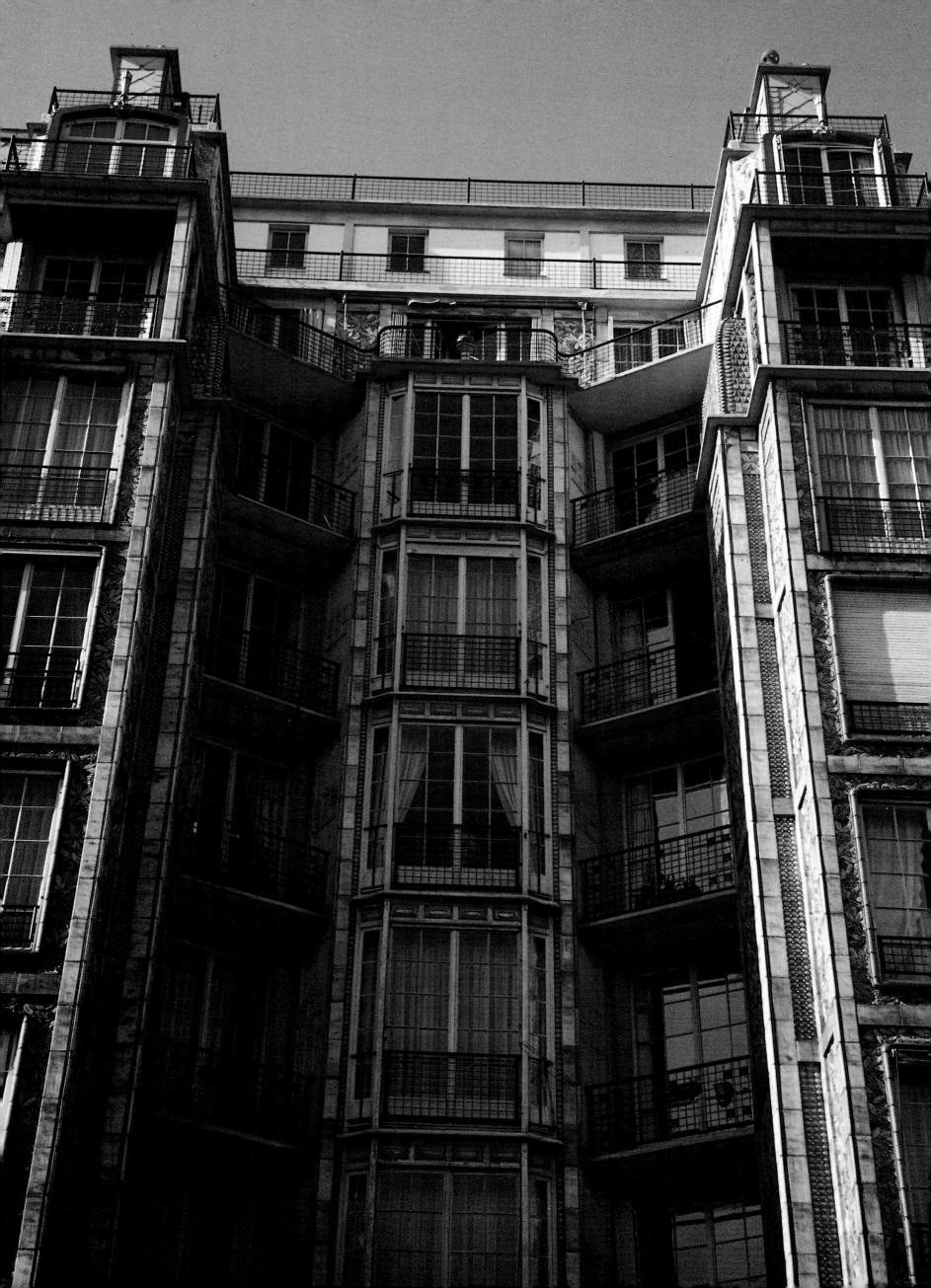

LEFT: *Auguste Perret's Rue Franklin apartment building of 1902 was a departure from his earlier Art Nouveau designs.*

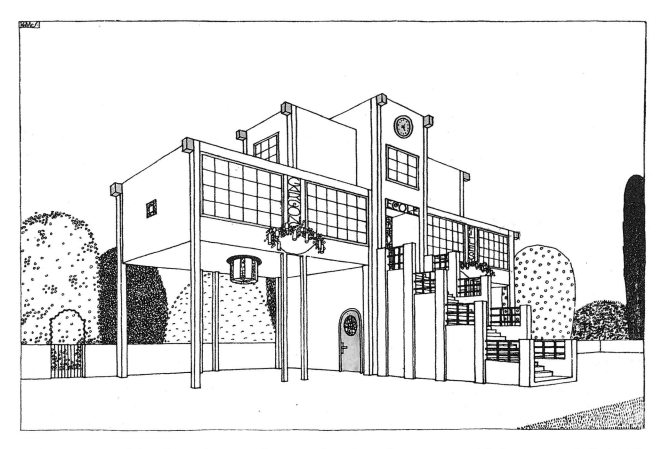

RIGHT AND BELOW RIGHT: *Robert Mallet-Stevens created elegant designs reminiscent of Hoffmann's* Palais Stoclet *for a school and church in his* Une Cité Moderne.

The 1937 Paris exposition also saw the erection of the classical moderne and sculpturally ornamented Museum of Modern Art and the *Palais de Chaillot,* both by Dandel, Aubert, Viard and Dastuque. Among the other important classical moderne civic structures of the era was one of the most important European concert halls of the 1920s. The *Salle Pleyel* (1925-27) in Paris by André Granet sought acoustic excellence by means of a fan-shaped interior. Tony Garnier, author of the utopian *Une Cité Industrielle,* produced monumental structures of stripped classicism, including his municipal slaughter house at La Mouche (1908-09) and his Lyon Olympic Stadium (1913). A departure from classicism was attempted by Henri Sauvage, a collaborator on the 1925 Paris exhibition *Primavera* pavilion. In 1912, after working in the Art Nouveau style, Sauvage produced a remarkable pyramidal stepped-back Paris apartment building, a prototype for the zigzag style.

The white functionalist Cubist boxes of Adolf Loos and Le Corbusier were a major influence in the Art Deco era. They were interpreted in the spirit of Art Deco: romantically in *le style paquebot;* with discreet geometric or floral motifs in sculptural ornament, metalwork or glass in the apartment houses of Michel Roux-Spitz; or in the elegant amalgam of classical abstraction and austere functionalism typefied by the designs of Pierre Patout. Other French architects working in the mode of reinterpreted functionalism were André Lurçat, Gabriel Guevrékian, Jean Ginsberg, Djo Bourgeois and Georges Henri Pingusson.

Robert Mallet-Stevens was undoubtedly the most successful of these rationalists, as they were called. Prolific and eclectic, he produced a series of sophisticated designs for private homes, apartments, offices, public buildings, shops, factories and exhibition pavilions, as well as for film sets and furniture. He enjoyed collaborative design work and often commissioned leading artists and Art Deco craftspeople to create metalwork, glass, murals and furniture for his buildings. Probably the most radical French experiment in domestic architecture was the *Maison de Verre* in Paris (1928-31) by Pierre Chareau and Bernard Bijvoet. Inserted into an existing building, the combination of three-storey glass façades and exposed metal structure was a *tour de force* of machine-age design.

The Scandinavian countries possessed a strong tradition of abstracted classicism and, during the early decades of the twentieth century, restrained modernistic stylization and ornament brought their buildings into the realm of classical moderne. Typical, in Finland, was the work of Armas Lindgren, who left the partnership with Eliel Saarinen before 1907. Saarinen's Helsinki station was, of course, a proto-Art Deco monument. Representative of classical moderne in

Sweden was the elegantly ornate Stockholm concert hall (1926), along with earlier buildings, by Ivar Tengbom. Ragnar Ostberg's Stockholm Town Hall (1909-23), was in an abstracted medieval style, although it possessed ornamental interior detail reflecting the latest modernist trends. In a similar spirit in Norway was Oslo city hall, designed in 1920 and under construction from 1931 to 1950. Erik Gunnar Asplund, Sweden's major architect of the era, started out in the

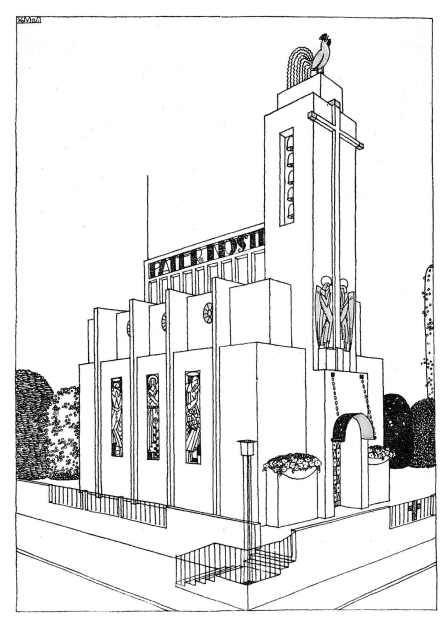

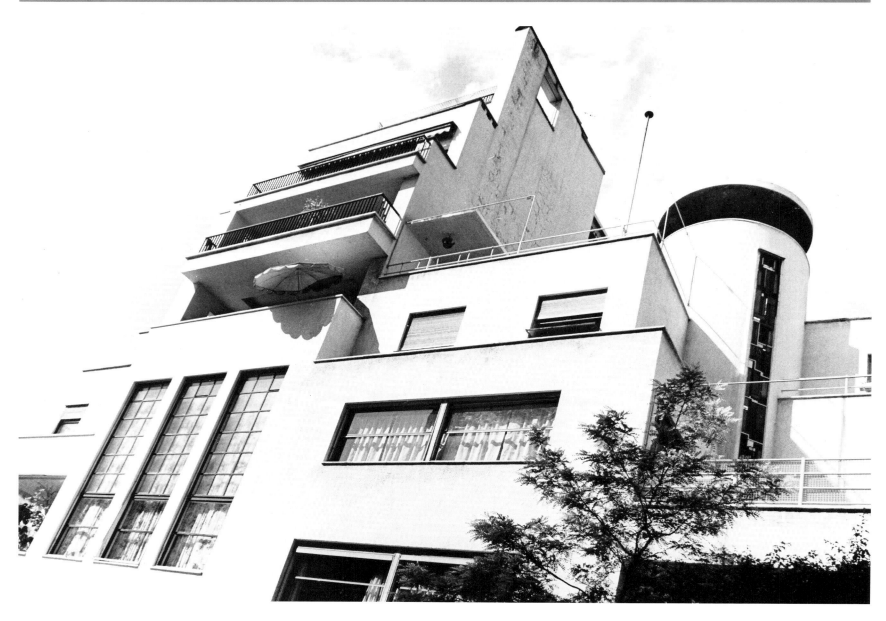

classical moderne mode. His Skandia cinema (1922-23) was notable, but his primary achievement was the Stockholm city library (1924-27), which took the form of a monumental cylinder atop a cube. Along with Dudok's Hilversum designs, this conservative Scandinavian modernist interpretation of classical forms was particularly attractive to British architects of the era.

In the British Isles during the last decades of the nineteenth century an innovative group of architects developed new interpretations of traditional forms and produced designs widely admired abroad. Under the aegis of the Arts and Crafts Movement, abstracted variations on medieval, vernacular and classical forms led to such remarkable proto-modernist designs as Arthur Mackmurdo's classical moderne house in Enfield, Middlesex (1883-88); Charles Voysey's Perrycroft house (1893-94); C H Townsend's Horniman Museum (1896) and Whitechapel Art Gallery (1901); Charles Rennie Mackintosh's work on the Glasgow Art School, beginning in 1896; and Edgar Wood's stylized Lindley Tower (1900-02), later followed by his Royd House in Manchester (1916), which is now cited as a pioneering Art

ABOVE: *While active in a wide range of areas, Robert Mallet-Stevens completed various commissions for imposing residences. A Paris street, on which a number of his houses stand, is named after him.*

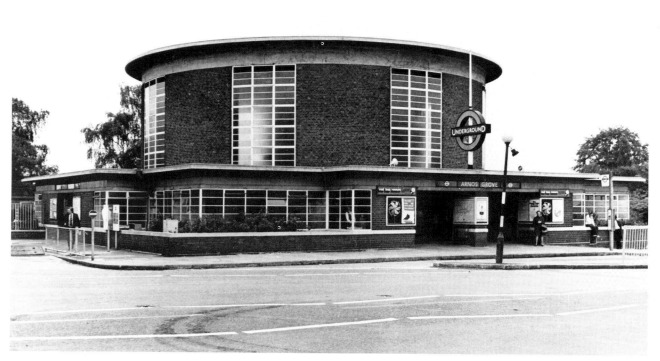

LEFT: *Charles Holden designed many buildings for London Transport, including Arnos Grove station on the Piccadilly Line.*

RIGHT: *The London Transport headquarters building by Holden was completed in 1929.*

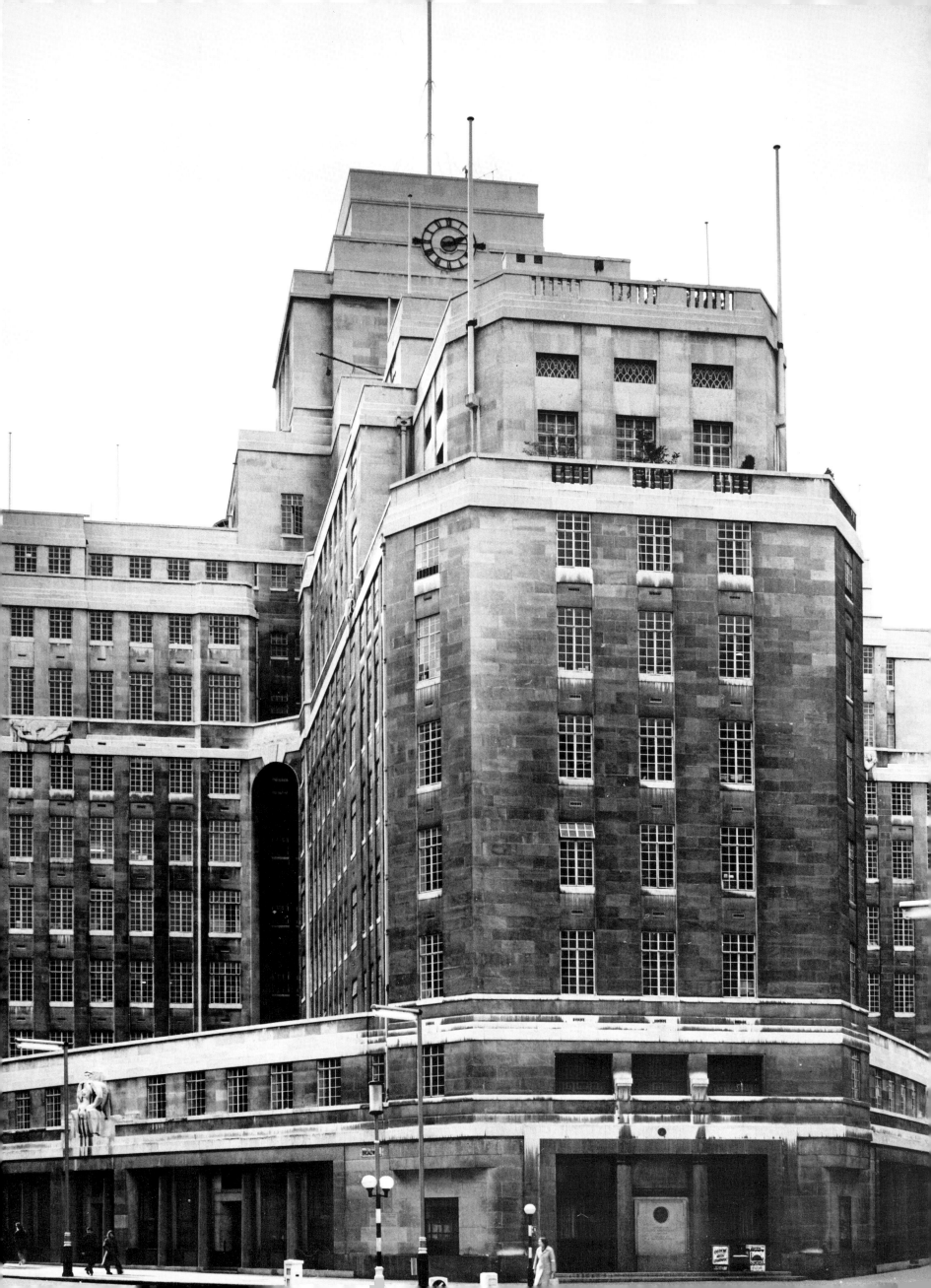

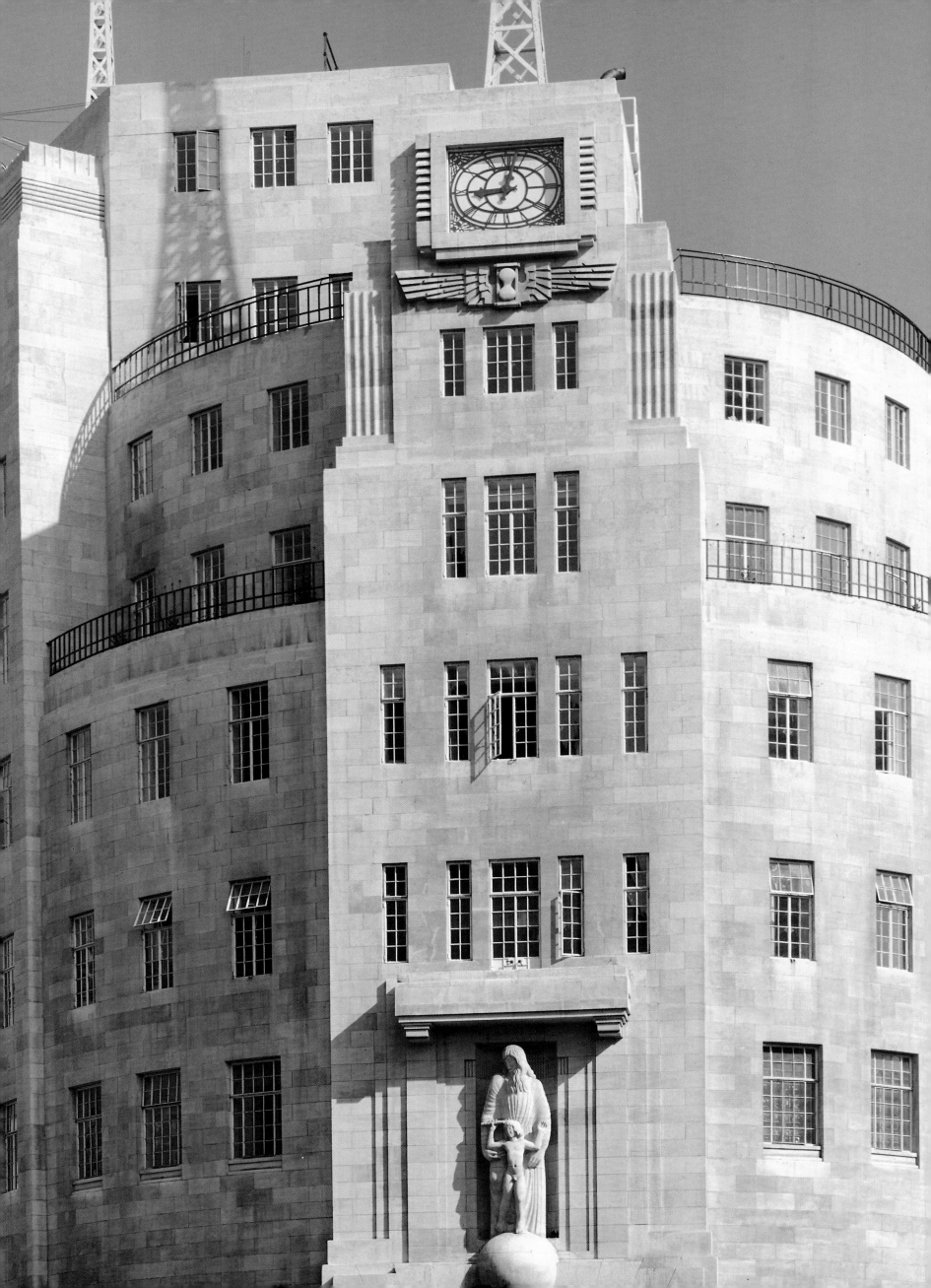

Deco design. A prolific country house builder to the nouveau riche, Sir Edwin Lutyens came to classicism late. Moderne or not, his essays in abstracted classicism include the final monuments of the British Empire. His inventive designs included several World War I memorials, the finest of which was the Memorial to the Missing in Thiepval, France (1923-25); the uncompleted Liverpool Cathedral; and foremost, New Delhi's Viceroy's House (1912-30), a palatial amalgam of Mughal and classical. Influenced by Lutyens in India was the truly extraordinary St Martin's Garrison Church (1928-30), a stepped-back Cubist monolith by Lutyens' assistant, A G Shoosmith.

One of the most active architects of the 1920s and 1930s, Charles Holden also started with the Arts and Crafts Movement. His inventive early works – the Soane medallion market hall design (1896), the Danvers Tower design (1897), the Bristol Library designs (1905-06), the British Medical Association building (1907) with sculpture by Jacob Epstein and, again with Epstein, the 1911-12 Oscar Wilde tomb in Paris – led to his mature classical moderne period. Holden's major work included, for London Transport, the stations on the Northern line, completed in 1927 and the 1932-34 Piccadilly Line stations, including the one at Arnos Grove so reminiscent of Asplund's Stockholm Library. A unique design was his London Transport headquarters (1927-29), a massive stepped, cruciform building enlived with the stylized sculptural reliefs of Epstein, Eric Gill and Henry Moore. In his projects, Holden tried to incorporate sculpture whenever possible. Another major classical moderne commission was Holden's Senate House for London University (1933-37).

LEFT: *Val Myer's 1932 Broadcasting House for the BBC, with sculpture by Eric and Vernon Gill, is another monument of classical moderne architecture in London.*

RIGHT AND BELOW: *The Boots factory (1932) in West London, by Owen Williams, drew on the new ideas coming from the Bauhaus.*

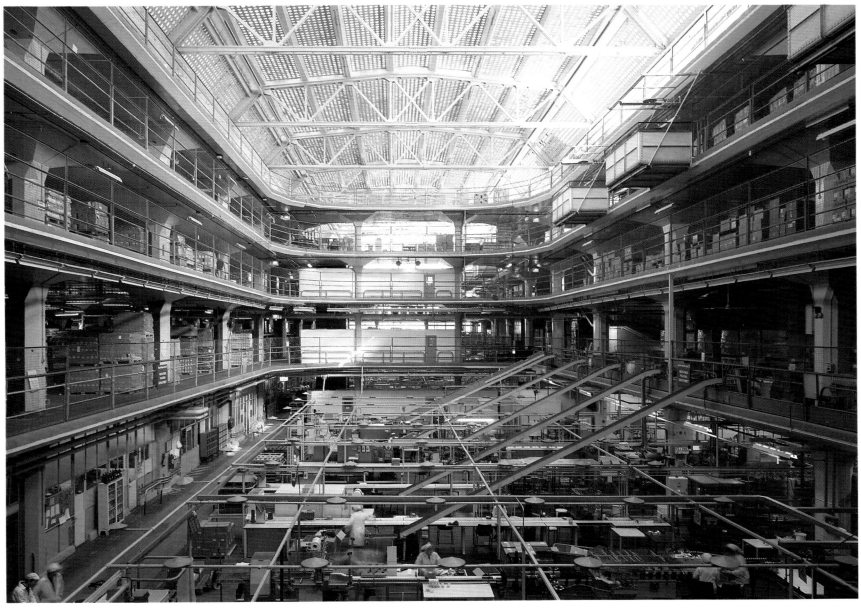

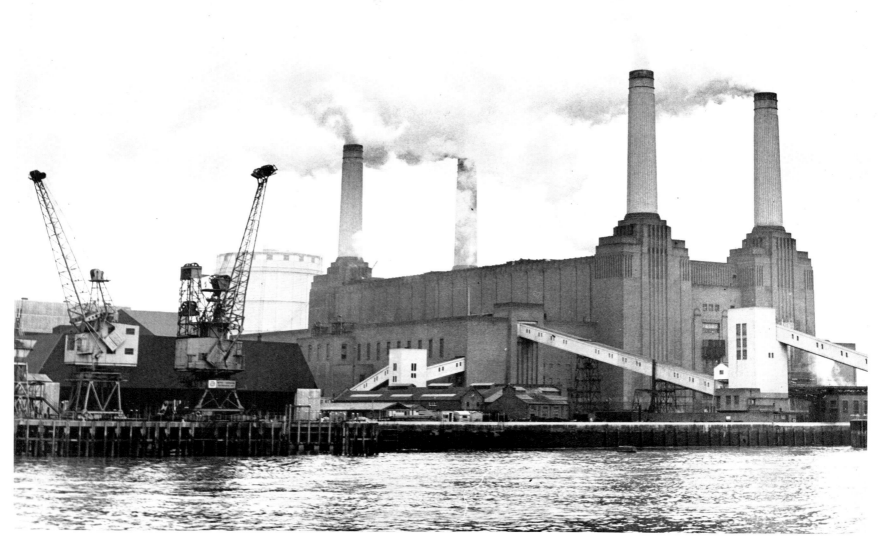

Monumental classical moderne also informed the 1929-1931 river-front remodeling of the gigantic Shell Mex building, as well as Val Myer's BBC Broadcasting House (1932), with sculptures by Eric Gill and Vernon Gill. Called a leviathan or a battleship of a building, Broadcasting House, like the London Transport headquarters, had to occupy a cramped site, which resulted in a similar adaptation of classical moderne with unusual angles and curves.

The other leading architect of the Art Deco years was Sir Giles Gilbert Scott, who came from Gothic Revival to combine modernist ideas with the high quality techniques and materials of traditionalism. Scott's major commissions in the classical moderne style included the library for Cambridge University, the New Bodleian Library for Oxford University, the new Waterloo Bridge and London's Battersea Power Station. Scott was hired on the basis of his previous work to allay initial protests at the intrusive siting of the power station on the River Thames. His successful aesthetic solution to this industrial problem – a design of elaborate parapets, decoratively fluted columns for smokestacks and bold symmetry – established the ideal for power stations over the next decades. Shortly after its completion, Battersea Power Station was judged in a newspaper survey as one of the most beautiful buildings in London.

Important buildings also were designed by the firm of Burnet, Tait & Lorne. Glaswegian Sir John Burnet, who had practiced simplification and abstraction in inventive buildings during the Edwardian era, produced with his partners an elegant, modernistic, classically massed, sculpturally adorned design for the Royal Masonic Hospital (1930-32). Thomas Tait, a fellow Scot who had studied under Mackintosh, later explored functionalist ideas and had also acted as a consultant on the jazzy *Daily Telegraph* building in London's Fleet Street (1928). But in the staider Edinburgh government building St Andrews House, Tait opted for the traditional grandeur of the classical moderne style.

Classical moderne was the preferred style for civic buildings outside London: in Scotland in Glasgow's Scottish Legal Building and in Edinburgh's Lothian House by Stewart Kaye, with sculpture by Pilkington Jackson; in Wales in Cardiff's Hall of Nations and Swansea's city hall by Sir Percy Thomas; in Liverpool's Royal Philharmonic Hall and the Mersey Tunnel ventilating station (with a touch of skyscraper deco) by Herbert Rowse. One of the most ambitious projects of the era was Stratford's Shakespeare Memorial Theatre by Elizabeth Scott, Chesterton & Shepherd. The simplified massing of the exterior recalled Swedish modernism while the ornament, including Eric Kennington's sculpture, was stylishly Art Deco.

A major architectural controversy centered on the competition for the new building for the Royal Institute of British Architects. Chosen from 284 entries, the winning classical moderne design by Grey Wornum was criticized by traditionalists as too modern and by modernists as too traditional, and by both as too influenced by Swedish neoclassicism. But with the passage of time, the RIBA building has come to be accepted as appropriate in its fusion of old and new, and as eminently suitable for its site. The lavish interior design included ornate metalwork, glasswork, wall paneling and floors of unusual and opulent materials, as well as extensive mural and sculptural programs by Raymond McGrath, Eric Gill, Eric Kennington and others.

The glitter and flash of the American-type zigzag style was seen far less but was not entirely unheard of. It was not only present in the hotel and restaurant interiors by Oliver Bernard and others, but also in building exteriors. An early model was Ideal House, later Palladium House, in London. With its sheer black granite and rich gilded floral motifs, it was a smaller version of architect Raymond Hood's New York American Radiator building for the same company. One architectural critic nicknamed Ideal House the 'Moor of Argyle Street.' Another design receiving much publicity was that by Ellis & Clark for the flagship of Lord Beaverbrook's press empire, the *Daily*

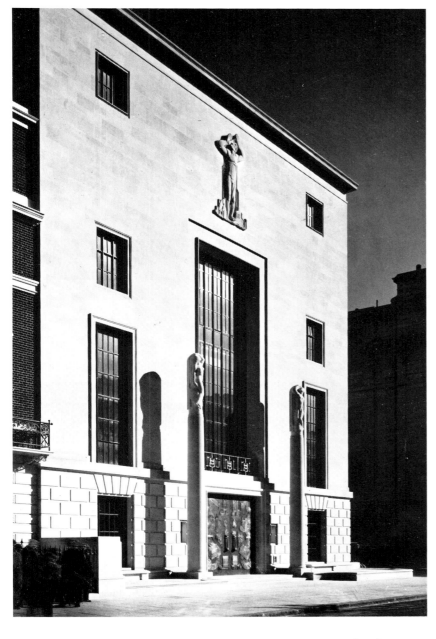

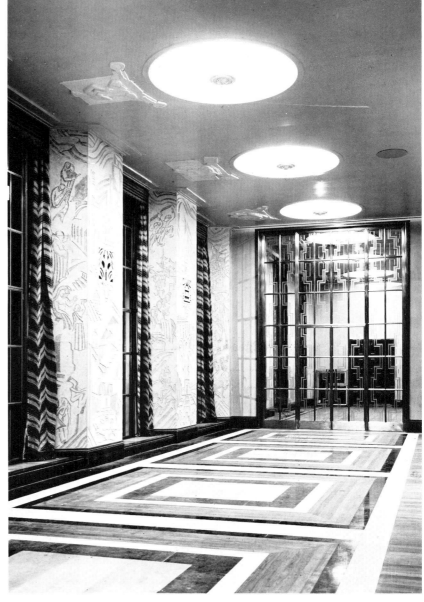

ABOVE LEFT: *Sir Giles Gilbert Scott's design for Battersea Power Station (1929-34) was declared one of London's most beautiful buildings.*

ABOVE RIGHT: *Britain's leading artists and designers of the Art Deco era collaborated on the interior of the RIBA building.*

ABOVE: *Grey Wornum's dignified classical moderne design for the new RIBA building was selected from 284 competition entries.*

RIGHT: *London's* Daily Express *Building owed its jazzy black glass façade and pyramidal profile to Owen Williams.*

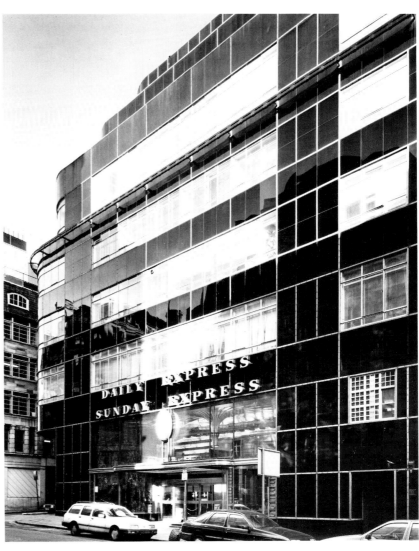

Express Building. Owen Williams, brought in as a consultant, was credited in large part for the bold (and 'unneighborly') design of ascending setbacks with streamlined corners sheathed in horizontal bands of windows alternating with polished black glass. Robert Atkinson was responsible for the striking interior design. A similar effect was evoked by the new buildings for sister papers in Manchester and Glasgow. Williams, an engineer rather than an architect, was also the author of other important structures of the era, including the Boots factory (1932) and the Empire Swimming Pool at Wembley (1934), at the time the largest covered pool in the world.

'American style' was a title also applied to the Hoover factory and others along London's Great West Road and Western Avenue. By Wallis, Gilbert & Partners, the Hoover complex was an unusual and colorful combination of streamlined and zigzag deco. Besides the Firestone factory and the Pyrene factory, Wallis, Gilbert & Partners were also responsible for other new deco style buildings such as London's Daimler Car Hire Garage (now American Express), Victoria Coach Station and the Green Line Coach Station in Windsor.

The growth of aviation required new structures too. Art Deco provided an appropriate stylistic vocabulary for buildings such as the Imperial Airways Building in London (1939) by A Lakeman, and David Pleydell-Bouverie's streamline-style design for Ramsgate Airport which, with its swept-back wings, echoed an airplane in appearance.

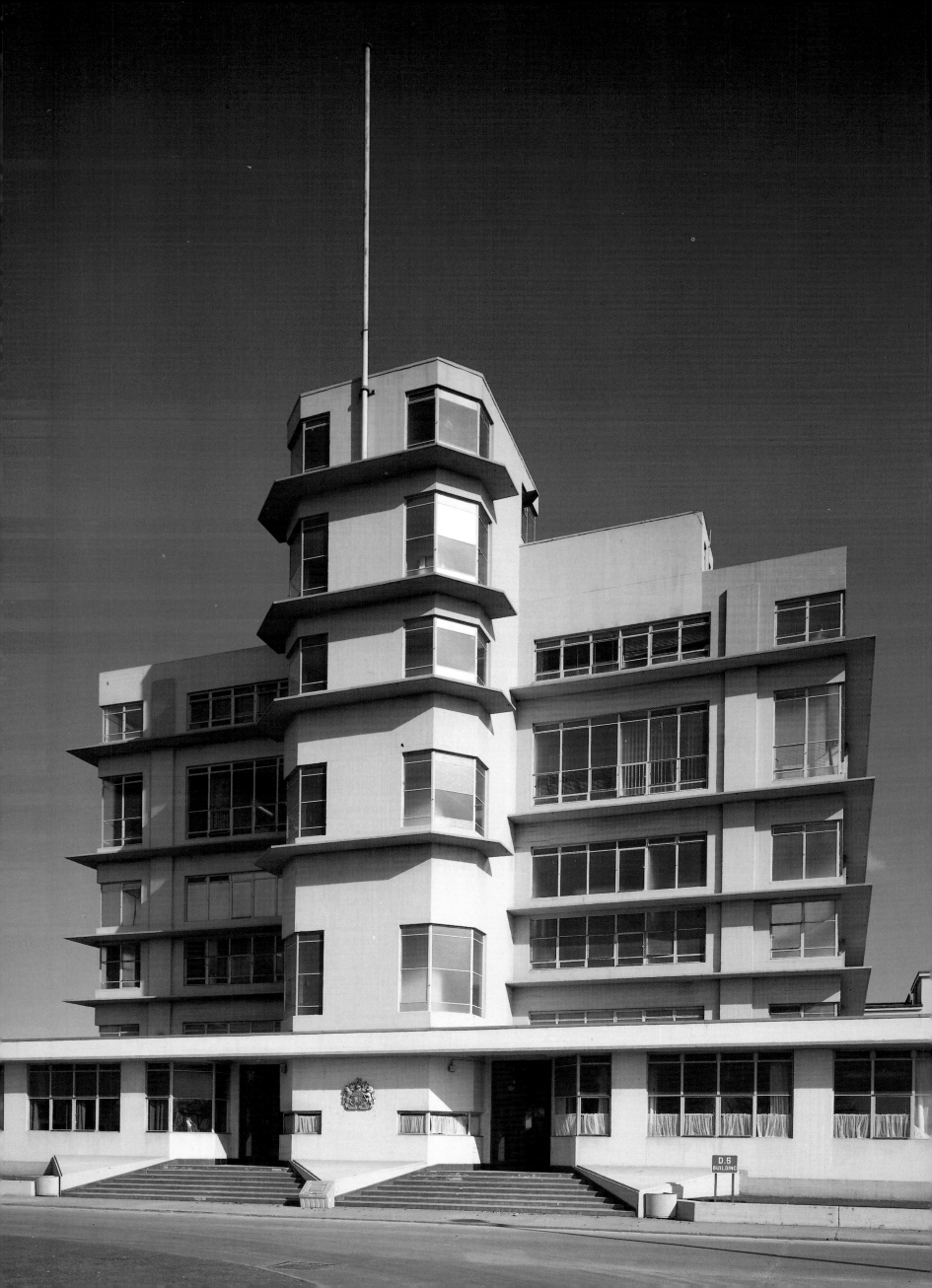

FAR LEFT: *Façade of the Boots factory by Owen Williams.*

LEFT: *The colorful Hoover factory was considered 'American style' by conservative British.*

ABOVE: *The Hoover factory (1932-35) in West London, by Wallis, Gilbert & Partners.*

BELOW: *Wallis, Gilbert & Partners designed the Firestone factory.*

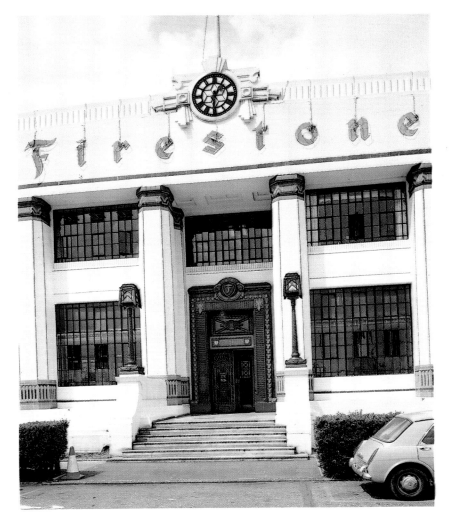

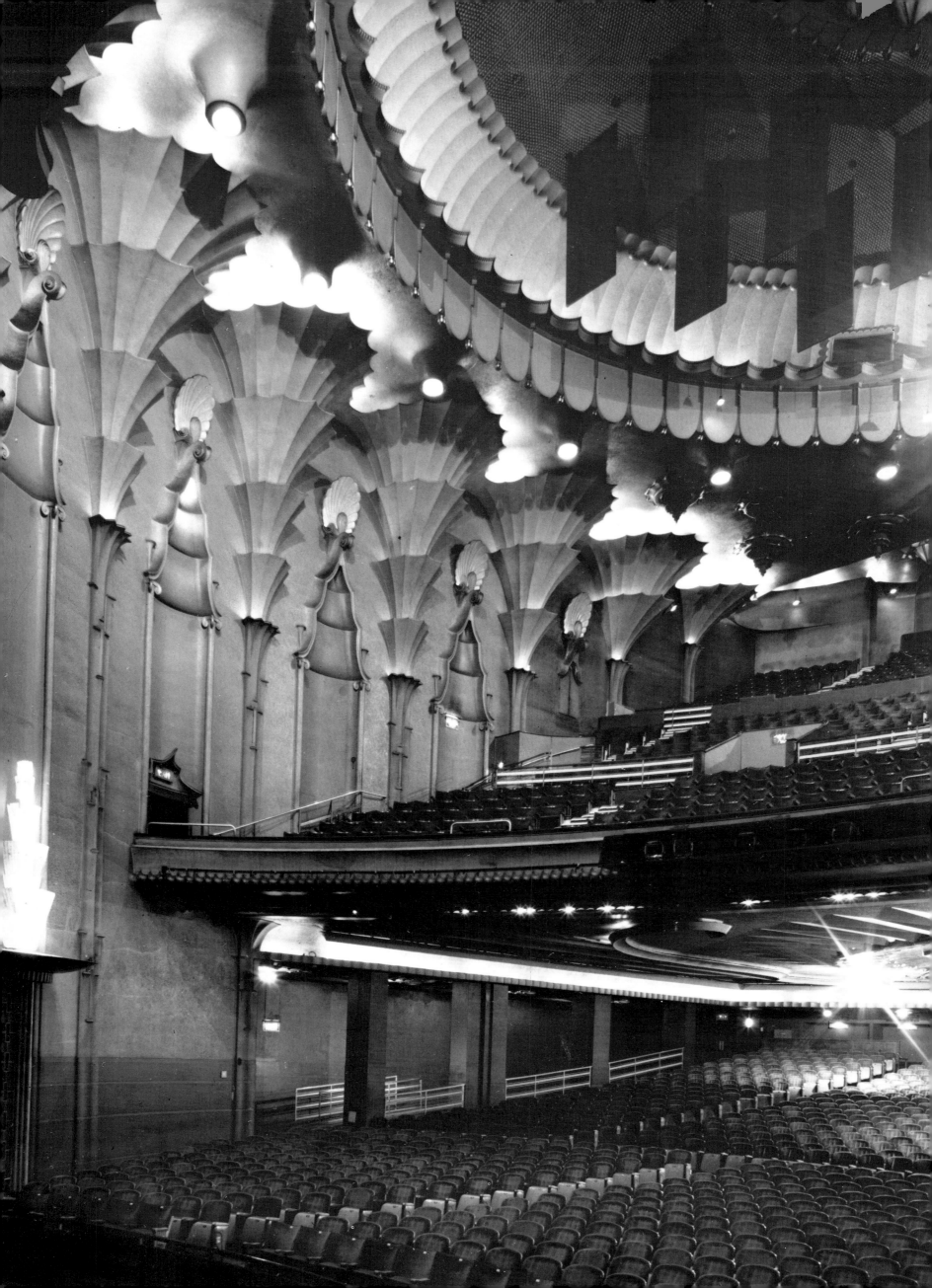

LEFT: *The New Victoria (1929-30) by E Wamsley Lewis was one of London's most spectacular Art Deco theaters.*

RIGHT: *The Dreamland cinema (1935) in Margate, Kent, by Iles, Leathart & Grainger epitomized the streamline style.*

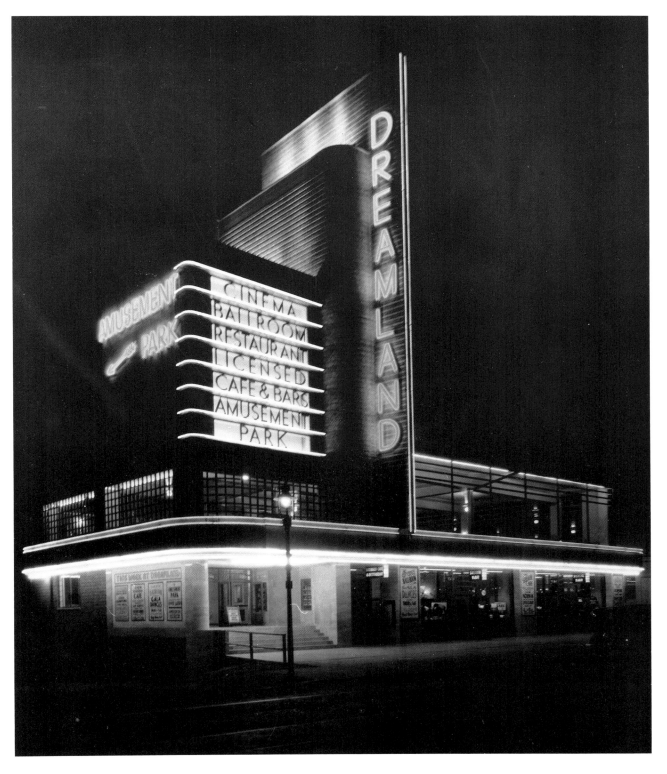

The streamline style came to have many applications. Not only was it used in religious contexts such as the Manchester church of St Nicholas by Welch, Cachemaille-Day & Lander, but it also became increasingly popular for the growing body of roadside architecture that developed for the automobile culture. Streamlining even brought a modernist flair to the traditional British institution of the pub – a prime example was E B Musman's Hatfield 'Comet' road house with an interior design of aviation motifs and sculpture by Kennington – as well as to a new generation of resort architecture. With its pastel hues and nautical flavor, the Showboat Lido in Maidenhead was an adaptation of American tropical deco.

During the 1930s, shop and restaurant owners looking to update their outmoded shop fronts provided a sizeable business for modernist architects and designers. Leading architects such as Burnet, Tait & Lorne designed an elegant streamlined façade for a Glasgow men's shop; Walter Gropius and Maxwell Fry produced a curved façade of glass block and vitrolite for a London electric shop; Joseph Emberton transformed a Regent Street tobacco shop; Frederick Etchells did Jaeger's in Oxford Street; Raymond McGrath designed for the Polyfoto shops; and Oliver Bernard created an exciting deco exterior and interior for the Lyons Corner Houses. A similar transformation occurred abroad where in Paris, for example, Robert Mallet-Stevens consulted on the design of two shop fronts and Pierre Patout designed others. Hotels and department stores were also important

clients for new buildings. London's leading deco style hotels included the Savoy, Claridge's, the Cumberland and the Dorchester; and among the department stores were Derry & Toms, Simpsons and Peter Jones, while Selfridges commissioned Edgar Brandt to design lift interiors in the early 1920s.

The burgeoning film industry gave rise to a large body of Art Deco cinema architecture, one of the finest examples of which was London's New Victoria cinema by Wamsley Lewis. Certain architects concentrated exclusively on cinemas; R Cromie, for example, who designed the Ritz in Southend, Essex (1934), was a leader in the field of independent cinema design, producing over 50 theaters from 1928 to 1930. With the advent of the talkies in the late 1920s, good soundproofing and effective acoustics became a priority. Another new development, neon lighting, came to be widely employed for attention attracting cinema marquees. The streamlined cinema façades of the 1930s were frequently at odds with the palaces of escapist fantasy within, where Moorish, baroque and other themes rubbed shoulders with Art Deco in a riot of splendid illusions achieved through the use of plaster, paint and colored lighting effects. One of the most consistent exterior and interior programs was that developed for the Odeon circuit under Harry Weedon. The low-key modernist streamlining was both elegant and cost efficient, and the standardization of fixtures, furniture and design created a recognizable identity for the Odeon chain of theaters.

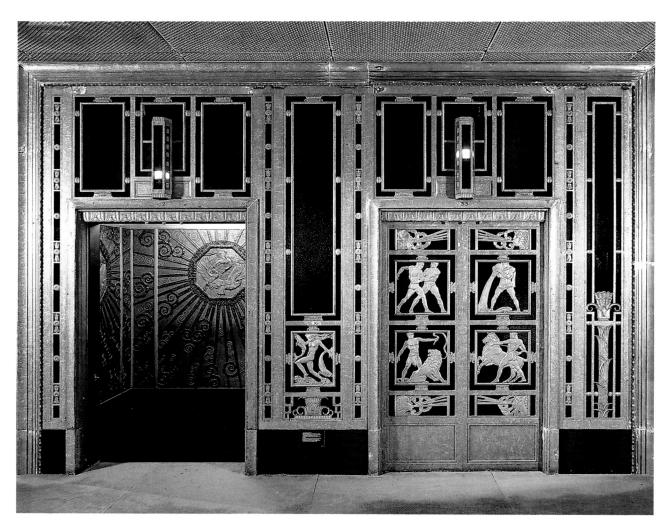

LEFT: *Edgar Brandt's splendid lift doors (1922-23) for Selfridges department store adapted motifs from classical mythology.*

BELOW: *The preliminary design proposed for the façade of the New Victoria Theatre by Lewis was an austere contrast to the elaborate sculptural decor later created within.*

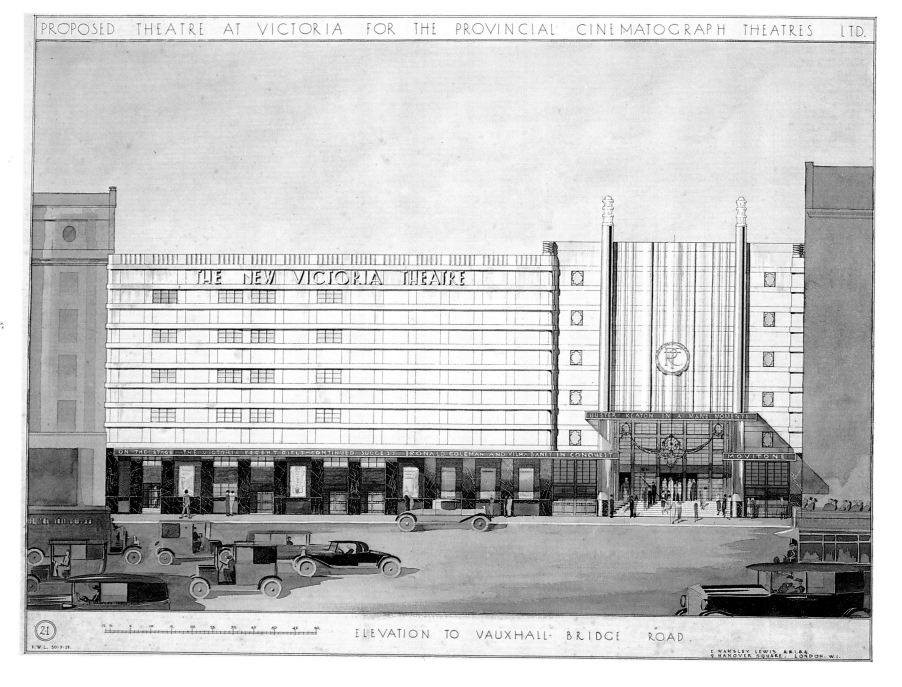

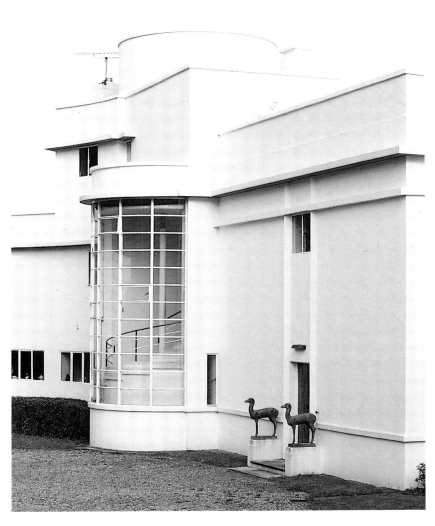

LEFT: *In Joldwyns (1930-32), Oliver Hill tempered the austerity of functionalism with curves and discreetly elegant ornament.*

BELOW: *Highpoint One (1936-38) in London was a landmark of the functionalism promoted by Berthold Lubetkin and others.*

Modernism, in the form of white Cubist boxes, had a limited success in England with its rainy climate. The decks provided little opportunity for sunbathing, the flat roofs often leaked, the concrete walls frequently cracked and the metal window frames soon stained the white walls beneath. In fact architects had to commission photographs of these buildings for their portfolios immediately after completion before the inevitable decay began to set in. To alleviate the blandness of the designs, architects and photographers soon became expert at devising dramatic lighting effects and using oblique angles.

Some architects came to modernism from classical moderne, as did Joseph Emberton when he pioneered the use of the steamship style in England with his yacht club of 1930-31. He had previously collaborated on London's Summit House, produced a new façade for the Olympia exhibition hall, and later went on to design Simpson's department store. A leading adapter of functionalism was the eclectic and fashionable Oliver Hill. Discreet deco ornament and detailing enhanced such private villas as Joldwyns (1930-32) and the more nautically flavored Holthanger (1933). Hill's Midland Hotel in Morecambe (1932-34), with decorative mosaics and sculpture by Eric Gill,

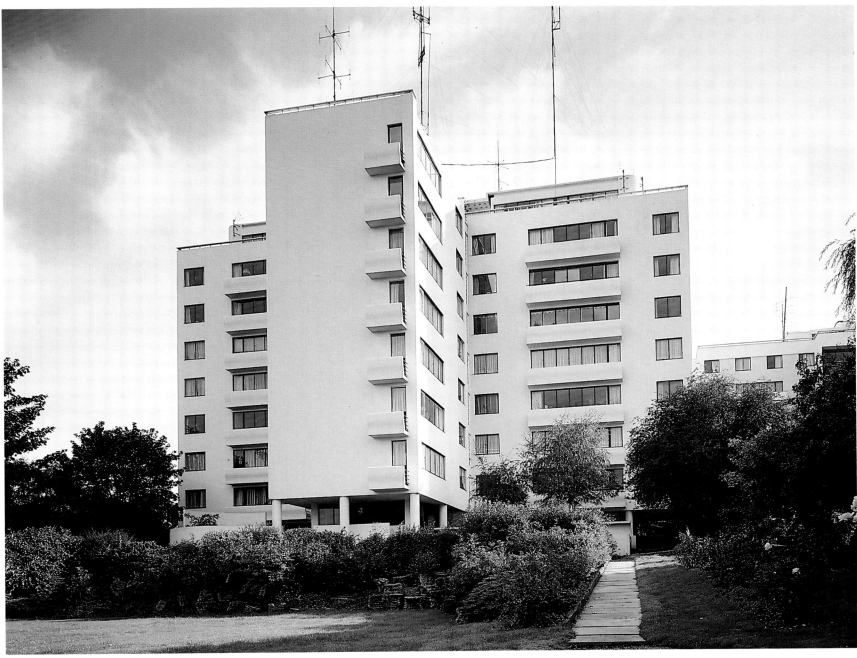

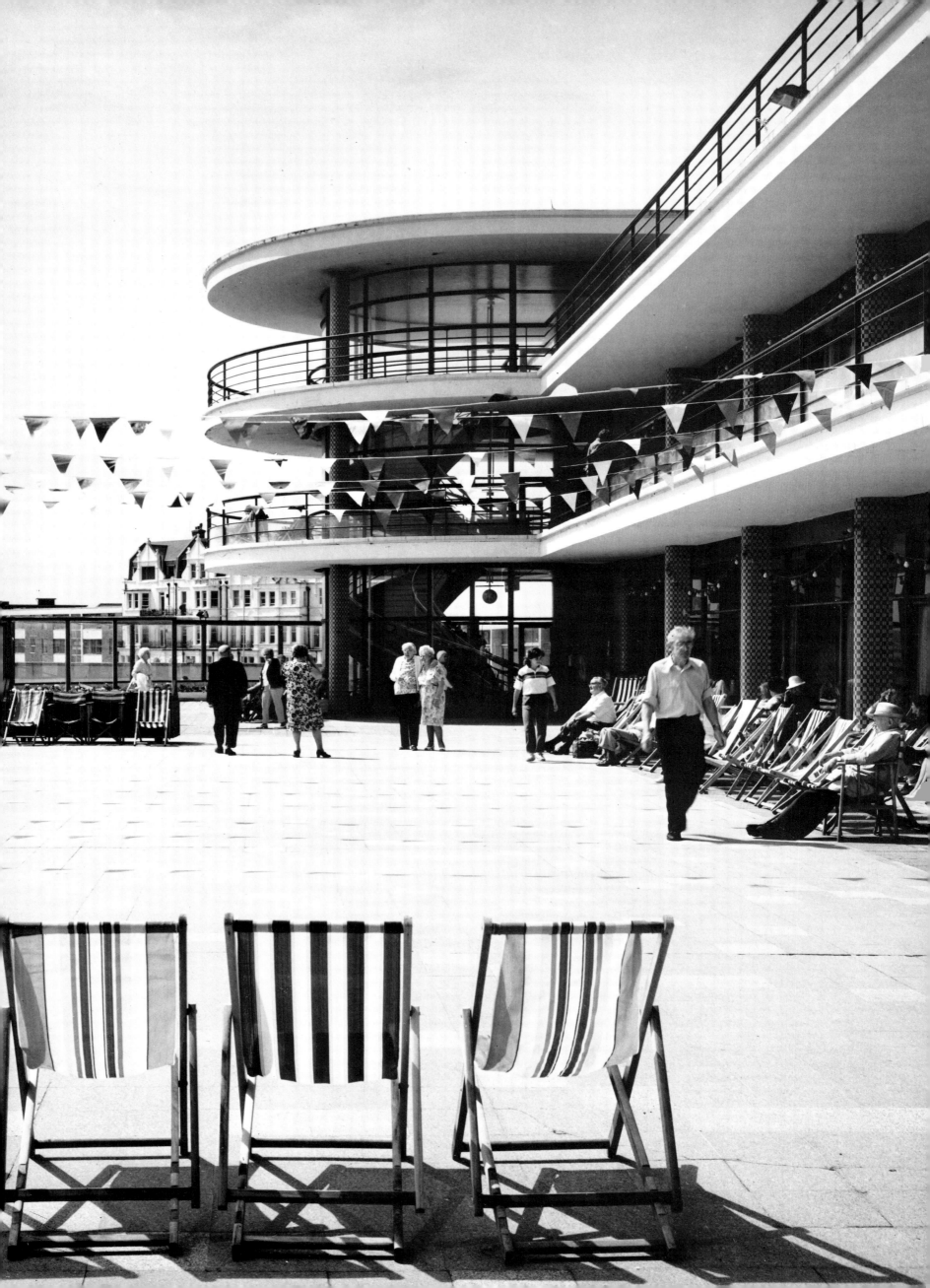

LEFT: *Serge Chermayeff collaborated with Eric Mendelsohn on the De La Warr Pavilion at Bexhill (1934-35).*

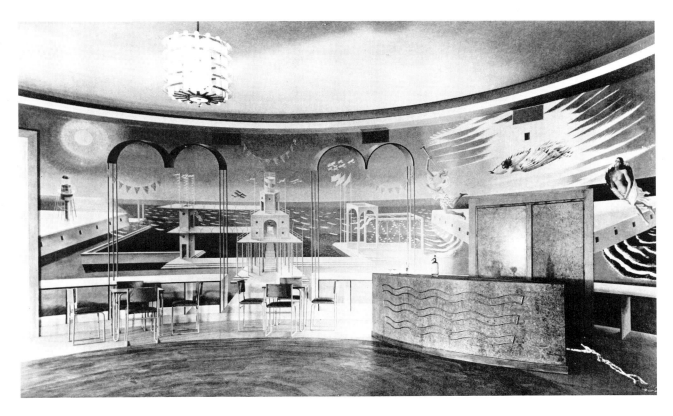

RIGHT AND BELOW: *In his design for the Midland Hotel in Morecambe, Lancashire, (1932-34), Oliver Hill emphasized luxury.*

was the first British hotel in the modern style. A later resort complex in a purer functionalist mode was Serge Chermayeff and Eric Mendelsohn's socialist pleasure palace, the De La Warr Pavilion at Bexhill, which became a source of some controversy because its designers were foreigners. Many functionalists were motivated by the socialist principles that informed Maxwell Fry, Walter Gropius, Erno Goldfinger and Berthold Lubetkin's public housing projects, although others were content to produce functionalist villas for the fashion conscious, as did Christopher Nicholson and Amyas Connell & Basil Ward. One of the first functionalist apartment buildings was the Lawn Road flats commissioned by Isokon from Wells Coates. Of monolithic

reinforced concrete, these service flats for the well-heeled but footloose were completed just as the political emigrés from Germany began to arrive. The tenants came at various times to include Walter Gropius, Marcel Breuer, Moholy-Nagy, Siegfried Giedion and E H Gombrich, as well as Le Corbusier and Agatha Christie. Although many leading functionalists soon moved on to America, a more stringent functionalism, shorn of any remnants of ornament, developed and became an ideological expression of socialism. With its implications of low cost and efficiency, it supplanted Art Deco entirely in the years following World War II, not only in England but also in most of the rest of the world.

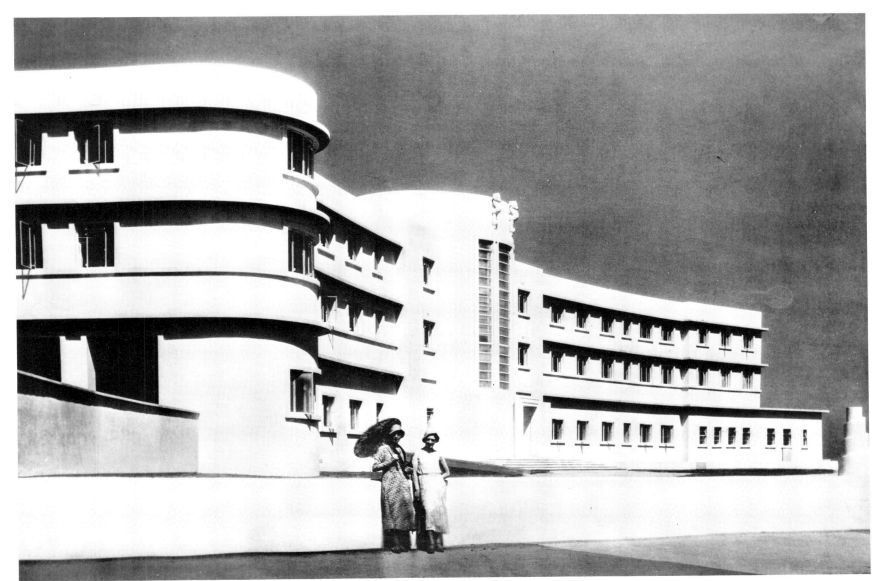

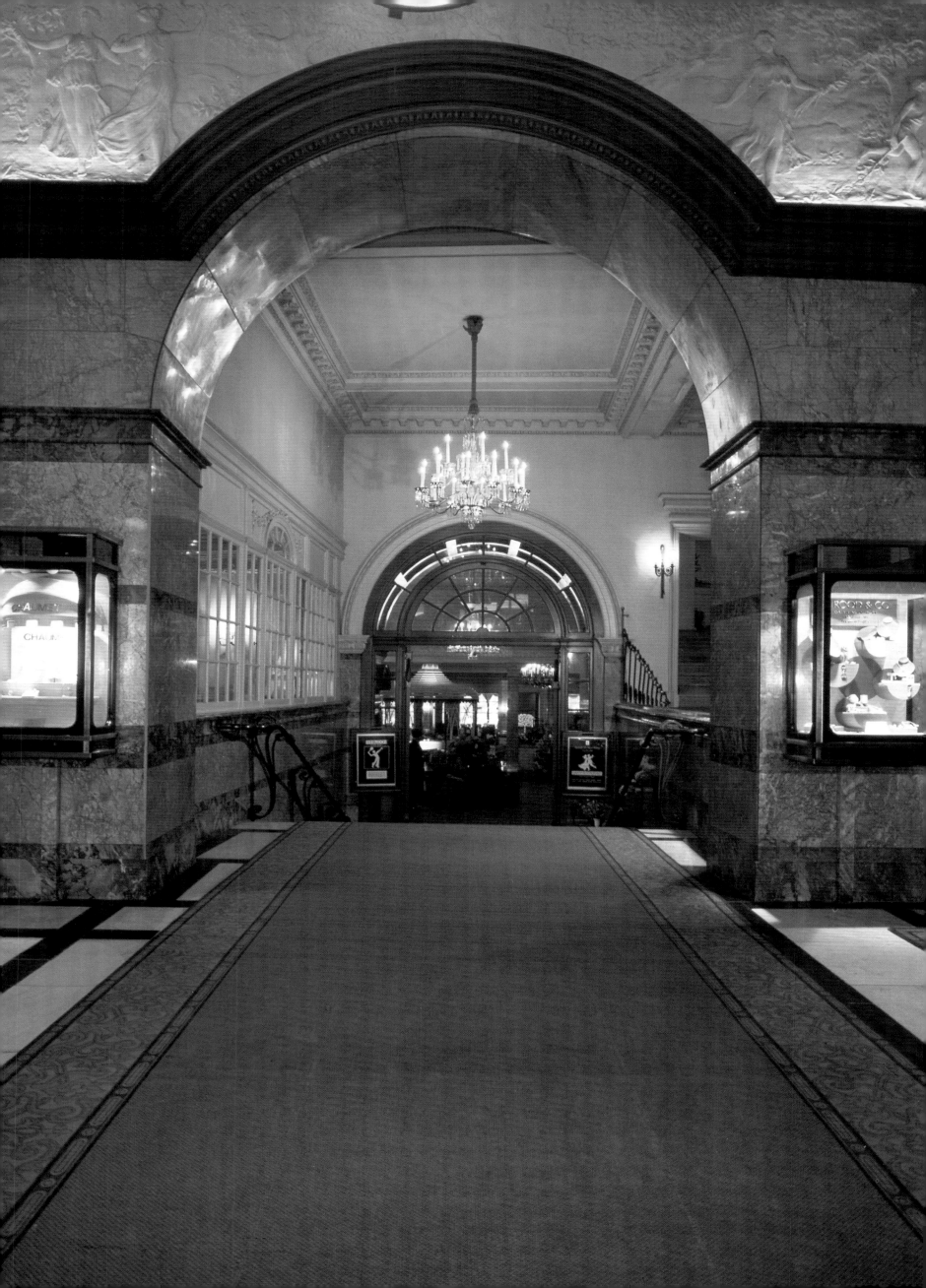

Furniture and Interior Design

It is widely acknowledged that the greatest masterpieces of Art Deco furniture were those produced by the French. France had a tradition of furniture-making virtually unmatched in artistic inventiveness and almost overwhelming opulence. Though the patrons of furniture in the styles of Louis XIV, Louis V, Louis XVI and Louis-Philippe were inevitably aristocratic and necessarily wealthy, the names of makers, or *ebénistes* and *menuisiers,* such as André-Charles Boulle, Charles Cressent and Jean-François Oeben became household words throughout Europe.

The stylistic roots of Art Deco can be found in the linear, geometric purity of neoclassicism. This rebellion against the gilded and curvilinear excesses of the baroque and rococo began, paradoxically, as the style of Madame du Barry and the late Marie Antoinette, and enjoyed a relatively brief success in France. In its moralistic and intellectual rigor, neoclassicism predicted the Revolution in which many of the paragons of conspicuous consumption were beheaded. The austere Roman classicism of the directoire style that followed was soon subsumed in the late neoclassical self-conscious grandeur of Napoleon's ponderous empire style, which incorporated Egyptianate motifs commemorating his military adventures in the land of the pyramids. As orchestrated by Percier and Fontaine, with furniture by Jacob-Desmalter, the empire style was highly symbolic, responsive to contemporary events and developments, and a vehicle of collaborative total design in a way that foretold the concerns of Art Deco.

At the end of the nineteenth century, winds of change – this time artistic rather than political – swept Europe once again. Art Nouveau was a deliberate attempt to forge an entirely new style, free of all historicist motifs and associations with the past. As the decorative equivalent of the Symbolist movement in the arts and literature, French Art Nouveau was marked by the use of sinuous, elongated stylized plant and other forms derived from nature. The work of such French masters as Emile Gallé and Louis Majorelle owed much to rococo in its emphasis on the voluptuously decorative and the inventively fanciful; indeed Majorelle also made rococo reproductions. As its direct predecessor, Art Nouveau lent Art Deco its floral and faunal imagery, which arose from attitudes of asymmetrical languor and reassembled in syncopated ranks of kaleidoscopic geometry.

While the masterpieces of French Art Nouveau looked essentially toward the past, a more progressive form of the style evolved elsewhere – the culmination of decades of debate, led by the British Arts and Crafts movement, about standards of decorative design and about the impact of industrialization on the arts. The Art Nouveau furniture of the Austrian *Sezessionstil,* as practiced by Vienna modernist Josef Hoffmann and others, began to undergo an elegant linear styl-

ization while retaining an old-world opulence. Hoffmann's masterpiece was the *Palais Stoclet* in Brussels (1905-11). He not only acted as the architect of the building but also designed the luxurious unified furniture and accessories. By 1910 Hoffmann was making stepped, or ziggurat-shaped case furniture that was, perhaps, more Art Deco than anything else.

To the north, the secessionists of Munich – center of the German *Jugendstil* – began to design simplified veneered pieces recalling the furniture of the Biedermeier period. Although German furniture making had been through a neoclassical phase of its own with the work of David Roentgen, purveyor of classicist cabinetry to Marie Antoinette, Louis XVI and other crowned heads of Europe, the legitimate Germanic parent of Art Deco was the Biedermeier style. Pioneered by the Berlin architect Karl Friedrich Schinkel and the Vienna furniture factory owner Joseph Danhauser, Biedermeier flourished between the 1820s and the 1840s. Compared to the highly embellished aristocratic styles, Biedermeier – which was produced for the middle classes – was characterized by very restrained ornament, clean lines based on geometrically simplified forms, and light toned woods. To modern eyes, it looks a lot like Art Deco.

To the French critics who saw the new neoclassicist works of Munich Secessionists such as Bruno Paul at the 1909 Munich *Werkbund* exhibition or at the 1910 Paris *Salon d'Automne,* this furniture seemed clumsy and garish. They did admit, though, that they were impressed by the German concern with total design, or *Gesamtkunstwerk* and, in a climate where Art Nouveau was coming to be seen as increasingly decadent, the new German ideas did not take long to sink in. In 1911, after visiting Hoffmann in Vienna and German crafts schools during a grand European tour, Paris couturier and trend-setter Paul Poiret established the interior design studio Atelier Martine and, according to Erté's autobiography, 'launched the "Munich" style, as it was called at the time.'

The quintessential French furniture maker of the Art Deco era was Jacques-Emile Ruhlmann. Regarded as a 'magnificent anachronism' for the remarkable quality of his work in the long tradition of opulent French furniture, he established his own decorating firm in 1910. Ruhlmann's furniture, constructed of the finest materials by means of the most exquisite craftsmanship, fetched astoundingly high prices from wealthy sophisticates. His simple, elegant pieces, a modernistic variant of neoclassicism, were characterized by the use of rare veneers, exotic woods, discreet inlay of ivory or other materials, restrained ornament, a historicist vocabulary, and slender tapering legs often capped by silver 'shoes.' Ruhlmann's workshop artisans – masters of *ebénisterie* (cabinet making), *menuiserie* (joinery and

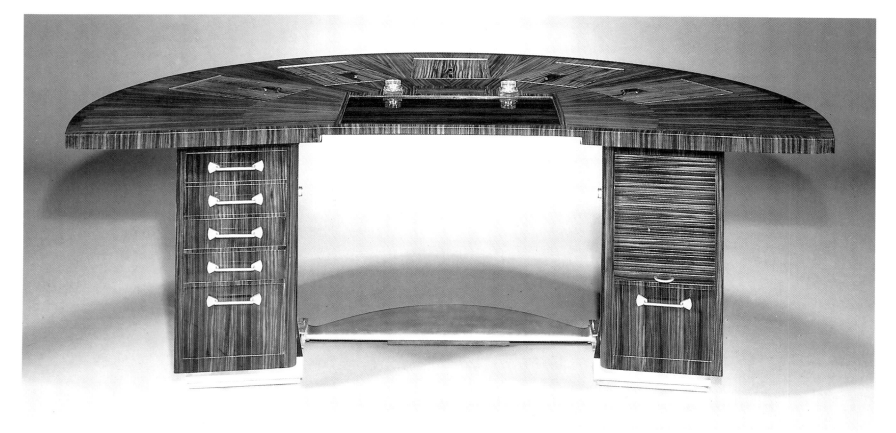

carved pieces), lacquer and upholstery – executed his designs with a degree of perfection that made Ruhlmann's *Pavillon d'un Collectionneur* at the 1925 Paris exposition a sensation. Despite the fact that Ruhlmann acknowledged the rise of functionalism around 1930 by using metals and plastic and by designing sectional pieces, his peerless furniture remained conservative, classic and essentially timeless.

An initial conservatism also typified the work of Jules Leleu, Clement Mere, Süe et Mare, and André Groult. The designs of many of those who made the transition from Art Nouveau to Art Deco – among them Paul Iribe, Leon Jallot, Paul Follot, Maurice Dufrêne, René Lalique, Louis Majorelle and Clement Mere – frequently used floral motifs. Paul Iribe helped to popularize the flower as a motif when his stylized rose came to symbolize the spirit of France during World War I. Jules Leleu, who opened a studio in 1922, often used the Iribe rose together with blond shagreen (sharkskin). Unusual materials such as shagreen, ivory, mother of pearl, galuchat, eggshell, ormulu, tortoiseshell, leather, painted parchment, snakeskin, exotic animal hides and silver and gold leaf often were featured in the French Art Deco furniture of the 1920s and earlier. Clement Rous-

seau, who began making furniture in 1910, used finishes such as lacquer, stamped and patinated leather and inlaid ivory – used previously in the making of snuff boxes – for the unique pieces he created for Baron de Rothschild and others.

In order to cater to a less exclusive clientele, Louis Süe and André Mare as Süe et Mare established in 1919 the *Compagnie des Arts Français,* an association of workshops and artisans like those found in Austria and Germany. Süe et Mare were known for well designed curvilinear furniture inspired by the Louis-Philippe period and available at affordable prices. In the years of transition from Art Nouveau around 1910, Majorelle and Léon Jallot also called on the Louis-Philippe period to help achieve a modernist simplification.

The large department stores played a major role in popularizing the Art Deco style by hiring Paul Follot, Maurice Dufrêne and others to head their newly organized modern design ateliers. Follot and Dufrêne had been among the pioneering designers showcased by the annual salons of the *Société des Artistes Decorateurs,* established in 1901. They began to move away from Art Nouveau around 1903, seeking out new design ideas in the neoclassical furniture of the late

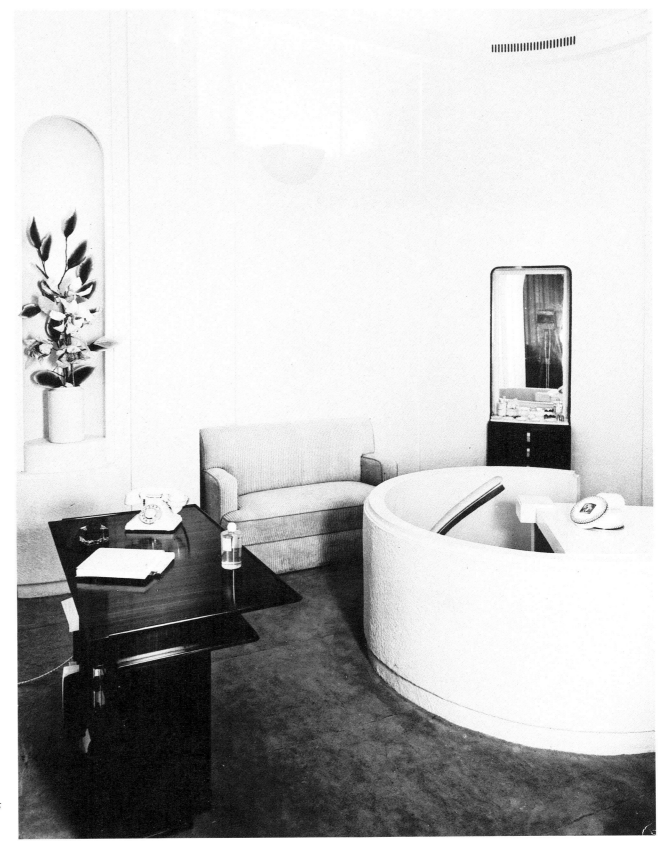

LEFT: *France's leading Art Deco furniture designer Emile-Jacques Ruhlmann created this ebony and gilt bronze desk in 1929.*

RIGHT: *Yardleys, under design director Reco Capey, refurbished its London showroom with furniture by Ruhlmann.*

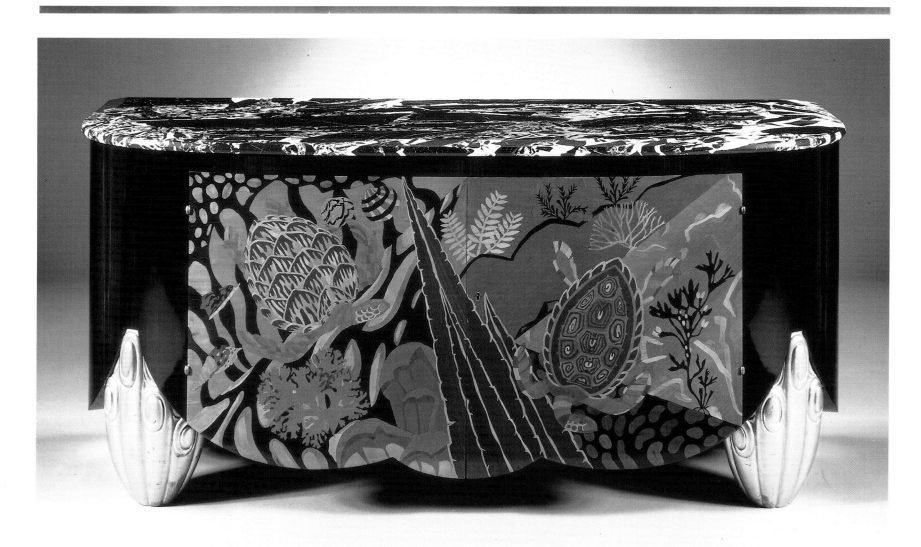

eighteenth century. In 1910 the salon exhibited the furniture of Ruhlmann for the first time. The years preceding the First World War gave rise to traditionalist and floral versions of Art Deco. Follot, for example, was known for his use of the fruit basket motif. Of the department stores, the Magasin du Printemps was the first to found its design workshop, Atelier Primavera, in 1919. Three years later, the Galeries Lafayette followed by asking Maurice Dufrêne to head its La Maîtrise, and Bon Marché hired Paul Follot to supervise Atelier Pomone. The Louvre store set up Studium in 1923. These design workshops produced not only furniture but also a whole range of modernistic interior accessories in a unified style, and offered their design services as well. They catered mainly to the middle-class customer, but offered to take on exclusive commissions too.

André Groult, Poiret's brother-in-law, who earlier had explored neoclassical variants of Art Deco, produced in 1925 some rather unique pieces with swollen bombé forms covered in sharkskin and detailed in ivory. The visual vitality of Groult's designs and of Art Deco furniture in general owed something to the fact that many of the leading Paris designers such as Ruhlmann, Louis Süe, Eileen Gray, André Mare and Francis Jourdain had started out as painters, while others such as Clement Mere and Jean Dunand had begun their careers as sculptors.

Dunand came to the Art Deco style after World War I. His technical virtuosity in lacquer work was recognized by Ruhlmann and Pierre Legrain, who used his services. Besides his magnificent lacquered folding screens (discussed in the chapter on sculpture and painting), Dunand's workshops produced a whole range of luxury items including jewelry, *dinanderie* – vases decorated with nonprecious metals and lacquer – and furniture. His specialties included carved lacquer and *coquille d'oeuf*, a technique of setting crushed eggshell into lacquer.

Some of the more experimental French Art Deco furniture was produced by designers influenced by the avant-garde art movements. In the 1920s Pierre Chareau's angular and volumetric armchairs clearly reflected Cubism, as did the geometrically stylized pieces of Jean Michel Frank. And primitivism obviously was the root of the sculptural exotic furniture, which was at times deliberately

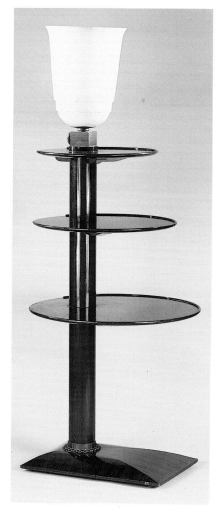

ABOVE: *An ebony, marquetry, giltwood and marble commode by Süe et Mare, with doors decorated after a design by Mathurin Meheut.*

LEFT: *A combination standing lamp and display stand by Ruhlmann.*

ABOVE RIGHT: *A lacquered cocktail cabinet by Paul Follot.*

RIGHT: *A 1925 dining room by Süe et Mare.*

made in a crude manner in order to suggest tribal carvings, by Pierre Legrain and Marcel Coard. Primitivistic furniture received a further boost from the Paris 1931 international colonial exposition, and was sometimes referred to as *le style coloniale*. The designs of Eileen Gray, a British expatriate working in France, reflected various avant-garde trends. Her 1930 *pirogue* (or canoe) sofa of lacquered wood

and silver leaf was a luxurious interpretation of a Polynesian dugout canoe, while through her Paris gallery Jean Désert, opened in 1922, Gray offered elegant screens, lighting fixtures, rugs and furniture. Some of her pieces reflected the influence of Cubism, others a more austere functionalist aesthetic.

The French focus on luxury Art Deco furniture was due in large part to the influential patronage of the leading Parisian couturiers Jacques Doucet, Paul Poiret, Jeanne Lanvin and Suzanne Talbot. The single greatest patron was Jacques Doucet who created a sensation in 1912 by suddenly selling off his collection of eighteenth-century art – including works by Houdon, Boucher, Fragonard and others – along with his antique furniture. Having decided to devote his attention to avant-garde art and to modernist designers, Doucet retained Paul Iribe to oversee the considerable project of redecorating and re-furnishing his Paris house, to be followed by a similar project at his villa in Neuilly. Over the following years, Doucet commissioned works by Iribe, Marcel Coard, Pierre Chareau, Rose Adler, Eileen Gray, Gustave Miklos, Clement Rousseau, Josef Czaky and Pierre Legrain. When Iribe departed in 1914 for the United States, Legrain took over the project.

Doucet was the first major sponsor of many of the leading Art Deco designers, encouraging some, like Legrain and Gray, to explore new directions. With Doucet's support during most of the 1920s, Legrain received the freedom to develop his ideas on primitivism in modernist furniture, while Gray was first hired in 1913 to make lacquered frames for Doucet's new art collection. She went on to create some very fine work for Doucet, including the lacquered screen, *Le Destin*, followed by other lacquered screens and tables such as the lotus motif table specifically requested by Doucet. Doucet, who had a special fondness for rare and exotic things, sometimes influenced designers to create some of their more unusual items for him. Between 1919 and 1922 Gray completed another important project in

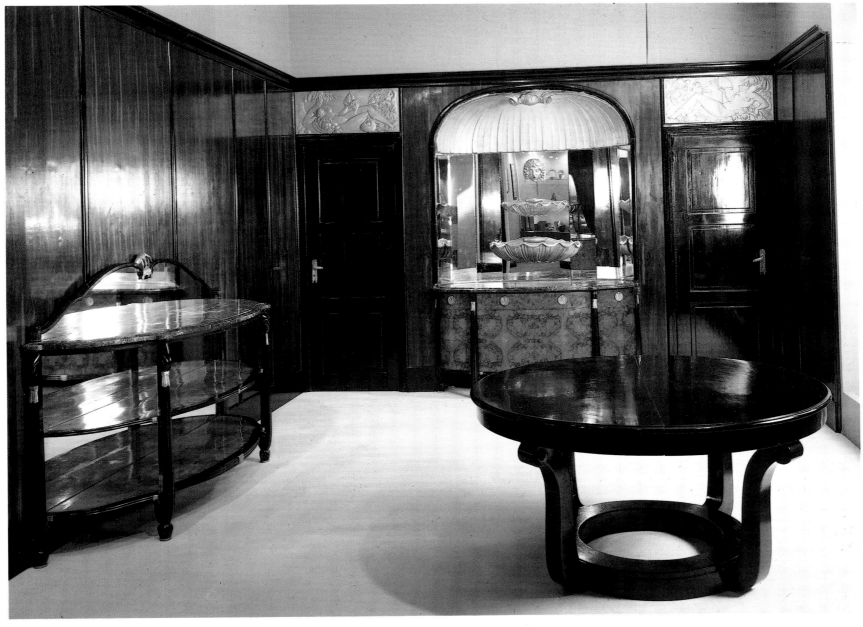

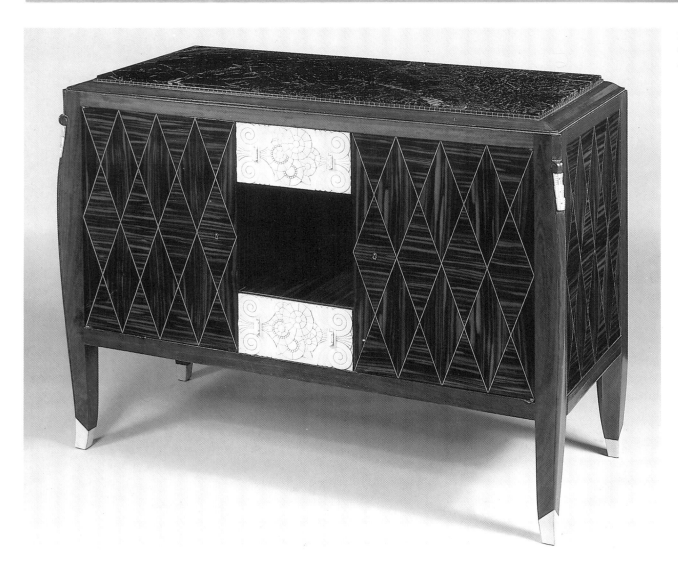

the design of the Suzanne Talbot's apartment, for which she created lacquer panels for the walls, carpets, lighting fixtures and plush furniture. In 1927 Gray turned to more austere furniture, influenced by the example of Le Corbusier, and to architecture as well.

Couturier Jeanne Lanvin commissioned interior decorator and furniture designer Armand-Albert Rateau to modernize her premises between 1920 and 1922. His stylish decor and furniture – notably in Lanvin's blue and floral bedroom, as well as her elegant new bathroom – became landmarks of Art Deco design. Some of the Lanvin furnishings are now in the Musée des Arts Decoratifs. Rateau was also interested in oriental and Pompeiian art and, as director of Lanvin-Décoration, went on to provide sumptuous settings for the Rothschilds, the Duchess of Alba, New York art collector George Blumenthal and many others.

Paul Poiret, who started out under Doucet, unquestionably reigned in the realm of style in women's fashion and interior design in Paris from 1915 to 1925. He hired Iribe, Georges Lepape, Erté, José Zamora, Raoul Dufy and others to execute and design illustrations, women's dresses, theater sets and costumes, textiles and domestic accessories for his fashion design house and for his interior design studio, Atelier Martine. Poiret was especially significant for setting the trend for such new modernist colors as tango orange, silver, black and the vibrant hues of the Russian Ballet.

With the 1930s came a rejection of ornament and a turn to ascetic metal furniture inspired by Le Corbusier and the Bauhaus, and a shift to mass production techniques. The *Union des Artistes Modernes*, founded in 1928, was in effect a secessionist group protesting against the ostentatious excesses of 1920s style French Art Deco design. René

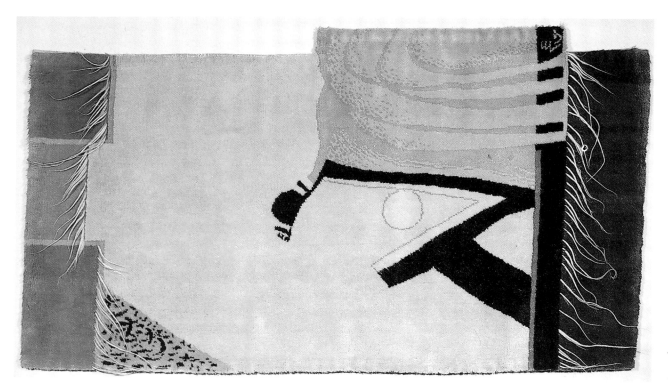

RIGHT: *Pierre Legrain's cabinet dating from 1925 hints at his interest in primitivism.*

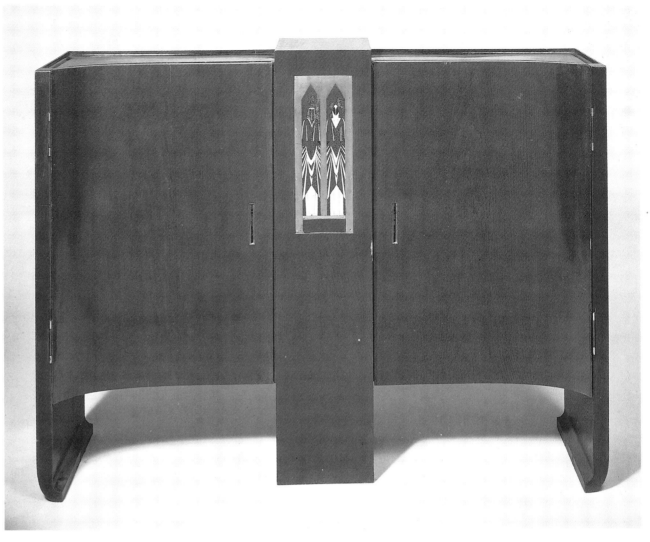

BELOW: *Eileen Gray's 1924 armchair looks ahead to the functionalism of the 1930s.*

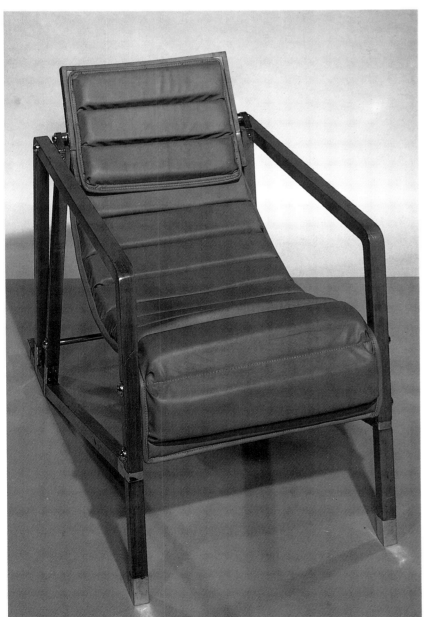

Herbst led the revolt; he was soon followed by Pierre Chareau, Eileen Gray, Robert Mallet-Stevens and others. The torch of aesthetic innovation had passed to the functionalists.

In the context of the totally designed Art Deco environment, textiles – not only in the form of upholstery, curtain fabrics and wall coverings, but also carpets and tapestries – played an integral role. Many of the design studios, including Poiret's Atelier Martine, Primavera and Pomone, produced lively textiles in stylized floral and other Art Deco motifs; Paul Iribe, Raoul Dufy, Robert Bonfils, Paul Rodier, Robert Mallet-Stevens, Marie Laurencin and Edouard Benedictus were also active in this field.

Some of the more abstract designs were produced by avant-garde artists such as Alexandra Exter, Jean Lurcat, Fernand Leger and, foremost, Sonia Delaunay. In 1912 she and her husband Robert had founded the school of abstract color painting known as simultaneism; she now adapted its geometric arcs, circles, discs and wedges, and its vibrant primary hues, to the field of textile design. Her first group of fifty textile designs for a Lyons company brought Delaunay fame in 1923, and led to collaboration with couturier Jacques Heim. Their designs at the *Boutique Simultanée* were a highlight of the 1925 Paris exposition. Some of her more memorable projects included the Citroën car she painted with a pattern matching a coat worn by its driver, and the coat of many colors she created for the Hollywood film actress Gloria Swanson.

The Art Deco years were a golden age for the ironsmith, or metalworker. Architects, designers, and shops provided a vast market for the elegant stylized gates, grilles, stair and balcony railings, elevator doors, radiator covers, lighting fixtures and other architectural adjuncts included in their unified design schemes. Among the French metalworkers were sculptors such as Jan and Joel Martel and noted *ferroniers* such as Raymond Subes.

The giant of this craft was Edgar Brandt, the creator of some of the finest metalwork of the modern age. Brandt, who founded his business in 1919, was known for his curvilinear designs of frozen fountains, stylized flowers and other nature imagery. These motifs appeared on the decorative panels, room dividers, screens, mirrors, lamps and console tables he designed in addition to architectural

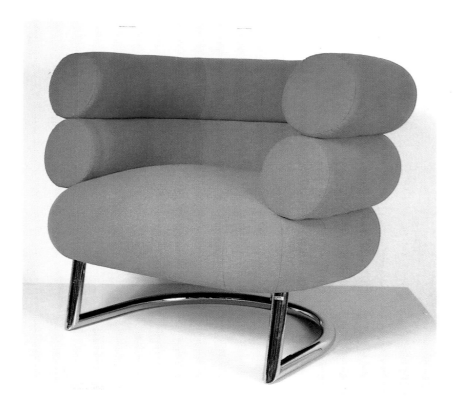

items. His early studies as a jewelry maker as well as a smith certainly contributed to the exquisite quality of his work, which brought him major public commissions from the Louvre, the Banque de France, the Marseilles opera and for the eternal flame at the Tomb of the Unknown Soldier in Paris. The 1925 Paris exposition where Brandt's metalwork was seen everywhere, marked a turning point. His work there included the gates and doors for the Ruhlmann pavilion, the Porte d'Honneur and the *L'Oasis* screen of copper, brass and iron for the room he designed in the *Ambassade* pavilion. The acclaim and international exposure that Brandt achieved at this exhibition led to the opening of his own Paris gallery and of a New York branch which operated under the name Ferrobrandt.

Brandt executed both his own designs and those of others, and employed a large number of artisans to do so. He worked not only in wrought iron, but also incorporated other metals such as bronze, steel and aluminum; the effects were widened further by gilding and patinating – the artificial induction of a film of green or brown oxide on the surface of the metal. In view of the relatively reticent, functionalist aspect of much of the French Art Deco architecture, Brandt's delicate metalwork was just the thing to give these buildings a tasteful touch of ornament or lend a commercial establishment that inimitable imprint of style. His entrance door to Poiret's Paris fashion house did just that.

Brandt also worked on many commissions abroad. An important one came from Selfridges store in London for wrought-iron and bronze decorative panels for the lift interiors (1922-23); after redecoration, these panels were given to British museums. His first New York project was for the Cheney Brothers textile store, where he designed not only the large doors of stylized florets and palm fronds surrounding frozen fountains, but also the wrought-iron 'trees' on which the silken fabrics were displayed. Ferrobrandt, his New York office, continued in business for some three years, bringing the essence of Parisian Art Deco to the New World. Another important New York building with French style ornamental metalwork was the Chanin building (1929); its opulent design was the work of Jacques Delamarre.

Brandt also produced lighting fixtures, some with glass shades by Lalique, Daum and others. His cobra lamp, which came in three sizes, was the most successful. The glass manufacturers also sold lighting fixtures with metalwork by Brandt and Majorelle, while many architects and interior designers created fixtures appropriate to specific environments, such as Armand Rateau's birds' heads lamp for Lanvin and Pierre Chareau's sliced alabaster lamps. Simonet Freres was an important source of Art Deco lighting, while Donald Desny and Jean Perzel came up with avant-garde models in the functionalist vein.

In French Art Deco, the concept of total design was perhaps best realized in the collaborative work by leading designers on those ostentatious anachronisms, the luxury ocean liners. Some of these palatial ships were planned during the 1920s but were not actually launched until the following decade. In contrast to the extravagant New York skyscrapers which came to completion after the Wall Street crash and hence lost many of the tenants they were intended to

ABOVE LEFT: *Eileen Gray's 'Bibendum' steel and canvas chair (c 1929).*

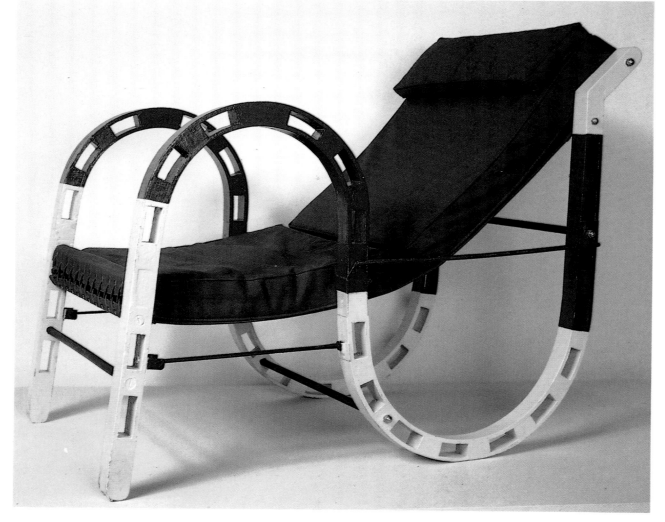

LEFT: *A wood and canvas armchair by Eileen Gray from the late 1930s.*

RIGHT: *A lamp with metalwork by Edgar Brandt.*

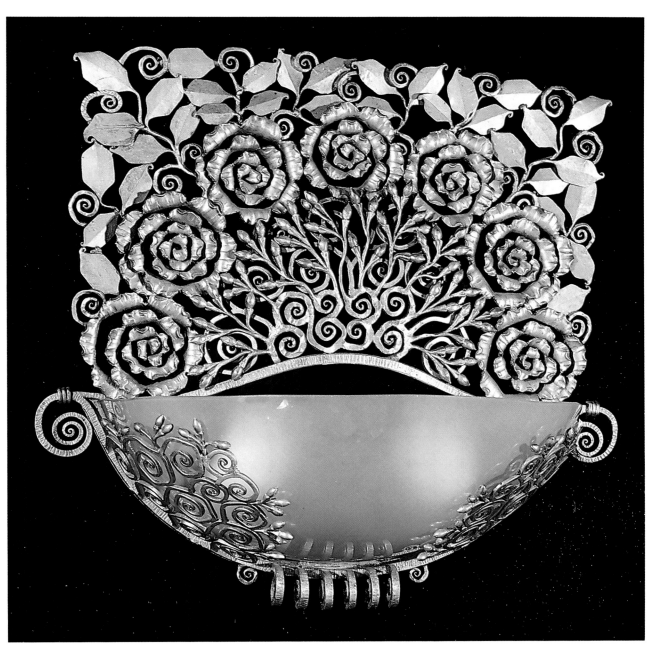

BELOW: *A detail from the set of ten murals designed by Jean Dupas for the French ocean liner* Normandie.

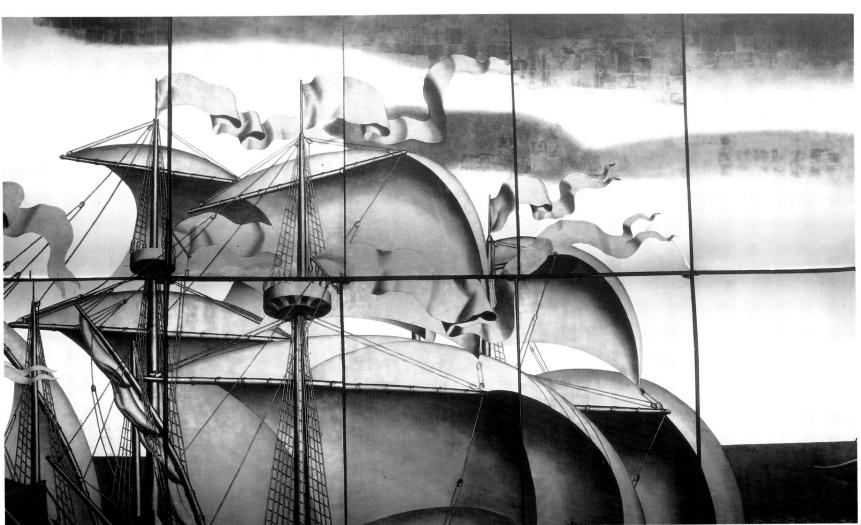

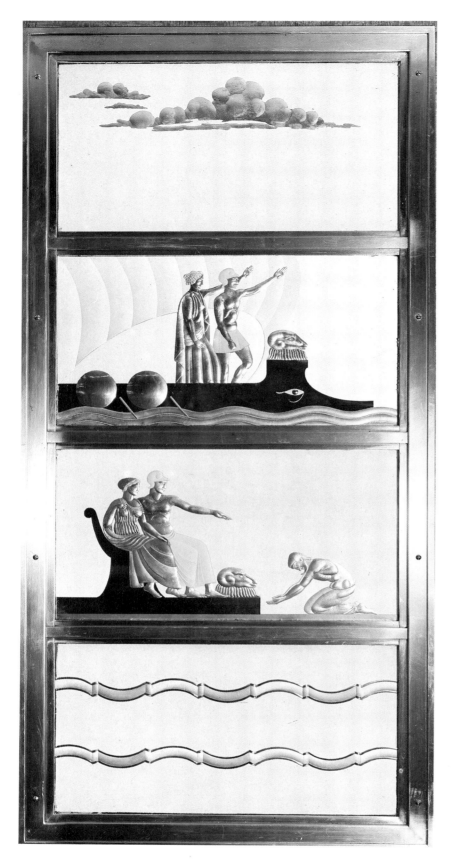

ABOVE: *Glass panels engraved with the legend of Jason and the Golden Fleece for the* Queen Mary *by Jacob Drew.*

shops, children's playrooms, libraries, and even the brokerage offices through which capitalists on the high seas were able to track their vanishing fortunes in October 1929. The *Ile de France,* launched in 1926, was the first big liner built after World War I and it established the standard in modernist luxury. After intense competition, over 30 top interior designers were selected to collaborate in the decor and furnishing of such features as the 700-seat first class dining room by Pierre Patout, with molded glass light fixtures by Lalique and a dramatic entrance staircase with metalwork by Subes at one end; the main salon by Süe et Mare; the large Salon de Thé by Ruhlmann; the four-storey grand foyer with a concourse of tiered shops; and the deluxe bedroom suites, each of them the work of a different designer.

Even more than the *Ile de France,* the *Normandie,* which entered service in 1935, was intended as a floating showcase for the leading French designers, artists and artisans of the 1920s and 1930s. It was an opulent dream world, a fantasy enhanced by an etched and painted glass panel by Jean Dupas, colossal Lalique chandeliers, an enormous carved lacquer mural by Jean Dunand and Ruhlmann furniture in the more exclusive suites.

The atmosphere of gaiety and elegance on these ocean crossings – with celebrities, noblemen, Hollywood film stars, diplomats, musicians, vaudeville performers and members of high society on the passenger list – the shipboard revelry, entertainments, sports and romances, the festive embarkations and gala arrivals, were all part of a social ritual remote from the paltry comforts of contemporary first class air travel.

In the other European countries, Art Deco design never formed a broad based movement to the extent that it did in France. In avant-garde European circles, it was the functionalist aesthetic that soon came to dominate. This does not mean, however, that Art Deco furniture and related items were not made outside of France. That they were (though certainly to a rather limited extent) is documented by the design and architectural periodicals of the 1920s and early 1930s. From Germany, which published such important modernist journals as *Dekorative Kunst* and the Art Deco magazine *Styl,* came furniture and other Art Deco designs by Bruno Paul, Berlin cinema architect Oskar Kaufmann, *Werkbund* members Theodor Reimann and Waldemar Raemisch, designer Willy Lutz, and Darmstadt's prolific Josef Emanuel Margold, who produced a whole range of wares in the floral and Cubist styles, including chairs, lamps, metalware and ceramics. Italy's protean Gio Ponti, ever responsive to international design trends, created furniture, ceramics and interior designs, among them work for ocean liners.

Just before World War I, Czechoslovakia's Prague Art Workshop members Pavel Jonak, Josef Chochol and Josef Gocar sought to transmute Cubist ideas into architecture and furniture of crystalline forms and multiple planes, inspiring designer Vlastislav Hofman to proclaim that 'Form . . . is superior to function.' In the 1920s rather more conventional Art Deco designs were created by Prague architect Fritz Lehmann in glass, ceramics, metalware and interior decor. The Scandinavian giant of the decades between the wars was Finland's Alvar Aalto. His graceful, innovative blond-toned birchwood furniture of bent plywood was not precisely Art Deco, but it had much in common with the curves of streamlining.

Despite England's inherently conservative response to the excesses of decorative modernism, a surprising amount of activity revolved around the production and presentation of Art Deco furniture, particularly for hotels, restaurants, shops and style-conscious private clients. That very competent pieces of Art Deco (or jokingly, George V style) furniture were created in the late 1920s is testimony to British achievements in furniture design during earlier eras. The neoclassicism of Robert Adam was, perhaps, more influential on Art Deco furniture in its unity of design rather than its style. The designs of Hepplewhite and Sheraton, Thomas Hope's Egyptianate exoticism and the Regency style can all be seen as precursors of Art Deco, and the proto-modernist Anglo-Japanese designs produced in the 1860s by E W Godwin (whose work influenced Charles Rennie Mackintosh), followed by the elegant linear pieces of Ernest Gimson, had a distinctly 1920s look to them.

house, the luxury liners had not yet been challenged by the airplane on the North Atlantic route and thus sped on through the waves, spectacular symbols of an already passing era. Although the names of such French ships as the *Ile de France* and *Normandie* evoke the essence of Art Deco, other nations produced somewhat more restrained variations on this theme, including such successful examples as Britain's *Queen Mary* and Holland's *Nieuwe Amsterdam.*

These ocean liners were not just a means of transportation; like the international expositions of the era, they were vehicles of chauvinistic pride that offered the best possible opportunity to publicize a nation's artistry and cultural authority. Nor were they simply floating luxury hotels either; they were more like floating cities of thousands of passengers and crew, who were serviced by restaurants, bars, theaters, hospitals, chapels, barber shops, beauty salons, gymnasiums and other sports facilities, swimming pools, dry cleaning

RIGHT: Queen Mary's *tourist class swimming pool.*

BELOW: Queen Mary's *first class cocktail bar.*

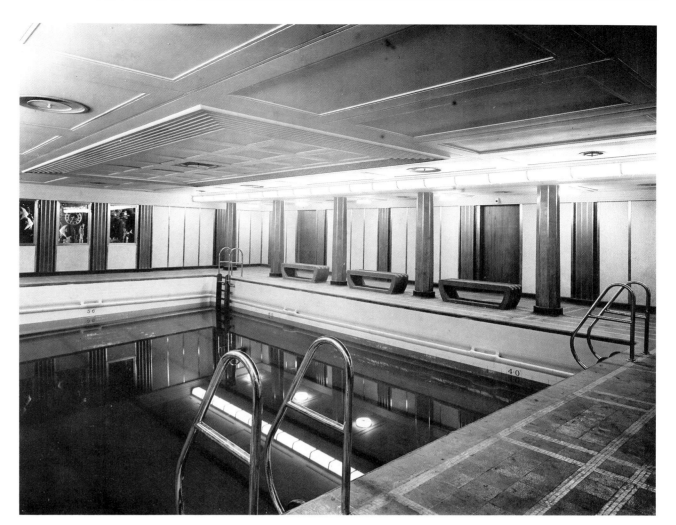

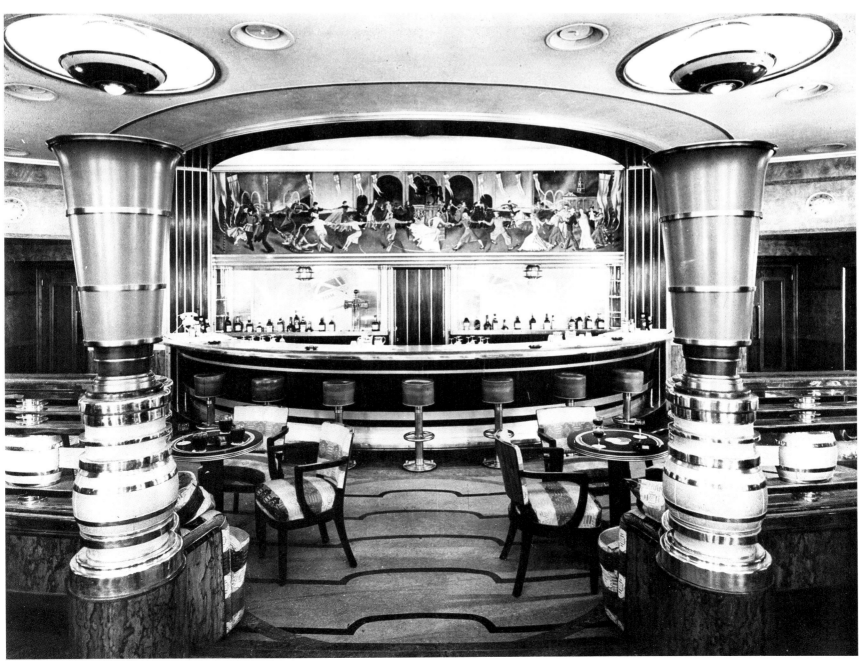

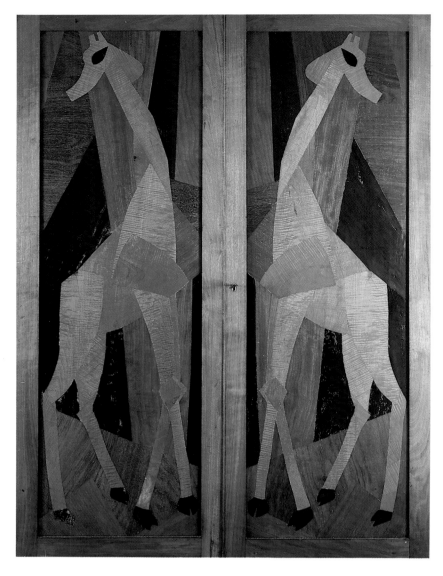

Around 1913 the Omega Workshops assumed a pioneering role in the development of modernist furniture. Though the furniture itself was not very innovative, the decorative marquetry designs by Roger Fry, Henri Gaudier-Brzeska and Duncan Grant, as well as some of Fry's painted panels on case furniture, were a brave attempt to apply the principles of Cubism to the decorative arts.

In line with the development of the new style on the continent, such traditional furniture companies as Ambrose Heal, Gordon Russell and even Liberty began to include some modernist pieces among their generally Arts and Crafts style lines. The venerable company of

Waring & Gillow was certainly the most forward-looking in its commissioning of work by avant-garde designers; in 1929 the firm placed Serge Chermayeff, together with Paul Follot, in charge of its department of modern furniture. Chermayeff, who was later to embrace functionalism, designed a wide range of attractive Art Deco furniture. Some of his work featured French-style floral motifs, although most of his designs achieved their effect through the application of exotic veneers, paint or silver leaf to simplified basic forms, and were frequently upholstered with Cubistic textiles. Some of Chermayeff's more satisfying works were his built-in furniture, his tub shaped armchairs and his multipurpose jazz-age pieces, such as his combination end table/cocktail cabinet/bookshelf/room divider.

Among the more elegant English Art Deco pieces were the designs by Charles A Richter, usually for Bath Cabinet Makers. A few of Richter's more remarkable designs were heavy, abstracted classicist pieces on plinth-like bases. R W Symonds and Robert Lutyens produced some similar work, with light colored veneers, including a truly monumental piano. This furniture had much in common with the Biedermeier style, and today looks very like postmodernism half a century before its time.

Some of the best-made British modernist furniture was that produced by Betty Joel Ltd. Joel's simple and luxurious designs, characterized by rounded curves and discreetly ornamented with contrasting veneers, were executed by yacht fitters. These pieces, along with accessories such as light fixtures by Lalique, were sold to the exclusive clientele of her London gallery. Joel executed commissions for the Savoy Hotel group and for such private customers as Lord Mountbatten and Winston Churchill.

Betty Joel's success came in an era when the female interior designer first gained ascendancy in Britain in the years that followed World War I. Among the most gifted of these decorators was Syrie Maugham, who claimed credit for being the originator, in 1927, of the 'all-white' room. This idiosyncratic concept established her reputation and was later adapted by Hollywood set designers to create scenes of ultimate glamor. Maugham's social connections, as well as her talents, played no small part in attracting such celebrity clients as Tallulah Bankhead, Noel Coward, Gertrude Lawrence, Wallis Simpson and the Prince of Wales.

Modernist architects played a significant role as well in bringing French Art Deco ideas to British interiors. A key event was the redesign of Finella, the 'mouldy Victorian villa' of Cambridge University Master Mansfield Forbes by young Australian architect Raymond McGrath. Following this well publicized success, McGrath went on to other commissions for shops and restaurants, eventually becoming

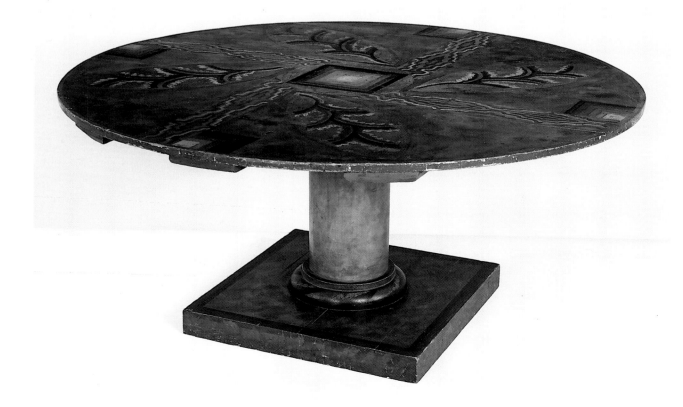

ABOVE LEFT AND LEFT: *From the Omega Workshops came such decorative furniture as Roger Fry's cupboard with 'Giraffe' marquetry doors, and his painted circular dining table.*

RIGHT: *Oswald Milne supervised the 1929 redesign of Claridge's ballroom and its anteroom, seen here. The carpets were designed by Marian Dorn.*

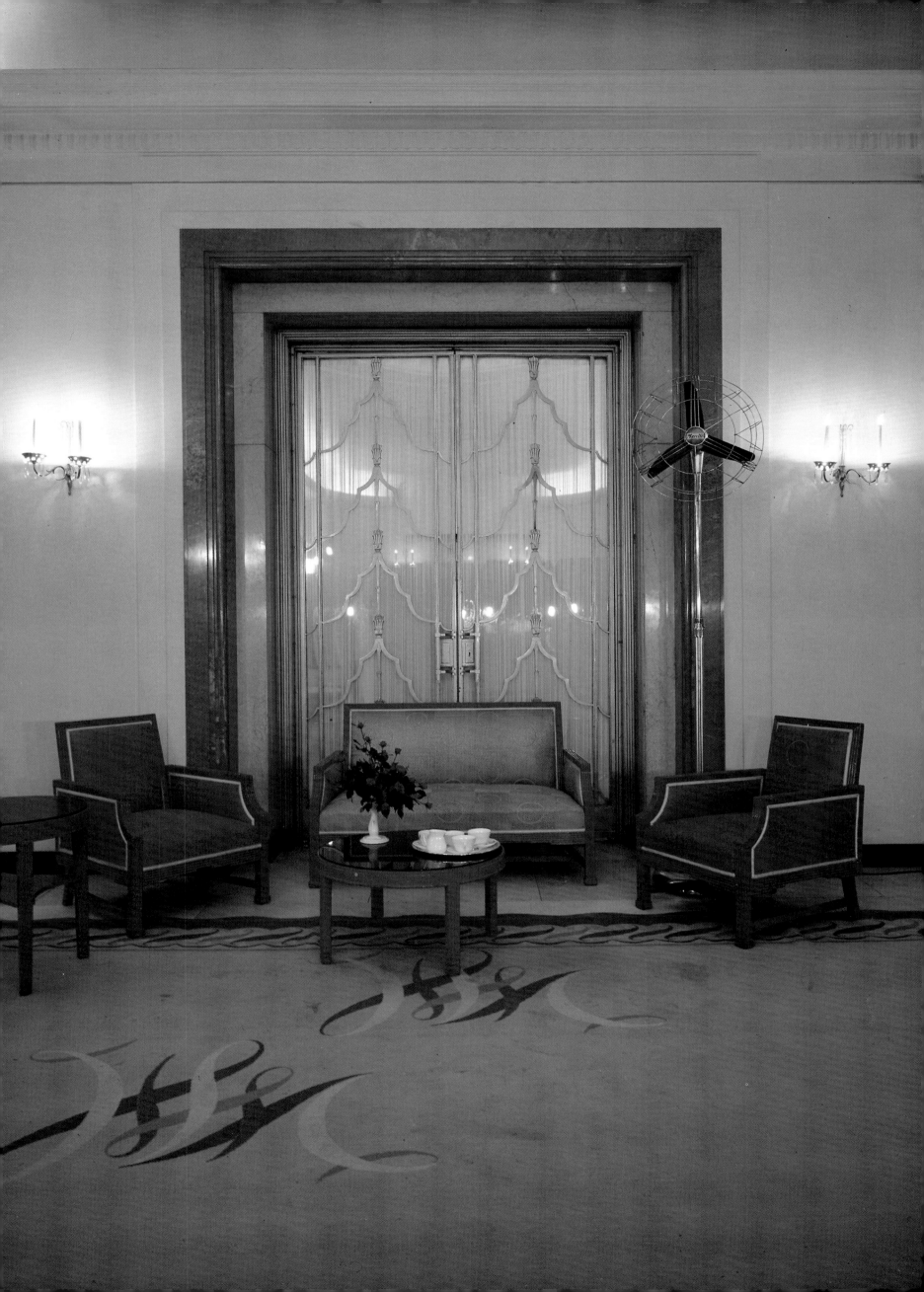

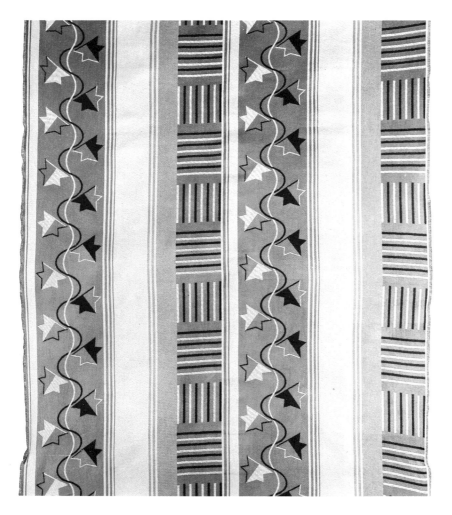

panels are now disassembled and in storage at the Victoria and Albert Museum.) Bernard's use of Cubist glass effects reflected a British taste for vitreous design. Raymond McGrath decorated the Embassy Club with panels of cut and polished glass, while architect Oliver Hill created a stylish bathroom with ceiling, walls and fittings all faced with gray mirror glass. During the 1930s there was a vogue for tables, cocktail cabinets and other furniture faced with white or tinted mirror glass; peach was a particularly popular color.

Neoclassicism inspired some of the many schemes of Basil Ionides, notably his transformation of the Savoy Theatre (1929). Ionides was also kept busy with commissions for the Savoy Hotel and the Swan and Edgar department store. A major project, under his supervision, was the complete modernistic refurbishing of Claridges in 1929. This transformed the hotel – even down to the bathrooms – into a showcase for the work of top British designers. Oswald Milne's plan for the new ballroom with decorative panels by George Sheringham, and Marion Dorn's carpets, were particularly noteworthy.

Other private and commercial clients also sought modernistic decorative design schemes by Ionides, Guy Elwes, Edward Maufe, Symonds Lutyens, Serge Chermayeff, Lord Gerald Wellesley and others. Reco Capey, working together with Ruhlmann who provided the furniture, created a completely new image for Yardleys. And the new Simpson's store by Joseph Emberton drew on the services of Moholy Nagy to work out the interior displays and of Ashley Havinden to create a unified range of graphics, as well as suitably modernistic carpets.

That a wide range of modernistic textiles and carpets was made available to the British public was largely due to the fact that many leading artists and designers created textile designs; among them were Raymond McGrath, Serge Chermayeff, Betty Joel, Evelyn Wyld, Paul Nash, Francis Bacon and McKnight Kauffer. The leading figure in the British textile design of the Art Deco era was American expatriate Marion Dorn, who became instrumental in raising the craft of textile design to new heights of artistry. She began collaborating with McKnight Kauffer in 1927 on carpet designs for Wilton Royal and by the 1930s was signing her name to the rugs that came to function as the decorative equivalents of paintings. Dorn's characteristically stylized abstract designs in subdued hues harmonized well with modernistic interiors by Oliver Hill, Wells Coates and others, and earned her the title 'Architect of Floors.'

design consultant to the British Broadcasting Corporation. Other deco transformations of the dwellings of the fashion conscious included that of New Ways, a Northampton house, by Peter Behrens, and Joseph Emberton's 1927 decoration of Stratford Lodge and of a Portman Square flat.

Oliver Bernard, a former theatrical set designer, created some of the most dramatic Art Deco interiors in England for such restaurant and hotel settings as London's Oxford Street Corner House, the Empire Room of the Trocadero Restaurant, the Cumberland Hotel and, surely his masterpiece, the Strand Palace Hotel. (The entrance

ABOVE LEFT: *Textile design by Marian Dorn.*

LEFT: *Paul Nash's textile pattern 'Fugue,' screenprinted on linen.*

ABOVE RIGHT AND FAR RIGHT: *More views of the 1929 Claridge's redesign featuring carpets by Marian Dorn.*

RIGHT: *In this 1928 dining room by Serge Chermayeff for Waring & Gillow the black and yellow furniture veneers were echoed by the rugs and curtains.*

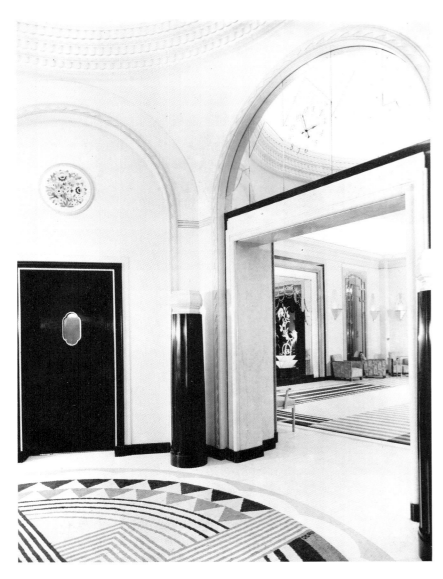

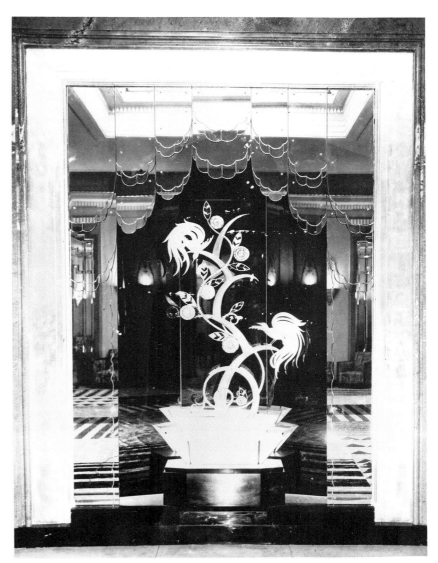

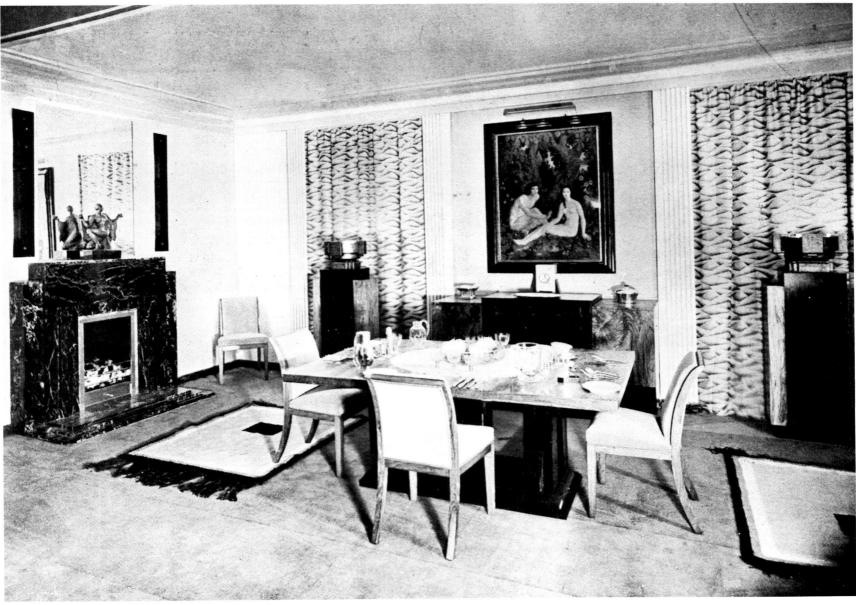

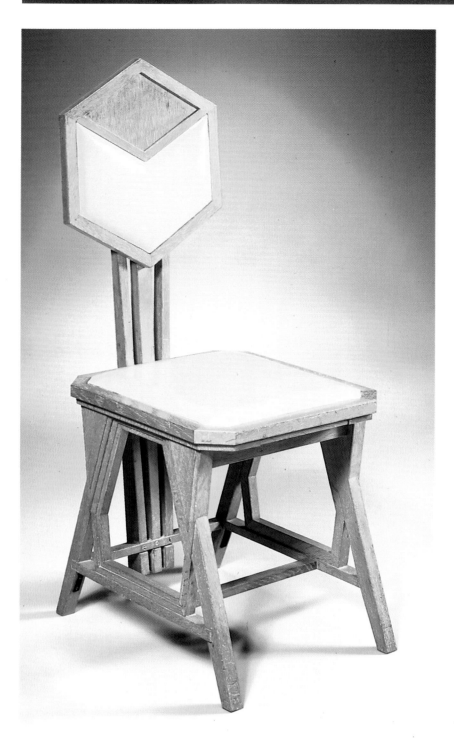

The United States produced some remarkable Art Deco furniture, which drew upon the resources of a strong furniture-making tradition that had developed over the previous centuries. Some of the masterpieces produced by eighteenth- and nineteenth-century makers were equal and, in some cases, superior to the works of their European counterparts. The elegantly veneered and geometrically linear furniture of the federal period – the era of neoclassicism – in the decades following the American Revolution was a direct stylistic antecedent of Art Deco; among the products of this period were some quite exceptional pieces by the likes of Thomas Seymour, Samuel McIntire and Duncan Phyfe.

Some of the first truly modern pieces of furniture, certainly akin to Art Deco, were those designed by Frank Lloyd Wright. Wright was as much a virtuoso in interior and furniture design as he was in architecture. Some of his decorative items, such as lighting fixtures and leaded windows, began to fetch extremely high prices at auction in the 1980s, creating a powerful economic motivation for the unscrupulous to dismantle some of his classic houses which in some cases were worth less than single decorative pieces. This is particularly distressing because Wright was the most insistent proponent of the environment unified by design, a concept central to Art Deco. From the time of his pioneering prairie houses, Wright had designed unique freestanding and built-in furniture to complement the architectural surroundings. While his earlier furniture designs resembled the works of the Arts and Crafts movement, those of the 1920s and 1930s reflected Art Deco ideas. Wright also designed lamps, rugs and stained glass for his interiors. As he disliked curtains, he came up with the idea of using exquisite geometrically stylized leaded glass as screens in projects such as his prairie houses, Midway Gardens and Barnsdall House.

The chairs Wright made for the exotic Tokyo Imperial Hotel were allied in their lively geometric lines to the zigzag style. A later analogy to the zigzag style was seen in the 1937 office interior Wright designed for Edgar Kauffman's department store. Here the geometrically patterned wall paneling harmonized with the Cubistic furniture; both were of a matching, light-toned natural finish. Wright's major commercial projects also provided him with furniture design opportunities. For the Larkin building (1903) he designed some of the earliest metal office furniture, introduced vertical steel filing cabinets and attached legless steel chairs to the desks to make office cleaning easier. Wright returned to the problem of office furniture with the Johnson Wax company in the 1930s, designing desks and chairs in curved and streamlined forms that echoed the architecture.

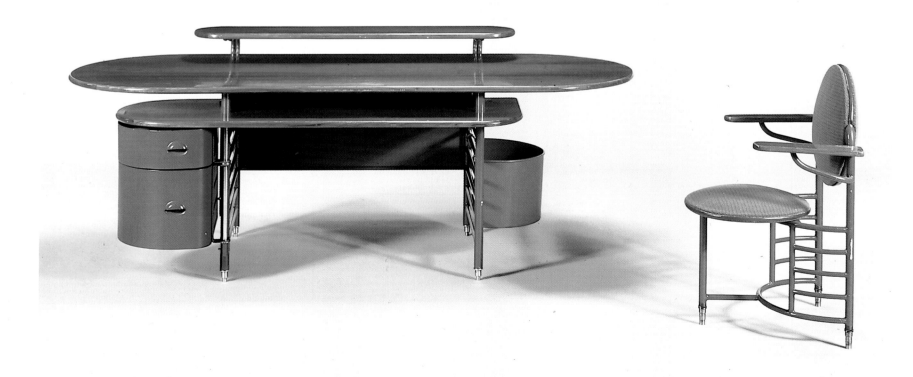

Although visually sophisticated and artistically inventive, Wright's chair designs generally ignored the needs of their users and were notoriously uncomfortable. One critic compared them to a 'fiendish instrument of torture,' and Wright himself once admitted that he had become black and blue from sitting on one of his own chairs; a case of form taking precedence over function. Though some avant-garde furniture-makers consistently ignored the idea of comfort, most of the later American Art Deco designers, particularly those producing for a mass middle-class market, were fairly sensitive to such utilitarian considerations.

Although the 1925 Paris exposition served to popularize the Art Deco style, prophets of decorative modernism had reached American shores over a decade earlier. In this first wave, from the Germanic regions, arrived designers who were to take a leading role in the conversion to Art Deco. From the Vienna *Sezession* and the Wiener *Werkstätte* came Joseph Urban in 1911 and Paul Frankl in 1914. And the new German ideas came with Winold Reiss in 1913 and in 1914 with Kem Weber, who had studied under Bruno Paul.

Thus the primary impetus for American Art Deco furniture design came from Europe. This wave of European designers, which in-

ABOVE LEFT: *Oak side chair by Frank Lloyd Wright for Tokyo's Imperial Hotel (1916-22).*

BELOW LEFT: *Office desk and chair by Frank Lloyd Wright for the Johnson Wax building (1936-39).*

BELOW: *A recent view of the Storer house including Frank Lloyd Wright's furniture in both original and reproduction form.*

cluded Eliel Saarinen, Wolfgang and Pola Hoffmann, William Lescaze, Ilonka Karasz and Walter von Nessen, provided the leaders of a movement that sought to transform the fashionable domestic and commercial interior environment, bringing it in line with the concepts of modernism and of the machine aesthetic. At the same time, many leading American-born designers – among them, Donald Deskey, Gilbert Rohde, Eugene Schoen, Ruth Reeves, Raymond Hood and Ely Jacques Kahn – had either studied or traveled in Europe, gaining firsthand knowledge of the latest developments in modern design. Travel, though, was not essential since many European modernists had participated in earlier international expositions. At the 1904 St Louis fair, the interior design and furniture by Bruno Paul and other Munich modernists excited interest in the American architectural establishment, not only for its innovative style but also for its emphasis on total design. It is significant that many of the American Art Deco furniture and interior designers were architects, or originally had studied architecture.

At the 1925 Paris exposition the luxury Art Deco furniture of leading French designers came as a revelation to the thousands of Americans who attended. A selection of works from the Paris exposition later traveled to New York's Metropolitan Museum and to eight other American museums, evoking widespread interest and creating a demand for such items. Specialized shops and galleries had already made French and Austrian designs available to the American customer. One of the earliest was the Austrian Workshop opened in New York in 1919 by Rena Rosenthal, the sister of Ely Jacques Kahn. After the Paris exposition major department stores began to host exhibitions of modern design. Toward the end of the 1920s, however, many French designers began to refuse to participate in American exhibitions because of the practice of some department stores of making unauthorized reproductions.

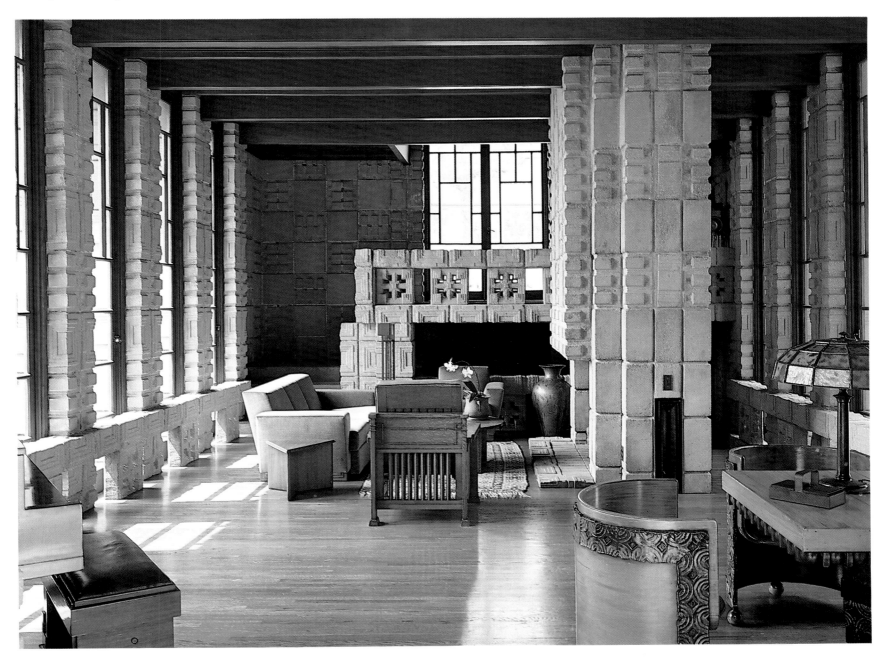

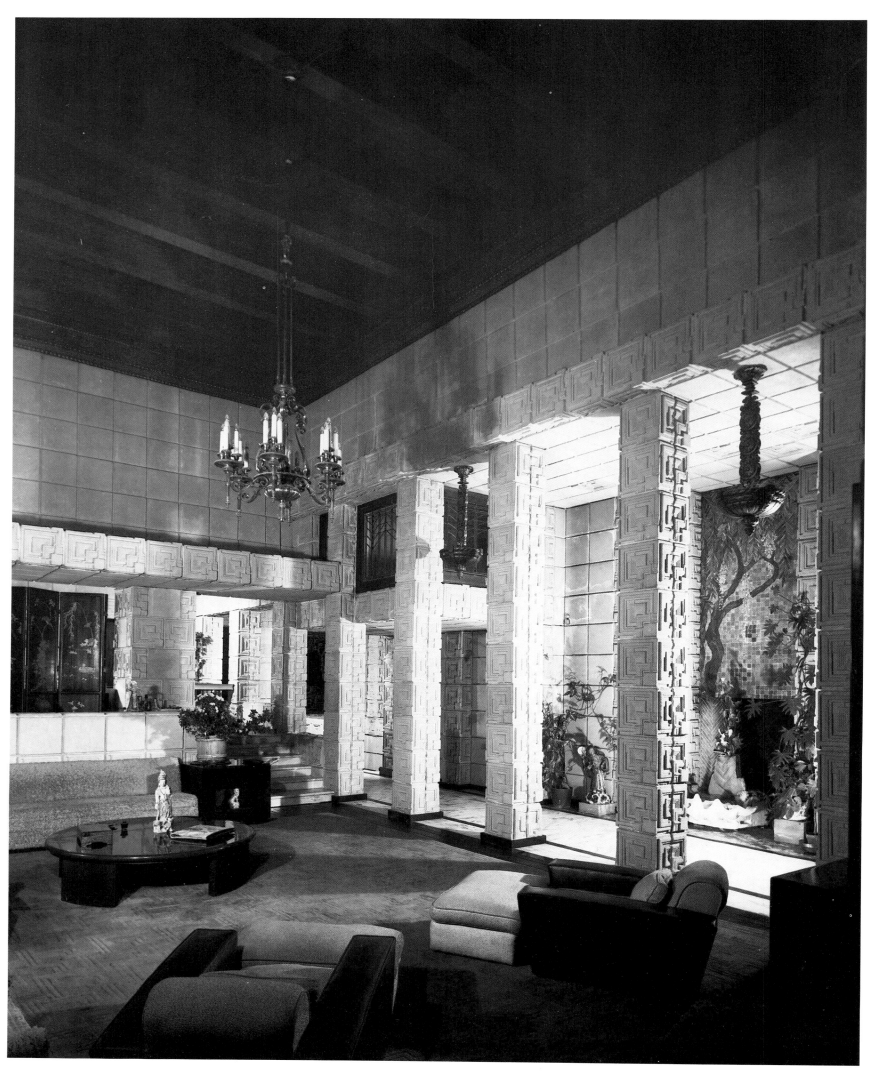

The first important exhibition of American contributions to Art Deco was that staged by the Metropolitan Museum in an effort to foster collaboration between designers and industry. The 1929 *Architect and the Industrial Arts* featured 13 room ensembles created by leading architects, among them Ely Jacques Kahn, Ralph Walker, Joseph Urban, Eugene Schoen, John Wellborn Root, Eliel Saarinen and Raymond Hood. This show was so popular that it had to be extended from six weeks to six months. The versatile architects designed not only the integrated modernistic furniture and accessories, but also the textiles and the decorative geometric wall treatments. As was typical of the 1920s style, most of the furniture consisted of expensive, one-of-a-kind pieces. Only Root later put his bedroom furni-

LEFT: *A recent interior view of Frank Lloyd Wright's textile block Ennis house.*

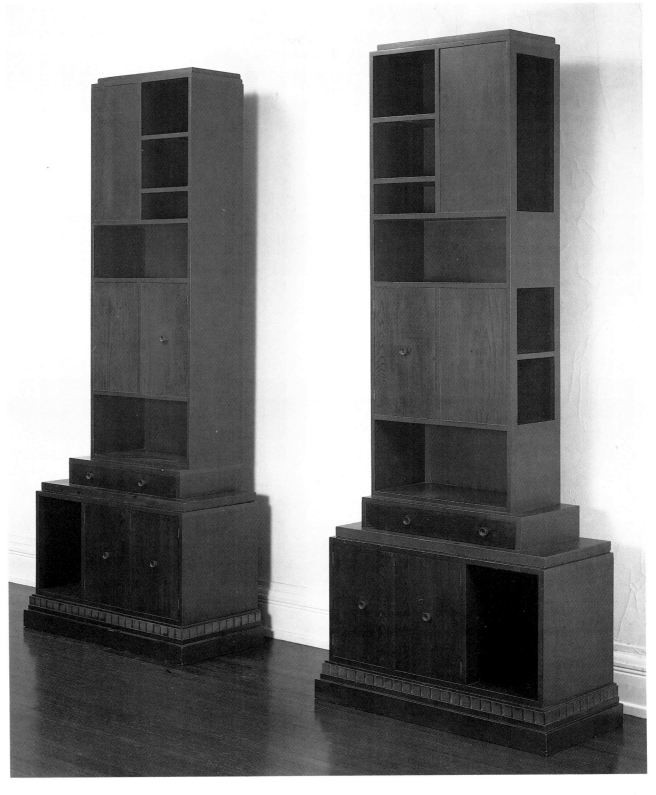

RIGHT: *This pair of 'Skyscraper' bookcases by Paul Frankl date from the late 1920s. They are of California redwood with nickle-plated steel trim.*

ture into production and had it sold through Montgomery Ward outlets. Some critics complained, justifiably, that the designs were inaccessible to all but the wealthy few.

The stylistic sources of the 1920s American Art Deco furniture were diverse. From the neoclassical and empire styles came the refined use of contrasting veneers, of fluting, of octagonal and oval forms, of sunburst- and fan-shaped motifs, and of pedestal bases; from Chinese furniture the low center of gravity and the use of black and lacquered finishes; from the machine aesthetic the use of industrial materials such as chromium, aluminum and bakelite; from Cubism the angular, sculptural shapes and the use of vibrant colors and stylized geometric ornament; and from primitivism, the use of exotic woods and other unusual natural materials.

The most distinctive motif of American Art Deco furniture in the 1920s was the skyscraper style so enthusiastically promoted by Paul Frankl in his articles and books on the modern design movement. Frankl designed desks, desk-bookcases and dressing tables in the stepped skyscraper style, often in exotic wood veneers or highly polished lighter toned woods enhanced with brightly hued lacquers or with gold and silver leaf. Frankl held that the furniture inside a modern urban apartment should harmonize with the metropolitan skyline seen through the windows. He also produced more con-

servative, neoclassically inspired pieces. As did many other designers, Frankl also designed smaller interior accessories such as a Telechron brass and bakelite mantel clock with a decorative sunburst of rays of silver and gray. The skyscraper style was adapted by other designers such as Abel Faidy.

Frankl's fellow Austrian Joseph Urban, whose most important architectural designs were New York's Ziegfeld Theater and the New School for Social Research, had worked as a theatrical designer for the Metropolitan Opera and the Ziegfeld Follies. He also designed lively, theatrical-looking furniture, usually characterized by contrasting veneers and mother-of-pearl ornament. Urban's designs were among those sold through the New York outlet of the Viennese workshop, of which he was the American director in the early 1920s. Urban worked on numerous interior design commissions for hotels, restaurants and stores in New York and the hinterlands, though not all of his usually exuberant floral mural designs were executed.

In the late 1920s Winold Reiss also developed a substantial career as an 'interior architect,' as he called himself. Some furniture commissions were included among his many projects for restaurants and hotels such as the Crillon, the Elysee, the Esplanade, Longchamps Restaurant, the Ritz-Carleton Hotel, the Hotel Almac's Congo Room and the South Sea Island Ballroom in Chicago's Sherman House.

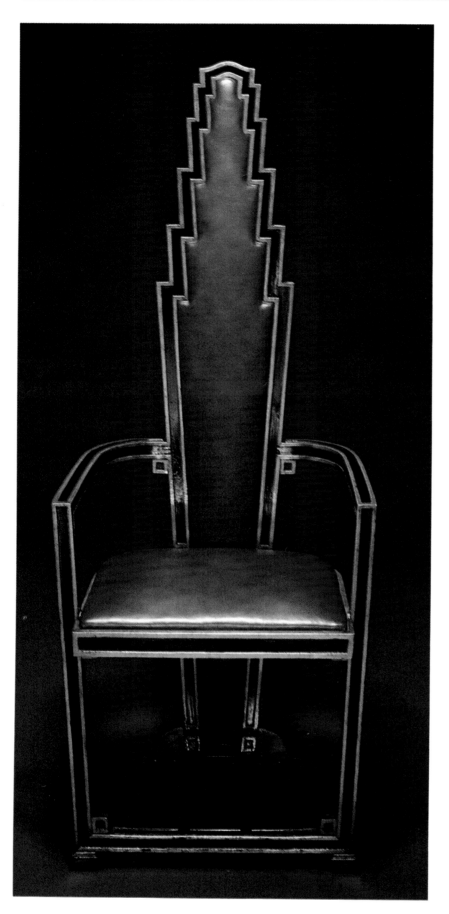

stitution that trained under his directorship a generation of innovative designers, artists and artisans. Among the results of Saarinen's activity were some of the finest examples of Art Deco furniture created in America. Some of Saarinen's most elegant designs were the furniture for his own residence at Cranbrook. Restrained zigzag motifs in veneer embellished the surfaces of the living-room chairs, cabinets and tables, which were constructed in a combination of exotic woods. A neoclassical influence was seen in the dining-room chairs with their graceful linear fluting, and the circular table inlaid with a radiating geometric pattern. Originally the dining room's octagonal shape, the octagonally patterned rug, the custom designed light fixture, the textiles, the paneled walls and even the dishes (designed by Saarinen to match the chairs) harmonized with the furniture. Elements from the Saarinen residence – notably the tiled living room fireplace and the octagonally patterned rug – were displayed as part of Saarinen's dining-room ensemble at the 1929 Metropolitan Museum exhibition. There, though, the exhibited chairs were of a different design, and subtly reflected the skyscraper style.

The leading New York Art Deco architect Ely Jacques Kahn also executed many interior design commissions that required the creation of specialized furniture. An unusual example was his glass, marble and chromed metal luminaire/planter. The design of new types of combination furniture to meet modern needs was characteristic of the Art Deco era. The more cramped quarters of the fashionable skyscraper apartments called for furniture adaptable to many functions; and the social life of the jazz age also required new types of furniture such as bar consoles and cocktail tables with bakelite tops resistant to spilled alcohol and cigarette burns. Even such traditional furniture types as wicker armchairs were redesigned by Frankl, Deskey, Rohde and others in cubistically angular shapes with compartments for drinks or magazines. The incorporation of electric light fixtures into furniture was another Art Deco phenomenon. Kem Weber, for example, designed a skyscraper-style dressing table with vertical light tubes flanking the mirror.

One of the finest American furniture designers of the 1920s was Eugene Schoen, who established an interior design firm and a New York gallery selling his own and imported designs. In his various commissions for luxury apartments, bank interiors, theaters and department stores, Schoen exploited the decorative possibilities of contrasting wood veneers, of lacquered orientalism and of dignified classicistic proportions. Schoen's most important project was the interior design of the RKO Theater at Rockefeller Center. His later furniture pieces ranged from the conservatively moderne to the exploration of such machine-age materials as glass and metal.

Art Deco ideas also spread out from the urban centers, as seen in the unique modernist furniture hand made by Wharton Esherick, a painter, sculptor, graphic artist and woodworker who practised his craft in the relative seclusion of rural Pennsylvania. Through his work as an avant-garde stage designer in the 1920s, Esherick had become familiar with German Expressionist stage sets. As a result, his 1929 Victrola cabinet, designed as a sculptural and functional base for the carved wooden statue of a stylized dancer, reflected expressionist as well as Art Deco ideas in its attenuated triangles and oblique geometric surface articulation.

The Wall Street crash brought about radical changes to the design and production of Art Deco furniture, marked by a repudiation of the luxurious style of the 1920s and a turn to mass production. This move toward a functionalist aesthetic coincided with political events in Europe. In 1933 the Nazis closed the Bauhaus, bringing a second wave of top European designers to the United States. The move toward functionalism was given an added impetus by the attention given to Bauhaus ideas by American industrial design exhibits of the late 1920s, and especially by the new Museum of Modern Art's vigorous promotion of Bauhaus design concepts.

The hitherto symbolic and decorative use of modernistic and machine age materials such as plastics, industrial metals and new glass products gave way to a simplified, structural use of these materials. The functionalist Art Deco furniture was transformed by the streamline style promoted by the rising generation of American industrial designers.

Fellow immigrant Kem Weber became a pioneer of modern design on the west coast. His varied activities included interior design, Hollywood film set design, industrial design and the design of individually commissioned and mass-produced Art Deco furniture, ranging in style from the zigzag to the streamlined and from the ornately decorative to comfortably upholstered tubular metal chairs. Weber's avowed aim was 'to make the practical more beautiful and the beautiful more practical,' a philosophy he publicized through lectures and articles. One of Weber's most prestigious interior commissions was the opulent zigzag-style interior for the Mayfair Hotel in Los Angeles.

Shortly after his arrival in the United States from Finland, Eliel Saarinen became involved in the founding and construction of the Cranbrook Academy of Art outside Detroit. As chief architect, interior designer and furniture designer, Saarinen created a sophisticated integrated setting for the artistic community and educational in-

LEFT: *One of the most picturesque manifestations of the skyscraper style was Abel Faidy's 1927 armchair, part of a furniture suite created for a Chicago penthouse.*

RIGHT: *A desk with nested seat designed by Paul Frankl.*

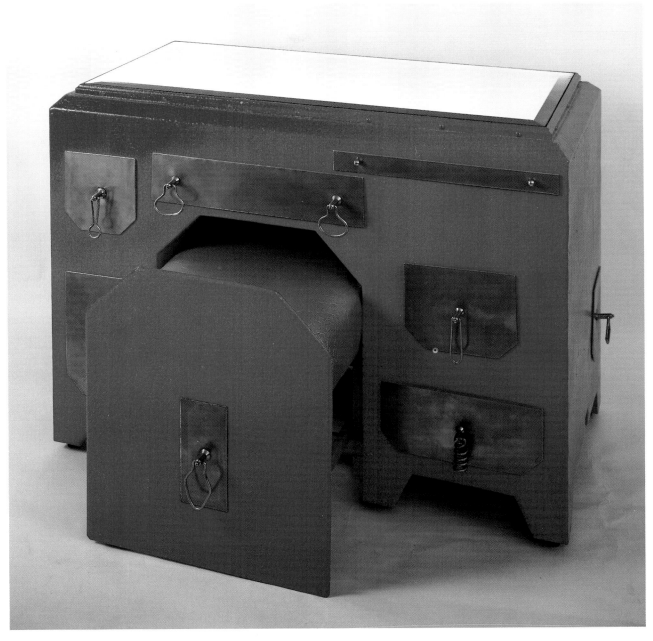

BELOW: *A tiered glass table (1928-29) by Kem Weber.*

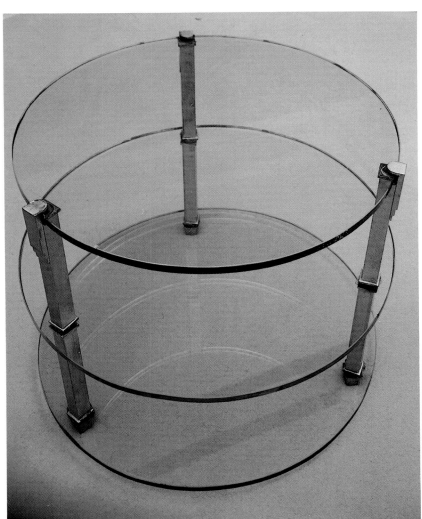

Nowhere was the change more apparent than in the 1934 Metropolitan Museum exhibition, *Contemporary American Industrial Art,* where the architect-designed rooms embraced the new aesthetic. The chairs, tables and even a Steinway piano were mounted on metal legs and bases; glass-brick window walls were featured; and there was even a lady's room by Saarinen with blocky built-in furniture embellished with horizontal speed stripes.

During the Depression a number of furniture designers such as Donald Deskey, Gilbert Rohde and Kem Weber carved out successful careers by creating functionalist Art Deco designs for mass production by formerly traditional furniture companies. Often the manufacturers turned to modernist designs from sheer economic desperation and some, in particular the Herman Miller company, even thrived as a result.

Donald Deskey was one of the most successful designers of the 1930s. He had originally studied architecture and painting in the United States and Paris. While traveling in Europe he visited the Bauhaus, and was also impressed by Dutch *De Stijl* design. Deskey achieved an initial success with the Art Deco folding screens he painted for Paul Frankl's gallery and on commission for individual clients. In 1927 he established the design firm of Deskey-Vollmer together with Phillip Vollmer. Between 1930 and 1934, over 400 of Deskey's furniture designs were put into production. Though he admired Bauhaus ideas, Deskey maintained a sensible respect for comfort and ornament, as well as an eclectic regard for historicism. He would not have been so successful in the age of mass production without this pragmatic instinct.

Gilbert Rohde, whose modernist designs for the 1933 Chicago exposition's Design for Living house brought him widespread recognition, developed a successful career in the 1930s creating furniture designs that utilized new materials and new manufacturing

techniques. Among Rohde's notable mass-produced designs were laminated and bentwood chairs inspired by Finnish architect Alvar Aalto's designs, and sectional sofas. Stylistically, Rohde ranged from 1920s deco veneered furniture to functionalist pieces of plastic and tubular steel. His 1935 desk-bookcase for the Herman Miller company combined the exotic veneering of the opulent Paris style with a design that was typically inventive in its space-saving, multi-functional concept. For less traditional tastes he designed a bakelite topped, tubular metal-framed desk advertised as the ultimate in modern functionalism not only in its clean geometric lines, but also for its 'no mar,' 'no tarnish' surfaces. The desk's color combination of silvery metal and black bakelite was a popular one in Art Deco furniture design of the 1930s. Rohde also offered such typically Art Deco interior settings as walls decorated with alternating horizontal bands of brushed copper and cork; he was also one of the era's leading clock designers.

Some of the more unusual pieces were created by people not primarily concerned with furniture design. Photographer Edward Steichen, for example, designed two jazz-age pianos with mirrored panels above the keyboard to reflect the pianist's hands. These models were entitled 'Vers Libre' and 'Lunar Moth.' Lee Simonson, active in the theater, dreamed up 'Death of a Simile,' a piano of white holly accented with turquoise lacquer.

Architectural glass was an important feature of Art Deco interior design, and art glass manufacturers met the demand by producing stained glass for residential and commercial settings. These panels were made not only for windows but also for doors, screens and skylights. Among the more favored motifs were the inevitable geometric patterns, zodiacs and stylized elements from nature.

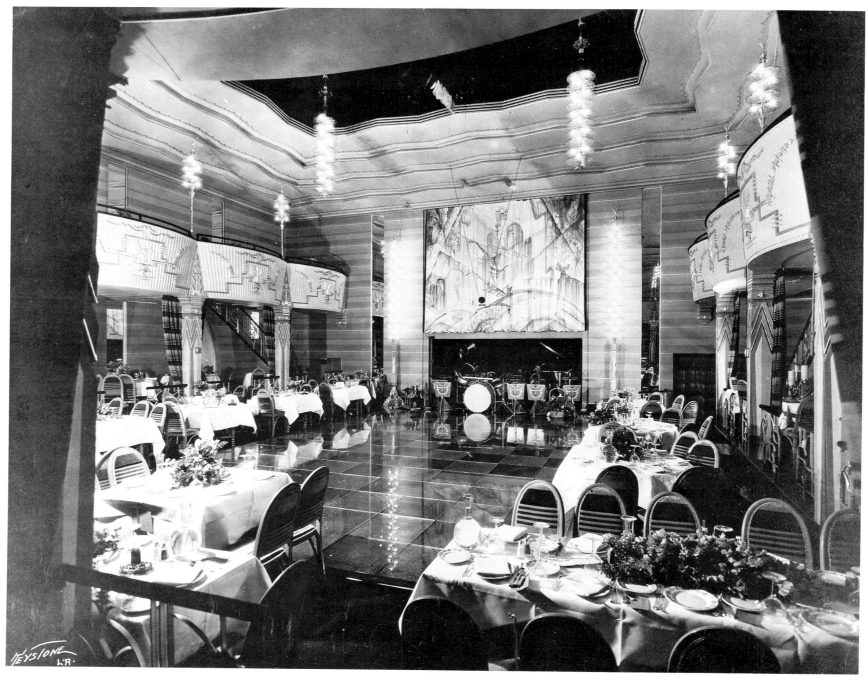

LEFT: *Joseph Urban's End Table of black lacquer with silver trim (c 1920).*

BELOW LEFT: *Kem Weber's design for the Mayfair Hotel, Los Angeles (1926-27).*

RIGHT: *Donald Deskey's 1934 Dining Room for* Contemporary American Industrial Arts *exhibit at Metropolitan Museum of Art in New York.*

BELOW: *Eliel Saarinen's Room for a Lady at the same exhibit.*

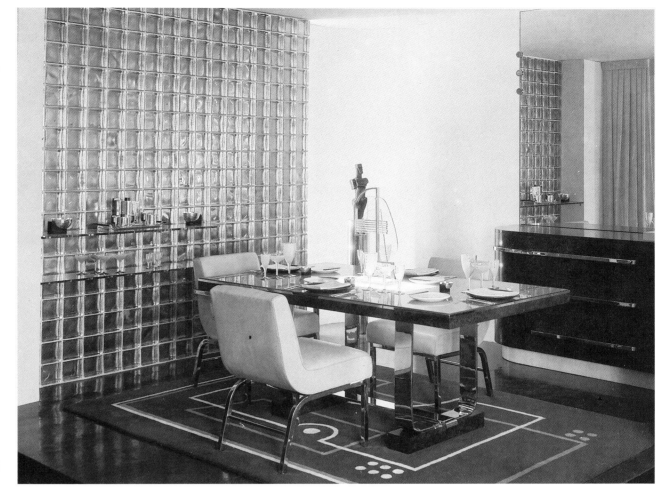

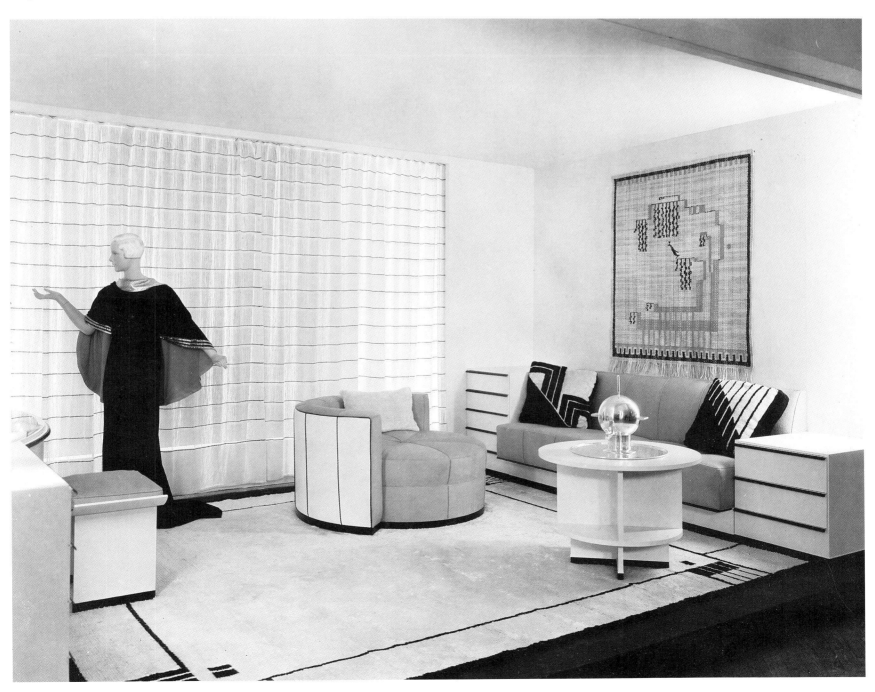

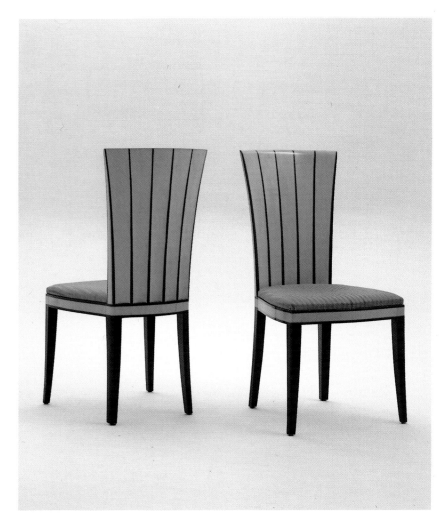

FAR LEFT: *Eliel Saarinen's side chairs (1929-30) originally designed for his residence at Cranbrook.*

LEFT: *Walter von Nessen's torchère floor lamp (c 1928) of brushed chrome over brass.*

ABOVE RIGHT: *Eliel Saarinen's peacock andirons for his residence at Cranbrook.*

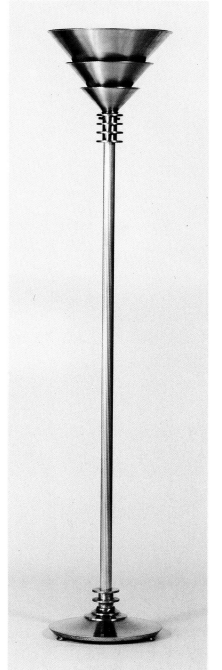

Another speciality was clear glass that was etched, sandblasted, painted or embossed with designs. The panels designed by Edgar Miller for the clerestory of Chicago's Diana Court were characteristic of this kind of work. Their classically-derived imagery echoed Sidney Waugh's Steuben Glass designs and Art Deco architectural relief sculpture. The versatile Miller designed architectural glass, made sculptures and executed murals for churches, restaurants and clubs. Maurice Heaton made a striking contribution in this field with his glass murals for interiors designed by Eugene Schoen. Heaton's illuminated *Amelia Earhart* mural for Rockefeller Center's RKO

BELOW LEFT: *Chromed metal and black lacquer desk lamp by Donald Deskey.*

BELOW RIGHT: *'Animal Carpet' (1932) designed by Maja Andersson Wirde and woven by Studio Loja Saarinen of linen and wool.*

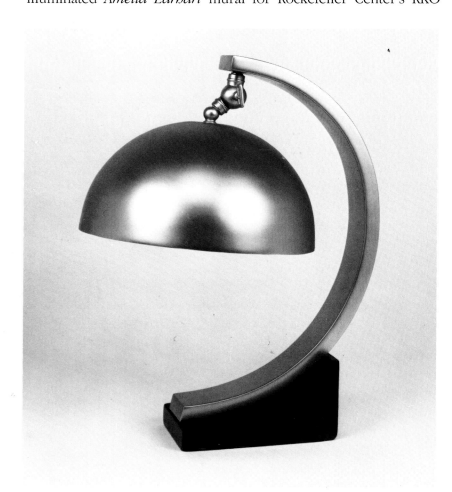

Theater was the most impressive. He also made smaller handcrafted art glass items sold in Schoen's and Rena Rosenthal's galleries. Interior designers used glass decoratively in other ways as well. Textured glass, glass block, geometrically leaded clear glass, mirror tiles, and black, blue and peach glass were used to create glamorous milieus, and reflected the persistent Art Deco fascination with dramatic lighting effects.

Electric light fixtures, both as architectural elements and as domestic necessities, were inventively interpreted. Frank Lloyd Wright and Alfonso Iannelli were among the many important Art Deco personalities who designed modernistic lighting fixtures. Those created by Donald Deskey varied in type from a rectilinear glass box on a fluted base to a hemispherical Cubist-inspired desk lamp allied to Bauhaus ideas. One of the most typical Art Deco lights was the torchere, a freestanding columnar lamp that provided indirect illumination by aiming the machine-age shade at the ceiling. The Art Deco torchere was a reinterpretation of a classical style lighting standard. Probably one of the most elegant versions was created by Walter von Nessen, although many others – among them Russel Wright and Eliel Saarinen – designed torcheres. Nessen, who initially supplied architects with lighting fixtures and metal furnishings, expanded his design studio during the 1930s to sell functionalist furnishings to retailers. In architecturally installed lighting, the fixtures drew upon the whole range of Art Deco motifs from the geometric shapes to the stylized figurative forms of the chromed bronze masks created by lighting specialist Walter Kantack for the RKO Theater. Decorative animal motifs were used by W Hunt Diederich for a more old fashioned light fixture, the chandelier.

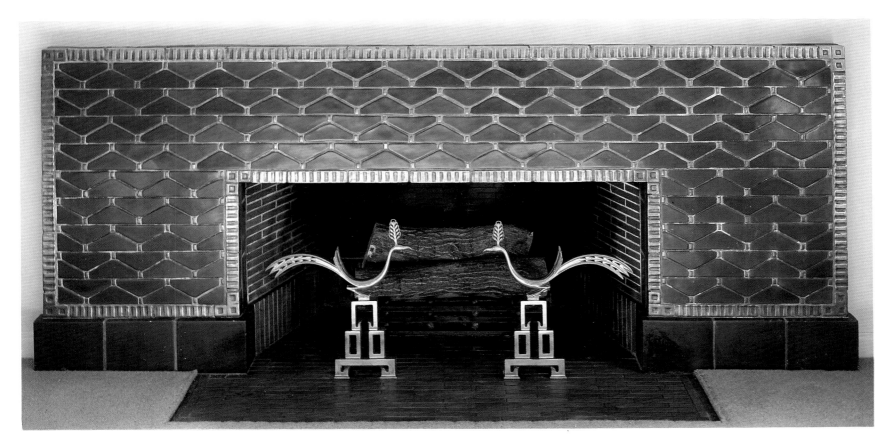

The skillful metalwork required to produce such fixtures was also employed in the creation of other interior accessories. Diederich designed firecreens embellished with graceful silhouetted greyhounds. Eliel Saarinen, too, was involved in the design of decorative metalwork, not only for the gates to Cranbrook Academy, but also the elegant peacock andirons for his fireplace there. The French-born designer Jules Bouy who headed Ferrobrandt, Inc – the New York outlet for Edgar Brandt – designed such pieces as an ornate wrought-iron mantelpiece. Among the other accessories sold by Ferrobrandt were lamps, fire screens, andirons, tables and mirror frames, all ornamented with graceful Art Deco motifs in the French style. Elegant metalwork was also executed by Oscar Bach for Radio City Music Hall and the Daily News, Chrysler and Empire State buildings, sometimes to the design of others.

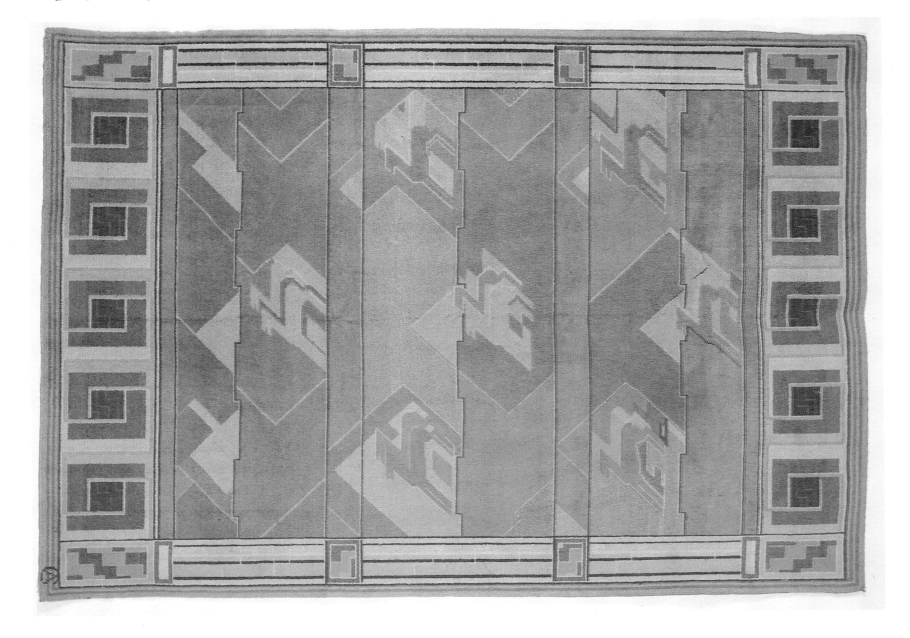

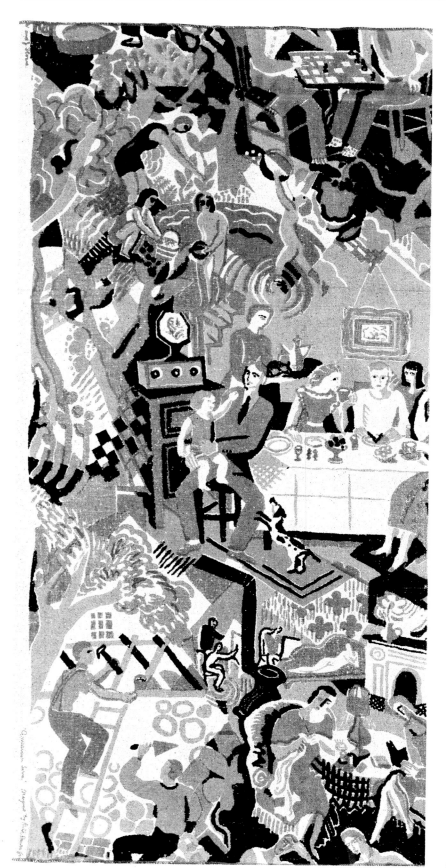

An important component of the co-ordinated Art Deco interior were textiles and carpets. Characteristic of the multidisciplinary activity of the artists and designers of the era were the textile and rug designs created by Ely Jacques Kahn, photographer Edward Steichen, photographer and precisionist painter Charles Sheeler and sculptor John Storrs. The leading textile designers were Ruth Reeves, Henriette Reiss and Ilonka Karasz. Reeves, who had studied at New York's Pratt Institute and the Art Students' League, spent most of the 1920s in France where she studied with Fernand Léger. Her handblocked textile and rug designs reflected the Cubist ideas of Picasso and Léger. In 1930 W & J Sloane commissioned her to create 29 designs that ranged in content from rhythmic geometric abstraction to stylized vignettes of representational imagery evoking the American urban and social life of the era.

Handworked and embroidered textiles and wall hangings were also created for interiors. Among the more important interpreters of stylized Art Deco imagery in this medium were Marguerite Zorach; Mariska Karasz, sometimes in collaboration with her sister Ilonka; Lydia Bush-Brown; Arthur Crisp; and pioneering tapestry designer Lorentz Kleiser, who was fond of jungle motifs. Avant-garde artists participated as well. In his Parisian Cubist days, Thomas Hart Benton produced several handsome Art Deco style rugs. The motifs occasionally extended even to the folk art hooked rugs worked by anonymous craftspeople.

Room-sized and wall-to-wall carpets for domestic and public interiors were much in demand. Chinese Art Deco rugs were imported, a new appreciation developed for Navaho rugs, and designers often created unique patterns for special settings such as Rockefeller Center or Oakland's Paramount Theater.

Eliel Saarinen's wife Loja headed a workshop that produced a remarkable series of sophisticated Art Deco carpets and textiles, primarily for Cranbrook Academy. Most were designed by Loja Saarinen, at times in collaboration with her husband, or by accomplished resident weavers such as Sweden's Maja Andersson. Deco geometric, zigzag, skyscraper, animal and other motifs were used in a way that harmonized subtly with their interior settings. The muted coloring of these works was a contrast to the garishness of many American commercially produced carpets.

LEFT: *'American Scenes' textile design by Ruth Reeves.*

BELOW: *'Rug No. 2' (1928-29) designed by Eliel and Loja Saarinen.*

RIGHT: *Chanin Building, New York, executive bathroom designed by Jacques Delamarre (1929).*

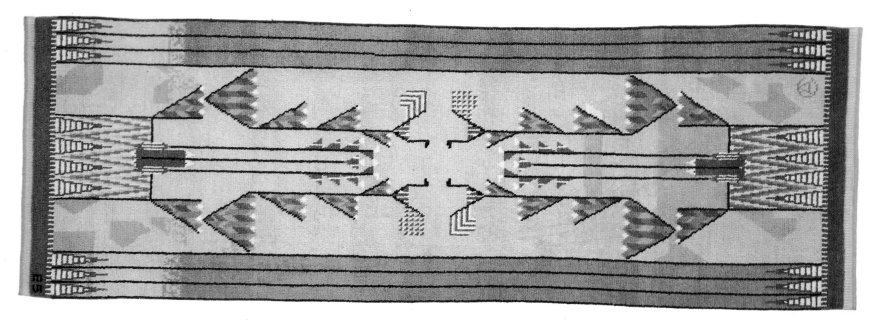

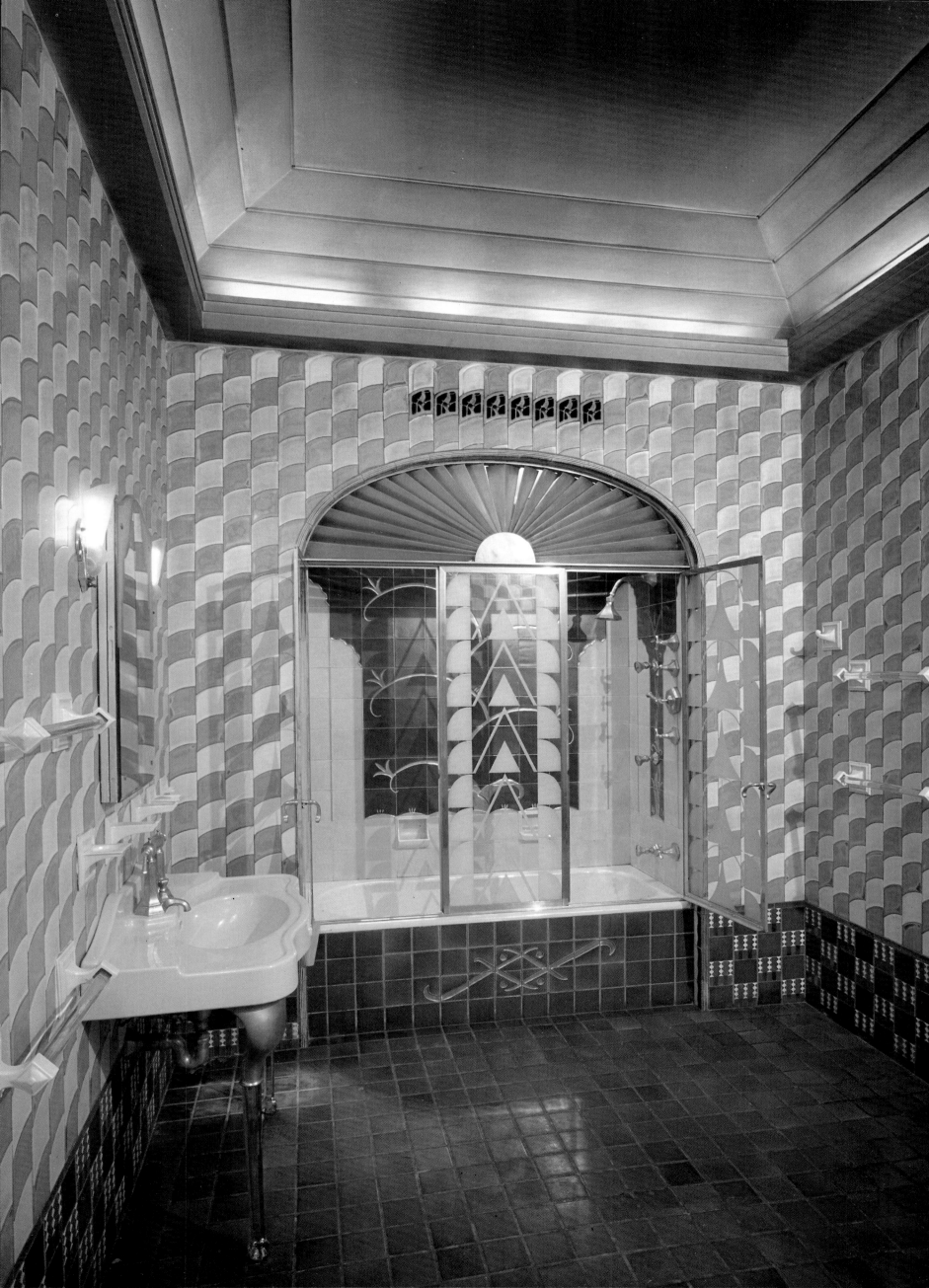

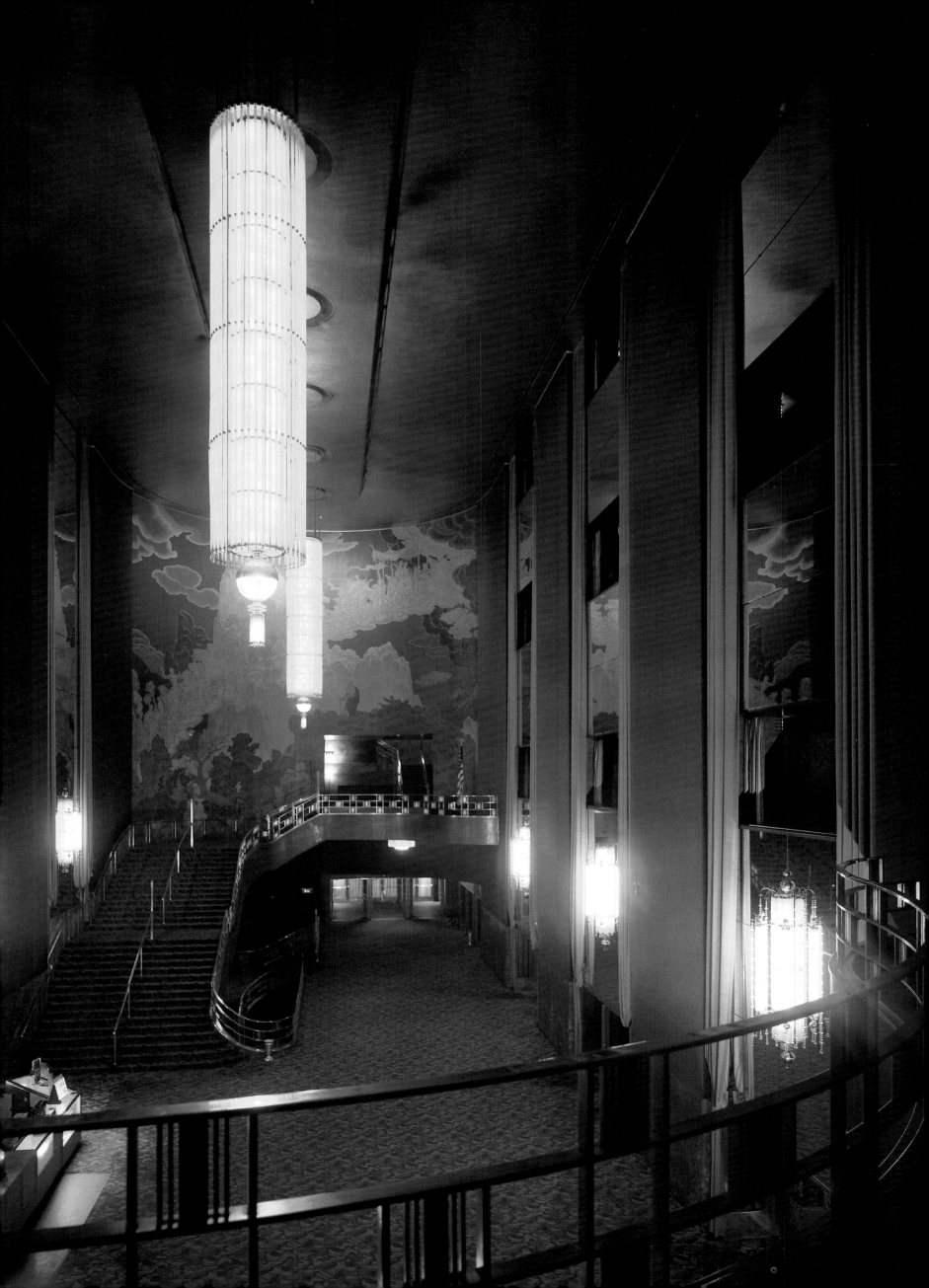

LEFT: *The lobby of the Radio City Music Hall at Rockefeller Center, New York with Ezra Winter's mural,* The Fountain of Youth.

RIGHT: *Yasuo Kuniyoshi's murals in Radio City Music Hall's ladies powder room.*

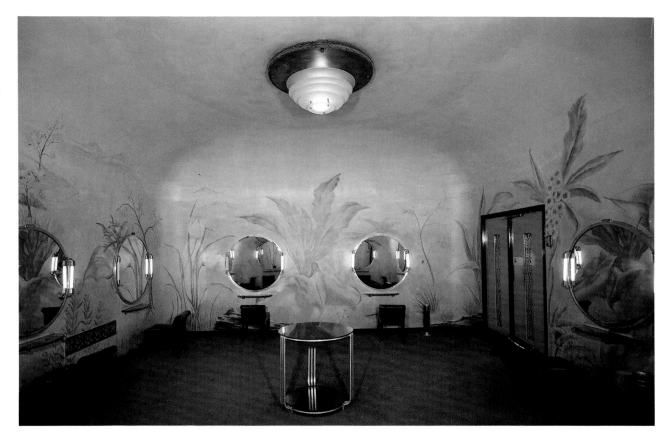

BELOW LEFT AND RIGHT: *From Radio City Music Hall, men's room 'Nicotine' wallpaper, and 'Jazz' pattern carpet.*

The stylish modernist quality of the Art Deco environment was distinctively seductive. Department stores had recognized the style's power of attraction early on by hiring the likes of John Vassos, Norman Bel Geddes, Louis Lozowick, Frederick Kiesler, Donald Deskey and even avant-garde sculptor Alexander Archipenko to create striking window displays. Ely Jacques Kahn transformed the interiors of the Broadmoor Restaurant and Rutley's Restaurant with stylized cloud murals on the ceilings and walls. John Mead Howells concocted an Art Deco aura for the tower lounge of New York's Panhellenic Building. Others conjured up exotic settings for Harlem's racially segregated night clubs. Even such sedate institutions as banks placed a high value on style; Hildreth Meiere's red and gold mosaics enveloped the main banking room of New York's Irving Trust building, while Detroit's Union Trust Company building, by architect Wirt Rowland was virtually unequalled in the splendor of its American Indian style decor.

The best known Art Deco environment, of course, was that created for Rockefeller Center, in particular the co-ordinated interior design of the Radio City Music Hall supervised by Donald Deskey, where the machine-age aesthetic of streamlining harmonized with the luxurious, stylized nature imagery of the earlier zigzag style. Actually Radio City was one of the last of the palatial movie theaters, and provided a fitting close to an era marked by such Art Deco milestones as Catalina's Avalon Theatre, the Pantages Theater in Los Angeles and, most dramatically, by Timothy Pflueger's Oakland Paramount. This magnificent combination movie-vaudeville theater conjured up a spectacular dream world of zigzag-style pattern, imagery and lighting effects.

Throughout the Depression, Hollywood films and vaudeville regaled the public with settings of vicarious luxury by Paul Iribe, Erté and many others. Art directors provided such films as *Top Hat, Grand Hotel* and Ernst Lubitsch's sophisticated romantic comedies with elegant Art Deco decor. A distinctive Hollywood specialty in both films and movie star homes was the 'white look,' which photographed so effectively in black and white. The stage settings of vaudeville dance extravaganzas also drew on the modernistic stylization of Art Deco. A recently uncovered archive of scenic renderings by Anthony Nelle, a choreographer, production designer and one-time partner of Anna Pavlova, who created stage sets for New York's Roxy Theater and for the Fox theaters in Detroit, St Louis·and San Francisco, showed such typical Art Deco devices as oblique diagonals, ray lines, soaring skyscrapers and streamlined transport.

These celluloid fantasies provided a necessary, if illusory, escape from the troubles of the Depression; the escape that finally did come was quite different. The economic Depression ended with the outbreak of World War II; the symbolic close of a unique era of modernist design came in 1942, when the archetypal masterpiece of opulent French Art Deco interior design, the *Normandie,* ignominiously sank in New York harbor after fire broke out as it was being refitted for service as a military troop transport.

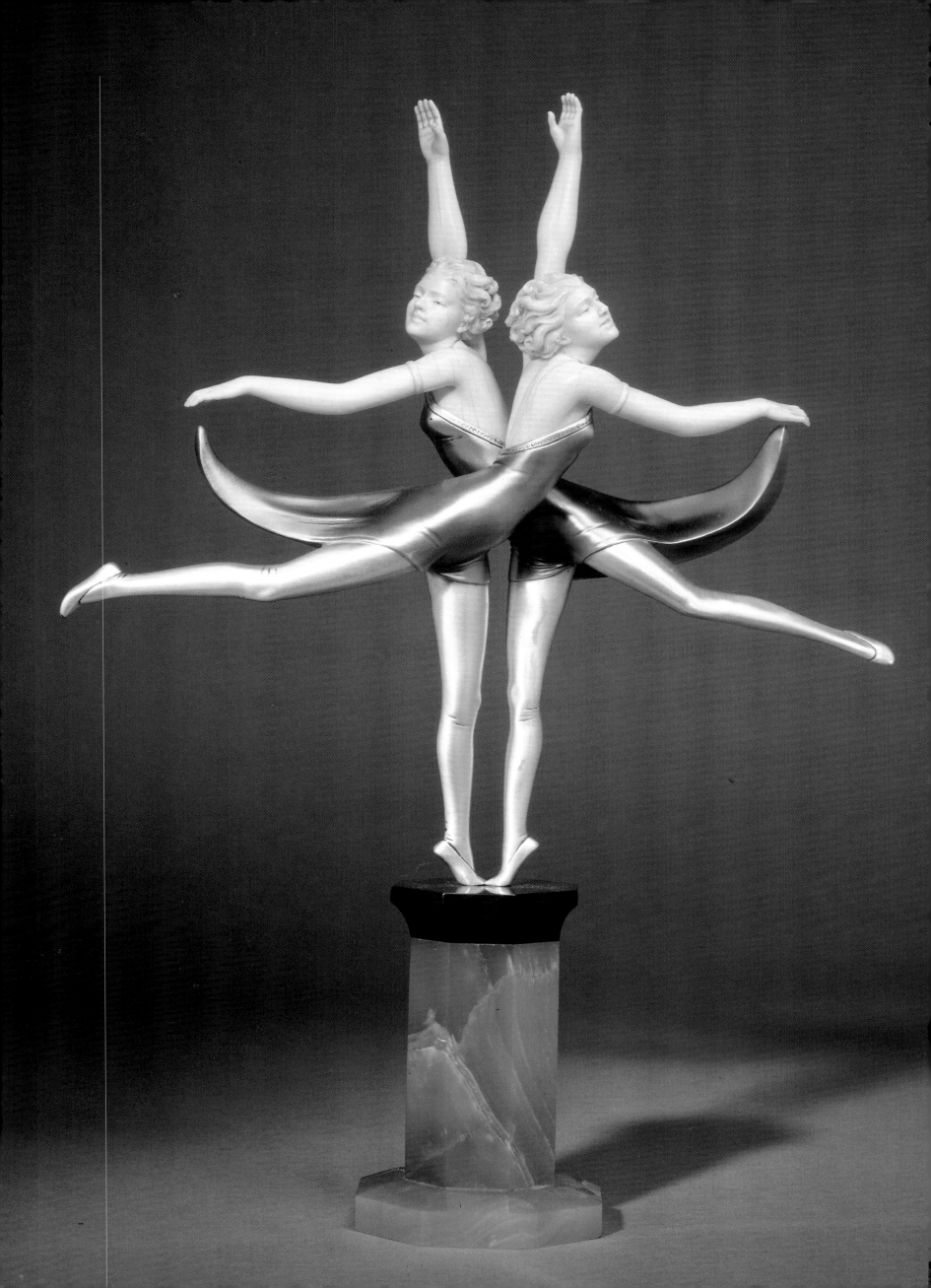

Sculpture, Painting and Photography

LEFT: Butterfly Dancers, *a silver, patinated bronze and ivory group by Ferdinand Preiss.*

Sculpture and painting played an integral role in the creation of the totally designed Art Deco environment. The deco variant of these arts was distinct from the works of avant-garde artists not only in that it was a more conservative adaptation of modernist trends, but primarily in that it was an art specifically intended to embellish architectural surfaces and settings, many of them public. Hence Art Deco sculpture includes the reliefs adorning building interiors and exteriors, and attached or accompanying statues in the round, as well as the sculpture produced for monuments, memorials, fountains, gardens and parks. Similarly, Art Deco painting is usually limited to murals, screens and panels, and may include works preferred or commissioned by interior decorators.

The form and content of the radical art movements of the early twentieth century inspired their more decorative counterparts. From Cubism came stylization and geometric abstraction, while the vibrant colors of Art Deco were shared with Fauvism, Orphism and Synchromism. Art Deco shared with Futurism and Vorticism a fascination with dynamic movement, expressed by means of diagonal ray lines and zigzags, as well as the imagery of machine technology and the modern city – an imagery also explored by the American Precisionists. From primitivism came the use of exotic natural materials; an interest in tropical settings and exotic plants and animals; and the adaptation of motifs from African, South Pacific, pre-Columbian and American Indian cultures as well as those of ancient Egypt, Assyria, Minoan Crete and archaic Greece. Like Constructivism, Art Deco experimented with innovative combinations of industrial materials, with an emphasis on mass production and a collaborative effort to create an aesthetically unified environment responsive to modern needs; its underlying spirit was utopian or propagandistic.

A far more traditional foundation of the Art Deco visual arts were the perennially persistent classical revival styles that had been explored by sculptors of the preceding decades. As in architecture, neoclassicism provided important precedents, which went back to the late eighteenth century and the elegant linear illustrations and rhythmically stylized funerary reliefs of British artist John Flaxman. The ideas of Flaxman were taken up during the first half of the nineteenth century by the enormously successful Danish sculptor Bertel Thorwaldsen, who was revered by his contemporaries for what they saw as his archaeological correctness, although modern tastes now prefer the livelier and more inventive sculptures of Jean-Antoine Houdon and Antonio Canova.

In the late nineteenth century, a reaction to the increasing looseness and naturalism of style that was to culminate in Rodin's work was led by German sculptor and theorist Adolf von Hildebrand. In his book *Problems of Form*, Hildebrand promoted a stylized, abstracted monumentality and the harmony of architecture and sculpture, particularly through the use of low reliefs flattened by an invisible frontal plane. Several major proto-Art Deco sculptures in the Germanic re-

gion embodied von Hildebrand's ideas, including the Secessionist Franz Metzner's Leipzig memorial to the *Struggle of the Nations* (1902-13) and Hugo Lederer's medievalistic *Bismarck* memorial (1906) in Hamburg. In the years preceding Cubism, the ideas advanced by the Vienna, Munich and Berlin *Sezession* groups promoted symbolic stylization in architectural sculpture.

ABOVE: *Relief by Georges Picot (c 1925).*

BELOW: *Antoine Bourdelle's* Aphrodite *relief for Marseilles Opera (1924).*

RIGHT: *Alexander Archipenko's* Woman Combing Her Hair.

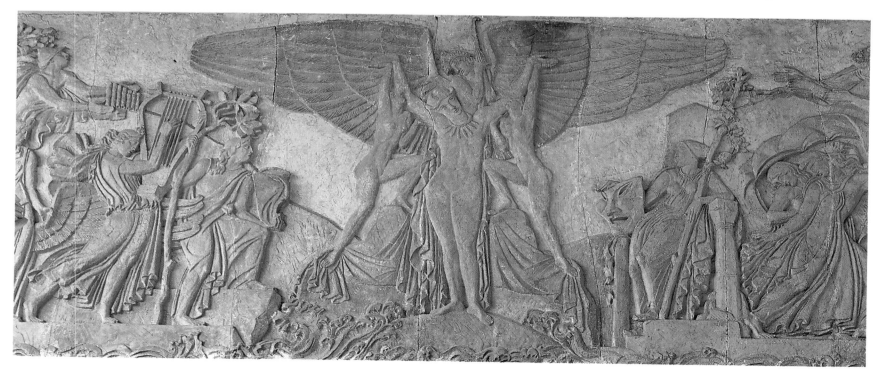

In France this trend was paralleled by the influential new classical abstraction of Paul Bartolomé, notably in his Paris *Monument to the Dead* (1899). Bartolomé, who opposed Rodin's modernism as well as the rigid canon of academicism, also produced decorative reliefs for private homes. In content, nevertheless, the typical allegory and didacticism of Art Deco sculpture continued a vital tradition of the academic art of previous centuries. In Belgium, meanwhile, the sculptor and early socialist Constantin Meunier began in the 1880s to produce bronze statues and reliefs of heroic laborers, a theme that was to become central to the Art Deco sculpture of the 1930s.

What is now considered by many as the pioneering Art Deco sculpture – the 'first great architectural sculpture done in the modern spirit' – was executed in Paris by an assistant of Rodin, paradoxically enough. Émile-Antoine Bourdelle's 1913 reliefs for Perret's *Theatre de Champs Elysées* suitably depicted the various arts in stylized rhythmic compositions based on ancient Greek prototypes. Soon to become a model for later Art Deco sculptors, Bourdelle's 21 relief panels and interior frescos included graceful dancing figures based on the iconoclastic Isadora Duncan, who was a source of inspiration to artists and dancers alike. The gala opening of the *Elysées* theater was recalled in 1975 by Erté as the most brilliant event he ever attended. Although Bourdelle also produced works in a more impressionistic mode, many of his subsequent public commissions continued this early Art Deco stylization. This duality of private and public styles was characteristic of many Art Deco sculptors. Art Deco was, in effect, a universal style aesthetically and symbolically accessible to the public, and eminently appropriate to its architectural settings in that its sharp contours and smoothed surfaces generally made it easily legible from afar.

In France the leading and probably most prolific creators of Art Deco sculpture were the twin brothers Jan and Joel Martel who experimented in all the new materials, including aluminum, glass and steel, and whose Cubist-influenced reliefs and sculptures embellished villas, theaters, architecture by Robert Mallet-Stevens and the Debussy monument in Paris. Major commissions arose from the international expositions and prompted the Martels' most memorable work, such as their Cubist 'trees' at the 1925 exposition.

Numerous other French sculptors worked on this and the later expositions. The most ambitious projects were the 1937 *Palais Chaillot* and the Museums of Modern Art, which were encrusted with reliefs and surrounded with freestanding sculptures erected by a large number of artists, many of whose names are unfamiliar today. Perhaps one of the better known was Alfred Janniot, who also created sculptures for other expositions of the era.

Various smaller, stylized pieces by sculptors of the French avant-garde were also related to Art Deco, as such works were frequently chosen as fashionable accessories for modernistic interiors. In line with the elegant abstraction initiated by Brancusi with his *Sleeping Muse* heads were the works of Elie Nadelman and Gaston Lachaise, while Cubism inspired the more geometrically angular works of Alexander Archipenko, Joseph Csaky, Henri Laurens, Jean Chauvin, Gustave Miklos and Jean Lambert-Rucki. Lambert-Rucki often worked with Jean Dunand, as seen in his exotic surface treatments, as well as for architects such as Robert Mallet-Stevens, Henri Pinguisson and even Le Corbusier. Many of these mainstream sculptors had been attracted to Paris from Russia, Poland, Hungary and other parts of eastern Europe. A number, including Archipenko, Nadelman and Lachaise later moved on to the United States.

A large output of graceful and frivolous figurines was produced for the more popular or nouveau riche tastes of the era. Many were freestanding pieces while others formed parts of lamp fixtures or other tabletop accessories. Popular subjects included Amazon women, flappers, dancers and acrobats, as well as animals. While some were made of blown glass or ceramic, the most costly wares were of chryselephantine, an exquisitely detailed combination of bronze and ivory. Among the leaders of this craft were D H Chiparus, Ferdinand Preiss, Alexandre Kelety, Bruno Zach, Pierre Le Faguays, Gerdago, and Josef Lorenzl. Chryselephantine work first became successful in Austria and Germany, although firms producing these goods were later opened in Paris.

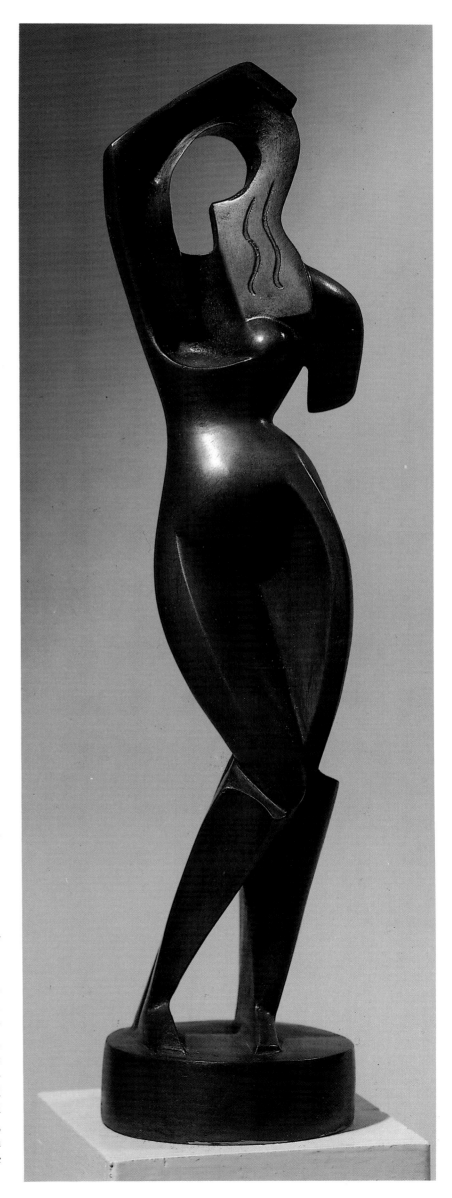

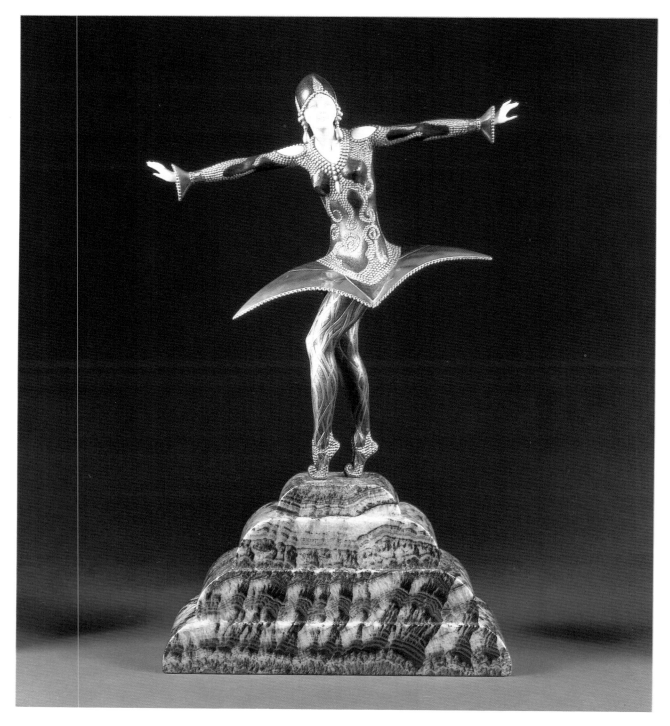

LEFT: Kora, *the figure of an exotic dancer designed by Demetre Chiparus.*

RIGHT: Testris, *a chryselephantine figure on a marble base, by Chiparus. Chryselephantine work combined ivory with patinated bronze to produce a sumptuousness that was characteristic of much Art Deco.*

In the early decades of the twentieth century, architectural sculpture in Germany and Austria was used symbolically to accent relatively austere building façades and courtyards; the work of Josef Riedl and Otto Hofner at Vienna's *Karl Marx Hof* is typical of this school. In northern Germany, under the influence of Expressionism and a tradition going back to Gothic art, the sculpture tended more toward the grotesque. This was changed, however, with the accession of the Nazis; idealized male nudes, propagandistic superman symbols of state power and Aryan purity, arose everywhere to inspire and intimidate the populace. Among the leading practitioners of this genre were Josef Thorak and a disciple of Maillol, Arno Breker, who returned in 1934 from Paris to find favor with the new regime and to produce stylish classicist male nudes for the new Reich Chancellery.

In the Soviet Union, stylized heroic workers became the norm in the 1930s. The most characteristic was the stainless steel *Worker and Collective Farm Woman* by Vera Mukhina, who had studied with Bourdelle. Mounted atop the 1937 Soviet pavilion in Paris, this work was later displayed in various sizes throughout the USSR. The Italian sculptures of the fascist era were somewhat more inventive. Stylized columnar fasces, militaristic paraphernalia, political allegories and, yes, heroic workers and athletes, embellished the new buildings, memorials, monuments and triumphal arches. In some cases classicist stylization gave way to crude cubistic planes symbolizing raw power, as in the work of Mario Sironi, the chief fascist sculptor, and even to the quasi-caricature of Mussolini in Ferucchio Vecchi's *The Empire*. The heroic workers of the totalitarian countries were paralleled in America in the relief and freestanding sculptures produced by artists

working in the government-subsidized and politically-motivated New Deal public building programs.

In England sculptors balanced Cubist emanations from Paris with the more staid, stylized classicism of Scandinavia. Perennially at the center of controversy was Jacob Epstein, whose modernistic architectural and monumental commissions inevitably resulted in a public uproar. The reaction to his Oscar Wilde tomb in Paris (1911-12) was typical. An exotic amalgam of Assyrian and archaic Greek motifs, the work was seen as scandalously erotic and was covered by a tarpaulin for two years. (This assimilation of alternative historicist decorative motifs from Egyptian, Assyrian, Cretan and archaic Greek sources became a strong current of Art Deco early in the history of the style.) A harsher fate met Epstein's series of niche figures on the theme of procreation for the British Medical Association building façade (1907). Some 30 years later, the building's new tenant had the figures mutilated. Vehement criticism in the press also met his Rima memorial to the writer W H Hudson (1925) and his primitivistic figures of Night and Day for the London Transport building. Architect Charles Holden, his frequent and enthusiastic sponsor, was offered the London University commission solely on the condition that he did not employ the controversial sculptor. Epstein received no public commissions for over 20 years and subsisted mainly on his Rodinesque portrait heads.

Holden's London Transport building also featured allegorical reliefs of the four winds by other leading sculptors, among them Eric Gill, Henry Moore and Eric Aumonier. Gill, who had trained as a stonemason and, like many other sculptors working in the Art Deco

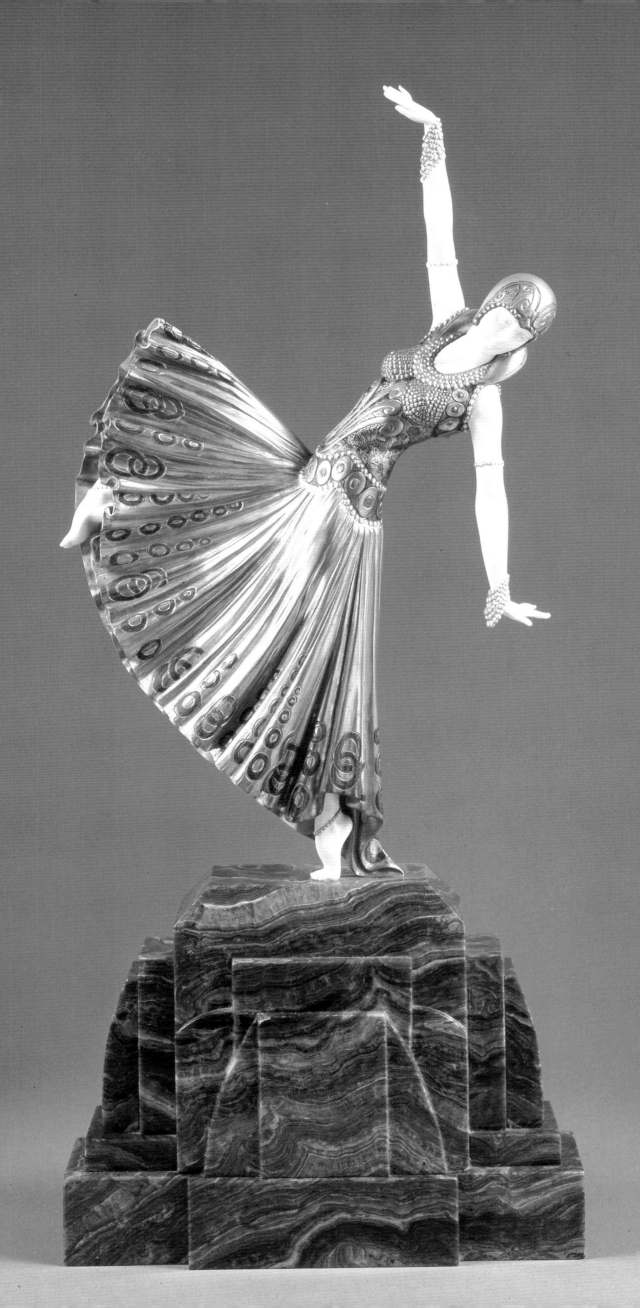

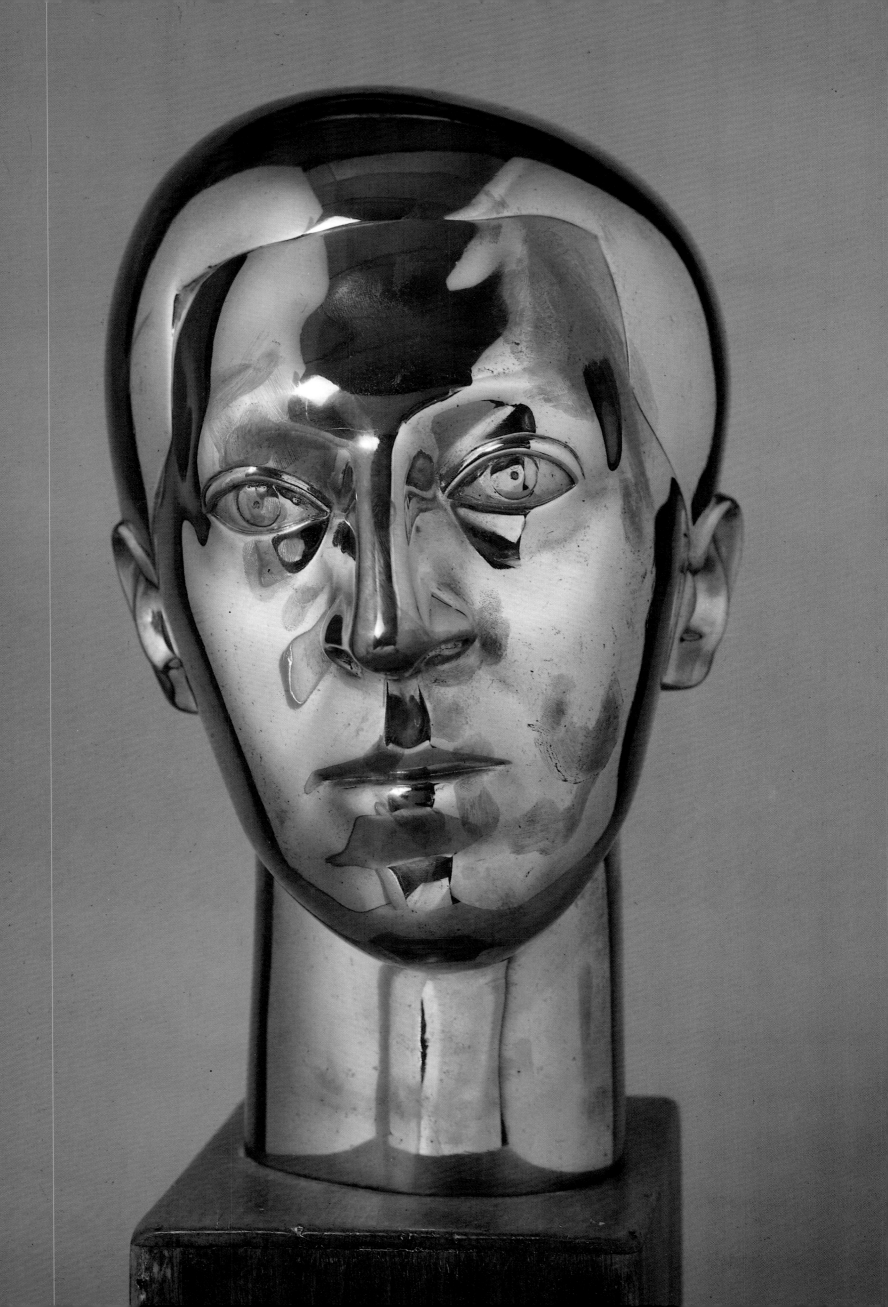

LEFT: *Frank Dobson's head of Osbert Sitwell.*

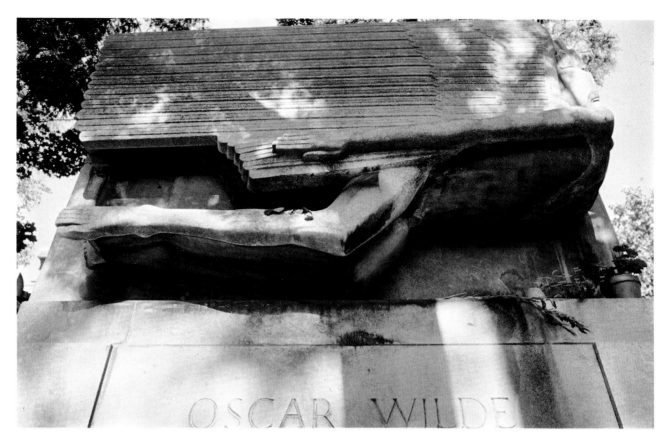

RIGHT: *Jacob Epstein's sculpture for Oscar Wilde's tomb (1912) in Paris.*

mode, was an advocate of direct carving, also produced Ariel and Prospero reliefs for the BBC building and an Odysseus and Nausicaa panel for Oliver Hill's Midland Hotel in Morecambe. Gill received commissions for the Palestine Museum in Jerusalem and for the League of Nations building in Geneva, as well as various religious commissions, for which he produced medievalistic sculptures. And the numerous World War I memorials raised during the era provided work for Gill and other sculptors. Aumonier also executed the Empire relief panels for the Daily Express building.

A sculptor popular with the Bloomsbury set was Frank Dobson, whose polished brass head of Osbert Sitwell reflected the fashion for stylized and elegant portrait heads, as did Jacques Lipschitz's *Gertrude Stein* (1920) and Matisse's *Henriette II* (1927). Though Dobson also completed a sculptural panel of reliefs in gilded faience for London's modernistic Hays Wharf Building, his career went into eclipse in the 1930s. A far more disturbing head was the cubistic *Hieratic Head of Ezra Pound* (1914) by the tragically short-lived Henri Gaudier-Brzeska, who also produced stylish woodwork designs for Omega Workshops and was active in the vorticist movement.

Numerous British sculptors studied in Paris and went on to produce graceful sculptures for the domestic and public setting. Typical of this output were the elegant dancer figurines produced by Antony Gibbons Grinling, though Grinling had a wider range of activity because of his collaboration with Serge Chermayeff. An important public commission resulted in his relief for the Cambridge Theatre.

The most public of the era's sculptures were the World War I memorials raised throughout the British Isles and the rest of Europe. Among the British examples, a quintessential one was the Hyde Park Corner Royal Artillery Memorial executed by Charles Sargeant Jagger and noteworthy for its Assyrian motifs combined with zigzag Art Deco rhythms. Jagger also sculpted the Cambrai Memorial in Louveral, France. One of the finest British memorials in France was Eric Kennington's Soissons monument. Kennington modeled his Battersea Park Memorial (1924) on his friend Robert Graves, and carved the T E Lawrence tomb (1939) with Lawrence of Arabia as a medievalistic recumbent effigy. Another major commission led to the carved reliefs of modern allegories of treachery, war and love for the façade of the new Shakespeare theater.

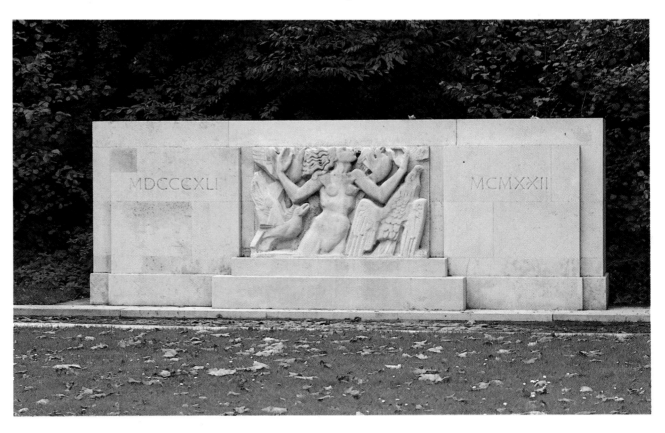

RIGHT: *Jacob Epstein's Rima memorial (1925) in London's Hyde Park.*

In the sculpture of Scandinavia, as in its architecture, a stylized classicism ruled. The *Guardians of Transportation* by Emil Wikström for Saarinen's Helsinki railroad station, however, probably owed their folkloric primitivism to the ideas of the Germanic Secessionists and to Expressionism. Far more typical was the work of Gustav Vigeland, whose ambitious grouping of over 150 sculptures for Oslo's Frogner Park constituted the largest European governmental commission of the era. Though his earlier fountain bronzes, which he began producing in 1906, were allied to Art Nouveau and Expressionism, the later idealized granite figural groups – seen by some contemporaries as too overtly erotic, and by others as the outpourings of a megalomaniac – owed much to classicism.

Although Vigeland was little known outside of Norway, Sweden's Carl Milles achieved international reknown and became one of the most successful sculptors of the Art Deco era. The master of numerous fountain groupings, garden and courtyard figures, Milles had worked for a time as an assistant to Rodin. Following his European triumphs, he moved to the United States to teach at Cranbrook Academy under Saarinen. Milles's major works included his *Europa* fountain (in Sweden, at Cranbrook and the Chicago Art Institute), the *Diana* fountain for Chicago's Michigan Square building, the *Orpheus* fountain in front of Tengbom's Stockholm Concert Hall, the Aztec-style *Peace Monument* for St Paul City Hall and the *Meeting of the Waters* fountain in St Louis.

The international reputation of Milles was equalled only by that of the versatile and prolific Yugoslav Ivan Mestrovic, who had studied with Otto Wagner and others of the Vienna *Sezession*. In the years immediately before and during World War I, Mestrovic's stylized but distinctively expressive sculptures – some inspired by archaic Greek

art, others by Rodin – were seen in major exhibitions in Vienna, Rome, Paris and London, leading to important commissions for public monuments at home and abroad. Most characteristically Art Deco were his bronze equestrian Indians for Chicago's Grant Park (1926-27), and the *Monument of Gratitude to France* and the *Tomb of the Unknown Soldier*, both in Belgrade. Mestrovic also produced many religious works, some of which were related in style to Gothicism, while others could be classified as Art Deco. His carved wood relief cycle of the Life and Passion of Christ, and his commissions for the Vatican were particularly impressive. After World War II Mestrovic moved to the United States where he continued to produce his by now conservative works, which were still eagerly sought after by such well-endowed patrons as the Mayo Clinic and Washington's National Shrine of the Immaculate Conception.

In the United States the late nineteenth-century Gilded Age decades known as the American Renaissance saw architectural sculptors achieve enviable status through the patronage of leading architects such as Richard Morris Hunt and McKim, Mead & White, who worked with Augustus Saint-Gaudens, Daniel Chester French, Frederick MacMonnies and others. The era's crowning achievement, the Boston Public Library (1887-97), was profusely decorated by a collaborating team of pre-eminent painters and sculptors.

One of the first public monuments to display modernistic stylization was New York's *Carl Schurz Memorial* (1913); its reliefs by Karl Bitter were indebted to archaic Greek art. A Viennese sculptor who had arrived in 1887, Bitter had worked with Richard Morris Hunt on Biltmore, the palatial Vanderbilt estate, and on the facade figures of the Metropolitan Museum of Art, among other major public and private architectural commissions.

Frank Lloyd Wright was undoubtedly the first American architect to use geometrically stylized sculpture, sometimes after his own design. Sculptor Richard Bock, who arrived for the 1893 Chicago World's Fair and who had worked for Adler & Sullivan, spent some 20 years working closely with Wright. Among the projects in which he participated were the 1903 Dana House, the Larkin Building, the Unity Temple and Midway Gardens. Bock's sculpture, along with that of Alfonso Iannelli, who also worked on Midway Gardens, is reminiscent of the architectural sculpture of the Amsterdam School. As did Bock, Iannelli later collaborated with other Prairie School architects, including Purcell & Elmslie and Barry Byrne, on courthouses, schools and churches. A major commission for Iannelli was the sculptural embellishment of Chicago's Adler Planetarium.

Some leading sculptors of the era were able to balance avant-garde experimentalism with public commissions in the Art Deco style. John Storrs, who had studied with Rodin and stayed on in France with frequent trips back to New York and Chicago, produced Cubist figural studies, along with elegant nonobjective explorations of new material combinations, coloristic effects, and geometric motifs; among his most typical work were the 'skyscraper' sculptures, which resembled abstracted architectural models. His interest in Bourdelle's *Elysées* reliefs and in Joseph Stella's futuristic paintings was reflected in his designs for public monuments, particularly in his polished cast aluminum *Ceres* (1929) for the top of Chicago's Board of Trade building. This streamlined machine-age colossus has been called the 'ultimate Art Deco goddess.'

Equally versatile was the young Isamu Noguchi, who had studied with Gutzon Borglum of Mount Rushmore fame and in Paris with Brancusi. The influence of Brancusi could be seen in his gleaming machine-like head of Buckminster Fuller (1929). The Oscar statuette of the Academy Awards by art director Cedric Gibbons was Hollywood's counterpart of Noguchi's intellectual 'superman.' Noguchi also produced a tribute to another of the era's cultural stars in his stylized head of George Gershwin. Elegant depersonalized mask-like heads became a popular Art Deco motif, and were produced by Elie Nadelman, Gaston Lachaise, William Zorach and Sargent Johnson, among others. Noguchi's large-scale public works included the 10-ton stainless steel depiction of heroic newspaper workers for Rockefeller Center's Associated Press building, and a 72-feet long re-

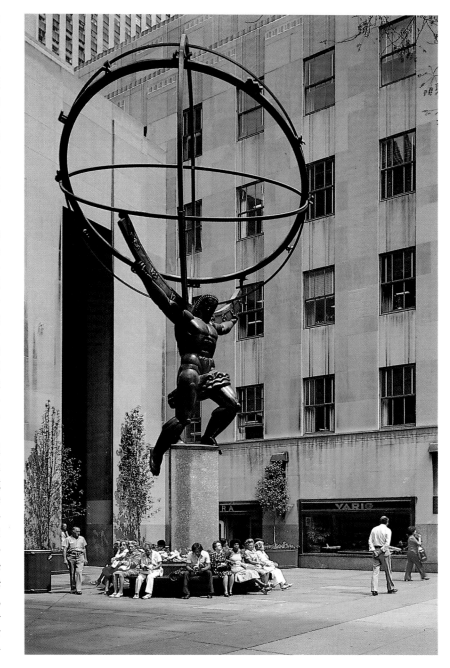

ABOVE RIGHT: *Lee Laurie's sculpture of* Atlas *at Rockefeller Center.*

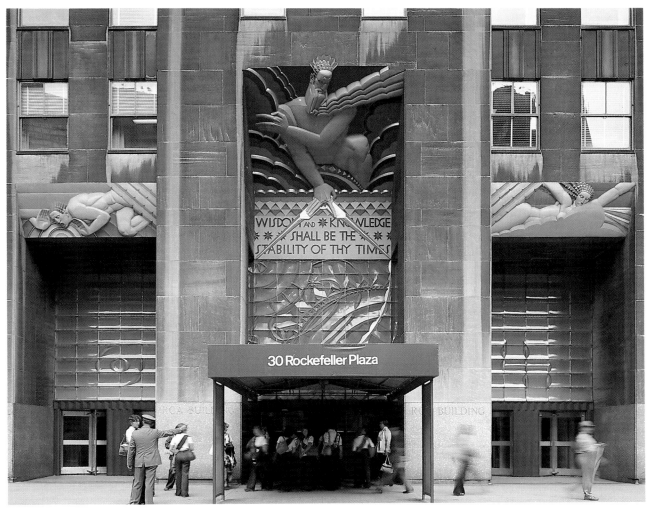

RIGHT: *Lee Laurie's* Wisdom *relief at Rockefeller Center.*

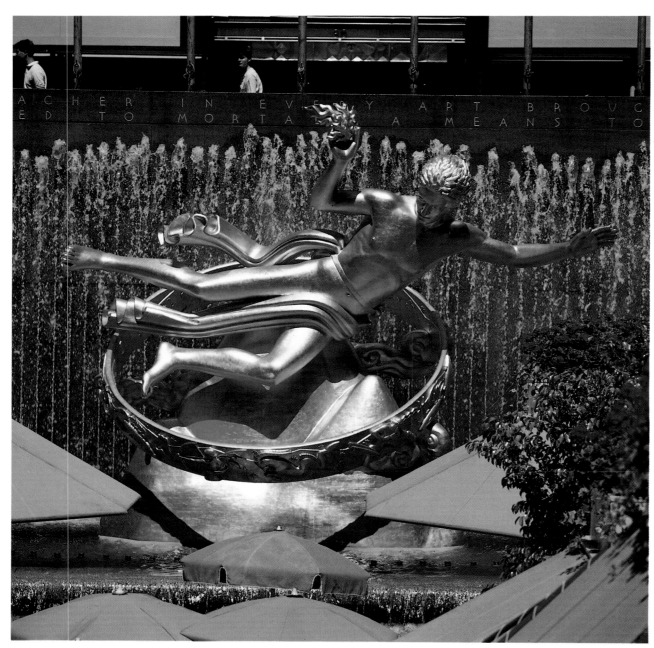

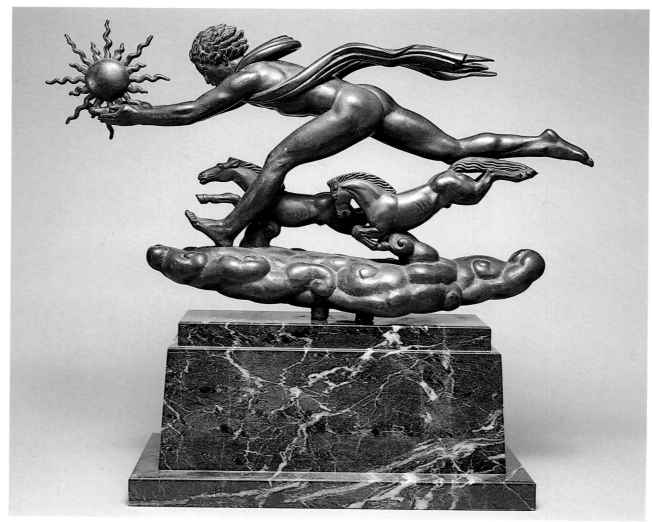

lief of polychrome cement, *The History of Mexico* (1935-36). In a more constructivist vein were his *Chassis Fountain* for the 1939 New York World's Fair, and the 1933 competition design, *A Bolt of Lightning: A Memorial to Benjamin Franklin*, which was finally erected in Philadelphia some 50 years later.

The American building boom of the era offered wide opportunities for architectural sculptors and was a magnet for European artists. German-born Lee Lawrie, who worked with architect Bertram Goodhue on the Nebraska State Capitol and other projects, became known as the 'dean' of American architectural sculptors, not only for his impressive body of work but also for his teaching of other sculptors. Key examples of Lawrie's work are the 1922 Chicago *Fountain of Time* and Rockefeller Center's *Atlas*.

The major sources of architectural sculpture commissions were the zigzag skyscrapers of the 1920s, the classical moderne civic and governmental buildings of the 1930s, the complex of new federal buildings in Washington, the various international expositions, and Rockefeller Center. A vast army of sculptors was kept at work, and the stylistic variations ranged from the lively, graceful imagery of the 1920s French style to a more pompous allegorical and heroic imagery based on classical roots, and encompassed primitivistic works inspired by Aztec, Indian, African or oriental motifs.

Among the busiest sculptors were those who had studied at the American Academy in Rome, and foremost among them was Paul Manship, an accomplished producer of elegant decorative interpretations of classical mythology, with linear stylization that drew on ancient Mediterranean art. His fellow graduates of the American Academy included Sidney Waugh (who also had studied with Bourdelle), Carl Paul Jennewein, Edmond Amateis and Leo Friedlander. And this American sculpture boom kept many other sculptors busy, including the prolific René Paul Chambellan, Lorado Taft, John Gregory and Edgar Miller. The European modernists who arrived in the United States did not devote themselves exclusively to the larger architectural works; William Zorach, Robert Laurent, Boris Lovet-Lorski and W H Diederich also drew on Cubism, Futurism, the machine aesthetic and streamlining to create stylish works for fashionable interiors.

ABOVE RIGHT: *Edgar Miller's etched glass panel of the goddess Diana (1929-31) from the Diana Court of Holabird & Root's Michigan Square Building in Chicago.*

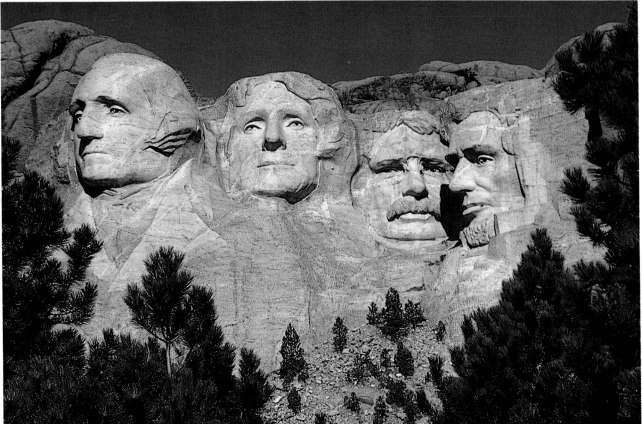

RIGHT: *Gutzon Borglum's colossal Mount Rushmore Memorial (1925-41) in South Dakota set the precedent for New Deal arts programs of the 1930s.*

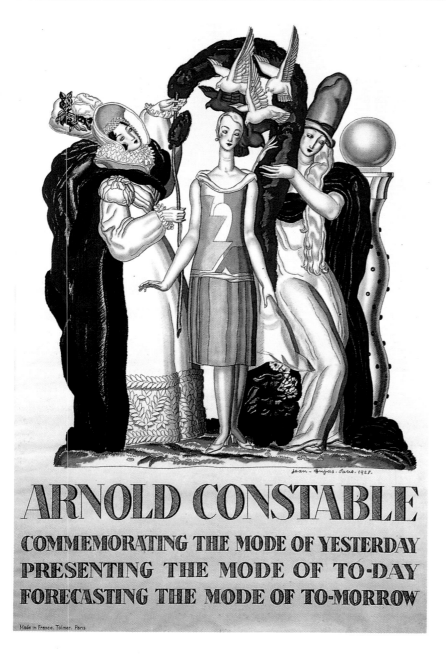

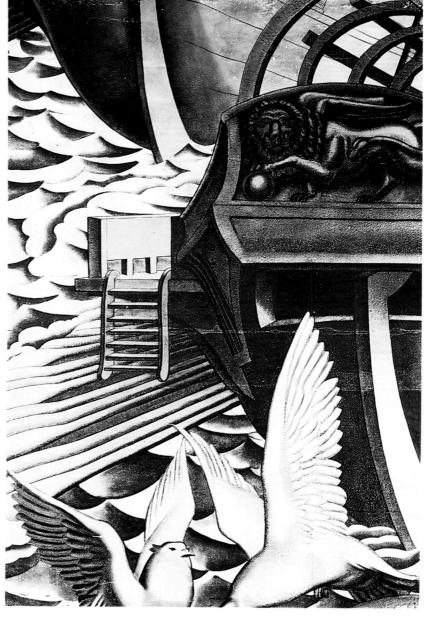

Art Deco painting shared many themes with sculpture. Since it was frequently employed in a less formal manner, however, it was able to present, in elegantly stylized and strikingly colored images, a vivid chronicle of the times. An important subject of the painting and graphic arts of the period were the hedonistic pleasures and fashionable entertainments of the frivolous 1920s: the liberated flappers with their chic clothes and accessories; the new open sexuality; sun worship; public cigarette smoking for women; cocktail parties; the popular sports; night club life; pulsating jazz music; the latest theatrical sensations; the intoxicating escapism of speeding automobiles, trains and planes; the allures of travel; the exoticism of the primitive; and above all, the quintessential activity of the jazz age, dance – that of Isadora Duncan, the Russian Ballet, the tango, the Charleston, the uninhibited Josephine Baker with her pet leopard and snakes, and the sophisticated Fred Astaire and Ginger Rogers.

In France, many of the leading decorative painters also produced illustrations and graphic works. The Bordeaux group formed the vanguard of this trend; its members included Jean Despujols, Robert Eugene Pougheon, Emile Aubry, Jean-Gabriel Dormergue, Raphael Delorme and, foremost, Jean Dupas. Also a major graphic artist, Dupas executed panels for Ruhlmann's 1925 exhibition pavilion and received major commissions to provide works for the ocean liners *Ile de France, Normandie* and *Liberté*. The consummate jazz-age woman, an idealized, sensual goddess, was depicted in portraits by the Russian emigré Tamara de Lempicka. Other artists producing decorative works and pieces designed to complement Art Deco interiors were Kees Van Dongen, Marie Laurencin, Tsuguharu Foujita, Jean Lambert-Rucki, Raoul Dufy (who also produced textile designs), André Lhote, Gustave Miklos and Auguste Herbin.

Some of the most splendid French Art Deco paintings were those executed for folding screens. The master of this genre was Jean

Dunand, who had come from Switzerland to Paris to study sculpture. He worked on the monumental winged horses of the Alexandre III bridge, and went on to specialize in exquisite lacquer work which elegantly interpreted the entire repertoire of Art Deco motifs. Dunand, who worked in metal as well as the lacquer adornment of panels, cabinets and tables, built up a workshop of nearly 100 artisans and designers. His most famous work was the colossal carved lacquer screen for the smoking room of the *Normandie*. Leon Jallot, François Louis Schmied and Charles Martin also produced some memorable Art Deco screens. Eileen Gray, a British designer working in France, executed some 20 screens in lacquer and also in metal, celluloid and cork. These screens displayed a more austere interpretation of Art Deco, and were intended as architectural adjuncts. Shop displays provided a ready market for painted screens and many important designers, including Robert Mallet-Stevens, co-ordinated such projects.

The participation of avant-garde artists in Art Deco projects underlines the fact that the demarcation line between the fine arts and the decorative arts was at times tenuous. Robert Delaunay, a central figure in the development of Simultaneism and Orphism, worked closely with Mallet-Stevens to provide appropriate paintings for exposition pavilions of the 1920s, and 1930s. Delaunay also produced stylish portraits such as the one of Mme Heim wearing a dress and scarf designed by Sonia Delaunay, his wife. Together Robert and Sonia Delaunay completed several painted screens. Fernand Léger, a pivotal figure in Cubism, was intensely interested in mural painting, seeing himself as a 'destroyer of dead surfaces.' He was eager to integrate art and architecture by collaborating with architects to create an art that could be enjoyed by all social strata. Léger's work – stylized, colorful, hieratic, relief-like and informed by the machine aesthetic – was appropriate for the adornment of domestic and public modernist settings. Similarly, some of the output of the Futurists was

FAR LEFT: *Jean Dupas, the leading French Art Deco painter, was known for his elongated tubular women, as seen in this 1928 poster.*

LEFT: *Dupas also executed glass panels for the liner* Normandie.

BELOW: *Tamara de Lempicka's painting* Romana de la Salle *(oil on canvas, 95"×27", 1929).*

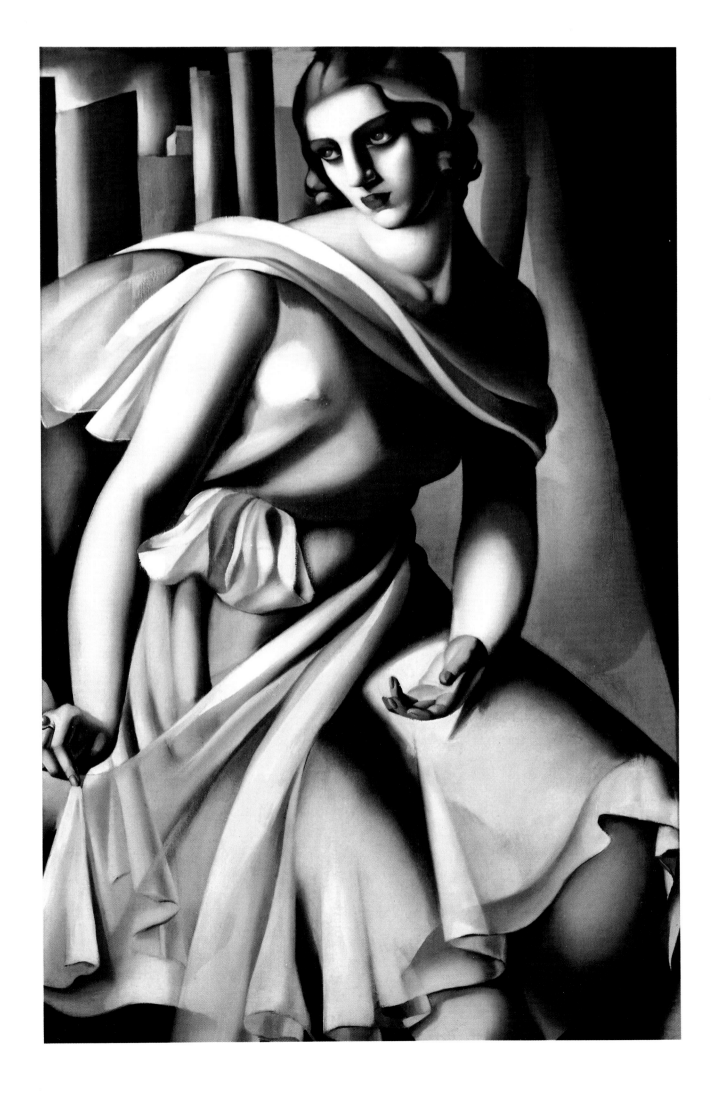

LEFT: Claire de Lune, *a five-fold lacquer screen by Jean Dunand.*

RIGHT: Praxitella *(1921), a portrait of Iris Barry by Wyndham Lewis.*

BELOW: Battle of the Angels: Crescendo and Pianissimo *(1925-26), a pair of three-panel screens lacquered by Jean Dunand, with figures designed by Seraphin Soudbinine.*

quite decorative in quality. The Italian artist and designer Fortunato Depero, for example, created striking geometrically stylized wall hangings, cabaret and restaurant interiors, theater sets, furniture and graphics, all of which were allied to Art Deco.

Vorticism, the iconoclastic British response to Futurism and Cubism, was another source of decorative work. The movement's leading spirit, Wyndham Lewis, produced not only elegantly cubistic portraits, but also vibrant red murals for Ford Madox Ford's London study, murals for the Rebel Art Centre, and a 'Vorticist Room' for the *Restaurant de la Tour Eiffel*. Lewis also collaborated on the decor of London's first avant-garde night club, the Cabaret Theatre Club,

which was opened in 1912 by the divorced wife of August Strindberg. There, modernistic murals depicting dance, outdoor sports and tropical scenes by Lewis, Charles Ginner and Spencer Gore were accompanied by the sculptures of Jacob Epstein and Eric Gill.

In 1913 Lewis produced a painted screen of dancers and acrobats for the opening of Roger Fry's Omega Workshops, an enterprise that sought to apply Cubist and Fauvist principles to the decorative arts. Among Omega's mural projects were those by Duncan Grant, Frederick Etchells and others for Borough Polytechnic, and interior work for the Cadena Cafe. While Lewis, Gaudier-Brzeska and others seceded from the group, Duncan Grant, Vanessa Bell and Fry went on

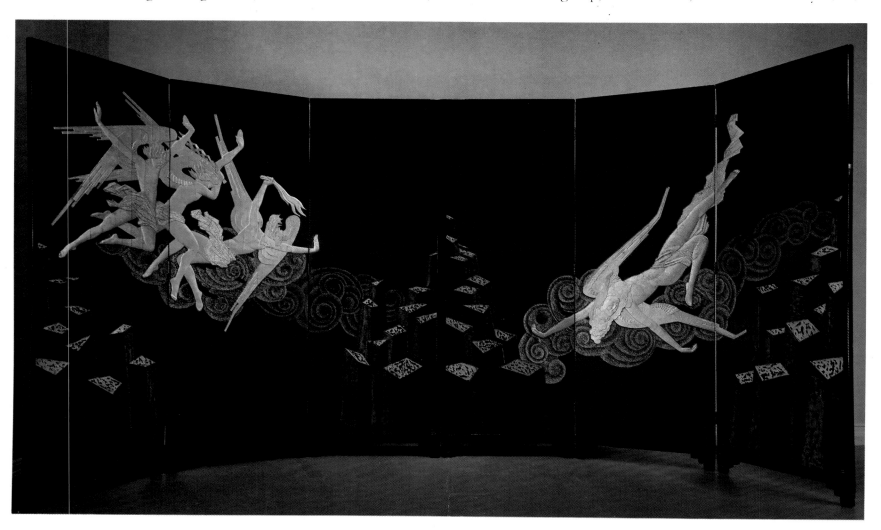

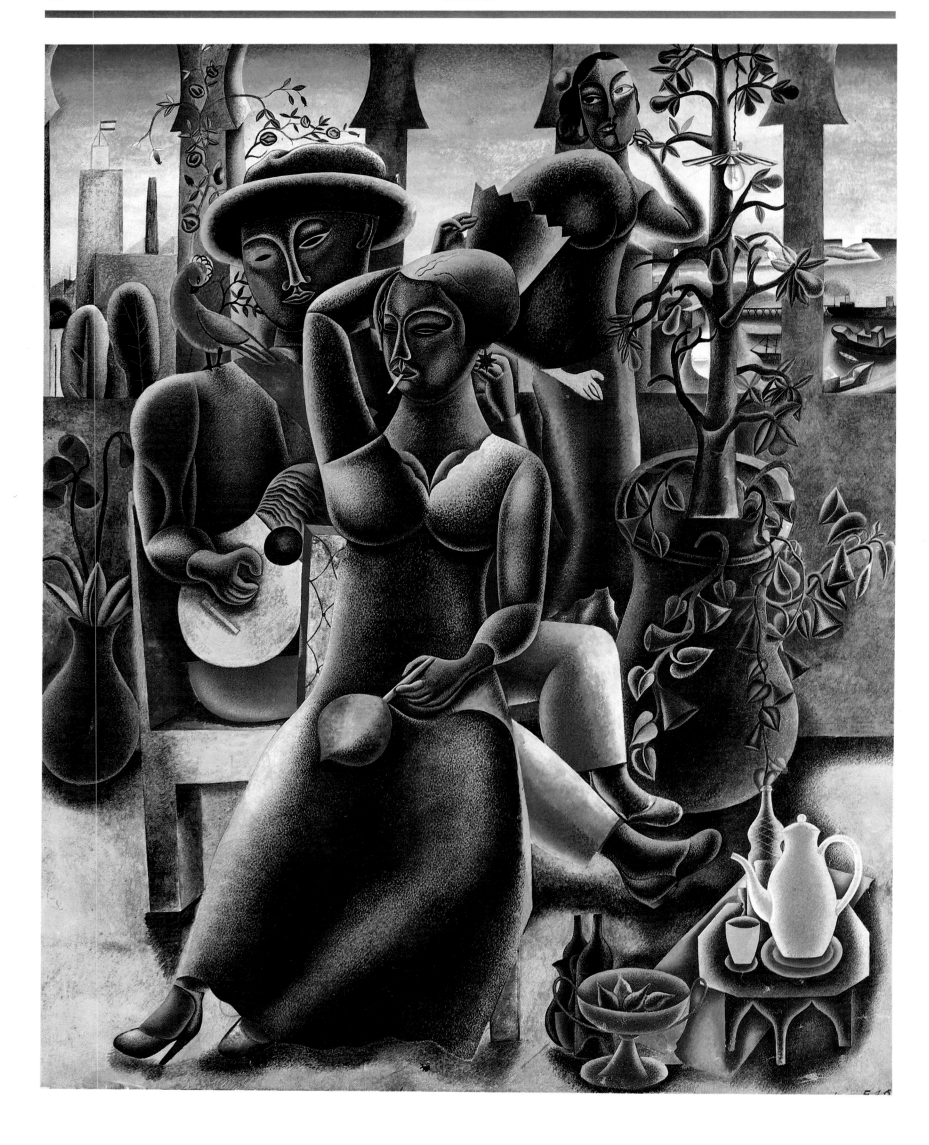

ABOVE: *The decorative stylization of*
Art Deco is seen in The Terrace
(gouache, 23"×18", 1929) by
British painter Edward Burra.

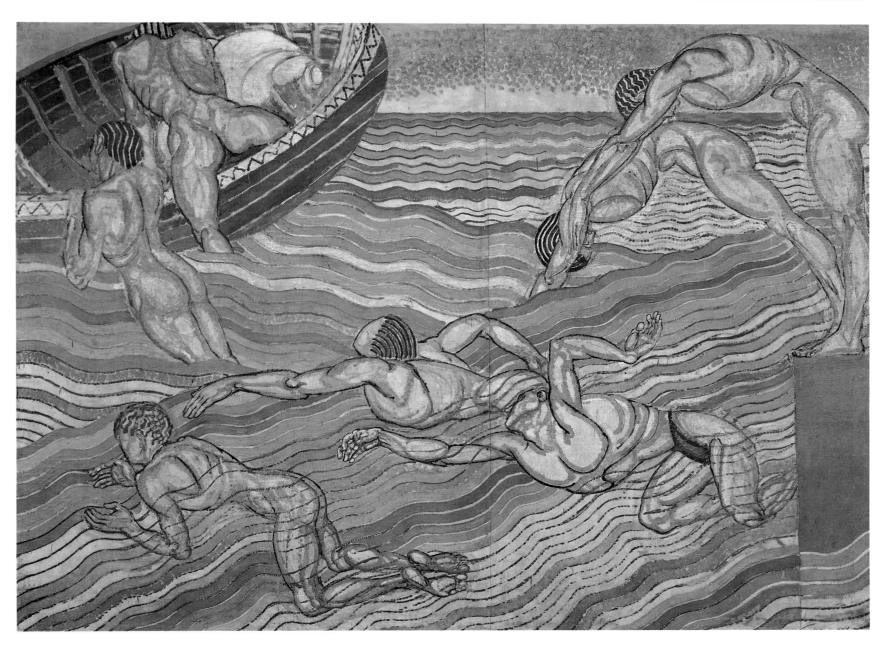

to execute some handsome modernistic screens and painted furniture panels. Some years later, Grant's large panels for the *Queen Mary* were rejected.

Frank Brangwyn, whose work was often reminiscent of the Arts and Crafts era, was active throughout the Art Deco years, designing furniture and creating screens and murals. A major project were the 18 panels commissioned by the House of Lords in memory of the peers lost in World War I. The stylized paintings glorifying the British empire were rejected after considerable controversy, and later placed in the guildhall of Swansea, Wales. In England, the Depression hit artists particularly hard and many turned to designing china, screens and decorative paintings for private clients and shops, not just in the Art Deco style but in the whole range of revival styles, as well as those reflecting Impressionism and Surrealism.

A characteristic of the American avant-garde painters of the early decades of the twentieth century was their inherently conservative response to the European artistic experiments: Man Ray's interpretation of Cubism, Joseph Stella's version of Futurism and Louis Lozowick's Constructivist creations all possessed decorative qualities similar to those seen in the work of the later French Cubists. The emphasis was on distinctively American subject matter; skyscrapers, bridges and factories were glorified in the work of Charles Sheeler, Elsie Driggs and other Precisionists.

Much of this subject matter and stylistic technique was adapted, together with the elegant motifs from French Art Deco, by the numerous decorative painters at work on the nightclubs, hotels, restaurants, theaters and movie palaces of the era. Of the private projects that provided commissions, Rockefeller Center was the most ambitious; there, the murals of leading decorative painters were combined with the work of Art Deco sculptors to produce interiors of unequalled stylishness. Many of the same painters, some 33 in all, went on to produce 105 murals for the New York World's Fair, just as

ABOVE: *Duncan Grant's* Bathing *mural for Borough Polytechnic (c 1913).*

BELOW: *Vanessa Bell's screen* Bathers in Landscape *(1913) showed the influence of Cubism.*

LEFT: *Eileen Gray's lacquer screen* Le Destin *(c 1913).*

BELOW LEFT: *A screen by Charles Baskerville (1932).*

BELOW RIGHT: *A screen of inlaid woods by Frank Brangwyn.*

ABOVE: *An abstract painted screen (c 1929) with metal leaf by Donald Deskey.*

they had provided mural decoration for other expositions of the decade. Some of the leading names were Hildreth Meiere, Winold Reiss, Witold Gordon, Ezra Winter, Henry Billings, Boardman Robinson, Yasuo Kuniyoshi, Alfred Tulk and Pierre Bourdelle (son of the French sculptor).

As in Europe, painted screens were sought after as accessories to Art Deco interiors. In his earlier days, Donald Deskey painted a number of screens with abstracted and geometric designs, and at times incorporating leather and silver or bronze leaf. Thomas Hart Benton, in his pre-regionalist years as a Cubist, completed several attractive screens, including one with an abstract motif of waves and clouds. Among the more prolific decorative screen painters were Robert Winthrop Chanler, whose best Art Deco screens were of stylized tropical and jungle scenes, and Charles Baskerville, who completed many screens and murals for private houses. Many of his screens depicted exotic animal and plant motifs, and some of them were executed in lacquer work. Baskerville's most important commissions were panels of Everglades scenes for the ship *SS America*, for which Pierre Bourdelle also executed mosaic and linoleum murals.

The Depression years brought a more serious tone to architectural mural painting. To allay the economic catastrophe, President Roosevelt's administration initiated a vast and unprecedented experiment in government patronage of the arts. Thousands of artists, designers and architects were kept employed by the various New Deal programs. The beneficiaries of this largesse included decorative, conservative and avant-garde artists. Some artists who were allied to Art Deco, including Ruth Reeves, Sargent Johnson and Elsie Driggs, became administrators of the programs, while others worked at easel paintings and murals to adorn post offices, libraries, schools, hospitals, courthouses, prisons, government buildings, air terminals and other public structures. Some 4000 murals were executed, most of

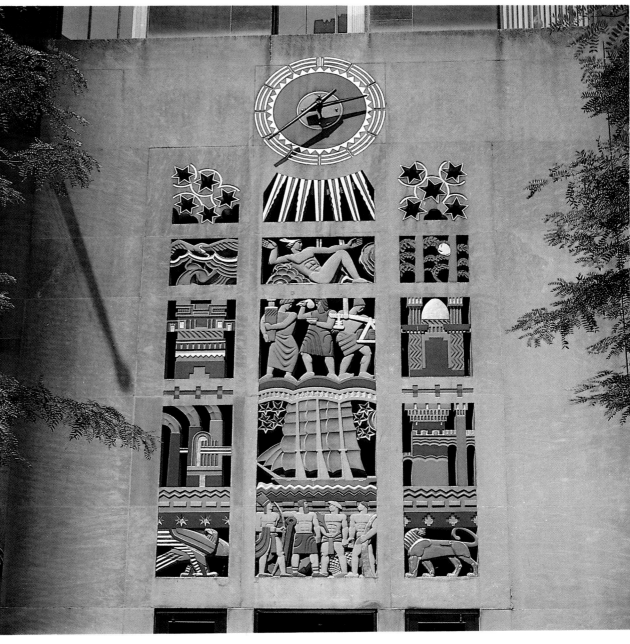

RIGHT: *Decorative mural reliefs at Rockefeller Center.*

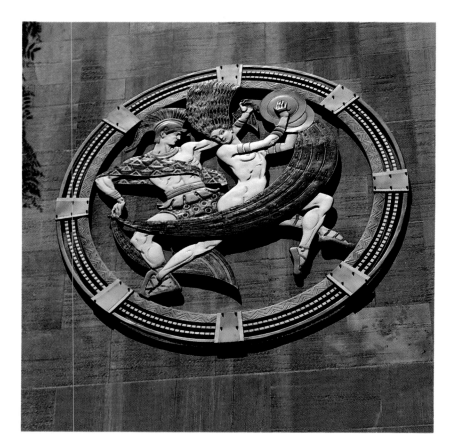

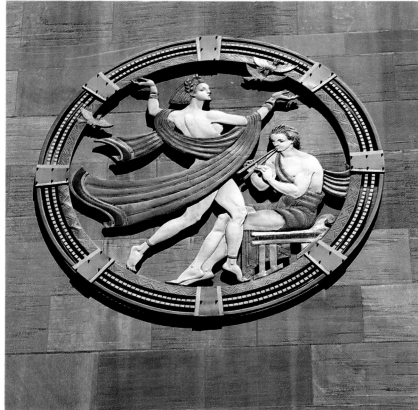

which still survive. Because of the conservatism of popular taste, especially in rural areas, radically innovative art was overshadowed by stylized representational imagery incorporating many of the Art Deco motifs dealing with transportation, communications, dynamic energy and allegorical heroic figures. A particular favorite were pompous panoramas of the progress of civilization, of national and regional history and legend, and of technological evolution, in which the present era was the self evident culmination of all that had come before. The New Deal murals, in their content and their reassuringly classicist style, reflected national aspirations for recovery, stability and endurance. The preferred works were optimistic, inspiring and didactic, celebrating civic virtues and human achievements, rather than those which criticized social and political conditions. Overtly or subtly inserted socialist, Marxist or anti-American messages inevitably led to controversy and frequently to censorship, as at San Francisco's Coit Tower, with Rockwell Kent's Washington Post Office mural, and with the privately commissioned Rockefeller Center mural by the Mexican revolutionary painter Diego Rivera.

ABOVE: *At Rockefeller Center's Radio City Music Hall the decorative plaques celebrating Dance (left) and Song (right) were designed by Hildreth Meiere.*

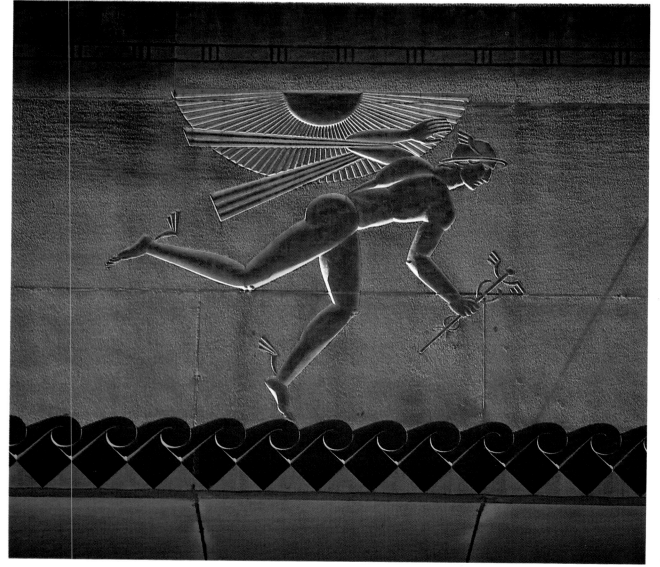

LEFT: *A gilded Mercury at Rockefeller Center.*

RIGHT: *In the RCA building lobby in New York, José Sert's murals replaced Diego Rivera's controversial pro-Marxist design.*

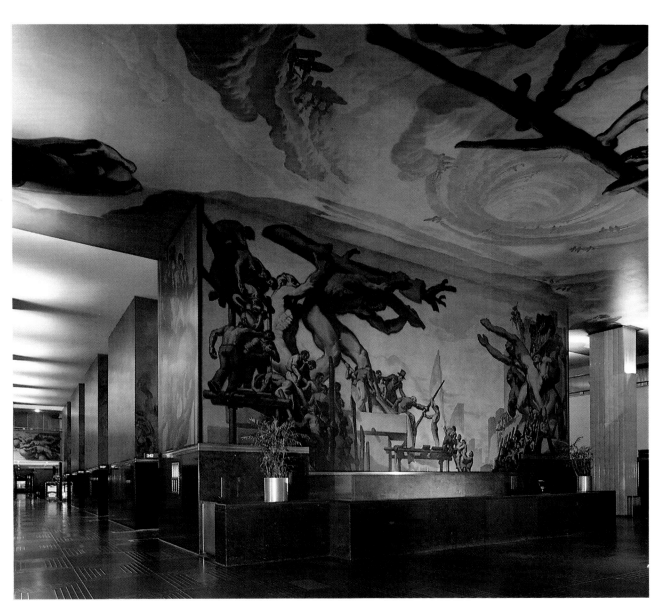

BELOW: *Diego Rivera's* Detroit Industry *(1932-33), a wall of his mural program at the Detroit Institute of Arts.*

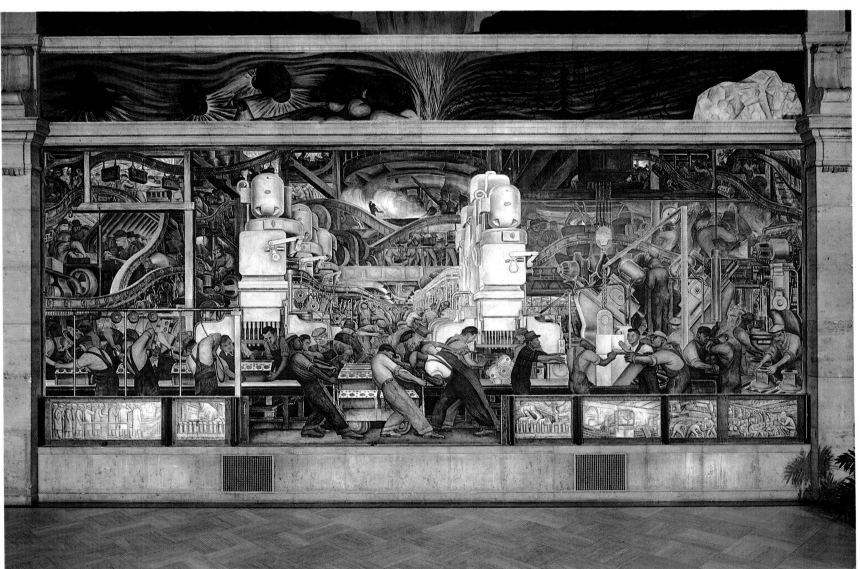

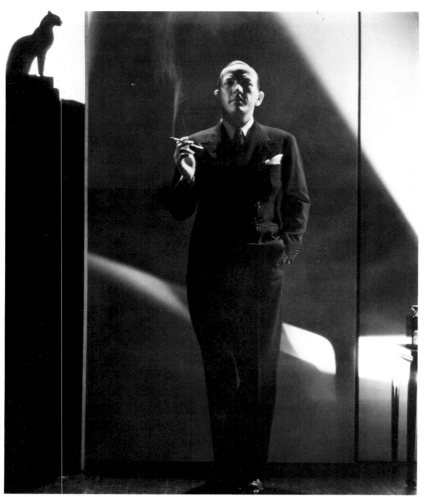

worked for *Vogue* and *Vanity Fair* magazines, also producing a re-markable series of portraits of celebrities of the era. Through the use of brilliant lighting and dramatic dark shadows, he brought the angular diagonals and decorative abstraction of Art Deco to many of his sophisticated fashion layouts and to his elegant portraits.

Among others exploring these avenues of fashion illustration and portraiture were Horst P Horst, George Hoyningen-Huene, George Platt Lynes, Baron Adolf de Meyer, Martin Munkacsi and Nicholas Muray, famous for his portraits of glamorous Hollywood film stars. Steichen's pioneering advertising works was paralleled by the activities of Victor Keppler. In England, stylish experiments in technique and image were carried on by Emile Otto Hoppé, whose speciality was theater photos, and the flamboyant Cecil Beaton, who sometimes obtained Art Deco effects through the inventive use of appropriate props and painted backdrops.

The glorification of machines, factories, bridges and skyscrapers that was characteristic of Futurism and American Precisionism, and also reflected in Art Deco, was a prominent feature of industrial photography during the 1920s and 1930s. Powerful examples were produced by Charles Sheeler, Margaret Bourke-White, Edward Weston, Andreas Feininger, Walter Peterhans, Germaine Krull and by Berenice Abbott, who came back to the United States from France to document New York during the height of its skyscraper building boom. Lewis Hine participated by documenting heroic laborers in his book *Men at Work* (1932). President Calvin Coolidge summed up

Many politically radical New Deal muralists revered, and some even had worked as apprentices to, the Mexican master Diego Rivera. Such a cult developed around Rivera and his compatriots that many artists with socialist and Marxist leanings considered it a vital part of their artistic education to travel and study in revolutionary-era Mexico, where official patronage of the arts gave rise to an impressive body of public murals. After his early years as a Cubist in Paris, Rivera had returned to Mexico to find inspiration in pre-Columbian art for his own stylized, primitivistic and propagandistic frescoes, which also incorporated motifs from technology. Some of Rivera's finest work was executed in the United States where, ironically, the 'Raphael of Communism' received major commissions from leading capitalists for the San Francisco Stock Exchange, for Rockefeller Center and for what is probably his finest work, the mural cycle sponsored by Edsel Ford for the Detroit Institute of Arts. In 1931 New York's Museum of Modern Art granted its second ever solo exhibition to Rivera (the first had gone to Matisse) in tribute to his central role in the modern mural movement.

Nor did photography remain unaffected by the Art Deco style. The revolution in the fine and decorative arts initiated by Cubism had a significant impact on the advertising, fashion, and portrait images produced by leading photographers of the 1920s and 1930s. Motifs from the Art Deco repertoire were highlighted, and its stylistic characteristics emphasized by means of specific camera and dark-room techniques. Typical was the use of dynamically oblique or diagonal camera angles; the use of dramatic close-ups; the use of strong contrasts of light and shadow; the use of silhouetting and mirroring effects; the exploitation of decorative or flattened geometric patterning; and the deliberate compositional selection and cropping of images to enhance rhythmic repetition, to create artistically abstract images from machine parts, or to give a powerful emphasis to diagonal structural elements.

The way in fashion and advertising photography was led by the American Edward Steichen, who had started out as a painter and pictorialist photographer specializing in hazy romantic effects. During duty in World War I as an aerial photographer he was required to produce images of the utmost clarity. The results of his aerial work were such a revelation that Steichen systematically set out to relearn the fundamentals of photographic technique. From 1923 to 1938 he

ABOVE LEFT: *This portrait of Noël Coward (1932) by photographer Edward Steichen captures the spirit of the artist and the era.*

BELOW: *Cecil Beaton used painted props to evoke Art Deco in his unconventional portrait of Lady Milbanke (1927).*

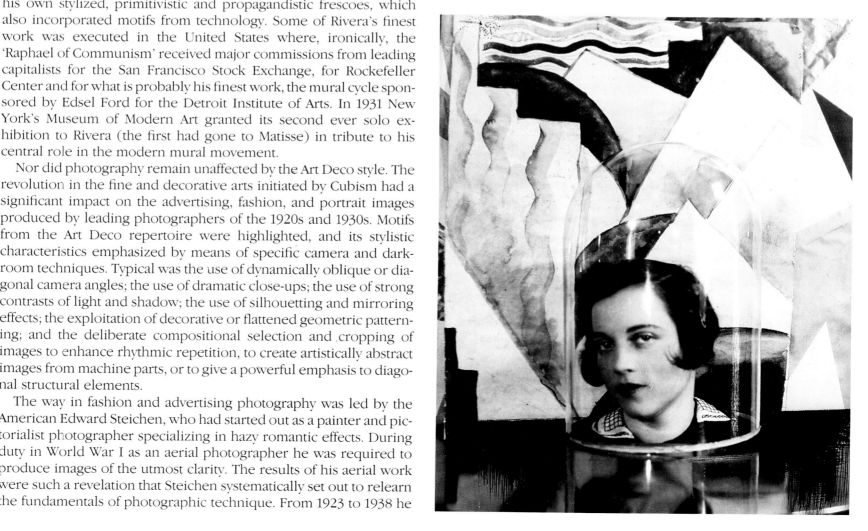

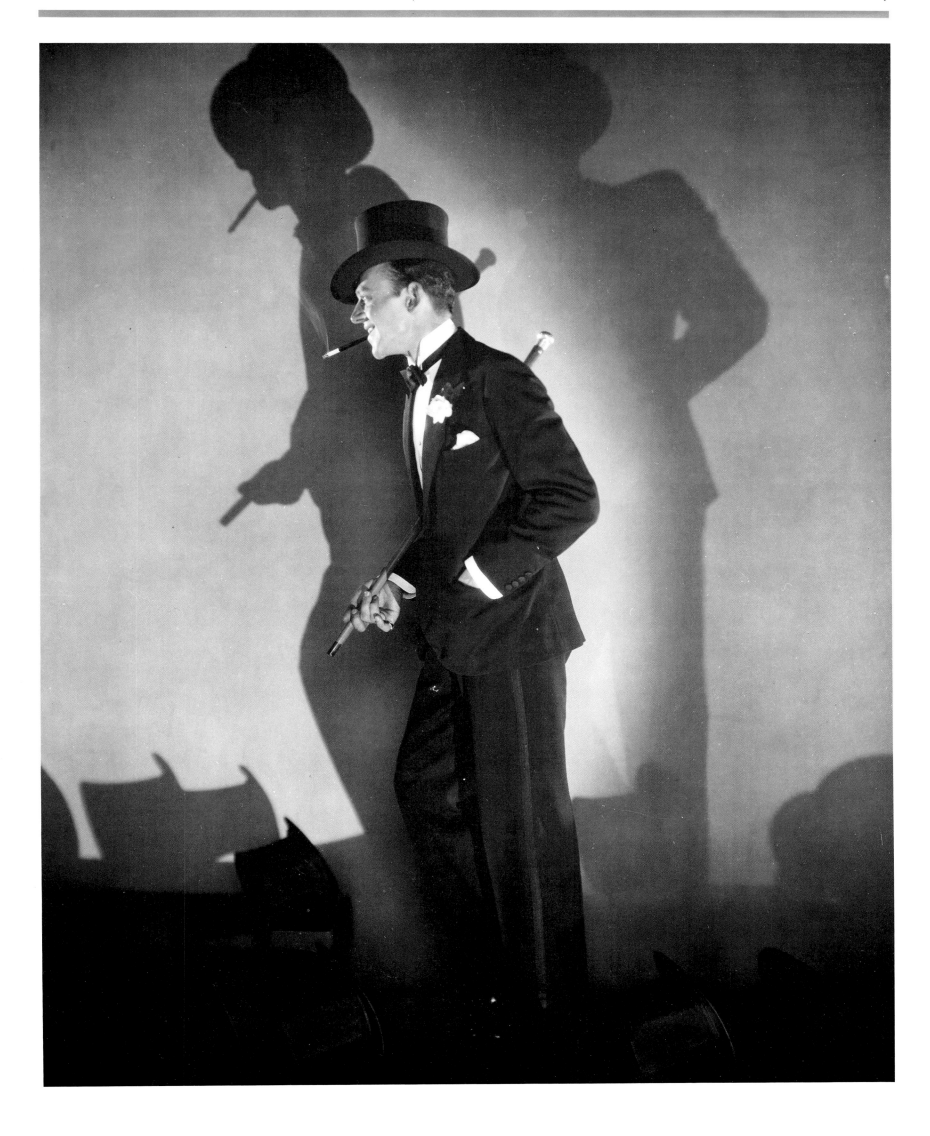

ABOVE: *Edward Steichen's portrait of Fred Astaire (1927).*

LEFT: *Lewis Hine's mechanic at work on the radial motor of an airplane from* Men at Work *(1932) was a photographic equivalent of the heroic workers so prevalent in the murals and sculptures of the 1930s. The strong diagonals are a typical compositional effect in Art Deco photography.*

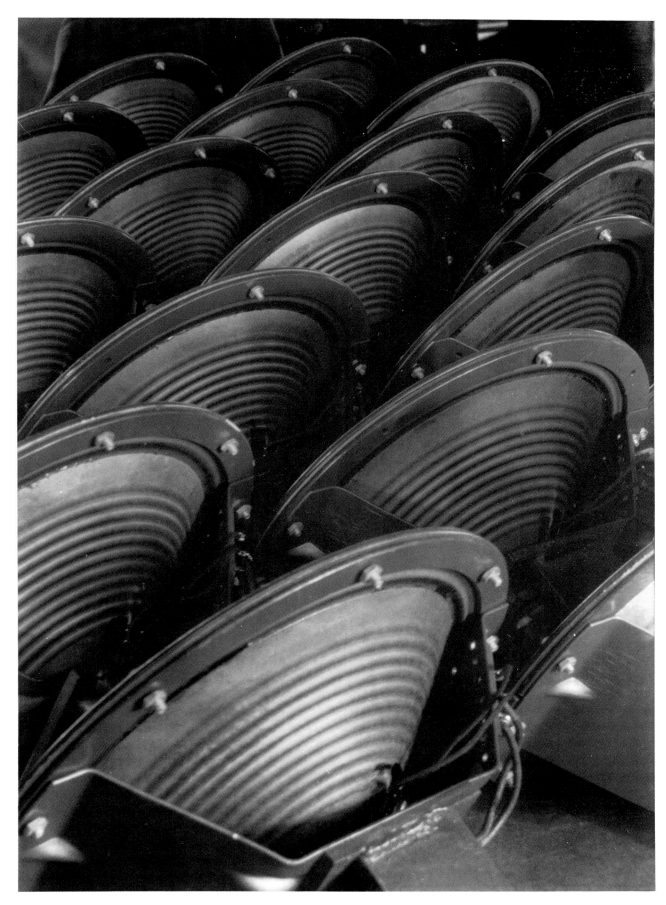

RIGHT: *Margaret Bourke-White's NBC photomural at Rockefeller Center included the panel,* Loudspeakers in Factory at Camden, NJ.

the quasi-religious nature of this 'industrial mythos' when he stated that 'the man who builds a factory builds a temple, (and) the man who works there worships there.'

The aesthetic stamp of approval was imprinted on such subject matter in 1932 when New York's Museum of Modern Art organized its *Exhibition of Photographic Mural Design*, which included designs by Abbott and Steichen as well as Charles Sheeler's montage triptych based on images from his seminal *River Rouge* portfolio, the publication of which had brought him worldwide recognition. In the following year, an architectural context was provided for such work when Rockefeller Center commissioned photomurals from both Bourke-White and Steichen. Bourke-White created a grouping of panels for the lobby of the new NBC offices composed of a series of juxtaposed and enlarged close-ups of technological components used in the broadcasting industry. Steichen executed a photomural based on the history of aviation for the men's lounge of the now demolished Roxy

Theater. In the same year, the Chicago exposition featured a colossal photomural.

Some of the more interesting photographic analogies to Art Deco came from the experimentalists of the avant-garde. The pioneering Czech photographer František Drtikol relied on relatively conventional means to evoke the Art Deco style. He combined large geometric wooden shapes, echoing Cubist forms, with carefully posed female nudes. Notable were the cameraless prints of opaque objects laid on light-sensitive photographic paper. While Moholy-Nagy named them photograms, Man Ray called them rayographs. Solarization, which became a favorite technique for Man Ray, Maurice Tabard and others, involved the exposure of negatives to light during the development process, thus bleaching out the intermediate tones. The result was imagery resembling silhouetted silvery flattened reliefs, an elegant photographic equivalent of the stylized, depersonalized figures of Cubism and Art Deco.

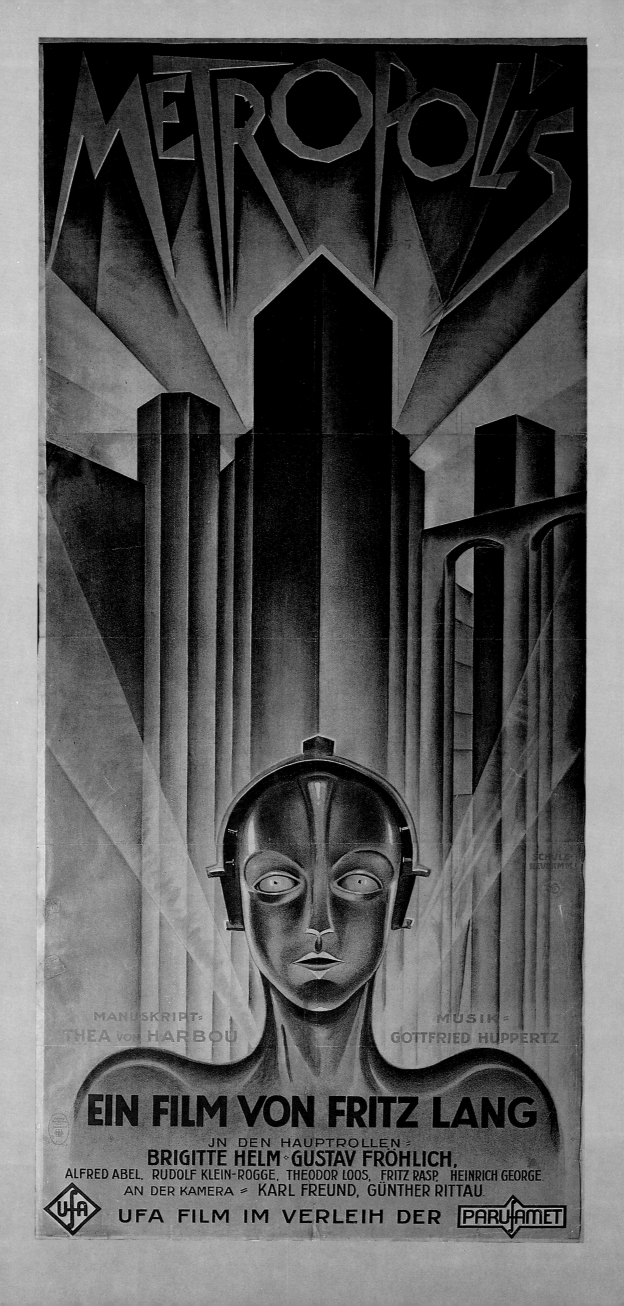

Graphic Art and Illustration

The Art Deco years saw the triumph of the arts of publicity. This was the era in which the poster and the advertisement first reached a high level of artistic accomplishment and psychological effectiveness. Compared to decorative sculpture and painting, the graphic arts and illustration were a far more ephemeral form of expression and as such they were freer from the strictures of convention. The essential purpose of posters and advertisements was to reach out and seize the attention of the onlooker through unusual or seductive subject matter presented in an attractive or eccentric manner. Avant-garde art combined the shock value of the new with the aura of high fashion and the cachet of elitism. As such it was a persuasive vehicle for commercial communicators. Hence the stylistic innovations of Cubism, Futurism and Constructivism soon made their way into the works of graphic artists and illustrators, and led to some of the more advanced designs of the age. As a truly democratic medium, the graphic arts disseminated in a direct and accessible manner the motifs and techniques of Art Deco, and of the modernist movements that inspired it, to a mass audience.

One of the first portents of rescue from the trailing tresses and sinuous fronds among which the Art Nouveau illustrators writhed occurred in England around 1895. An extraordinary and unprecedented foray into modernism was attempted by the duo operating under the name of the Beggarstaffs. Actually they were the brothers-in-law William Nicholson and James Pryde. The posters created by the Beggarstaffs consisted of abstracted yet evocative silhouettes of flat color, arranged by shifting pieces of cut colored paper around and executed at first by glueing them down or by means of stencil. The Beggarstaffs had originated an ideally economical technique for creating powerful and attention-attracting images. But they were too far ahead of their time and commercial success eluded them. Their impact, though, was felt by many who came later.

At about the same time as the Beggarstaffs were active, a countermovement against the excesses of mainstream Art Nouveau began to arise in the wilds of the American Midwest, in Glasgow and in Vienna. A revolution in geometric simplification and linear abstraction was initiated by Frank Lloyd Wright, as seen in his graphic designs for the limited edition book, *The House Beautiful* (1896-97). Similar developments were concurrently taking place in the graphic designs of the Glasgow group led by Charles Rennie Mackintosh. And in Vienna,

the formation in 1897 of the *Sezession* group, led by architects Josef Olbrich and Josef Hoffmann and artists Gustav Klimt and Koloman Moser, resulted in graphic works characterized by elegant geometric patterning, a modular or grid-like layout and refreshingly clean sans serif lettering. The Secessionists looked to classical art for their radical reordering of design techniques and motifs. Under the aegis of *Jugendstil*, the German counterpart of the Austrian *Sezessionstil*, the architect Peter Behrens also made important strides toward modernism in the graphic arts.

Radical modernist stylization in graphic art took permanent hold in Germany. In Berlin in 1903 Lucien Bernhard, citing the Beggarstaffs as a strong influence, created a shockingly simple prize-winning poster design that consisted of two matches and the single word 'Priester.' This reduction to elementary product name and stylized product image in flat colored shapes was recognized as an important development in poster art by the lithography firm of Hollerbaum and Schmidt, who signed Bernhard and others influenced by him, including Hans Rudi Erdt, Julius Gipkens and Julius Klinger, to an exclusive contract. Bernhard's *Sach Plakat* or 'object poster' concept served him well in the designs he produced over the next two decades. Also an innovator in the design of sans serif typefaces and of trademarks, Bernhard later studied architecture and moved to the United States in 1923, where he worked as an interior designer and a graphic arts teacher. Of the designers in the Berlin group, the witty designs of Vienna native Julius Klinger came closest to Art Deco.

In the years before World War I, Munich was the second important center of German modernism, with artists such as Thomas Theodor Heine, Ernst Neumann and Bruno Paul producing proto-Art Deco works. The unquestionable master of the genre was Ludwig Hohlwein, who had originally studied architecture but turned to poster

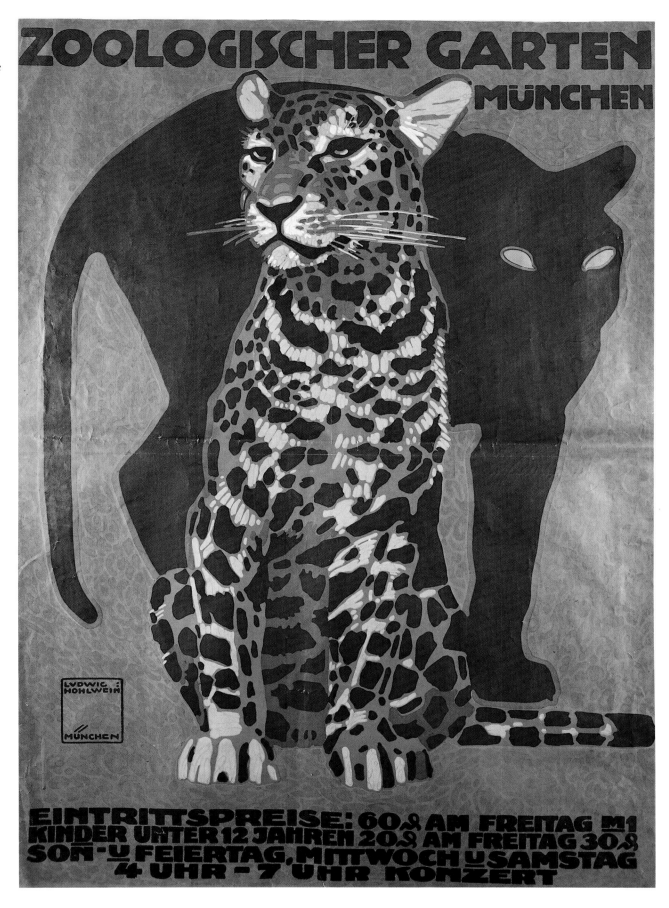

design in 1906. The sophisticated and powerful designs that he turned out over the course of his 40-year career were typified by flat, simplified images delineated by bright highlighting and deep shadows, and by sharp contrasts of color. With the advent of World War I, his posters became somewhat more naturalistic and painterly, although they were still modernistic compared to the old-fashioned pictorialism of the wartime posters coming from England and the United States. During the 1930s Hohlwein turned out numerous posters of heroic Aryan supermen for the Nazis.

Among other leading Germans producing graphic designs akin to Art Deco were Josef Fennecker who created lively dance, theater and cabaret posters; Julius Engelhard whose stylish fashion illustrations were a tribute to the new woman; and Walter Schnackenberg, whose best work hinted at decadence beneath the glittering surfaces. The significant German style was now Expressionism, and its morbid undertones aptly reflected the widespread pessimism in Weimar

Germany following defeat in the war. The 1926 film poster for *Metropolis,* with its expressionistic lettering, suggested menace rather than the characteristic Art Deco glorification of the machine.

By contrast, the overriding mood in France during the years following World War I was one of effervescent vitality and frivolous gaiety. This irrepressible *joie de vivre* made Paris the pleasure capital of the world, and the graphic arts reflected this milieu. The year 1908 is considered by many as the date Art Deco arrived in Paris. The key event was the publication by couturier Paul Poiret of his dress designs in a small book illustrated by Paul Iribe. Previously fashion illustrations had been drawn in an uninspired and straightforward manner but Iribe, a former caricaturist, produced elegant stylizations of elongated women wearing Poiret's provocative, loose-fitting designs. The arrival in 1909 of Serge Diaghilev's *Ballets Russes* galvanized the Parisian audience. Leon Bakst's spectacular costumes and sets for *Cléopatra* and, a year later, for *Schéhérazade* ignited the revolution

started by Poiret. Exotic patterns, brilliant colors and sumptuous materials soon permeated the world of fashion. With Poiret as the master of ceremonies, fashion and fashion illustration led the way in creating the new style.

A gifted publicist, Poiret orchestrated the Art Deco transformation of Paris through his splendid dress designs, beautiful publications, opulent costume balls, and the establishment of Atelier Martine for the design and co-ordination of smart interiors. Poiret had a sharp eye for spotting talent in others, and at various times either discovered or employed such leading Art Deco illustrators and designers as Georges Lepape, Erté and Raoul Dufy. And Poiret's new concept in fashion illustration opened the way for others such as George Barbier, E G Benito, Charles Martin, Louis Icart and many more, each with a distinctive flair. Martin showed the effect of Cubism, while Icart left over 400 drypoints and etchings of his soft romantic heroines and Erté's hard-edged exotic orientalism, inspired by an early interest in Persian miniatures, fueled a career that lasted more than 70 years. Erté held onto most of his original drawings, and was thus able to benefit fully from the Art Deco revival of the 1960s.

Poiret's elegant books of fashion plates inspired similar albums by others. Many of the earlier Art Deco books were exquisitely hand colored by the painstaking stencil process known as *pochoir*. Fashion magazines arising from Poiret's revolution also used the *pochoir* process. The most luxurious of these, *La Gazette de Bon Ton*, issued *pochoir* plates until about 1925. Throughout the Art Deco years the leading illustrators and graphic designers were commissioned to produce stylish covers and illustrations for the *Gazette, Femina, Vogue, Vanity Fair, Harper's Bazaar* and other fashion magazines, as well as periodicals of more general interest, throughout Europe and the Americas. Some of these publishers were significant patrons of Art Deco; during his exclusive contract with *Harper's Bazaar*, Erté provided some 240 covers and around 2500 illustrations for the magazine. Eventually, however, the shift to photography for advertising and fashion illustration cut off this flow.

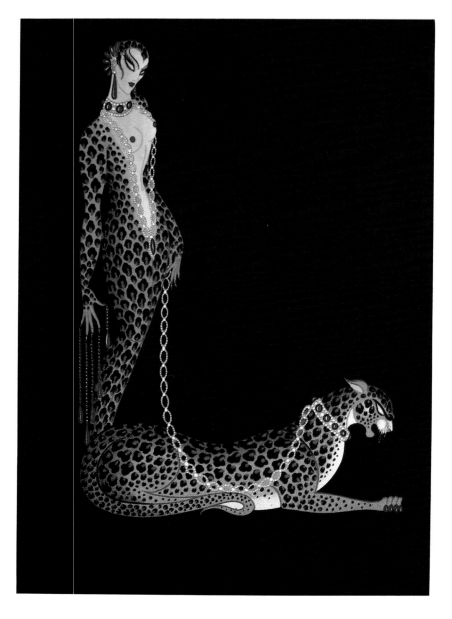

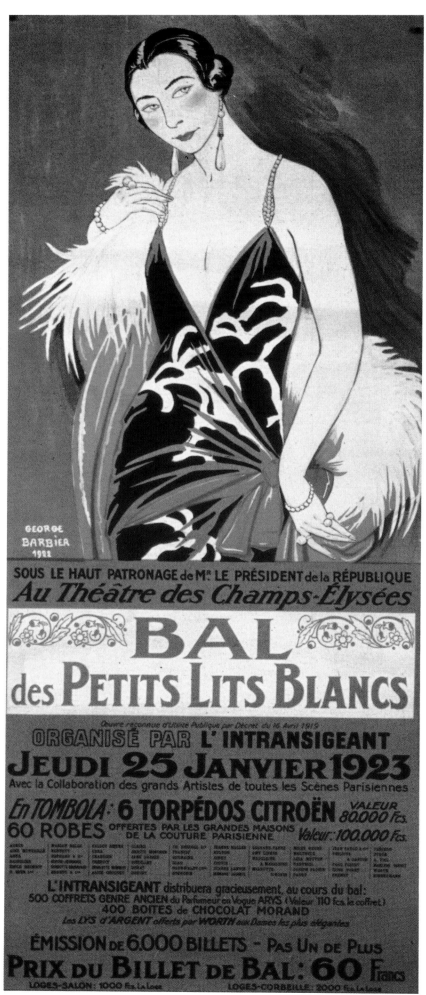

ABOVE: *A 1923 theater poster by George Barbier.*

LEFT: *A lady and a panther form the letter 'L' for Erté's* L'Alphabet.

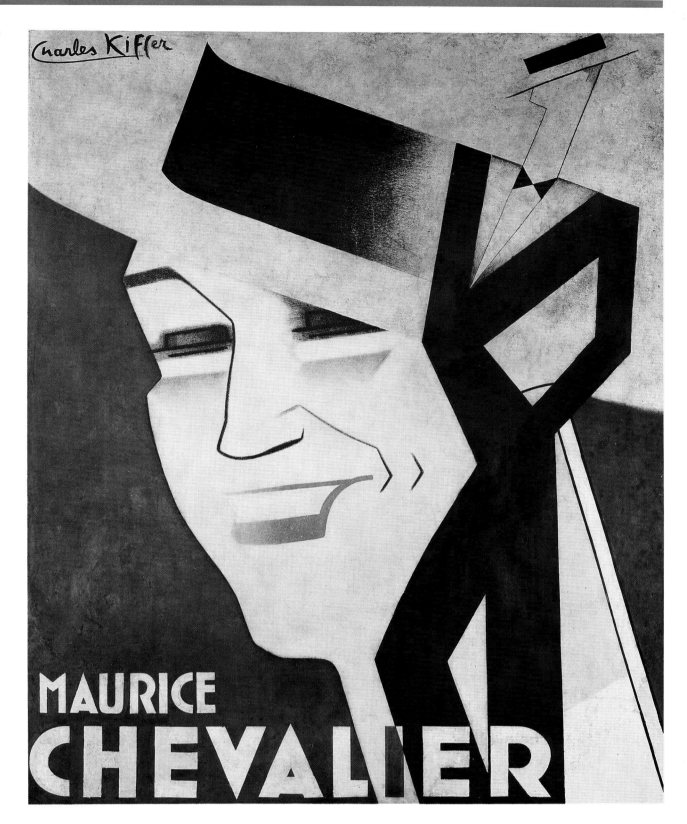

The Art Deco style had a far reaching impact on the design and illustration of limited edition and mass-produced books, not just in their layout and modernistic sans serif typefaces, but also in their jacket and cover designs. The illustration of finely produced literary volumes, many of them written by members of the Parisian avant-garde, provided work for many, including such fashion specialists as Barbier, Lepape, Martin and André Marty. Particular favorites of the era were sometimes reissued several times, as was Pierre Louÿs' *Les Chansons de Bilitis,* first illustrated by Barbier, then by Sylvain Sauvage and finally by Janine Aghion. Among the more prolific illustrators were Jean-Emile Laboureur, Charles Laborde and Marcel Vertès.

Unquestionably the finest book artist was François-Louis Schmied, who spent up to three years on the production of a limited edition volume such as Flaubert's *Salammbô* or Alfred Vigny's *Daphné,* not only creating the quintessential Art Deco illustrations, engraving illustrations in wood, designing the layout and the typefaces, selecting the paper, printing the pages on his own press, and frequently designing the binding. This meticulous attention was highly valued by collectors, who paid unheard of prices. Schmied, a gambler and, together with Jean Dunand, a yacht owner, soon spent the profits and was driven into bankruptcy by the Depression.

At the other end of the scale, the mass-produced series *Le Livre de Demain* provided a finely printed product, with woodcuts by leading artists, for the less affluent customer. The creation and crafting of sumptuous bindings for unbound portfolios by avant-garde or Art Deco artists or for limited edition literary volumes was a separate speciality. The leading exponents of this craft were Rose Adler, Paul Bonet, René Kieffer and, not least, Pierre Legrain, who used extravagant materials such as ivory, wood, mother of pearl and shagreen in his all-over designs.

Versatility was a quality shared by many Art Deco designers and illustrators. When called upon to do so, they could design almost anything, including packaging, textiles, wallpaper, furniture and even jewelry. Costumes and sets for theatrical productions and musical revues were a frequent diversion for many, including Barbier, Lepape, Erté, Iribe, Martin and Marty. For some, theatrical posters were only a sideline to their main activity. Charles Gesmar, for example, known for his lively Mistinguett posters, devoted himself almost exclusively to producing costumes and sets for her spectacular productions. Some graphic artists made a speciality of music-hall posters, often of particular performers. Charles Kiffer helped to publicize Maurice Chevalier and Edith Piaf, Kees Van Dongen produced posters for Arletty and Yvonne George, while Jean-Gabriel Domergue immortalized Régine Flory, Thérèse Dorny and Parisys. Some of the most

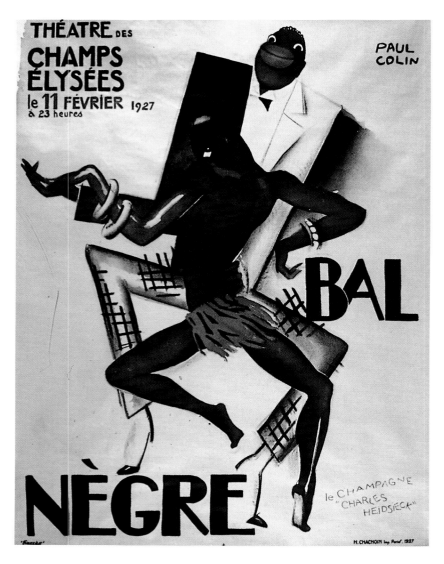

ABOVE: *A 1927 poster by Paul Colin*
for Josephine Baker and her jazz
ensemble.

BELOW: *A design by Paul Colin*
advertising Vichy water.

characteristic Art Deco entertainment posters were those produced by Paul Colin. After his *Revue nègre* poster brought him instant fame in 1925, Colin became best known for his series of posters publicizing the amazing Josephine Baker and her black jazz ensemble.

Colin was the fourth man to the 'Three Musketeers' of French graphic art, A M Cassandre, Jean Carlu and Charles Loupot. These great poster artists arrived center stage in 1925, brandishing the motto 'The poster should be a telegram addressed to the mind,' and went on to dominate French graphic arts for the next 15 years. The champion of Cubism and the machine aesthetic, Cassandre virtually redefined the modern poster by creating advertising images of unparalleled force and directness. He achieved this through a symbolic abstraction of image, combined with a sophisticated integration of typography to convey a simple and unmistakeable message. Among Cassandre's classic works were his travel posters of heroic ocean liners and sleek trains. Like Cassandre, Jean Carlu drew on avant-garde art techniques for his stylized, abstracted images for product advertisements. Some of Carlu's most powerful works were those in the areas of politics, war and disarmament, thus demonstrating the affinity of Art Deco and propaganda. At times more painterly than Cassandre and Carlu, Loupot had trained in Switzerland as a lithographer and later became a master of the airbrush, a technique ideal for achieving the slick mechanistic effects he used in his classic 1937 redesign of the men in the St Raphael liqueur advertisement. Such mundane jazz-age products as tobacco, liquors, toiletries, gasoline and men's clothes reached seductive new elegance through the expertise of Cassandre, Carlu, Loupot and others.

The 1925 Paris exposition, at which Cassandre won fame by receiving first prize for his *Au Bûcheron* poster, marked a turning point for

RIGHT: *A Bûcheron advertisement by A M Cassandre.*

BELOW LEFT: *A poster by Cassandre of the oceanliner* Normandie.

BELOW: *A cover design for* Harper's Bazaar *magazine by Cassandre.*

BELOW RIGHT: *A 1932 pacifist poster by Jean Carlu.*

Paul Poiret, who had started it all back in 1908. Despite his impressive displays at the exhibition, Poiret's brand of elitist design was now outmoded, and he was in deep financial trouble. In the summer of 1929, the House of Poiret finally closed its doors.

The graphic artists of the 1920s and 1930s drew increasingly on avant-garde art developments for new motifs and techniques. From Cubism came geometric stylization, the strong diagonals, oblique viewpoints and overlapping planes. Futurism contributed the glorification of the machine, and the fascination with the dynamism of movement and speed as expressed through dance, racing vehicles, and windblown hair, trees and clouds. Constructivism and the Bauhaus pointed the way toward compositions based on the bold and inventive use of typography, montage, and a progressive reduction of imagery to the basic design elements of pure line, form and color.

ABOVE: *A 1928 cover design by E G Benito for* Vanity Fair.

ABOVE RIGHT: *A 1929* Vogue *cover by Benito.*

Other European graphic designers allied to Art Deco heeded these lessons as well. The leading designer in Austria during the 1920s was Joseph Binder, who developed an international reputation with his striking product advertisements. Some of his most memorable work

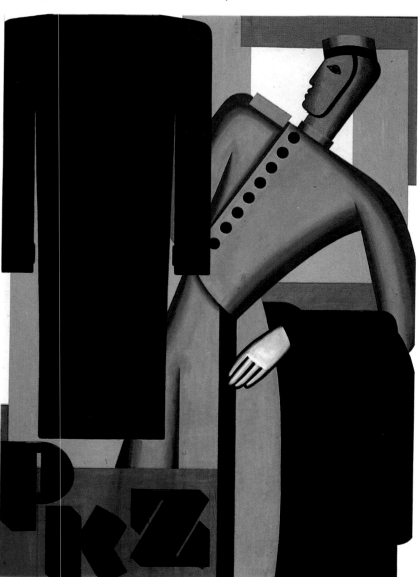

was produced during his later years in the United States, including his poster for the New York World's Fair and his work for *Fortune* magazine. Italy's leading designer was Marcello Dudovich, while Giovanni Nanni's postcards were outstanding. In Belgium, surrealist René Magritte produced some unique commercial designs, while Leo Marfurt created Cubist-influenced product advertising, tourism posters and a remarkable travel poster for the British market.

In England, some of the more enlightened patrons of the graphic arts were corporate institutions, and their numerous commissions kept a generation of artists busy. The leading sponsor of modern design was Frank Pick, who became co-ordinator of advertising for the London Underground in 1908. In order to promote a greater leisure use of the subways, Pick developed a poster campaign advertising attractive and exciting destinations – scenic sites on the outskirts of

London, department store sales, museums and galleries – as well as the efficiency and economy of the public transport system. Over the next 30 years, Pick commissioned works from dozens of leading artists from England and abroad, allowing them considerable freedom of expression. Among the British artists producing Art Deco works were Frank Newbould, Paul Nash and Austin Cooper. Pick also sought work from Jean Dupas, André Marty, Moholy-Nagy and Man Ray. His greatest protegé, however, was the transplanted American E McKnight Kauffer, a painter and a Vorticist who arrived in 1914. The prolific McKnight Kauffer soon achieved considerable success in the graphic arts with his colorful, cubistic and decorative adaptations of avant-garde ideas for Pick, Shell Mex and many other clients. Wyndham Lewis later ironically dubbed him 'the Underground posterking' who exhibited in 'subterranean picture galleries.'

BELOW: *A poster by Tom Purvis for the London & North Eastern Railway.*

RIGHT: *An advertisement by Ashley Havinden for British Petroleum.*

Tourism posters soon became a British Art Deco speciality as the various railway and shipping companies commissioned such fine works as Alexandre Alexeieff's haunting *Night Scotsman* and Leo Marfurt's stylish *Flying Scotsman*. High quality British works were produced by Tom Purvis, who had absorbed ideas from the Beggarstaffs and Ludwig Hohlwein, and by Austin Cooper whose Cubist geometric style possessed a French flair. Another important designer

LEFT: *An advertisement by E McKnight Kauffer.*

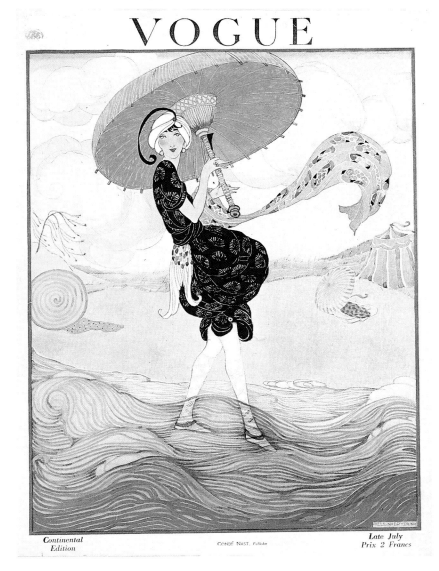

LEFT: *The* Savoy Cocktail Book *(1930), by Gilbert Rumbold.*

BELOW: Vogue *cover design by Helen Dryden.*

was Ashley Havinden, who created images of elegantly abstracted streamlined automobiles for the Chrysler company.

Among the leading illustrators was Fish (Anne Sefton), who sent satirical drawings of cartoonish Bright Young Things to *Vanity Fair*, *Harper's Bazaar*, *Punch* and *Tatler*. One of the most flamboyant illustrators was Gordon Conway, who arrived in London from rural Texas to become the toast of the town during the last social season before World War I. In her London and Paris studios, Conway made designs for Parisian plays, American commercial and publishing clients and the British cinema. The sophisticated jazz-age woman depicted in her *Zina* and *Jazz Lint* series epitomized the spirit of the times. The atmosphere of the 1920s can best be appreciated, perhaps, through ephemera such as sheet music covers and Gilbert Rumbold's illustrations for the *Savoy Cocktail Book*.

RIGHT: *An Art Deco book binding for the 1936 volume,* La Mort de Venise *by Maurice Barrès.*

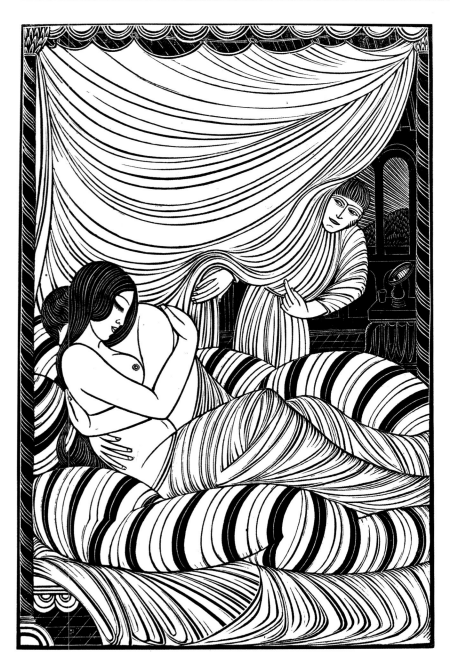

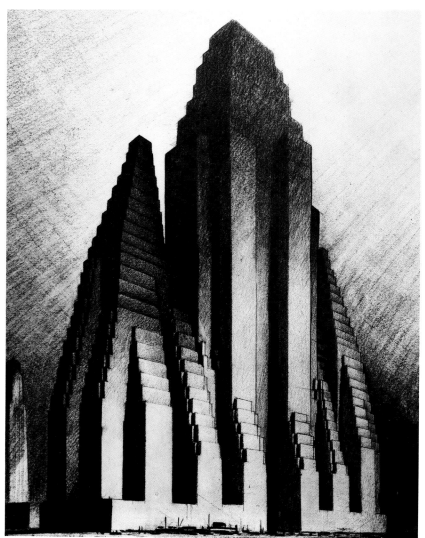

LEFT: *Sculptor Eric Gill also illustrated books.*

ABOVE: *With his dramatic architectural renderings, Hugh Ferriss helped to popularize the skyscraper style.*

LEFT: *Eric Gill, who designed typography as well, frequently worked in a medievalist mode.*

ABOVE: *By Rockwell Kent from his
book,* Wilderness *(1920).*

ABOVE: *By John Vassos from his
book.* Phobia *(1931).*

BELOW: *Cover design by John Vassos
for his book* Ultimo *(1930).*

Although Wyndham Lewis's Vorticist publication *Blast* had some
influence on modern British design, it was perhaps too radical to
serve as a model for the Art Deco books produced by such concerns
as Nonesuch Press, whose 1926 edition of *Benito Cereno* was illus-
trated by McKnight Kauffer. Conservative ideas lingered, as seen in
the work of John Austen and Alastair, who were considered members
of a school of Aubrey Beardsley still active in the 1920s. Some ex-
cellent work was produced by sculptor Eric Gill, who was also an en-
graver and typographer. Gill crafted some very fine stylized black and
white prints for new editions of such classics as *Canterbury Tales,
Troilus and Criseyde* and the *Song of Songs.* Sharply contrasting
black and white prints, incorporating Art Deco motifs by Robert Gib-
bings and others, were reproduced in *Studio* annuals of the era and
were a staple of Art Deco illustrated books.

In the United States, the most prolific book artist working in the
black and white Art Deco tradition was Rockwell Kent, whose bold
illustrations suggested epic events and primeval mysteries of man
and nature with their idealized monolithic human figures and topog-
raphy highlighted by dramatic contrasts of dark and light and of void
and mass. Kent's architectonic renderings illustrated modern re-
prints of literary classics, as well as books recording his own wander-
ings to remote regions. He was also overwhelmed with commissions
to design bookplates, jackets and bookmarks. Kent associated with
the Canadian Group of Seven, whose stylized northern landscapes
had much in common with Kent's work. Canadian artist Bertram
Booker, as well as many others, created prints and illustrations in this
bold black and white style.

Another important American working in a similar vein was Lynd
Ward, whose most outstanding works were his textless novels in
woodcuts: *Vertigo, Song Without Words* and *God's Man,* a Faustian
tale of a modern artist amid soaring skyscrapers and dramatic jagged
mountains. For other books, Ward also produced elegant, French
style Art Deco line illustrations.

A remarkable body of Art Deco illustration was produced by John Vassos, who worked as a stage, graphic and industrial designer. As well as illustrating literary classics, Vassos created several original works, usually in collaboration with his wife Ruth Vassos, who supplied the texts. *Contempo* (1929) was an indictment of contemporary American culture and its rampant commercialism; *Phobia* (1931) a consideration of psychic disorders; and *Humanities* (1935), an indictment of war. Executed in black, gray and white gouache and dramatically incorporating many Art Deco stylistic devices, Vassos's works were a source of inspiration for Hollywood designers.

Among magazine illustrators, the most idiosyncratic work was created by John Held, Jr, who satirically explored the frivolous and frenetic 1920s of Flaming Youth in line drawings and colorful magazine covers and posters. Caricature also informed the witty renditions of the famous and infamous by Mexican-born Miguel Covarrubias reproduced in *Vanity Fair, Vogue* and *The New Yorker.*

A pioneering figure was Helen Dryden, the leading woman cover artist for *Vogue's* international editions in the 1910s and 1920s. Other early *Vogue* covers were designed by the inventive George Wolf Plank, Rita Senger and E M A Steinmetz. Neysa McMein, who designed

all of the *McCall's* covers between 1923 and 1937, is credited with creating the 'flapper' – the liberated tomboyish woman of the 1920s. Also prolific was Ilonka Karasz, who executed 186 covers for *The New Yorker,* beginning in 1925.

For the most part, American illustration and graphic design remained relatively conservative, although there were some exceptions. Beginning in 1910, Alfonso Iannelli designed over 100 eye-catching, Cubist-influenced vaudeville posters for the Orpheum Theater, bringing him to the notice of Frank Lloyd Wright who subsequently commissioned architectural sculpture from him. Winold Reiss, who arrived from Germany in 1913, was particularly drawn to the decorative aspects of ethnographic, folk and American Indian art, which he drew on as a source for his own Art Deco designs.

Although American film posters were less artistically ingenious than those in Europe, some were nevertheless clearly associated with Art Deco in subject matter. The examples include the posters for *Wings* (1927), *Hells Angels* (1930), *Flying Down to Rio* and *King Kong* (both 1933). The theater posters, too, were more sedate, betraying an Art Deco influence in their mild abstraction, silhouetted contours, and flat areas of vivid color.

In the 1930s visiting and immigrant designers from Europe created more sophisticated modernistic works for such clients as magazine publishers and commercial corporations, as well as for the government. Among those who came to either work or stay were Dr Mehemed Fehmy Agha, who became art director for Condé Nast publications, Alexey Brodovich, who became art director of *Harper's Bazaar,* Erté, A M Cassandre, Herbert Bayer, Jean Carlu, Fernand Léger, Herbert Matter, Man Ray, Moholy-Nagy, E McKnight Kauffer and Joseph Binder.

One of the finest bodies of American graphic art of the 1930s, which has only recently begun to attract recognition, was the output of the New Deal administration's WPA Poster Project. From 1935 to 1943, this organization kept legions of artists and designers at work during the Depression years, producing some 35,000 designs of which some 2000 examples still survive. Under Bauhaus-trained Richard Floethe, posters were provided for a wide variety of federal, state and civic agencies to promote education, housing, health and safety issues, crime prevention, conservation, cultural events, tourism and, in the final years, to create war propaganda. The quality of these works was remarkably high and many of the most effective ones reflected Art Deco both in technique and in subject matter. The visual vocabulary of simple, direct messages executed in flat, screen-printed colors owed much to the examples set by Cassandre, Joseph Binder and others. In this context, graphic art was a potent and accessible medium for promoting social change.

LEFT: *Satire is an element of this* 1925 New Yorker *cover.*

BELOW LEFT AND BELOW: *Designs by the New Deal's WPA Poster Project promoted such social issues as work safety and advertised municipal services.*

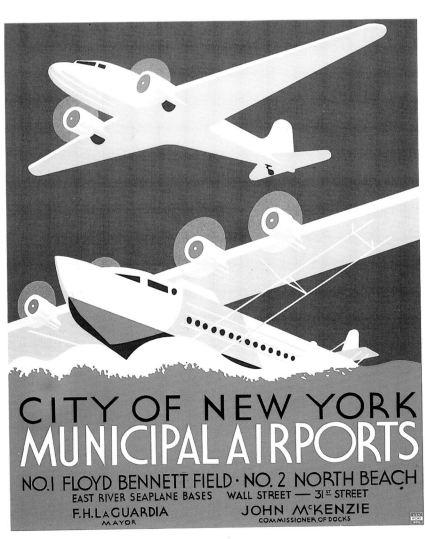

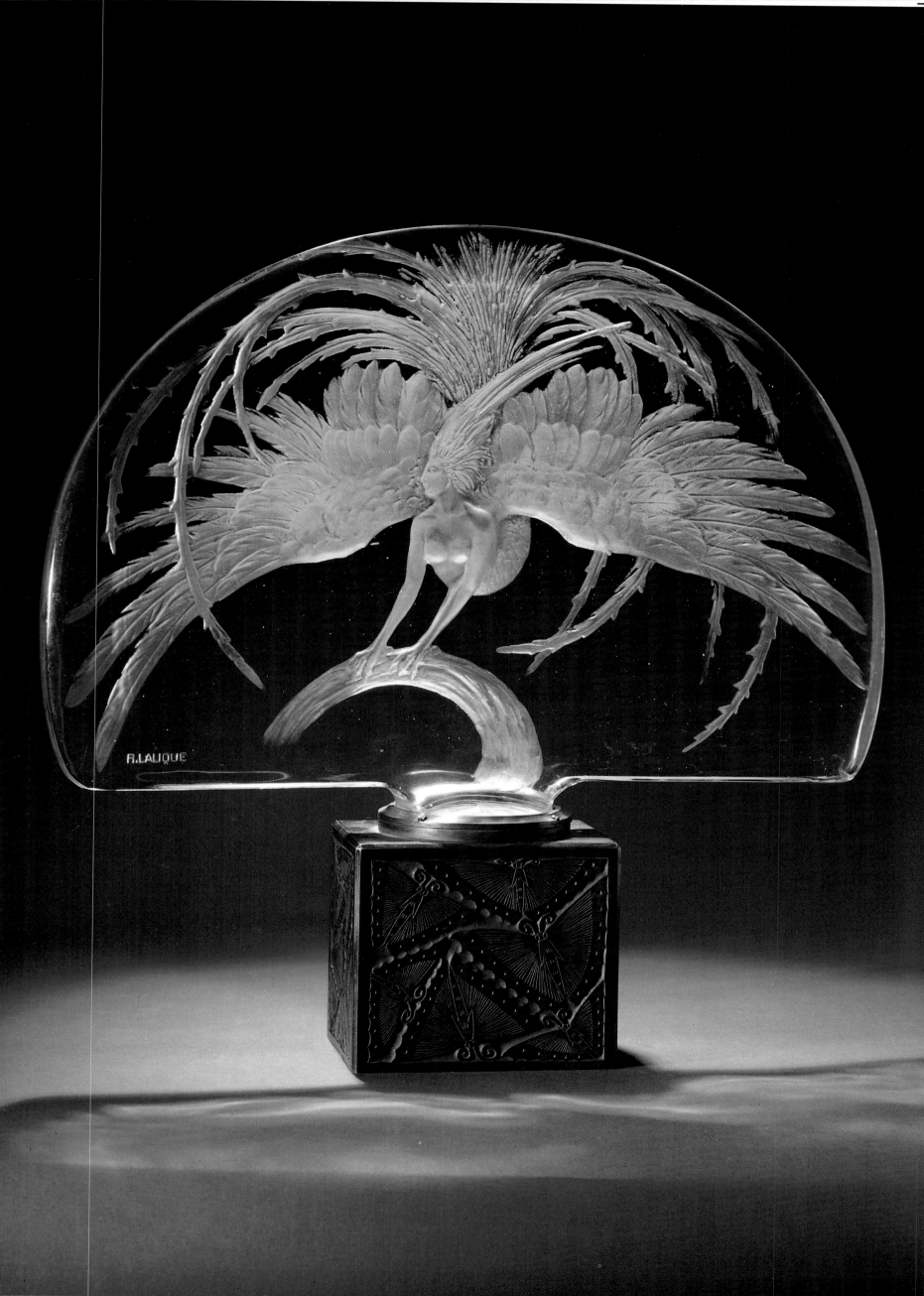

Glass, Ceramics and Metalware

LEFT: *René Lalique,* L'Oiseau de Feu *(Firebird) lamp.*

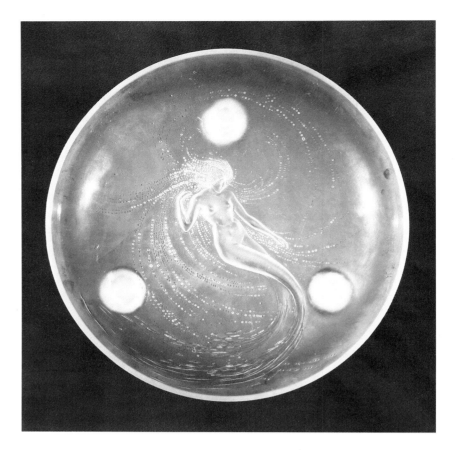

The Art Deco decades were a remarkably fertile period for designers working in all media. This range of activity was encouraged in large part by the Art Deco insistence on the unified design of the total environment. As a result, its modernistic stylishness extended to the output of the glass, ceramic and metal workers, giving rise to such extraordinary names in the annals of the decorative arts as René Lalique and Jean Puiforcat.

Some of the most exquisite Art Deco glass came from France where the outstanding figure in this medium was, of course, René Lalique, who had first established his reputation as a jewelry maker during the Art Nouveau era. In 1902, fascinated by the sculptural possibilities of the medium, Lalique learned to make glass; by 1909 he had opened his first glass works. His earlier designs for perfume bottles, vases, statuettes, automobile ornaments and lighting fixtures displayed floral, animal, figural and other characteristic Art Deco imagery in molded or engraved form. The business they generated proved so lucrative that they continued in production even after Lalique came to receive larger architectural commissions for glass panels and lights for hotels, cinemas, churches, luxury trains and the ocean liners *Ile de France* and *Normandie*. The 1925 Paris exposition was a triumph for Lalique – as it was for Ruhlmann and Edgar Brandt – and consolidated his international reputation. His ability to remain responsive to variations in style while maintaining a consistent quality made his glass a best seller of the Art Deco era.

A contrast to Lalique's commercially appealing Art Deco glass was provided by Maurice Marinot's investigations of color, form and technique. His unique blown, enameled and etched glass pieces in sculptural organic forms frequently recalled the flowing curves of the Art Nouveau style. A particular speciality of French Art Deco glass artistry was the use of *pâte de verre* – a paste of glass that had been ground into a powder and then refired in a mold. The colorful, sculptural qualities of the medium, and the fact that the works produced by this technique appeared precious, made it an appropriate vehicle of Art Deco expression. The finest *pâte de verre* artist of the Art Deco era was François-Emile Décorchement, who had started out as a landscape painter and began work in *pâte de verre* around 1900, at first producing richly embellished Art Nouveau pieces. By the early 1920s, he was making bold, simplified Art Deco works with molded reliefs or incised ornament of stylized flowers, fruit, reptiles and animals. Around 1928 he began to create massive geometric forms that reflected Cubism. Another artist highly accomplished in *pâte de verre* was Gabriel Argy-Rousseau, who started out in 1909 creating perfume bottles, and by 1928 had executed sculptures by Marcel Bouraine in *pâte de cristal*, which was translucent, compared to the more opaque *pâte de verre*. Important Art Deco glass also was produced by the

Daum factory (which specialized in chunky vases with geometricized patterns), Baccarat, Marcel Goupy and Jean Luce.

Luce, who founded his own company in 1923, established his reputation at the 1925 Paris exposition and sold exclusive items of glass, porcelain and faience from his Paris shop. Active in the design of stylish Art Deco ceramics and tableware, Luce was commissioned to provide tableware and decorative items for the *Normandie*, and his wares later came to be used by all the ships of the French line.

Design ateliers such as that of Süe et Mare, Primavera and La Maîtrise commissioned a wide range of Art Deco ceramics and tablewares, while the Sèvres factory kept pace with modernism by developing a new line of vases and dishes decorated by Robert Bonfils, Jean Dupas, Jan and Joel Martel, Ruhlmann and others. Perhaps the finest French Art Deco ceramic works came from René Buthaud, the director of Primavera's ceramics studio from 1923 to 1926. Jean Dupas and Jean Dunand took a special interest in Buthaud, whose mainly stoneware pieces in simple neoclassical shapes virtually served as the canvases on which he painted figures from Greek mythology, beautiful women, nudes and dancers. Some of Buthaud's

ABOVE: *René Lalique,* Tripied Sirene *plaque (c 1930).*

LEFT: *Vase by Lalique (1920-30).*

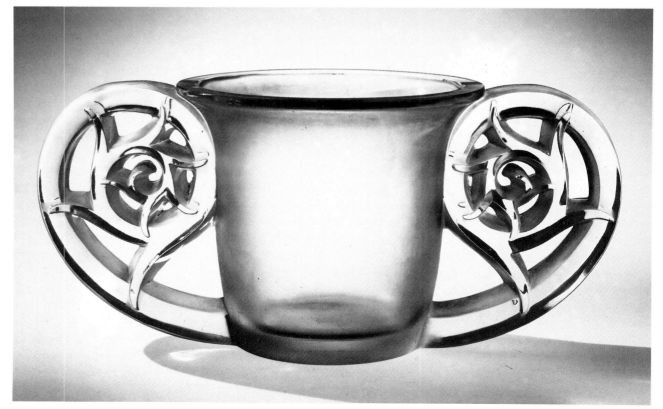

ABOVE RIGHT: *A pâte de verre* bowl *by Gabriel Argy-Rousseau.*

RIGHT: *Sculpture by Marcel Bouraine executed in* pâte de cristal *by Gabriel Argy-Rousseau.*

more striking works, with African subject matter, were inspired by the 1931 colonial exposition. Far less elegant and catering more to popular tastes were the almost kitschy figurines of Jean and Jacques Adnet, who also executed cubistic reliefs and architectural sculpture, and the comical *bibelots* from Robj.

In the area of small decorative items, a particular French speciality was *tabletterie* – accessories such as dressing table sets, paper knives, umbrella handles, small boxes, hand mirrors and hair combs, usually carved of such unusual or exotic substances as mother of pearl, ivory, horn, tortoiseshell, coral, jade, amber or rock crystal. Georges Bastard was a master of this craft, and he additionally provided exquisite handles for the furniture of Ruhlmann and other designers.

The design of small items was by no means limited to costly materials. In 1907 Belgian chemist Leo Baekeland developed the first completely synthetic resin, phenol formaldehyde, popularly known as bakelite, for use as electrical insulation. The versatility of bakelite soon led to its wide application in industrial design and the decorative arts. Its hardness and resemblance to wood saw bakelite molded into a variety of shapes for radio cabinets, pot handles, knobs and automobile dashboards, and incorporated into fine furniture in the Art Deco styles. Bakelite was also used in colorful Art Deco powder compacts, cigarette boxes and desk accessories. It was molded into jewelry, hair ornaments, and hat and shoe clips. Some of these plastic ornaments were intended as imitations of natural materials such as coral, agate, ivory, tortoiseshell, mother of pearl, or jade; while other jewelry and ornaments were designed in chunky, Cubist-derived forms with molded stylized decoration that appeared to be carved. Many of these latter ornaments did not try to resemble more costly materials, but colorfully and proudly proclaimed themselves to be pure plastic.

Bridging the gap between ceramics and metalware were the lacquered, inlaid and enameled metal vases by Jean Dunand, Camille Fauré and others. Dunand was a master of the craft of *dinanderie*. This involved the hammering of soft metals such as copper, pewter or lead into shaped vessels which were then embellished by a variety of methods: they could be inlaid with silver or other metals; embossed; gilded; lacquered; enameled; or given a green, brown or black patina by the use of acid. The resulting ornamented vases were objects of distinctive richness of effect. Claudius Linossier, a sculptor and silversmith who apprenticed with Dunand, went on to produce a wide range of *dinanderie*, the best of which displayed geometric and abstract ornament. Camille Fauré was known for his copper vases decorated with Art Deco designs in reliefs of Limoges enamel.

French designers also demonstrated high levels of skill in the area of silver work. Jean Puiforcat, who had studied sculpture also, was the premier silversmith of the Art Deco era, specializing in deceptively simple cubistic pieces for the luxury trade. A noted collector of antique silver, Puiforcat produced vessels characterized by smooth planes, sharp angles and the frequent incorporation of such precious materials as lapis lazuli and crystal. After he began work as an independent silversmith in 1922, Puiforcat's stylish wares were selected by Ruhlmann for his *Collectionneur* pavilion at the 1925 Paris exposition. Puiforcat later joined the functionalists led by René Herbst in the *Union des Artistes Modernes*. Important Art Deco silver also came from Donald Desny, memorable for his vessels based on cones and other essential geometric forms. The leading French silver manufacturer, Christofle, provided appropriately modernistic tablewares for the *Normandie*, and commissioned work by Paul Follot, Gio Ponti and other leading designers. Christofle was instrumental in publicizing French Art Deco silver by exhibiting it abroad in international exhibitions during the 1920s.

Although French silversmiths were acknowledged innovators of modernist style, many customers felt more comfortable with a more conservative interpretation of Art Deco. This left the way open for the master Danish silversmith Georg Jensen, who became the most important figure on the international scene during the 1920s and 1930s. A trained goldsmith who had initially failed at the porcelain business, Jensen made such a success of his jewelry and silver that he was able to open a branch in Berlin in 1908, in Paris in 1919, in London and New York in 1920, and in Stockholm in 1930. Though much of his line

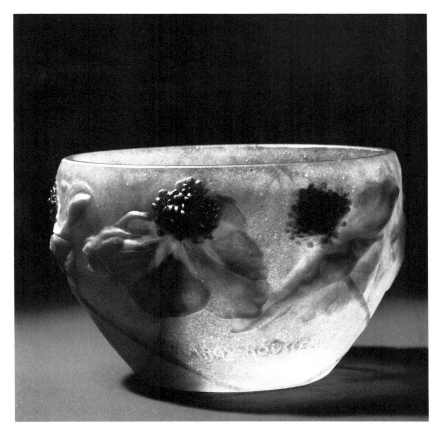

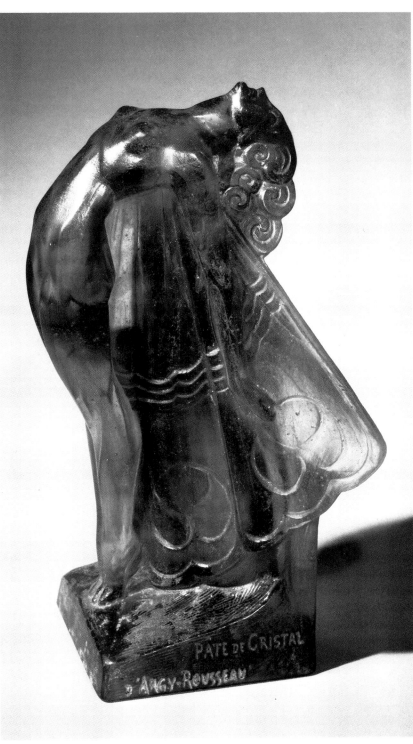

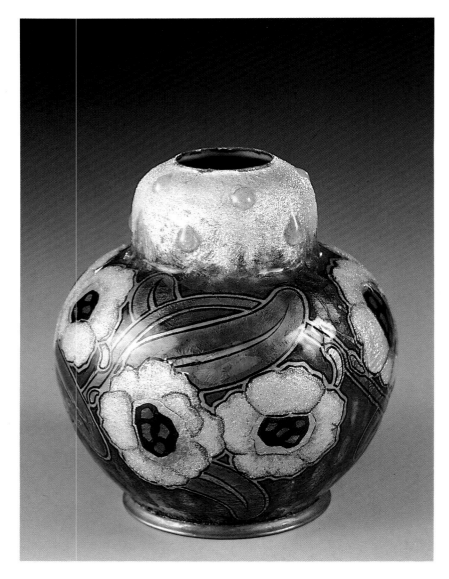

signers were the painters Simon Gate and Edward Hald. Gate concentrated more on neoclassical and mythological imagery while Hald, who had studied with Matisse, was known for his vignettes of contemporary life. The Orrefors offerings had a marked influence on other contemporary glass such as the work of Italy's Guido Basalmo Stella and the Steuben designs of Sidney Waugh in the United States.

The leading British entry in the field of Art Deco glass was the New Zealand architect Keith Murray, among whose designs was a memorable Cactus Decanter for Stevens and Williams (1932). The versatile Murray, who also designed metalware, was commissioned by Wedgwood to design a line of modernistic engine-turned vases, bowls, coffee sets and mugs ornamented by the parallel horizontal bands of the streamline style.

More figurative Art Deco imagery in the vein of the floral and animal French style of the early 1920s was seen hand painted on the pastel-hued pottery and in the stylized animal figurines made by Harold Stabler, Phoebe Stabler, Truda Adams, John Adams and Truda Carter of Carter, Stabler, Adams Ltd, Poole Pottery, Dorset. Stylized animal figures were also made by John Skeaping, among others. An innovative designer of tableware during the Art Deco years was Susie Cooper who produced stylish, elegant designs for Selfridges, Peter Jones, Waring & Gillow and other stores. The best known figure of British Art Deco ceramics, however, was Clarice Cliff. Her remarkable range of colorful and bold designs used both conventional imagery and, in her Bizarre line, lively geometric patterns that conveyed the essence of Art Deco.

In the United States, the glassware, ceramics and metalware of the 1920s and 1930s offered a broad range of aesthetic and technological approaches to the Art Deco style. This was especially apparent in the types of glass produced and the customers for whom they were intended. A leading producer of American Art Deco glass was the Steuben company, founded in 1903 by Englishman Frederick Carder, who came to be known as the father of American art glass. During the Art Nouveau era, Carder himself was the designer of many of the finest items, and he was quick, to follow contemporary trends. His gold aurene vase with an Art Deco design of patterned foliage perfectly caught the style of the 1920s, although it continued to be made into the 1930s. The vase was of encased glass, with a darker layer bearing the acid-etched decoration covering a thinner inner layer.

was relatively traditional, Jensen did issue some Art Deco designs, including cocktail shakers, cigarette boxes and his pyramid cutlery.

Sweden's Orrefors glass company was a highly regarded producer of Art Deco wares during the 1920s and 1930s, winning a grand prize for its entries in the 1925 Paris exposition. The company's chief de-

ABOVE: *Copper vase with enamelled design (c 1925) by Camille Fauré.*

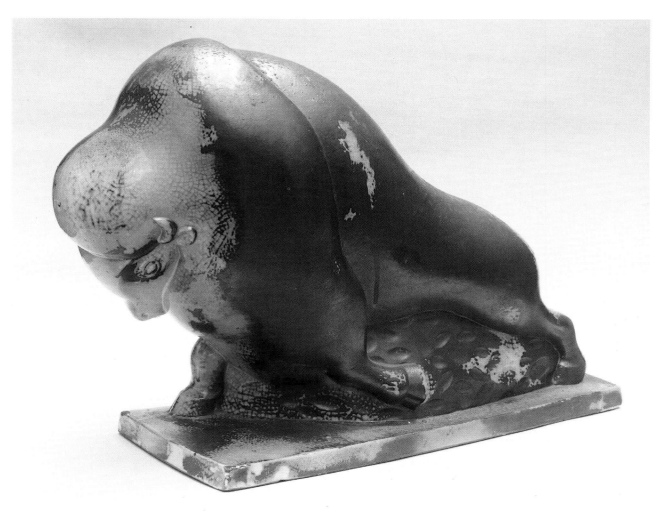

RIGHT: *Porcelain bison made for Primavera, the Paris design atelier.*

RIGHT: *Tureen and cover of silver and lapis by Jean Puiforcat.*

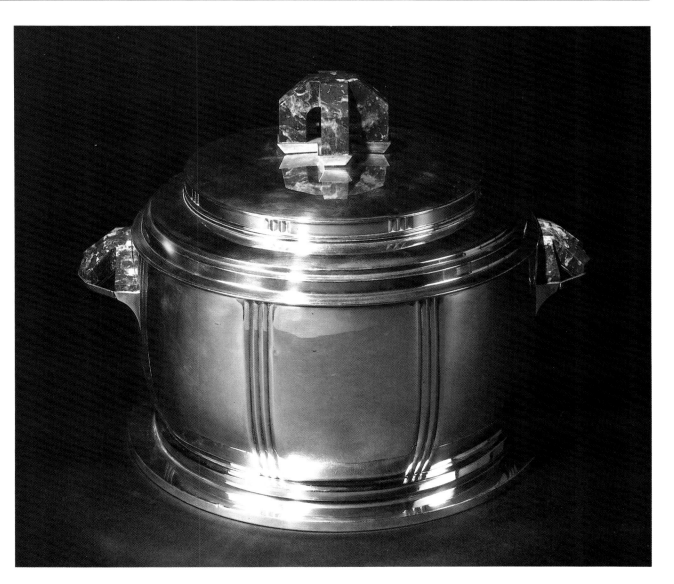

Another elegant vase, of acid-cut translucent red glass decorated with a hunting pattern, underlined Carder's debt to French Art Deco designers. The leaping gazelle, the dramatically stylized foliage and landscape, and the rhythmic curves and zigzags were motifs more frequently seen on European works.

The great Depression brought hard times to Steuben Glass, just as it did to many other companies. In an attempt to revive the faltering concern, Carder was replaced in 1933 as head of Steuben by Arthur A Houghton, Jr, whose family owned Corning Glass. Houghton immediately implemented radical policy changes. The colored glass

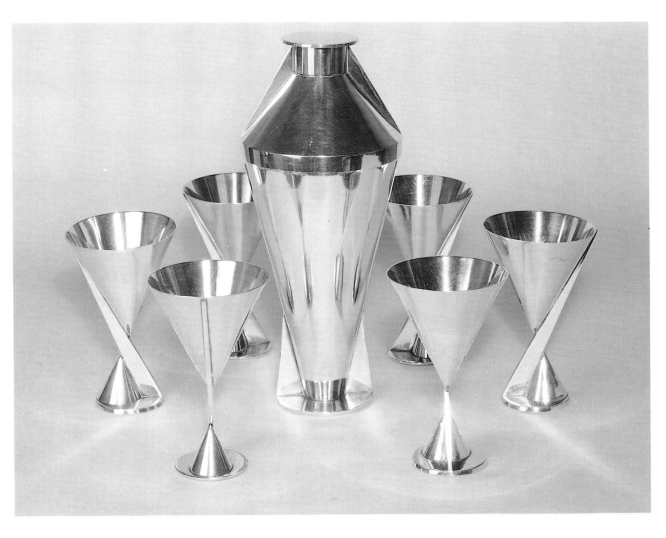

RIGHT: *A silver-plated cocktail set by Donald Desny.*

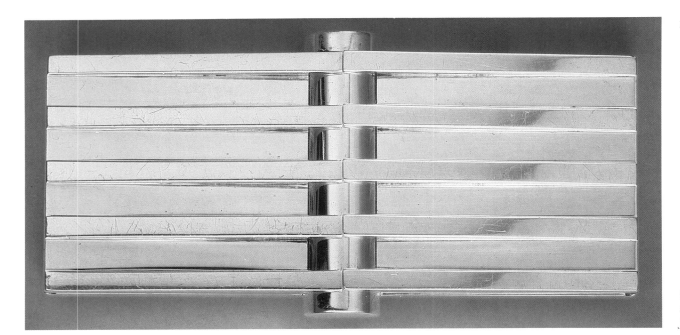

LEFT: *Vanity case by J Fouquet.*

BELOW: *Georg Jensen* Acorn *pattern table service designed in 1915 by Johan Rohde.*

line was completely eliminated; henceforth Steuben was to produce only items of colorless pure crystal, with an emphasis on harmony between the swelling fluid forms of the massive vessels and their engraved designs. This glass, based on a new formulation, had originally been developed for technological application but had proven too soft for such use. This industrial mishap was exploited by Houghton who, in short order, was able to raise Steuben's glass objects to a fine art status by hiring designers of the level of Sidney Waugh, a sculptor and 1929 Prix de Rome winner.

Now in the collections of major museums in the United States and abroad, Waugh's first design for Steuben was the 1935 *Gazelle Bowl*. The frieze of 12 stylized leaping gazelles was a restatement of a motif

popular in the 1920s; it had featured not only in French design, but also in the sculpture of Paul Manship, in ceramics and sculpture by W Hunt Diederich, and even in advertising illustrations for newspapers and magazines. Yet the understated, unornamented parallel paired lines above and below the gazelles reflected the 1930s streamline-style motif of speed stripes; and the massive quality of the bowl and its base echoed the Cubist interest in geometry and mass, as well as current developments in architecture such as the monumentalism of the classical moderne New Deal buildings.

Waugh's 1935 *Zodiac Bowl* depicted yet another popular theme of the era. Astrological imagery was frequently used in the ornate lobby decor of zigzag-style buildings. The sun motif too was often seen in

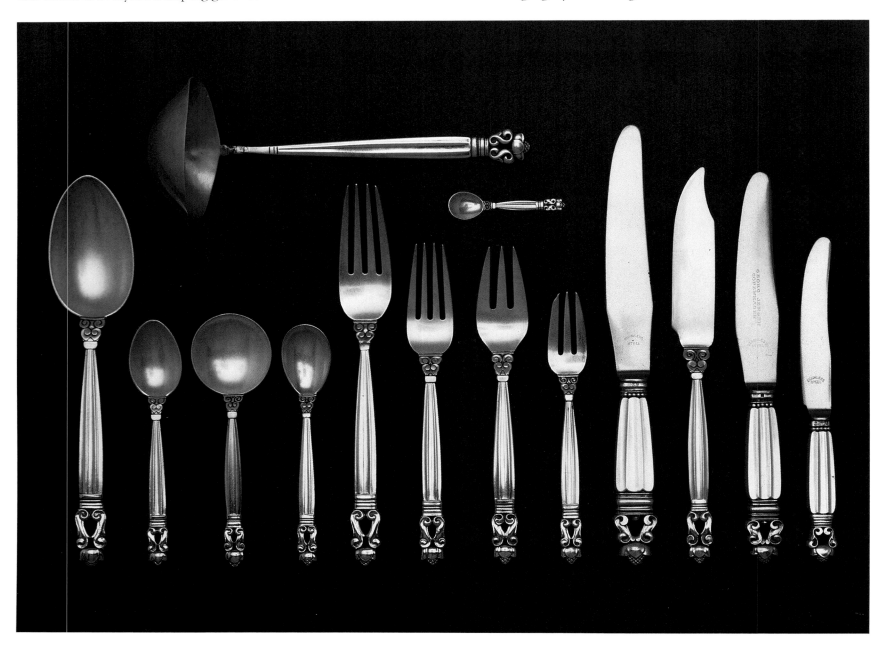

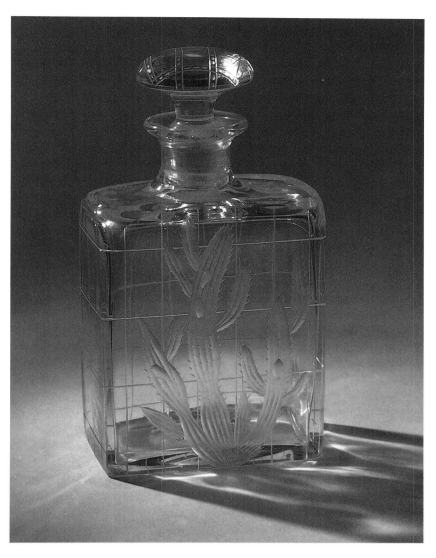

ABOVE: *Cactus pattern decanter (1932) designed by Keith Murray for Stevens and Williams, Brierly Hill.*

Art Deco works of those years. The idealized heroic figures decorating the bowl echoed the classicistic figures of the relief sculptures and murals decorating many New Deal buildings.

In 1932, to expand their range of Art Deco products, Steuben commissioned industrial designer Walter Dorwin Teague to design a series of crystal stemware. The names of the designs – Riviera, Spiral, Blue Empire, Winston and St Tropez – are evocative of the era and its entertainments.

As Steuben's international reputation increased, equalling those of such European glass producers as Baccarat and Lalique of France and Orrefors of Sweden, the firm was able, in 1937, to commission a group of 27 prominent American and European painters and sculptors to create designs to be engraved on glass. In the same years, Steuben received the gold medal at the Paris exposition. Steuben pieces were subsequently exhibited at the 1939 San Francisco and New York expositions, as well as in major American museums.

This development of an elite image for Steuben glass was undoubtedly reinforced by Houghton's innovative marketing strategy, which made Steuben objects less accessible to the general public. During the earlier Carder era, Steuben glass had been sold indiscriminately in a wide range of stores, but in 1933 Houghton decided to sell Steuben glass items only in specialized Steuben shops, on New York's Fifth Avenue and later in other major cities.

Nevertheless, the general American populace was also in a position to obtain Art Deco glass. During the 1920s and 1930s a kind of inexpensive glassware now known as Depression glass was widely manufactured. Produced in a variety of colors and decorative patterns, the molded and totally machine-made glass was produced mainly in the form of utilitarian household and restaurant dishes, bowls, cups, glasses, pitchers, candy dishes, and various other serving pieces. The majority of the Depression glass designs were based on traditional patterns such as Sandwich glass, in which the design

RIGHT: *Earthenware coffee set designed by Keith Murray.*

was etched into the mold, paralleling the effect of the much more expensive acid etching. Other molds gave the effect of cut glass. A limited number of Art Deco patterns were also made, utilizing Cubist and streamlined motifs.

Depression glass was usually made of the cheapest commercial glass. The colors included pastel green, yellow and pink (though eventually all hues, including crystal or clear glass, were made) and served to disguise flaws in the glass. But despite its impurities and poor finish, Depression glass sold widely. The smaller items cost three or four cents each, making them much cheaper than ceramic dishware; in those hard economic times, cost rather than quality was a primary consideration for the majority of Americans.

LEFT: *Clarice Cliff,* Fantasque *bowl (1932).*

RIGHT: *The ceramics designed by the Constructivists of the Russian revolutionary era had much in common with Art Deco design.*

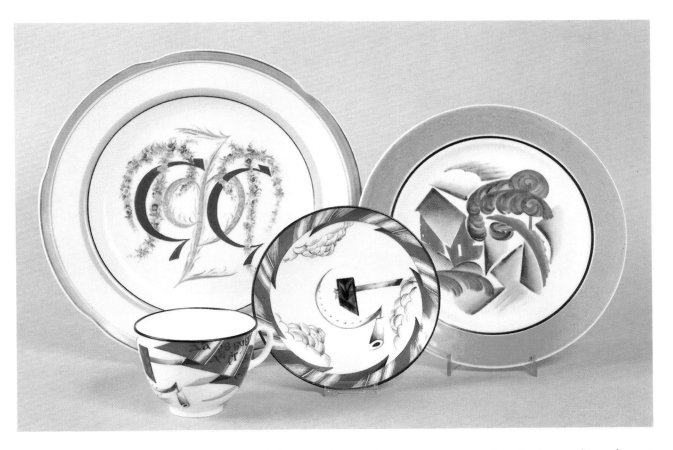

Depression glass also became an essential part of the marketing strategy of using premiums to promote other products and services. A number of movie theaters had 'dish nights,' on which customers could receive free glassware items; while some furniture stores would give away complete sets of Depression glass with the purchase of a dining room or living room suite, or of a major appliance.

While most Depression wares appeared in the form of translucent colored glass, some of the items were also produced in more costly opaque form – desirable no doubt to those who valued its resemblance to regular ceramic dishware, or perhaps its reported heat-resistant qualities. Among the opaque varieties appearing in Art Deco designs was the Ovide line, produced from 1930 to 1935 by Hazel

RIGHT: *Although Wassily Kandinsky's saucer could not be termed Art Deco, it shares with Art Deco the hard-edged geometric forms and the vivid colors, particularly the tango orange.*

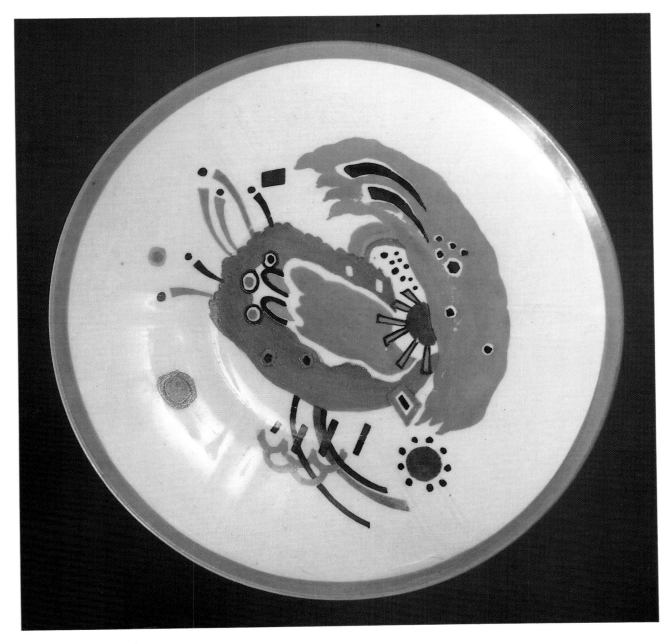

The Cubist influence was apparent in the Indiana Glass Company's Number 610 – renamed Pyramid by recent collectors – which was manufactured from 1926 to 1932. Here the exaggerated conical shapes of the pitchers and glasses, the abrupt angles of the handles, and the jagged silhouette of the molded design aptly translated the zigzag patterns of the skyscraper style. In practice, glass was more adaptable than ceramics to such angular shapes and patterns; similar Cubist effects could be produced in ceramics only through the use of applied decoration.

Also Cubist in design was the Jeannette Glass Company's Sierra pattern. It was only produced for a short while, between 1931 and 1933, however, as its stylish pinwheel design proved highly impractical; the serrated projecting edges chipped very easily. A more durable version of Cubist-derived Art Deco ware was made by Indiana Glass Company in a heavier glass from 1926 to 1931. Known as Tea Room, this glassware was intended primarily for the commercial tea rooms and ice cream parlors of the day. It could also be purchased for home use, since the increasing availability of domestic refrigerators meant that more people could enjoy ice cream at home. In the Tea Room pattern, the dynamic geometric shapes of the ridged and graduated block optic design appeared on banana split bowls, sherbert dishes, footed sundae dishes and ice buckets, as well as candlesticks and even lamps. Thus the commercial establishment using Tea Room glassware could also purchase matching lighting fixtures to achieve the unity of design so important to the Art Deco era.

The streamline style also inspired the design of various Depression glass lines. Streamlined curved forms and speed stripes appeared in various patterns manufactured by Hocking Glass during the 1930s. Among them were Ring, Circle, and most notably Manhattan. Also known as Horizontal Ribbed, Manhattan was made from 1938 to 1941. Although this simple but dramatic and futuristic-looking design was probably most effective in crystal, or clear glass, it was also available in pastel pink and green. From 1934 to 1942, Hazel Atlas Glass Company produced a similar pattern. In Moderntone, the concentric ring pattern was flatter than that of Manhattan, and the

Atlas Glass Company. The Platonite, as the manufacturer called it, had a fired-on colored design strongly reminiscent of the china designed by Frank Lloyd Wright for Tokyo's Imperial Hotel, although in the Depression ware the circular pattern was supplemented by a skyscraper motif. The shapes of the various Ovide plates and vessels remained relatively traditional. Opaque glasswares in more modernistic shapes, some of which had a marbled coloristic effect, were produced from 1913 to 1951 by Akro Agate Company.

ABOVE LEFT: *Frederick Carder, vase (c 1933).*

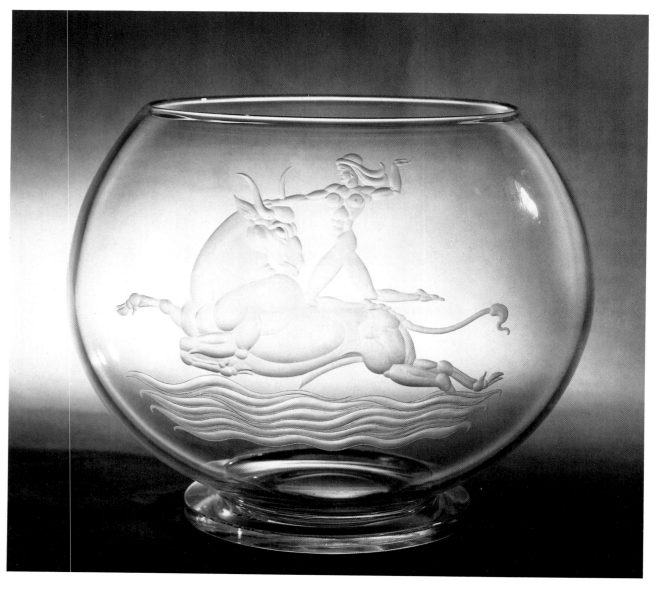

LEFT: Europa *bowl (1935) designed by Sidney Waugh for Steuben Glass.*

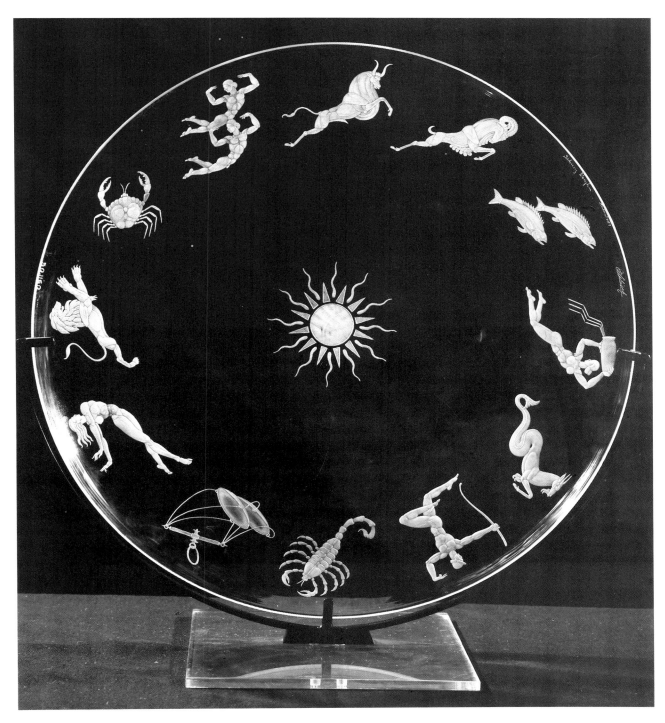

handles of its cups and pitchers were more angular, like those of the Cubist-derived designs. A unique feature of Moderntone was the pairing of many of its serving dishes with hemispherical chrome-plated lids. This combination was particularly effective when the glass hue was cobalt blue, or Ritz Blue, as it was then named; the Moderntone punch bowl set was a striking example. With the repeal of the Prohibition Amendment in 1933, glass companies vied to produce such items, as well as cocktail shakers, decanters, ice buckets and a wide variety of glasses. Before the repeal, such items had been advertised with the stated function of serving 'grape juice.'

Ceramics and pottery had become an important American arena of design during the Arts and Crafts era of the late nineteenth century. Some attractive and lively Art Deco designs were developed by leading Midwestern firms such as the Rookwood, Overbeck, Weller and Rosewood potteries, who kept abreast of developments in Europe. American artisans and the American public were already familiar with the Art Deco style originating from France in the years preceding the 1925 Paris exposition. But the important 1928 international ceramic art exhibit at the Metropolitan Museum of Art introduced to many Americans the sophisticated clay work of the Austrian artists of the *Wiener Werkstätte*. The witty Viennese figural ceramics were regarded by many as the finest examples of modern design to come out of Europe, though there were some American critics who disapproved of their 'frivolity,' a quality that was nevertheless so characteristic of the 'roaring twenties.' Following the 1928 Metropolitan exhibition, a number of American ceramists traveled to Vienna to study their craft.

The most famous of these Americans was Viktor Schreckengost from Sebring, Ohio. After an education at the Cleveland Institute of Arts, he studied ceramics and sculpture at the *Kunstgewerbeschule* under Michael Powolny from 1929 to 1930. While in Vienna, Schreckengost developed an interest in the Viennese speciality of large-scale clay figural sculpture.

Schreckengost was persuaded to return to the United States by the pottery manufacturer R Guy Cowan, who recruited him for a job at his Cowan Pottery Studio in the Cleveland suburb of Rocky River. This new position also permitted Schreckengost to teach part time at the Cleveland School of Art. Despite Cowan Pottery's need to mass produce such items as vases, candlesticks and centerpieces, Schreckengost was also allowed freedom to experiment, and an impressive result was his 1931 set of 20 punch bowls decorated with images representing New Year's Eve in New York City. Produced in two sizes and available in a variety of colors, a number of these punch bowls were purchased by Eleanor Roosevelt for entertaining in the New York governor's mansion. Decorated in sgraffito (scratched-in) technique, each bowl had a different design based on a dynamic interpretation of contemporary social life. The stylized, Cubist-inspired images of skyscrapers, cocktail glasses, bottles and other motifs from the 1920s were interspersed with such evocative words as 'follies,' 'dance,' and 'jazz,' in syncopated lettering. Schreckengost reported that his primary influence for this frothy mixture of words and images was the Vienna poster work of designer Joseph Binder. A mass-produced version of the punch bowls, with carved decoration, was later made available.

LEFT: Gazelle Bowel *(1935) by Sidney Waugh, Steuben Glass.*

BELOW LEFT: Ruba Rombic *candlestick (c 1928-33), Consolidated Lamp & Glass, Pennslyvania.*

BELOW RIGHT: *Viktor Schreckengost's punch bowl (1931).*

RIGHT: *This star-shaped hanging lamp (c 1930), attributed to C J Weinstein, is a stylish example of American Art Deco glass.*

A similar combination of Viennese liveliness and American imagery was also seen in Schreckengost's set of six plates with sporting themes in molded relief. The exuberant, stylized figures playing football, polo, golf and tennis, and hunting and swimming, were close in spirit to those drawn by John Held, Jr. During the 1930s Schreckengost continued to work in this whimsical vein as a conscious reaction, according to him, against the general gloom of the Depression years.

American interest in Viennese ceramics received a further boost when Vally Wieselthier, the head of the ceramics workshop of the *Wiener Werkstätte* and one of the most important European ceramists of the 1920s, moved to the United States in 1929. She joined the New York City decorative arts group, Contempora, for which she designed glass, textiles, papier-mâché department store mannequins, and the metal elevator doors for Ely Jacques Kahn's Squibb Building. She also designed ceramics for Sebring Pottery in Ohio and continued to produce from her New York studio her large-scale ceramic sculptures of flappers and other stylized figures. These works had an important influence on the development of ceramic sculpture in the United States during the 1930s. Like Schreckengost, Wieselthier saw her decorative sculpture, so expressive of the joy of life, as an antidote to the dreariness of the Depression.

Wieselthier's effective promotion of ceramic sculpture as a valid art form led such important artists as Alexander Archipenko, Elie Nadelman and Isamu Noguchi to try their hand at the medium. In those economic hard times, clay had the considerable attraction of being cheap in comparison to other materials such as stone or metal. Waylande Gregory was one such artist who abandoned the medium of bronze to become a major ceramist. Gregory had studied with the sculptor Lorado Taft at the Art Institute of Chicago and in Florence, Italy. After he joined the Cowan Pottery, he designed a number of sylph-like ceramic figures of women, among which was his *Margarita* (1929). These figures, with their simple stylized elegance of line and their graceful elongated proportions, were part of an important sub-genre of Art Deco. Some of the Cowan Pottery's later statuettes of this nature were apparently indebted to the ideas of sculptor Paul Manship, who rendered several such designs for the company in the last years of its operation.

As the Cowan Pottery began to falter in the early 1930s, Gregory went on to become artist in residence at Cranbrook Academy from 1932 to 1933. During that time, he developed Cranbrook's first organized ceramics program, but discord with the Cranbrook administration and other faculty members led to Gregory's precipitate departure. The ceramic sculptures he had created during his short stay at Cranbrook, however, gained national recognition for Gregory, as he continued to exhibit them in various exhibitions throughout the 1930s. Gregory later established his own studio in Bound Brook, New Jersey. His most monumental ceramic sculpture was *The Fountain of Atoms* (1938), in which each of the twelve ceramic figures – *Fire, Earth, Air, Water* and the eight *Electrons* – weighed over a ton. The impressive size of these pieces was made possible by Gregory's unusual hand building method, a remarkable technical innovation in which he built up the sculptures in an interior honeycomb pattern. The cosmic imagery and the monumentalism of the sculpture fit into the Art Deco canon, recalling the astrological

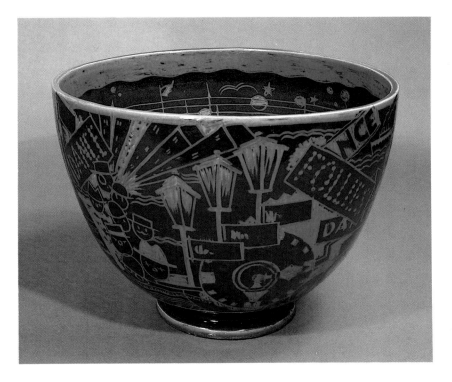

imagery often seen in skyscraper lobbies, and reflecting the conscious monumentalism of New Deal sculpture and architecture. *The Fountain of Atoms* was exhibited, as were many other Art Deco sculptures and murals, at the 1939 New York's Fair.

The departure of Gregory left Cranbrook Academy with no official ceramics program until 1938, when the Finnish-born artist-potter Maija Grotell took over the direction of the department. Grotell had studied painting, sculpture and design at Helsinki's School of Industrial Art, and spent the following six years working under the important European potter Alfred William Finch. She emigrated to the United States in 1927. After teaching at New York's Henry Street Settlement House, she became a pottery instructor at New Jersey's Rutgers University School of Ceramic Engineering.

Grotell's earlier artistic output in the United States included simple cylindrical vases with painted-on Art Deco designs in a decorative Cubist style. Her earthenware vase *The City* (1935) was an example of such work. Here the motifs were the same as those explored by Precisionist painters and photographers of the era: skyscraper skylines, steamships and other transportation vehicles, and the geometric aesthetic of machine and industrial forms. On other ceramic vessels, Grotell created more abstracted versions of the skyline and industrial motifs. She used a vivid range of colors, reflecting the interests of the synchromist painters and the decorative Parisian designs of Sonia Delaunay. Besides the urban scenes, Grotell also painted other lively images, including animal motifs, often in a simplified linear style.

Grotell's tenure at Cranbrook, where she was, according to all accounts, a stimulating and inspiring teacher, allowed her to develop her ideas more fully. The unusually large size of the Cranbrook kiln permitted her to produce more monumental and volumetric pots. A 1939 vase of simple horizontal bands on the spherical body of the vessel, accompanied by a checkerboard pattern on its cylindrical neck, combined Cubist geometric volumes with the streamline-style motif of horizontal speed stripes.

American Indian art was a rich source of ideas for designers. Particularly influential were its abstracted geometric patterns, as seen in Navaho blankets, the jewelry and basketry of various tribes and the pottery of the Southwest. These items were, of course, available to knowledgeable collectors, and became accessible to a wider audience with the publication of Franz Boas's profusely illustrated *Primitive Art*. Interest in American Indians and their art was further stimulated by the vast photographic documentation – a total of over 2200 images – of more than 80 western tribes from Alaska to Mexico completed by Edward S Curtis and published in 20 volumes between 1903 and 1930. In addition to the regal Indian portraits, Curtis also recorded their characteristic dress, ornamental beadwork, teepees painted with symbolic geometric designs, elegant basketry, and other visually striking crafts in *The North American Indian*.

During the 1920s and 1930s, there was widespread appreciation for the work of the Indian potters of the American Southwest, among whom the foremost were Maria Martinez of San Idelfonso Pueblo, New Mexico; Tonita and Juan Roybal, also of San Idelfonso; Nampayo of the Hopi mesa in Hano, Arizona; and Lucy Lewis of Acoma, New Mexico. The indigenous geometric Hopi, Pueblo, and Zuni designs which incorporated stylized bird, deer, flower, cloud, and lightning motifs frequently resembled and may have served as an inspiration for some Art Deco motifs. In any case, during the Art Deco era there arose a great demand for contemporary Indian ceramics based on the traditional patterns and techniques used by the potters of the Southwest. Their pots, which had been created anonymously for centuries, now came to be signed by the more famous potters.

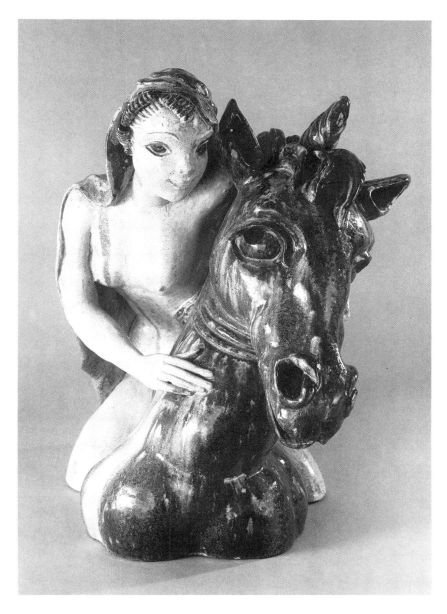

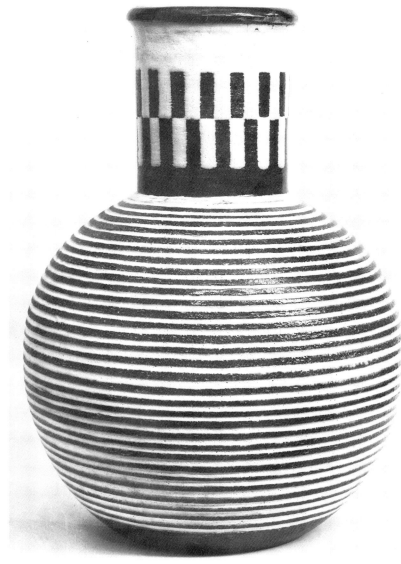

Probably the most highly respected of the potters was Maria Martinez, who learned the craft of polychrome pot making from her aunt. When asked in 1908 to replicate a unique kind of black pottery from ancient sherds found in a nearby archaeological excavation site, Martinez rediscovered the traditional technique of making black-on-black ware by smothering the flames during firing with dried manure. But the Martinez pots – of a polished silvery black, with or without the matte black geometric patterns – were judged superior to those made by her ancestors. These wares, along with her polychrome pots, brought her worldwide fame. Her pottery – which was usually made in collaboration with her husband Julian, and after his death with her children and grandchildren – was shown at nearly every important exposition up to World War II, including the 1933 Chicago Century of Progress fair and the 1939 New York World of Tomorrow fair. Maria Martinez also personally demonstrated pottery-making at a number of these expositions. Her remarkable achievement brought her two honorary doctorates, White House invitations by four presidents, and the unusual tribute of being asked to lay the cornerstone for the construction of Rockefeller Center.

The earthenware plates and bowls made by Martinez in the 1920s and 1930s demonstrated the affinity of Pueblo Indian art and Art Deco patterns. The stylization of natural forms into geometrized shapes such as zigzags, triangles, and stepped-back patterns (resembling the skyscraper style) all paralleled the modernist abstraction practiced by Art Deco designers.

The American Southwest also provided inspiration for European-trained designers working in the Art Deco style. A lively 1929 plate, *Cowboy Mounting Horse*, by W Hunt Diederich recalled, in style if not subject matter, his other ceramic works which portrayed elegant, silhouetted greyhounds or ibex. Yet, in spirit, this subject matter deriving from the American West was humorously treated in a way similar to the somewhat frivolous, Viennese-influenced works of American Art Deco. Diederich had become interested in ceramics as an artistic medium while on a Moroccan trip in 1923. The North

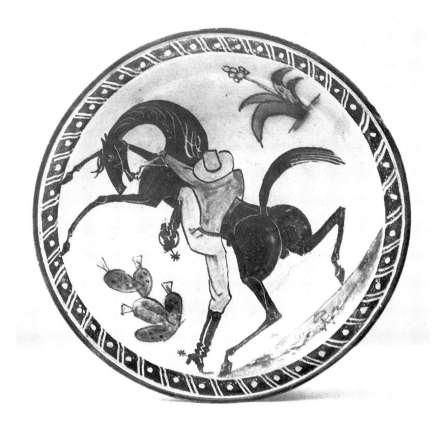

ABOVE: *Vally Wieselthier,* Taming the Unicorn, *ceramic sculpture.*

ABOVE RIGHT: *Glazed earthenware vase (1940) by Maija Grotell.*

RIGHT: *W Hunt Diederich,* Cowboy Mounting Horse *(1929).*

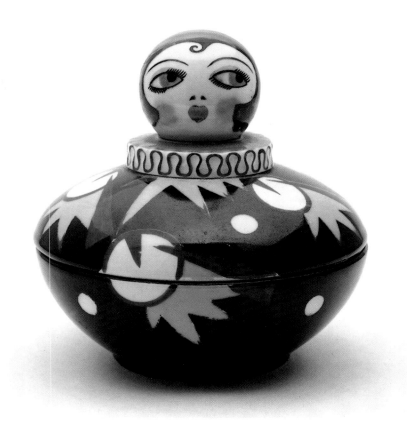

African wares so impressed him that he immediately began painting his own designs on individual ceramic pieces. Later, in the mid-1920s, he began to design for mass production as well. Diederich's *Cowboy* was perhaps a souvenir of a fondly remembered adolescent stint as a working cowboy in Arizona, New Mexico and Wyoming. Such regional adaptations of the Art Deco style were not unusual; just as the stylized cactus was a feature of Pueblo deco, so palm trees, flamingos and pelicans became part of the stylized architectural decoration of the tropical deco of Old Miami Beach and Los Angeles, and of the Louisiana state capitol building in Baton Rouge.

The international scope of Art Deco was emphasized by the production process of Noritake Art Deco porcelains, which were designed in New York City by a British art director for American buyers, were made in Japan, and then exported to the United States for sale. These Noritake porcelains were relatively low priced, of high quality, and decorated with sophisticated and vivid imagery, thus making the latest Art Deco designs available to the broad American public. They sold widely in department stores and gift shops across the nation from 1921 to 1941. Under the inspired leadership of Englishman Cyril

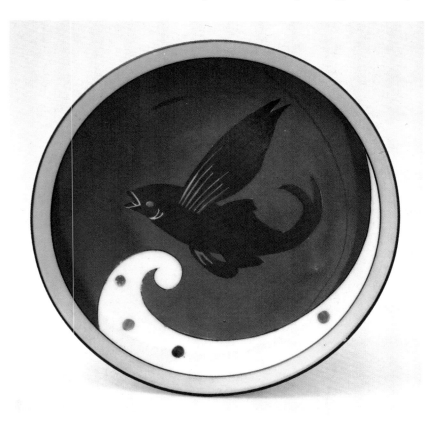

Leigh, the team of New York designers drew on the entire range of Art Deco motifs: conventionalized floral and animal decoration, geometric Cubist-influenced designs, stylized flappers and other elegant females similar to those seen in fashion illustrations, exotic vistas, decoration based on pre-Columbian artifacts, and vignettes of party life in the effervescent 1920s. The wares – plates, vases, bowls, novelties and other forms – were produced by the mold process, and the shapes of the vessels were based on simple classical and neoclassical prototypes that provided an effective setting for the vivid contrasting colors, glossy surfaces and bold, hard-edged images that were later applied by hand.

The Japanese Noritake works, a subsidiary of Morimura Brothers, used the latest in the mass production techniques to produce the so-called 'fancy ware' for export to western nations. An assembly line of porcelain decorators painted the wares by hand, each completing a specific area of the total design. Although the designs were generally done almost wholly by hand in the 1920s, during the following decade the use of ceramic decals became more widespread, undoubtedly for economic reasons. With ceramic decals, the image fused to the surface of the vessel when it was fired in the kiln. Originally the decals had been employed to imprint the black outlines of the designs, which were subsequently painted by hand, but in the final years of Noritake's Art Deco porcelain production, most of the decoration came to be applied by ceramic decal, with only a small amount of additional hand painting.

Another characteristic of these porcelains was the frequent use of iridescent metallic surface treatment applied over the glaze to create either gold or silver opaque lusters, or transparent lusters of mother of pearl and various other colors. There was undoubtedly a connection between the use of metallic lusters and the deep interest of Art Deco designers in the machine aesthetic. This is not to suggest, of course, that the use of iridescent finishes was unique to the Art Deco period; similar sheens had been used in the preceding Art Nouveau era, notably by Louis Tiffany in his acclaimed Favrile glass.

As the 1920s gave way to the 1930s, changes in the nature and content of the the applied designs also occurred. While the imagery of the 1920s was dynamic, diverse, exuberant and executed in vivid, arbitrary colors, the designs of the Depression-era 1930s tended to be more restrained and more symmetrical, with a greater use of all-over patterns. The conservatism of the Noritake porcelains of the 1930s paralleled developments in Art Deco design elsewhere. As a result, the large body of Noritake Art Deco porcelains produced during the 1920s and 1930s provide a remarkable visual record of not only the fashion trends, lifestyles and art movements of the era, but also of its social changes.

Probably the most typical and most widely available Art Deco dinnerwares available from the mid 1930s were the mass-produced Fiesta and Harlequin lines, both made by West Virginia's Homer Laughlin Company. Fiesta ware began production in 1936, and some items continued to be made well into the 1960s. Harlequin ware, intended as a less expensive version of Fiesta and sold exclusively in Woolworth stores, was first issued in 1938 and was also produced into the 1960s. In celebration of Woolworth's 100th anniversary in the 1970s, Harlequin ware was reissued for a limited period.

The names Fiesta and Harlequin referred to the wide range of bright colors in which these dishes appeared. As with Russel Wright's American Modern, customers were encouraged to mix colors within the place settings. The vivid hues of the dishes probably helped to serve as a visual antidote to the general gloom of the Depression era. Both dishware lines were characterized by the angular geometric shapes of their cups, bowls, and other vertical containers. All of these items, including the plates, bore a decorative motif of incised concentric circles, or parallel encircling lines. These were similar to the designs of some contemporary, and slightly earlier, Art Deco glassware. The dramatic conical shapes of the cups and shakers reflected Cubist prototypes of the 1920s, while the bands of parallel lines and concentric circles were allied to streamlined motifs of the 1930s.

During the 1930s and subsequent years, a number of other inexpensive, heavier bodied, less well documented ceramic vessels were also produced, the most attractive of which were the bowls and

ABOVE LEFT: Arabella *powder puff jar, Noritake Art Deco porcelain.*

RIGHT: Susy Skier *oval tray, Noritake Art Deco porcelain.*

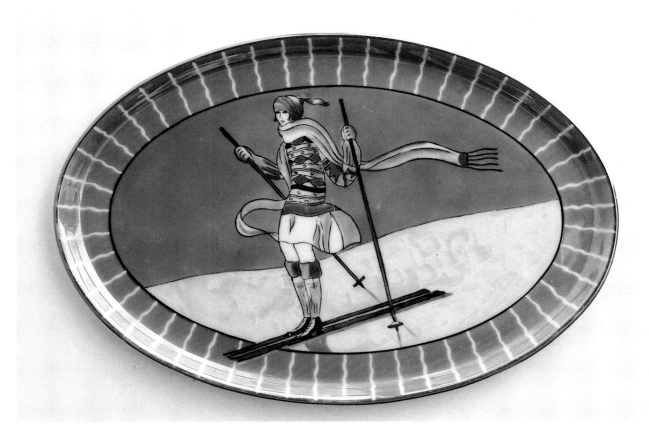

pitchers. Their vivid colors, volumetric shapes and ornamention of incised lines in geometric or circular patterns, or in parallel stripes, betrayed their indebtedness to Art Deco. During the World War II years, a number of these items were given away, as were Harlequin and Fiesta ware, as premiums with refrigerators or other major purchases. The more elite examples of Art Deco style created by the art potters and by the more cosmopolitan urban-based designers were gradually filtering down to stores across the country in a more conservative but still unmistakably Art Deco form.

The style-conscious American buying public had already been exposed to the finest examples of European metalwork design in serving dishes and flatware well before the 1925 Paris exposition. The work of Georg Jensen, the internationally respected Danish silver-

smith, had been displayed at the 1915 Panama-Pacific Exposition in San Diego where newspaper magnate William Randolph Hearst had purchased most of the Jensen silver on view. When Jensen opened a New York City store his simple, solid forms became a pervasive influence on American silversmiths. At the same time, French designs by Jean Puiforcat and others had been available in Manhattan's leading department stores from the early 1920s.

American manufacturing companies soon began to make their own mass-produced Art Deco designs available at moderate cost. International Silver Company of Meriden, Connecticut, introduced its 'Northern Lights' pattern with a linear stylized wave design around the base of the bowl, reportedly adapted from a motif by illustrator Rockwell Kent. In 1934 International Silver first offered signed pieces

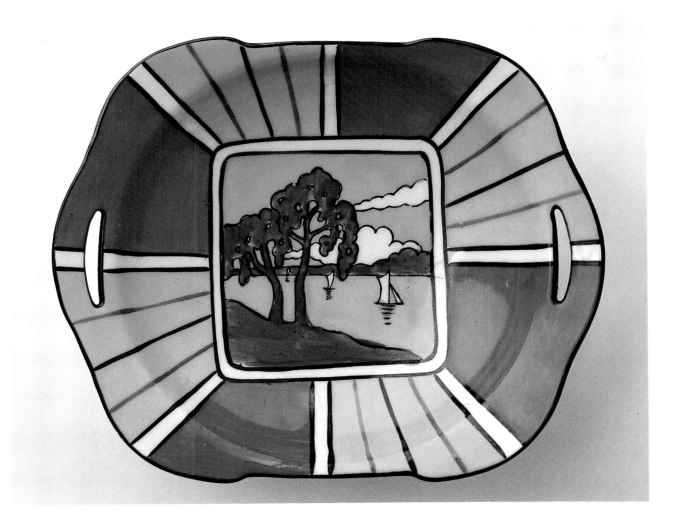

LEFT: White Cap *plate, Noritake Art Deco porcelain.*

RIGHT: Dutch Sunrise Landscape *bowl, Noritake Art Deco porcelain.*

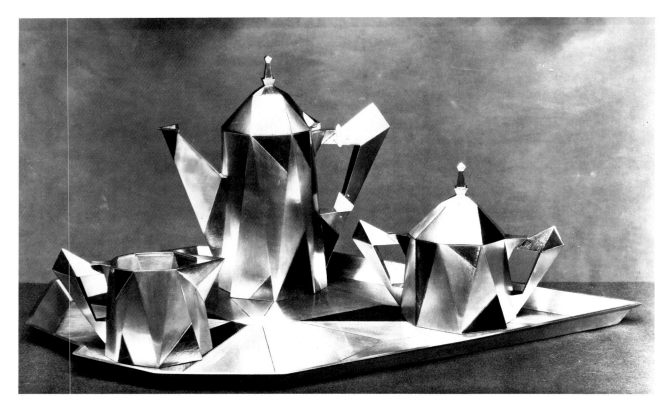

LEFT: *Erik Magnussen*, The Lights and Shadows of Manhattan *coffee service (1927), Gorham Manufacturing Company.*

BELOW LEFT: *Eliel Saarinen, urn and tray (1934), International Silver Company.*

by designer Lurelle Guild; his bowls, covered dishes and wine coolers were ornamented with streamlined stripes.

Other American-produced Art Deco metalware was designed by European trained craftsmen. Denmark's Erik Magnussen was left free to experiment with modernist ideas by the Gorham Manufacturing Company, for whom he worked from 1925 to 1929. His 1929 avant-garde coffee service, 'The Lights and Shadows of Manhattan,' with its faceted reflective surfaces was based on Cubist themes. More conservative interpretations of Cubist ideas in metalware were produced by a number of designers. Among them was Hungarian born and trained illustrator and designer Ilonka Karasz, whose 1929 tea set was typical of such work. The restrained shapes of her vessels were based on the Cubist-inspired geometry of the cone and cylinder; and the exaggerated rectangular handle silhouettes and the sharp angular spouts, along with the stepped-back lids, possessed a functional simplicity closely allied to Bauhaus designs, as well as to the French works of Puiforcat and Donald Desny. Cubist-inspired tea and coffee services by other designers working in America had pots in rectangular and even trapezoidal shapes, always with exaggerated angular or curved handles.

Following his credo that rejected historical styles, Eliel Saarinen also produced a number of designs for metal serving vessels and flat-

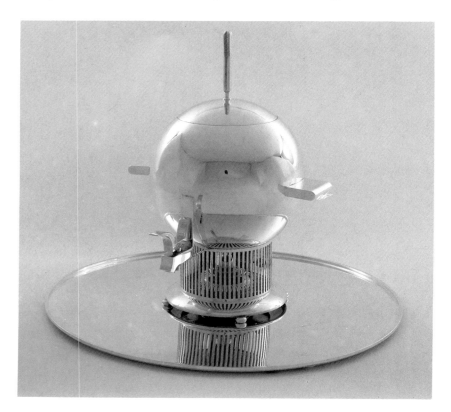

ware between 1928 and 1931. The International Silver Company fabricated some of Saarinen's prototypes for the 1929 and 1934 Metropolitan Museum of Art exhibitions, but the company actually sold only one item commercially, a flat silver centerpiece with a round foot. A number of Saarinen's designs for flatware incorporated Art Deco motifs. A 1931 design for a short-bladed knife had a geometric setback pattern for the handle, reflecting the then current skyscraper style, while a 1934 silver urn had, in its simple volumetric form, an affinity with the Cubist geometry of the sphere and cylinder. With its rejection of surface decoration, the urn celebrated, in its gleaming purity, the machine aesthetic that was so central to Art Deco. Incidentally, the versatile Saarinen had also designed ceramic dishes for the same 1929 Metropolitan Museum exhibition. Made by Lenox, his porcelain dinner service with its angular shapes and linear geometric pattern reflected an earlier design by Josef Hoffmann of the *Wiener Werkstätte*.

One of the more remarkable achievements in American silver work was that of Peter Müller-Munk. Born and trained in Germany, Müller-Munk was already an accomplished craftsman when he showed his work in an independent display at the 1925 Paris exhibition. The following year he arrived in New York and, after working briefly for Tiffany's, he opened his own studio to create works on private commission. Though his jazzy 1936 Normandie pitcher is memorable, most of his designs were elegantly restrained interpretations of modernism.

The machine aesthetic was thoroughly exploited by the Chase Brass and Copper Company of Waterbury, Connecticut, originally a producer of tubing, pipe and industrial wire. Chase's moderately priced chromium household accessories, initiated in 1930, included items such as smoking- and drinking-related speciality items as well as ornamental objects such as candlesticks, bud vases and more traditional coffee services. Most of these designs, of combined geometric forms, were fabricated from standard widths of industrial pipe and sheet metal. Many of these items also included some Art Deco style striping or similar detail. Designer Walter von Nessen's Diplomat coffee service for Chase was innovatively constructed from extruded chromium plated pipe, while its vertical fluted styling and ebony-like black plastic handles gave it an aura of Viennese elegance.

In 1937 the Revere Copper and Brass Company hired industrial designer Norman Bel Geddes to create a Skyscraper cocktail shaker and a Manhattan serving tray edged with architecturally inspired setbacks. This continuation of 1920s style Art Deco motifs well into the streamline era possibly suggests a nostalgic longing for that frivolous and prosperous decade from the austere perspective of the Depression-era 1930s. Industrial, furniture and interior designer Kem Weber also produced modernistic designs inspired by the machine

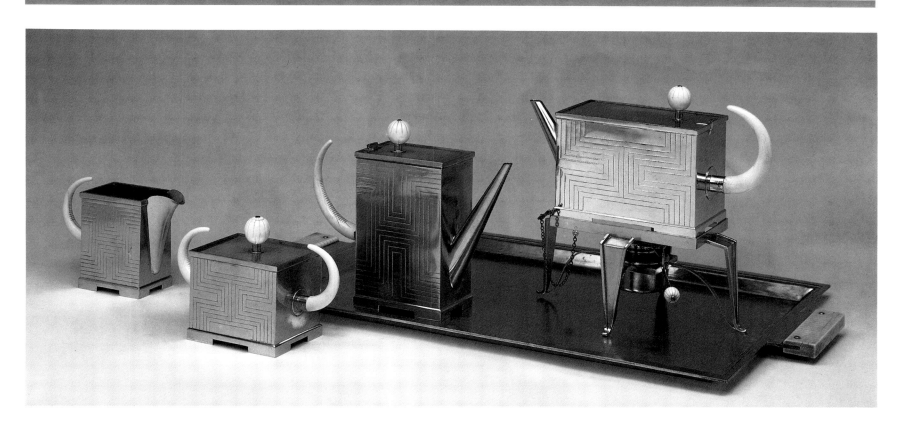

aesthetic for silver cocktail shakers, vases and other items for New York's Friedman Silver Company in 1928.

Like many other designers of the era, Russel Wright was deeply involved in the exploration of new materials and processes in order to provide aesthetic pleasure and appropriate function to the consumer at reasonable cost. In the early 1930s Wright began to experiment with chrome-plated steel and spun pewter made into bar accessories such as glasses, bowls and cocktail shakers in the form of gleaming cylindrical and spherical industrially inspired shapes. But the necessity for special plating and fabricating machinery for such items attracted Wright instead to the more easily worked aluminum which, spun and abraded with emery cloth, resembled pewter. Wright's spun aluminum line, designed in exaggerated shapes, was so successful that he widened his range of serving pieces to include trays, soup tureens, ice buckets, stove-to-table wares, and other vessels. Thus middle-class Americans were able to purchase modern design objects specifically geared to their more informal way of living. In this way the elitist object that resulted from stylistic innovation in the European avant-garde was adapted and assimilated in ways that eventually made it accessible to the masses.

ABOVE: *Peter Muller-Munk designed this silver and ivory coffee and tea service (1931).*

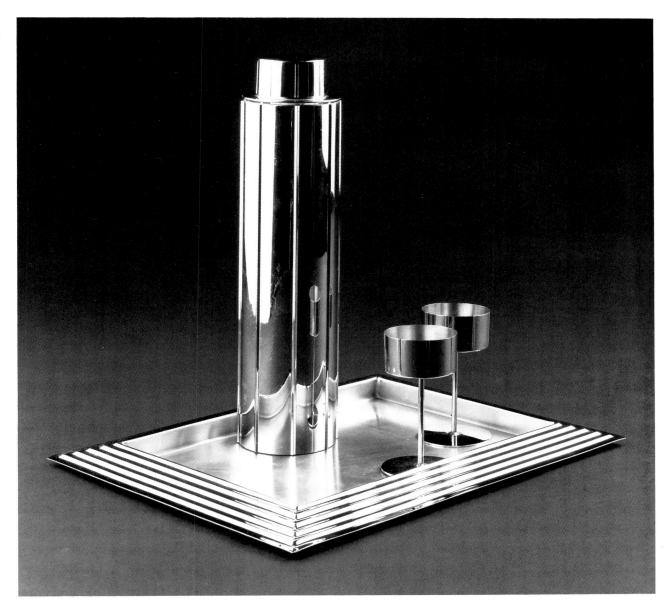

RIGHT: *Norman Bel Geddes, cocktail shaker and serving tray (1937), Revere Copper and Brass Company.*

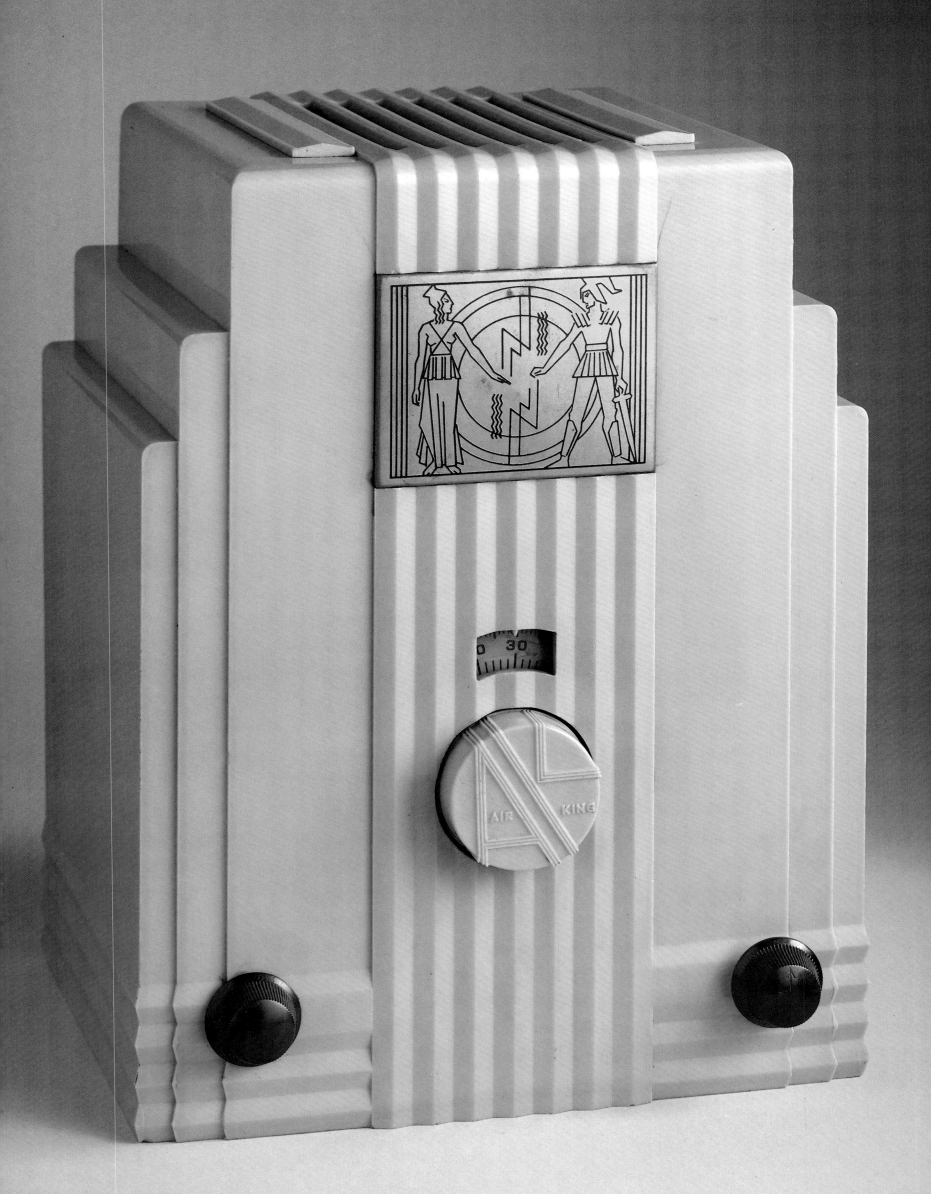

Industrial Design

'**A** racing car . . . is more beautiful than the *Victory of Samothrace.*' This proclamation of the 1909 Futurist Manifesto echoed an attitude that was widespread during the Art Deco years. Idealization of the machine during the era of such remarkable technological advances as the automobile, the airplane and the radio lent an heroic dimension to the evolving role of industrial designer. The foundations in modern design laid by the *Deutscher Werkbund* and the Bauhaus gave rise to such important advances as Frank Pick's London Underground plan and the American industrial design movement of the 1930s. The final phase of Art Deco known as the streamline style resulted from these earlier European attempts to foster collaboration between art and industry.

During the late nineteenth century, the ideas of William Morris about the superiority of handmade goods over those shoddily produced by machine had resulted in the flourishing crafts revival in England and the United States. One dissenting voice was that of Frank Lloyd Wright who, in a 1901 speech, raised the possibility of using machines to produce well designed and well made household furnishings. Although the Americans and British were not yet ready for such a revolutionary proposal, Wright's ideas fell on more fertile ground in Germany and Austria.

In 1907 the *Deutscher Werkbund* was founded, with an invitational membership of architects, designers and manufacturers, to counter negative attitudes toward the machine and to attempt to apply aesthetic principles to the design of machine-made goods. Among the group were modernist pioneers Peter Behrens, Walter Gropius, Hans Poelzig, Richard Riemerschmid and Henri van de Velde, as well as Austrians Josef Hoffmann and Otto Wagner. In its early years the *Werkbund* emphasized crafts-oriented work; later, interest shifted to the design of mechanical and electrical products, and transport; and still later attention focused on functionalist architecture and the domestic environment. To promote its new ideas, the *Werkbund* also established a museum of industrial design in Hagen and organized a series of traveling exhibitions, including one in 1912 to Newark in the United States.

The event attracting the most public notice was the *Werkbund's* major 1914 exhibition in Cologne. There the diversity of designs on view demonstrated that there was no one *Werkbund* style; Bruno Taut's glass pavilion was Expressionist, while Henri van de Velde's *Werkbund* Theater was a lingering example of Art Nouveau. The buildings by Behrens and by Hoffmann were classical moderne, while the elegant veneered furniture shown by Gropius predicted French Art Deco of 1925. Van de Velde was one of the first to apply his skills to the industrial design of steamships and locomotives. Most of the industrial designs documented in the 1914 *Werkbund* yearbook, however, were anonymous. These transport designs for aircraft, dirigibles, locomotives, ships and automobiles investigated aerodynamic principles and so were early attempts at streamlining.

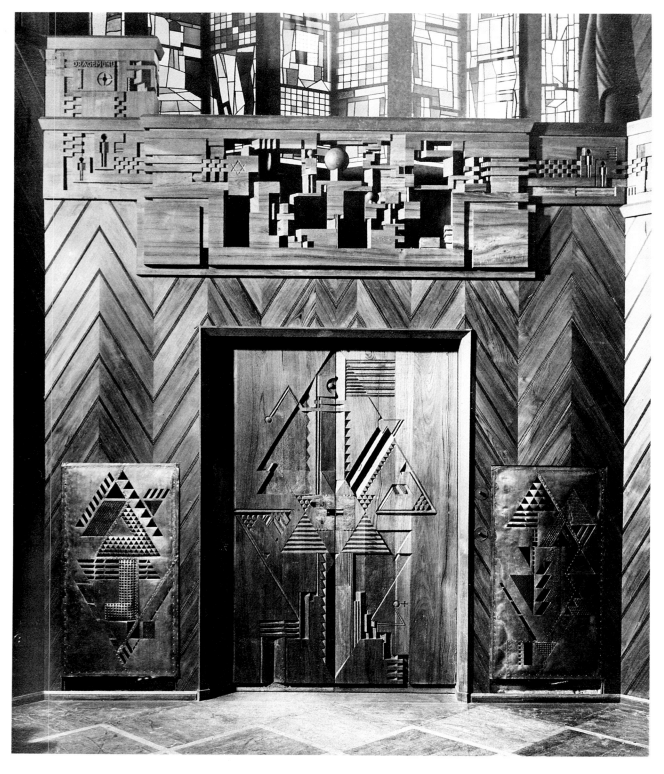

LEFT: *Sommerfeld house (1921), woodwork by Joost Schmidt and stained glass by Josef Albers.*

RIGHT: *Teapot (1924) by Marianne Brandt.*

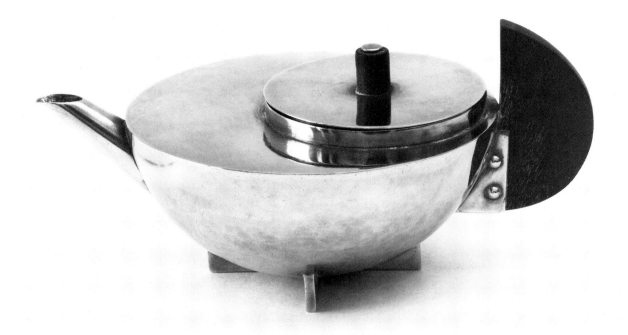

BELOW: *Chair (1926-27) by Marcel Breuer.*

BELOW RIGHT: *Table lamp (1926) by Wilhelm Wagenfeld.*

One of the most important achievements of the *Werkbund* years was Behrens' corporate redesign – of everything from factory buildings and products such as fans, lighting fixtures and kettles, to graphics – for the German electric company AEG. In this, the first planning of a complete corporate image for a modern company, Behrens set out to reject historicism and ornament, a course that would be taken up by the Bauhaus. Perhaps even more significant was the fact that among Behrens' assistants were three pioneers of functionalism: Gropius, Ludwig Mies Van der Rohe and Le Corbusier.

The machine aesthetic rapidly became an important feature of avant garde art, a key event in this development being the publication in 1923 by the French-Swiss painter and architect Le Corbusier of *Vers Une Architecture (Towards a New Architecture)*. In this seminal book, Le Corbusier promoted the idea of a house as a 'machine for living,' praised the mass-production assembly line techniques introduced in 1913 by Henry Ford, and saw the development of the airplane as a logical engineering model for the solution of other design and social problems of the modern age. He heralded the beauty of the machine and its concomitant efficiency as universal values. Le Corbusier explored the more practical applications of these ideas in collaborative designs for a tubular metal armchair in 1928 and an adjustable chaise longue in 1929. Among other French designers exploring such ground-breaking functionalist ideas were Robert Mallet-Stevens, Pierre Chareau and René Herbst.

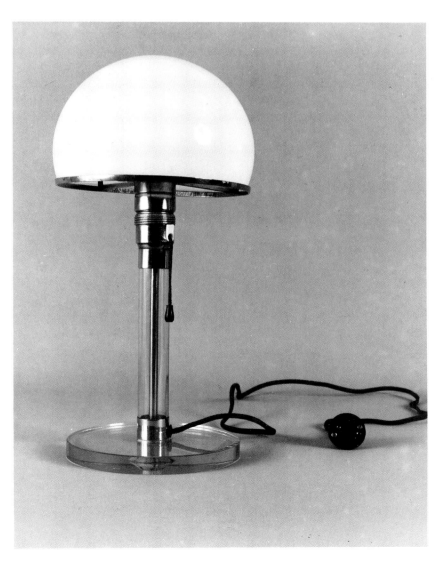

LEFT: *Note the Art Deco hubcaps on the Rolls Royce Phantom.*

Although the *Werkbund* continued until 1933, the leading role in German design was taken over in 1919 by the Bauhaus, originally under the direction of Gropius and then later of Mies Van der Rohe. The early Bauhaus years in Weimar focused on a crafts approach to design, as seen in the collaborative Sommerfeld house project (1921). Here the decorative geometric patterning of Joost Schmidt's woodwork for the door and its surround resembled Art Deco more than anything else. Utopian and communal, the Bauhaus initiated a curriculum of fine and applied arts that pioneered functionalist design. Influential were the ideas of the Dutch *De Stijl* group, which emphasized right angles, straight lines and industrial processes. In the Bauhaus years at Dessau, this coalesced into an aesthetic of unadorned surfaces, rectilinearity, reduction to geometric forms, exposed structure, muted colors and the bold use of undisguised industrial metals and glass.

The most important innovation of the Dessau years was the development of tubular steel furniture, followed by cantilevered tubular steel chairs, by Marcel Breuer and others. Breuer's designs – reportedly inspired by a bicycle frame or, according to other accounts, by Thonet's nineteenth-century bentwood chairs – were made by craftsmen at first, before being successfully produced commercially by Thonet and other furniture manufacturers. The low cost and efficiency of production justified Breuer's advocacy of standardization and mass production techniques.

Under the direction of Laszlo Moholy-Nagy from 1923 to 1928, the Bauhaus metal workshop stopped using precious metals, and turned instead to industrial materials such as nickel silver and brass to form utensils, vessels and lighting fixtures in the shapes of spheres, hemispheres and cylinders. Among the school's greatest commercial successes were the lighting fixtures of Marianne Brandt, Wilhelm

LEFT: *The original Volkswagen designed by Ferdinand Porsche.*

Wagenfeld and others, which were industrially produced by various companies. Wagenfeld was to become Germany's most important industrial designer during the wartime years and afterward. Although he was later known for his glass designs, he also worked with cutlery and ceramics.

The Nazi rise to power put an end to both the Bauhaus and the *Deutscher Werkbund,* and the focus of industrial output shifted away from the domestic habitat. Efficient transportation, in the form of updated vehicles and the construction of the highway system known as the Autobahn, became a national priority, as Nazi propaganda hailed such achievements as the Zeppelin. The most valued designers were now engineers such as Autobahn-planner Fritz Todt and aircraft designers Ernst Heinkel and Willy Messerschmidt. The conservatively streamlined *Flying Hamburger* of 1933 was a high point of German locomotive design. Hitler himself took a personal

interest in the development of a low-cost, efficient automobile for the masses. The result was Ferdinand Porsche's 1936 design for the Volkswagen, although the 'people's car' did not reach the production stage until 1946. Owing its flowing lines to the streamline styling of the 1930s, the Beetle became one of the best-selling cars of the postwar decades. France and Italy also developed similarly basic automobiles. The French people's car was the Citroën 2CV (1939), with a body by André Lefebvre and Flaminio Bertoni. Italy's contribution was Dante Giacosa's 1937 Fiat 500, nicknamed Topolino, or Mickey Mouse. With the founding of the magazine *Domus* by Gio Ponti, Italy had become an influential disseminator of modern design ideas.

That the British did not develop their own version of the people's car – the Morris Minor, designed by Alec Issigonis – until 1948 is symptomatic of how far Britain lagged behind the continent in the field of modern industrial design. During the first epoch of the in-

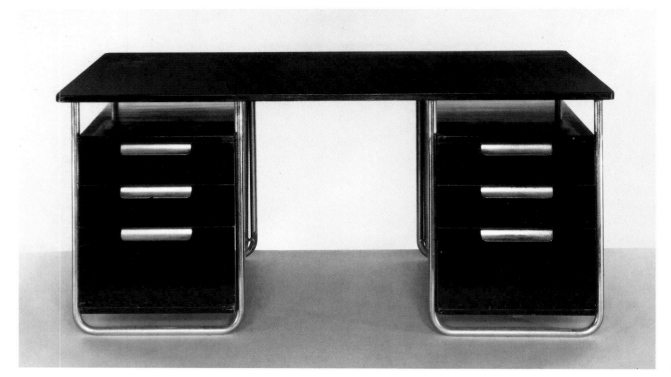

LEFT: *Tubular steel office desk (1933) designed by Wells Coates.*

BELOW LEFT: *Tubular steel armchair (1931-32), PEL Ltd.*

BELOW: *Tubular steel table (1931-32), PEL Ltd.*

dustrial revolution, the late eighteenth-century age of steam, Britain had led the way in technological design and production. The related trade within the far-flung British empire had placed Britain in an unequaled position of wealth and power. But in the later nineteenth century, while Britain's brightest students were prepared for careers as administrators at home and in the colonies, the German system of state technological schools promoted research and design in the new technologies that were to supersede steam power: electrical power and the steel and chemical industries. Plastics were to be a major development of the chemical industry. Most telling perhaps was the failure of the British Admiralty to foresee any military applications for the airplane when approached by the Wright brothers.

But despite its apparent reluctance to set trends in modern industrial design, Britain did achieve isolated triumphs. In the field of locomotive design, Nigel Gresley's aerodynamic A4-Mallard (1935) set the world steam speed record of 126 miles per hour in 1938. The World War II Spitfire aircraft, however, though much admired and highly romanticized, was complicated and expensive to manufacture compared to German military aircraft. Instead of modern, cost-effective standardization, the old ideals of industrial craft still ruled its production process, just as they did the making of such luxurious automobiles as the Rolls-Royce.

The lessons of the *Deutscher Werkbund* and particularly of its 1914 Cologne exhibition were not completely lost on the British, and a result was the establishment in 1915 of the Design and Industries Association. But in the end the DIA and other bodies with similar aims had a minimal effect on the attitudes of the public toward mass production and of manufacturers toward the collaboration of art and industry. This is apparent in the judgment that one of the most successful industrial designs of the era were the telephone kiosks designed by architect Sir Giles Gilbert Scott. Scott's 1926 kiosk No. 2 was followed by his 1936 No. 6 booth, which was smaller and was given a horizontal emphasis (perhaps related to streamlining) by the alignment of the window panes.

But despite the persistent British adherence to late nineteenth-century Arts and Crafts movement ideals, modernist ideas began to make some inroads, particularly with the London publication of Le Corbusier's *Vers Une Architecture* in 1927. Modern functionalist design, which had seen a British prototype some 50 years earlier in the metalwares of Christopher Dresser, won the endorsement of a few enlightened corporate sponsors. In 1931 PEL (Practical Equipment Ltd) began the production of tubular steel furniture by Serge Chermayeff, Wells Coates and others. Furniture manufacturer Jack Pritchard, who invited Le Corbusier and Moholy-Nagy to create designs for

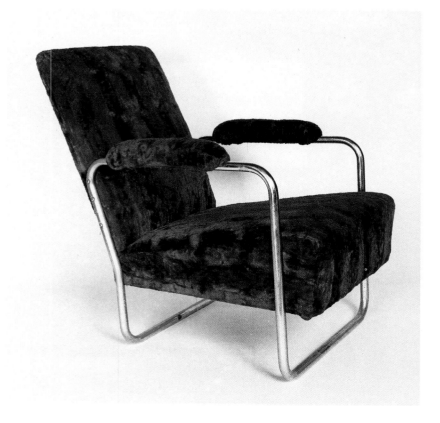

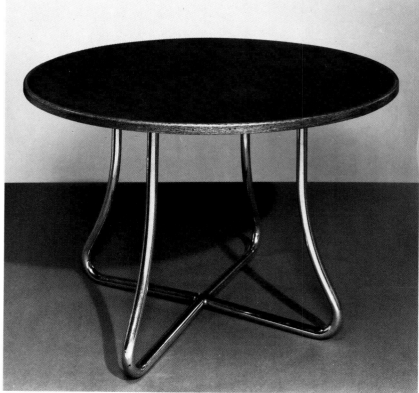

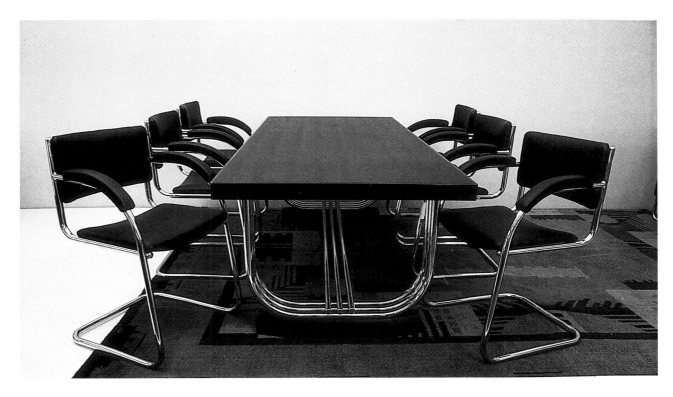

him, also founded Isokon in order to produce modernist molded plywood furniture by Marcel Breuer between 1935 and 1937. But in the conservative British climate, modernist furniture was not well received and the status of the industrial designer was undervalued.

Some of the more effective modernist designs were those created for the evolving radio cabinet. The earlier versions, particularly the Pye radio receiver of 1930, with a quintessential Art Deco sunburst motif for its loudspeaker grille, were traditional in their treatment of the radio as a piece of veneered furniture. An innovator was E K Cole Ltd, which in 1930 began manufacturing bakelite cabinets for its Ekco radios. The earliest plastic designs were in the zigzag Art Deco style. But with the successive Ekco designs of Chermayeff and Wells Coates, the appropriateness of plastics for the futuristic streamline style was fully realized, especially since curved seamless molds were far more cost efficient than those used in the production of boxier casings.

Wells Coates was probably the most active designer of the era. Like many of his fellow industrial designers such as Serge Chermayeff, Raymond McGrath, and Keith Murray, Coates was an immigrant. Apart from his Ekco radio designs, Coates collaborated, along with Chermayeff and McGrath, on the interior design of Broadcasting House. There he produced innovative solutions for BBC studio control panels, counterbalanced microphones and soundproofing.

Among his other projects were Ekco electric heaters; furniture for PEL and Isokon; the shopfront and interior design for the Cresta textile shops; and Sunspan House, a prototype prefabricated house design commissioned by Jack Pritchard. Besides working as an architect, Coates also co-ordinated modernist interior designs for fashionable clients like Charles Laughton.

Modernists also were hired as consultants to create integrated corporate designs, from interiors to graphics, often in a streamline or functionalist mode. The work of Raymond McGrath for the BBC, of Jack Beddington for Shell Mex and of Reco Capey for Yardley was particularly notable in this field. The most outstanding and ambitious unifying corporate design was the project for the London Passenger Transport Board supervised by Frank Pick. Pick, as vice chairman of London Transport and a founding member of DIA, was responsible for commissioning work from top modernist artists, designers and architects. The result was a series of distinctive Underground stations, signs, posters, maps, kiosks, benches and litter bins, uniforms, streamlined locomotives, passenger cars and the 1939 RT bus. The aim was to create and communicate a progressive and well-organized entity in order to unify disparate merged underground and surface transport companies, raise worker morale, and increase passenger confidence and leisure usage.

RIGHT: *Tubular steel bed and tub armchair (1932-36), PEL Ltd.*

LEFT: *Albert Cheuret, silvered bronze and onyx clock (c 1930).*

In the United States, the industrial designers who rose to prominence during the 1930s were a major source of designs for the streamline phase of Art Deco. As a profession, industrial design – in the form of freelance consultants – was an American phenomenon tied to the marketing needs of manufacturers who were under urgent pressure to stimulate consumer interest in their products during the Depression years. During the height of 1920s prosperity, many corporations had initiated ambitious expansion programs, with the result that the supply of manufactured products soon threatened to exceed consumer demand. The fierce competition that ensued led to the stylish repackaging of a whole range of mass produced items from railroad cars to pencil sharpeners, including automobiles, office equipment, household appliances, furniture, radios, and cameras. Attention also focused on optimal methods of promoting sales; a result was the modernistic transformation of sales facilities such as commercial interiors, store window displays, shop façades and advertising.

Few of those who became industrial designers had trained professionally either as engineers or architects. Many of them came from the field of advertising and commercial illustration, as did Walter Dorwin Teague, Raymond Loewy, Lurelle Guild, George Sakier, Egmont Arens, Joseph Sinel and George Switzer, or from stage design, as did Norman Bel Geddes, Henry Dreyfuss, John Vassos and Russel Wright. Many of the prominent designers were immigrants,

among them William Lescaze (also an important architect), Raymond Loewy, Frederick Kiesler, Otto Kuhler, Lucien Bernhard, Gustav Jensen, Joseph Sinel, Kem Weber and Peter Müller-Munk, while a number of the native-born Americans had studied in Europe.

Most of the industrial designers were remarkably versatile in the projects they tackled, although some remained relatively specialized. Gilbert Rohde, Kem Weber and Russel Wright concentrated on the design of mass-produced furniture and household accessories, while others such as Otto Kuhler concentrated on the design of transportation vehicles. In general, the industrial design movement was centered on the east coast, in and around New York City, but there were a few designers who carried on successful careers elsewhere, as did Kem Weber in California and Harold Van Doren, who designed his aerodynamic children's play vehicles in Ohio.

Donald Deskey's success was so great that in the 1930s, aside from his head office in New York, he also set up offices in London, Milan, Stockholm, Copenhagen and Brussels to produce product designs, tubular aluminum and steel furniture designs, and to develop prefabricated structures such as his weekend cottage, 'Sportshack.' And while most designers functioned as freelance consultants, there were also those who became in-house designers for large corporations creating a unified corporate image for their employers; among them were George Sakier at American Radiator, Donald Dohner at Westinghouse and Ray Patten at General Electric.

LEFT: *Poster by E McKnight Kauffer.*

Streamlining came to be the style almost universally applied by the industrial designers of the 1930s. With its flowing curved lines and aerodynamic form, the streamline style suggested efficiency and speed, an effect enhanced by the addition of parallel horizontal speed stripes on smooth, gleaming, often metallic surfaces. Stream- lining was ostensibly derived from the airplane, but its curves were already apparent, in the early years when airplanes were still angular, in World War I Zeppelins and *Deutscher Werkbund* locomotives.

The most active promoter – indeed the 'P T Barnum of industrial design' – of the streamline style was Norman Bel Geddes. Geddes

ABOVE LEFT: *London Transport sponsored innovative design in the 1920s and 1930s.*

ABOVE RIGHT: *Silver-plated* Normandie *pitcher designed by Peter Muller-Munk.*

RIGHT: *Kodak No. 1A Gift Camera (1930), designed by Walter Dorwin Teague, with its original box.*

LEFT: *Skyscraper-style scale designed by Joseph Sinel for International Ticket Scale Corporation.*

RIGHT: *Kodak Bantam Special camera (1936-37) by Walter Dorwin Teague.*

BELOW: *Electrolux model 30 vacuum cleaner (1937), designed by Lurelle Guild.*

was strongly influenced by German Expressionist architect Eric Mendelsohn who, in 1924, had given Geddes a book of his designs and a drawing of his Einstein tower, a remarkable early example of streamlining. Geddes, who established his industrial design firm in 1927, seemed little more than a visionary dreamer, but his fantastic designs for colossal luxury airplanes, svelte streamlined ocean liners and the 'ultimate car' illustrated in his persuasive book *Horizons* helped to popularize the style. His more outlandish ideas remained unrealized, but his firm did produce designs for stoves, radios and airplane interiors. In order to plan marketing campaigns, he also pioneered opinion polls and consumer use surveys. At the end of the decade, his utopian fervor was granted an international forum at the 1939 New York World's Fair, notably his Futurama display, 'City of Tomorrow,' in the General Motors pavilion.

A fellow visionary was R Buckminster Fuller. His six-sided 1929 Dymaxion House, intended for mass production, and his streamline designs for the three-wheeled Dymaxion Car and for prefabricated one-piece stainless steel bathroom units never progressed beyond the prototype stage. Success came to Fuller only much later, with the practical application of his geodesic dome.

French-born Raymond Loewy was another flamboyant exponent of streamlining. Although he was best known for his transportation vehicle designs, particularly the Greyhound buses, trucks and locomotives, he also produced progressively more aerodynamic designs for such diverse products as Sears Coldspot refrigerators and International Harvester cream separators. Loewy's automobile designs, notably the Hupmobile, were less successful. It remained to designer Gordon Buehrig to produce the masterpiece of American streamlined automobile styling, the 1936 Cord.

Industrial designers also redesigned store interiors, commercial showrooms and train and plane interiors. The prototype for a sleek industrial designer's office created by Loewy in association with Lee Simonson for the 1934 Metropolitan Museum industrial art exhibit conveyed, with its streamlined window and speed-striped walls, the ultimate in modern efficiency. Others, too, designed similar streamlined interiors for trains and planes. Occasionally an anachronistic

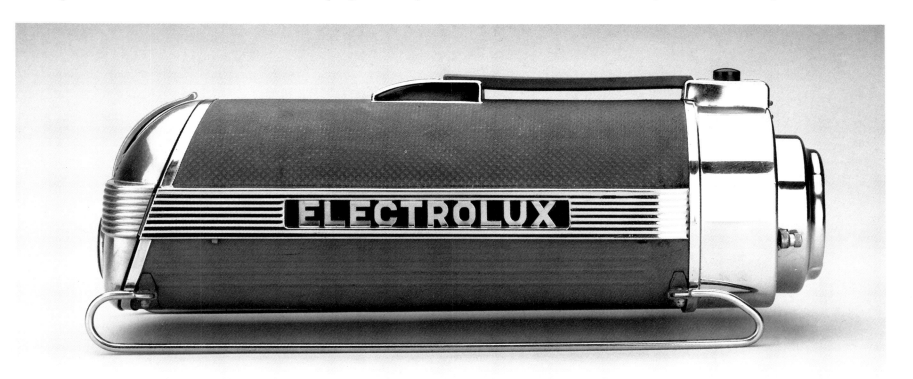

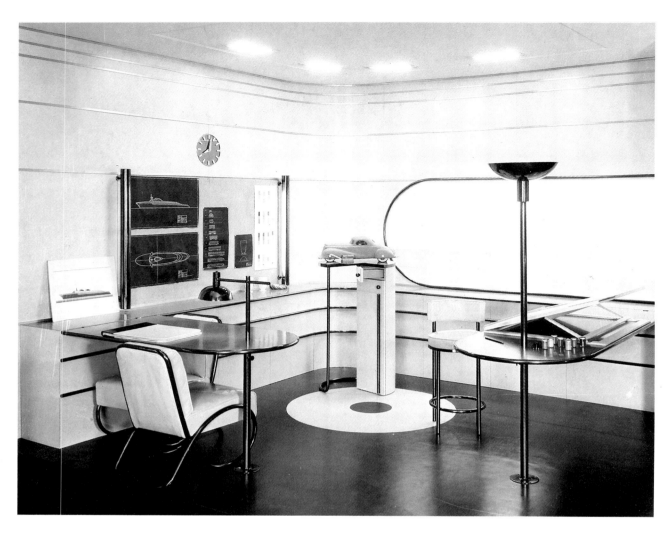

taste for 1920s opulence resulted in hybrid streamlined-zigzag moderne train interiors such as the Acoma Super Chief, with its Pueblo deco ornament, accompanied by richly veneered exotic wood paneling. Nor were all appliances streamlined. That the now passé zigzag style was still preferred by more conservative clients could be seen in Joseph Sinel's skyscraper-style weighing scale and in speed-striped skyscraper-style plastic radios designed by Harold Van Doren and John Gordon Rideout.

Henry Dreyfuss was unusual among industrial designers in his sensitivity to the special needs of each client and in his willingness to go beyond surface style to create designs suitable for the individual product. He preferred the term 'cleanlining' to 'streamlining.' This approach did not appeal to all manufacturers, but Dreyfuss nevertheless had notable successes with such projects as his locomotive designs for New York Central railroad's Mercury and the Twentieth Century Limited, as well as the 1937 Bell Telephone desk model, the

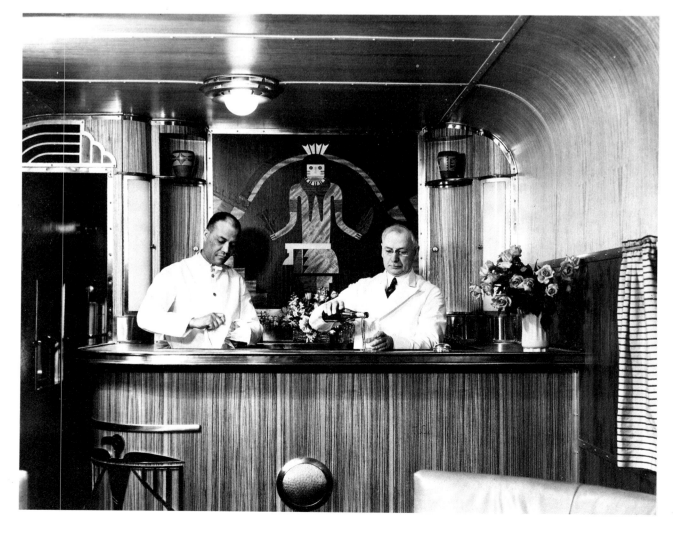

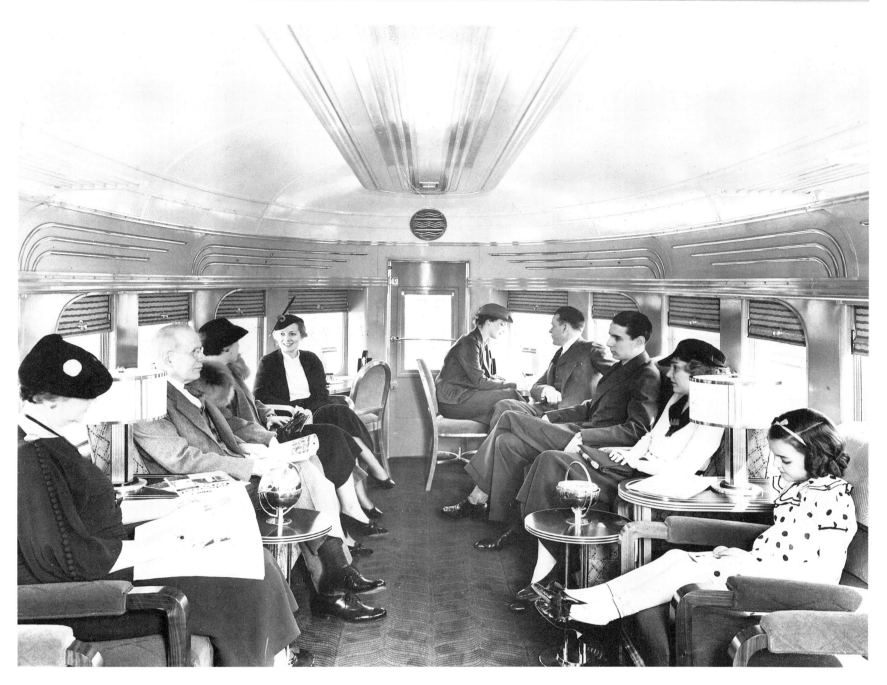

Hoover vacuum cleaner model 305 and his highly popular series of Big Ben alarm clocks.

Walter Dorwin Teague had a similarly pragmatic approach to design. His attention to manufacturers' needs and production techniques led to continuing commissions such as his 30-year association as design consultant to Eastman Kodak. Teague's elegant design for the 1936 Kodak Bantam Special camera epitomized the application of streamline styling to smaller items. Teague also left his mark on the design of tractors, X-ray machines, air conditioning equipment and a series of streamline-style gas stations for Texaco. His beliefs in the links between good design and the creation of a better world were typically utopian expressions of the era. These ideals culminated in

Teague's work on the futuristic exhibits at the New York World's Fair.

That characteristic invention of the modern age, the radio, was frequently restyled by its American manufacturers. The individualistic Russel Wright resisted the extreme application of the streamline style in his 1932 table model for Wurlitzer, while acknowledging its influence in the discreetly rounded corners, the applied motif of curved striping, and the smooth uncluttered surfaces. An outstanding success in the mass market was the plastic Fada radio, very well designed in the streamline mode and available in a range of colors. RCA Victor's pioneering television of 1939 was encased in a more traditional cabinet that combined the curves and stripes of the streamline style with the dramatic contrast of dark and light wood veneers seen

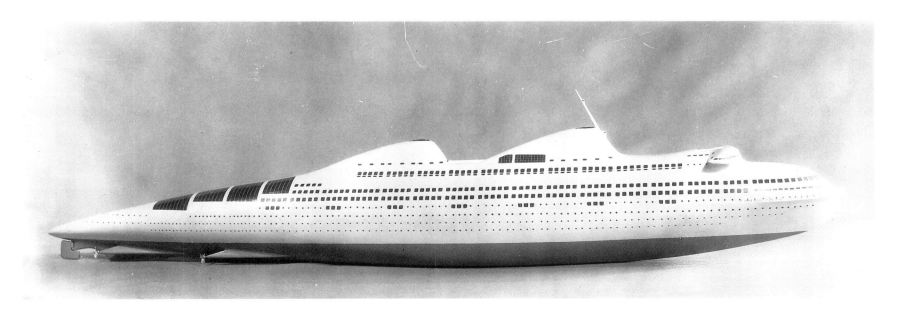

LEFT AND RIGHT: *The 1936 Cord 812, designed by Gordon Buehrig, was the masterpiece of American streamline automobile styling.*

in the French style of the 1920s. And juke boxes retained their hybrid and kitschy Art Deco ostentation well into the following decades.

During the Depression years, the New Deal administration sponsored industrial design projects as well as programs in the arts, crafts and architectural construction. New York City's Design Laboratory, co-directed by Gilbert Rohde, offered a professional curriculum in industrial design, textile design, advertising and photography. Like the Bauhaus, the Design Laboratory sought to apply fine arts principles to industrial production. Policy differences with the school's administration led the government to disband the organization in 1937. With the assistance of Moholy-Nagy, Chicago established a similar project, but here the focus was on a craft-based approach rather than industrial design.

Streamlining, despite its highly promoted functionalism, was in effect a surface veneer – a repackaging in a modernistic shell of the unwieldy and frequently unaltered machine parts underneath. The style's main function was to attract new customers by means of its persuasive allusions to modernism, high style, efficiency and speed. Certainly there was a seductive degree of logic to these allusions in

the case of appliances such as vacuum cleaners and washing machines, but the logic was more tenuous in relation to items such as stoves and refrigerators. It has been suggested that the style's symbolic allusions also had broader implications. The attempt to streamline the complete American environment during the 1930s was commercially appealing because it optimistically suggested the nation's ability to move forward – decisively, quickly and with little friction – leaving behind forever the chaotic social realities of the Depression years.

The idealistic industrial designers saw science and technology as the means to achieve a social utopia and capitalist golden age. But in the years following World War II, as the implications of the atomic bomb became all too apparent, the vanguard of the design movement shifted to more natural styles. Science and technology had suffered a severe loss of prestige, and the streamline style no longer seemed quite so glamorous. Maybe it simply became obsolete in the course of the continuous restyling of products that fueled the postwar economy; maybe, in the new atmosphere of the cold war era, the style had too many uncomfortable associations with totalitarianism.

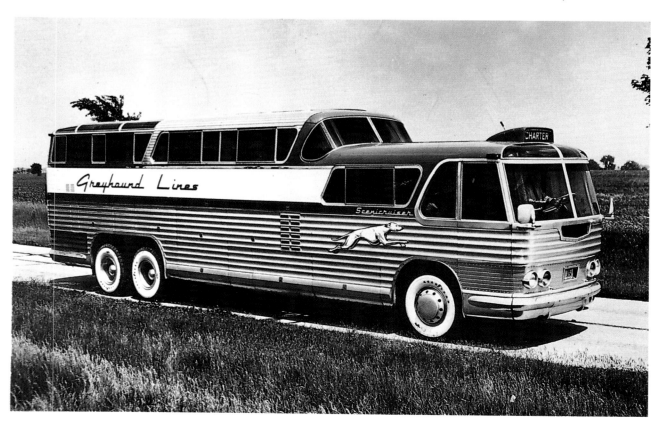

LEFT: *The Greyhound Bus Company adapted streamlining as a corporate style.*

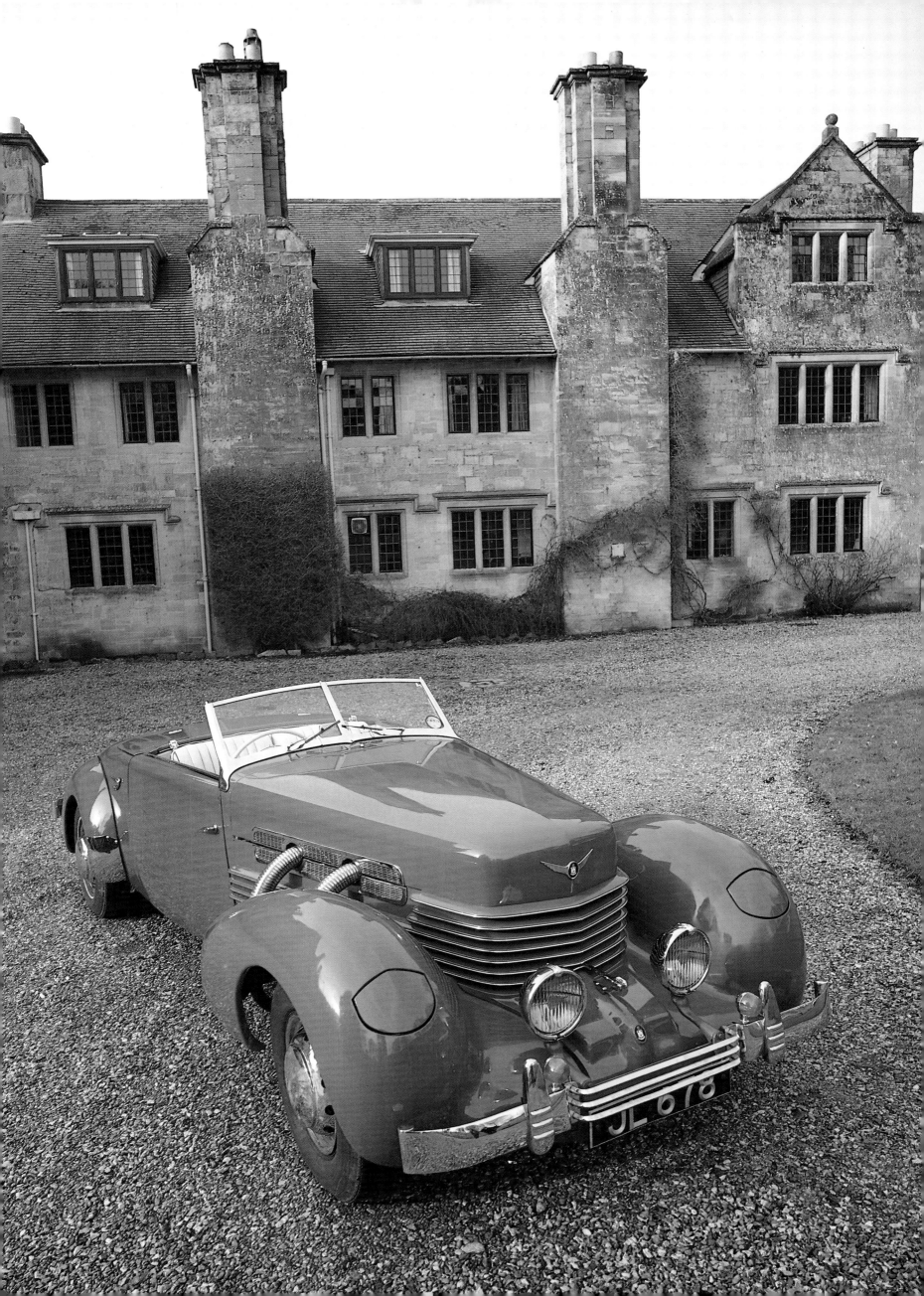

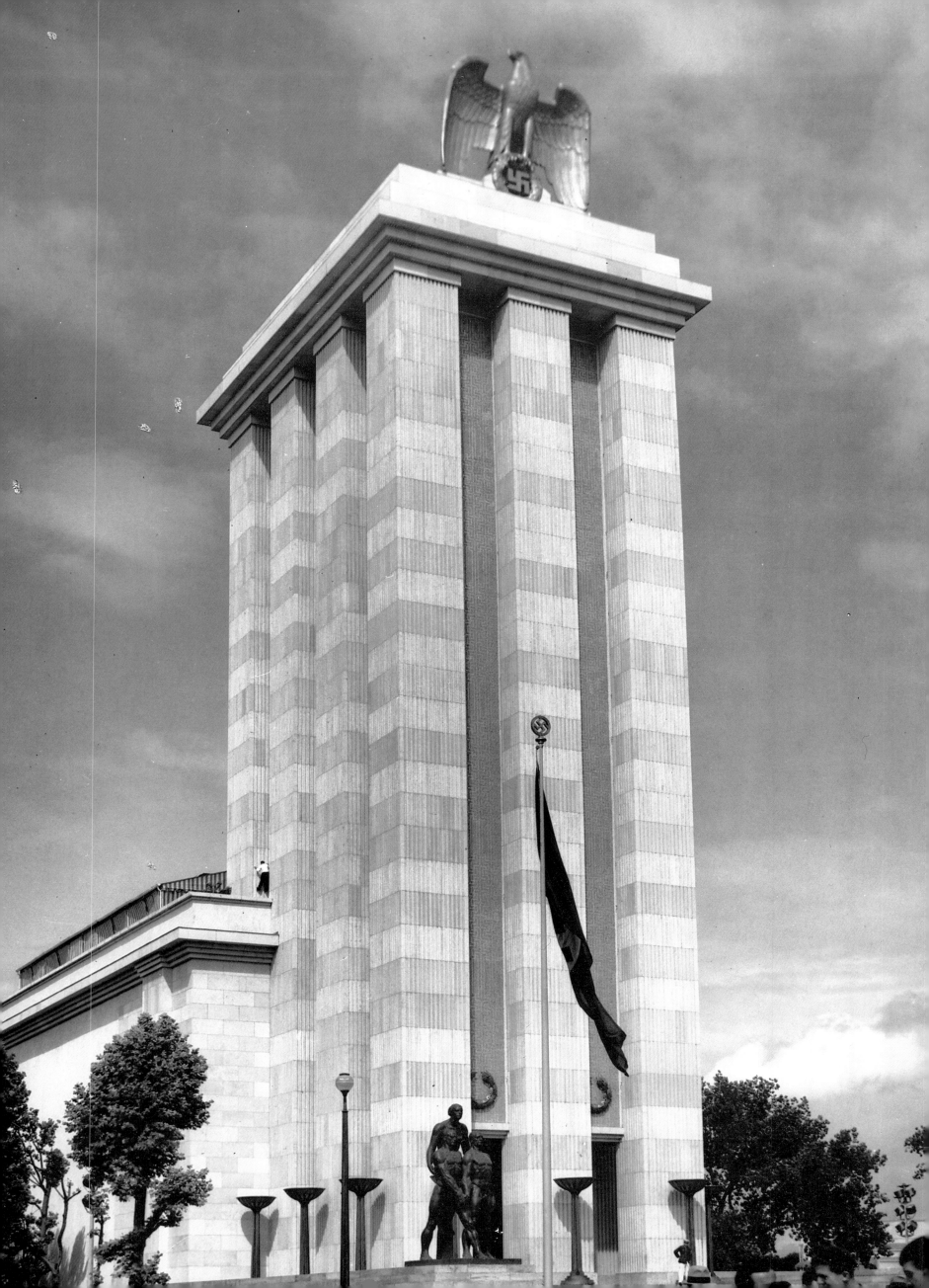

Totalitarianism and the New Deal

LEFT: *The German Pavilion designed by Albert Speer for the 1937 Paris International Exposition.*

The conservative variant of Art Deco architecture known as classical moderne was a style warmly embraced by the dictators of Europe. With the rise of Mussolini in Italy, Hitler in Germany and Stalin in the Soviet Union, classical moderne's abstracted monumentality was seen by totalitarians as ideally expressive of allusions to a glorious past and of aspirations for a similar future. In the United States at the same time, the massive public building programs of Roosevelt's New Deal administration erected scores of similarly styled edifices. Classical moderne buildings also continued to rise in Scandinavia, England, France and other countries throughout the 1920s and 1930s – the expression of an underlying conservatism.

As a contemporary adaptation of the architecture of ancient Greece and Rome, the classical moderne style had much in common with its antecedent, neoclassicism. Neoclassicism too was the product of troubled political times; it flourished during the era of the American and French revolutions. Through the use of classical revival styles as an official architecture in Washington, the new American democracy symbolically sought to consolidate its power. But a more direct precedent of classical moderne can be found in the designs of the French architects Etienne-Louis Boullée and Claude-Nicolas Ledoux. Boullée, whose most astonishing design was his colossal spherical centopath for Sir Isaac Newton, was something of an architectural visionary; few of his designs were ever realized, nor were they intended to be. Yet his remarkable poetic renderings, with their monumental abstracted forms coupled with a dramatic use of light and shade, epitomize this phase of neoclassicism. Indeed, Boullée hailed himself as the inventor of 'the architecture of shadows.'

The characteristic use of architecture in the service of politics to create an overpowering effect of order and control had as its ultimate goal the creation of a utopian society. It was a style particularly suited to such civic edifices as hospitals, theaters, libraries and prisons, as well as commemorative monuments. Ledoux, appointed royal architect in 1773, produced his more innovative designs for a ring of customs toll houses surrounding Paris. His juxtaposition of elementary geometric solids, such as cylinders and cubes, with flattened surfaces and abstracted classical ornament was a direct prototype for twentieth-century classical moderne style, not only in its forms but also in its political content.

The 1937 Paris exposition was an international showcase for the architectural ambitions for Hitler and Stalin. Their two national pavilions, ominously confronting one another across the Champs de Mars, were strikingly similar in their classical moderne monumentality. Albert Speer's German pavilion, surmounted with a Nazi eagle and swastika atop a massive square tower was the more conservative. Iofan's Soviet pavilion, with its skyscraper-style setbacks and sculptural friezes, displayed on its soaring pedestal Vera Mukhina's gigantic stainless steel sculpture, *A Worker and a Collective Farmer,* an idealized heroic man and woman striding forward dynamically with hammer and sickle triumphantly held aloft. Two years later, at the 1939

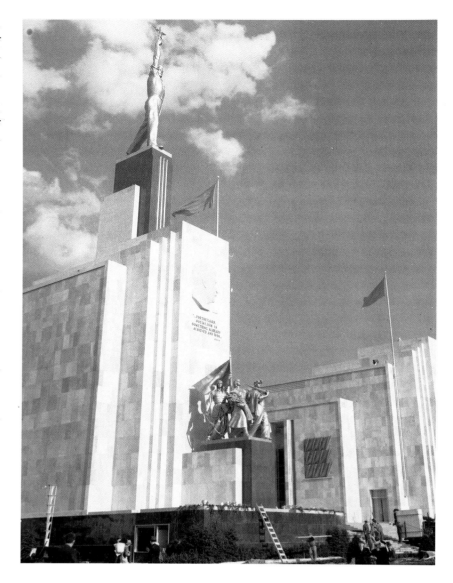

New York World's Fair, the Soviet Union and Italy erected similarly imposing pavilions. These exposition pavilions were aptly representative of the classical moderne style official architecture then being erected in the Soviet Union, Germany and Italy.

Following the Russian Revolution of 1917, the Soviet artists, designers and architects known as Constructivists surged to the forefront of the European avant-garde. But their experiments ended with the completion in 1930 of Schussev's monolithic, classicist Lenin mausoleum in Red Square. From then on, an unbending neoclassicism remained the official Soviet style until the mid 1950s. Lenin himself had regarded classical revival architecture as a valid reference to the past as represented by the imperial splendors of St Petersburg. Thus classical revival, renaissance and baroque styles could be used for government buildings, palaces of culture, workers' clubs, apartment buildings, concert halls, theaters, cinemas, sports facilities and

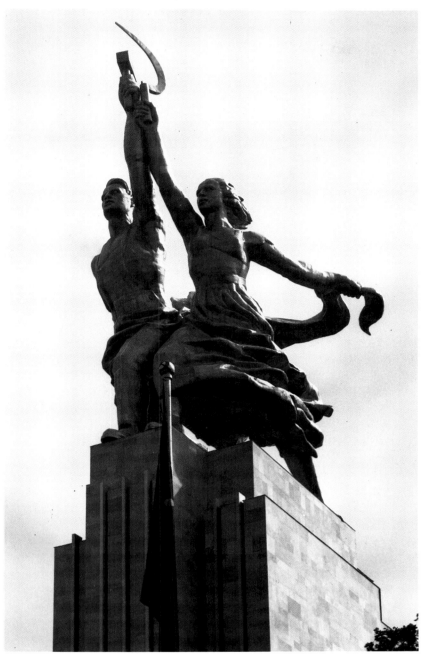

underground stations. While some designs were more conservative interpretations, others were boldly classical moderne, including Moscow's Lenin Library, Tbilisi's History Institute of Georgia and Kiev's Supreme Soviet building. Some of the most impressive examples of classical moderne were created for the Moscow Underground as part of an ambitious public works construction project. The Lenin Library Station and the Dynamo station were particularly striking examples. The Underground also formed a remarkable gallery of public art; Moscow commuters were regaled with Art Deco ornament such as Deneika's 1940 mosaic ceiling panels in a design of trains, planes and oblique angles at Novokuznetskaia station, and Motovilov's 1943 marble frieze of industrial scenes at the Electric Plant station. These ornate public facilities were part of a deliberate attempt to bring art out of the realm of the elite, to which it had been restricted in Czarist times, and into communal settings for the daily enjoyment of the workers.

Italy, where Mussolini seized power in 1922, also acted as a patron of massive building programs. The objective was to create employment and to promulgate the state ideology of fascism. The ruins of ancient Rome were, of course, the ultimate prototype for Mussolini, who dreamt of a modern Roman empire of his own. Emphatic links with the glories of the past were created by establishing ceremonial processional routes linking modern and ancient monuments. This was achieved by the widespread demolition of old buildings in Rome and other cities. The fascist obsession with social order and national discipline also led to numerous public projects such as the athletic complex of the Foro Mussolini, later renamed Foro Italico, where 60 statues of idealized male nudes ringed a stadium dedicated to the training of fascist youth.

Another major project was Rome's University City, where the Rectorate building by one of Mussolini's chief architectural advisors and designers, Marcello Piacentini, was typical of fascist classical moderne with its abstracted monumentality and ornament of stylized sculptural reliefs. Mussolini's sculptural programs frequently took the form of quasi-mythological portrayals of the struggle of fascism; another popular theme was the decorative juxtaposition of modern rifles, gas masks and cannons with the helmets, shields, bows and arrows of ancient Rome. Heroic idealizations of agricultural laborers and other workers also played a prominent part.

ABOVE LEFT: *Soviet Pavilion at the 1939 New York World of Tomorrow fair exemplified the heroic, monumental style favored by the totalitarian states.*

ABOVE: *The Soviet Pavilion designed by B M Iofan, with sculpture by Vera Mukhina, at the 1937 Paris exposition.*

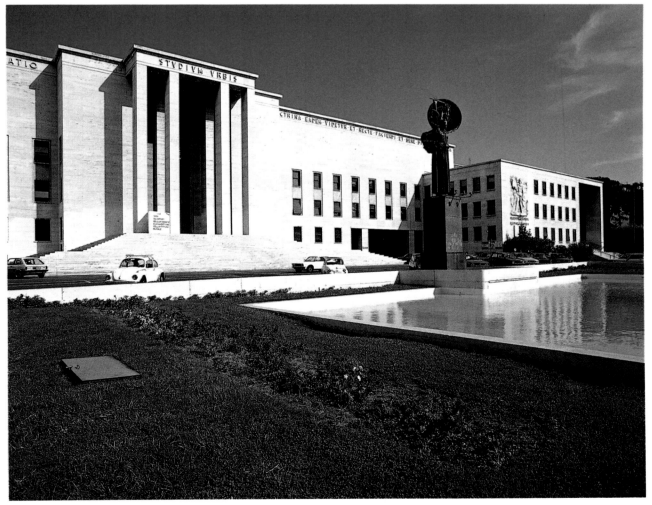

LEFT: *The Lenin State Library, Moscow (1927-38), designed by Shchuko & Gelfrein.*

RIGHT: *Building by Marcello Piacentini at Rome's Città Universitaria.*

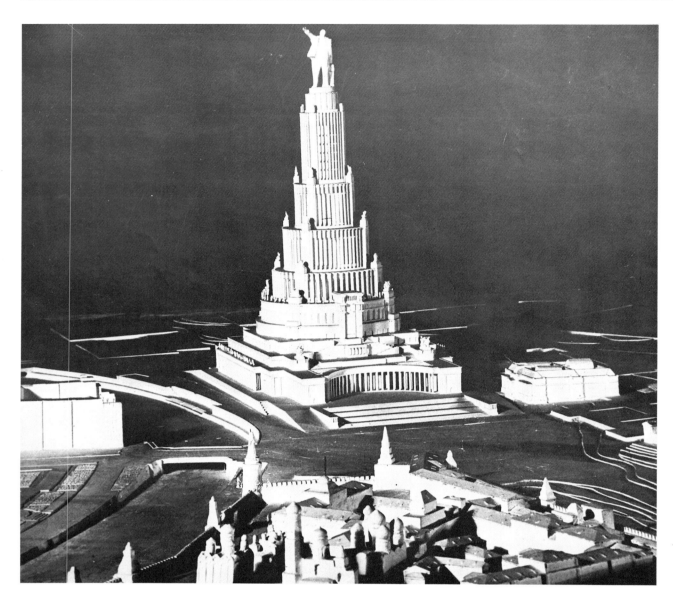

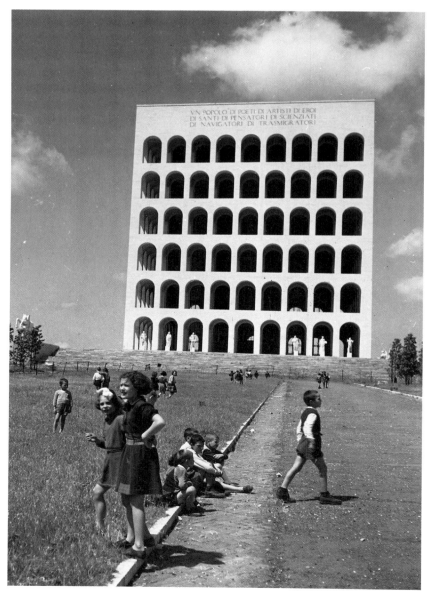

There was, nevertheless, room for a more avant-garde modernism in fascist Italy. Guiseppe Terragni's Monument to the Fallen in Como (1930) owed much to the visionary designs created by Futurist Antonio Sant'Elia in the years before World War I. And the vernacular Mediterranean architecture unearthed in ancient Ostia and Roman North Africa – a style of flat, unadorned surfaces and aqueduct-like arcades – also influenced Mussolini's designers, particularly those of the colossal *Esposizione Universale* complex outside Rome. Intended to celebrate 20 years of fascism, the complex was to have been erected under the supervision of Piacentini; these 'Olympics of Civilization' planned for 1942 never took place, however, as World War II intervened. The more grandiose fascist projects came late in the 1930s, and were probably influenced to some degree by Mussolini's alliance with Nazi Germany.

Hitler, who came to power in Germany in 1933, was himself a frustrated architect and consequently devoted inordinate attention and massive resources to the creation of a symbolically appropriate architecture. Nazism brought a swift end to the experiments of the Bauhaus and other modernists by associating their designs with decadence and Bolshevism, and by sending their practitioners into exile or into concentration camps. Henceforth the sole purpose of German art and design was to create propaganda for the totalitarian state.

Hitler's major building projects were centered in Munich, Berlin and Nuremberg. In Munich, Paul Ludwig Troost constructed the House of German Art and his Temples of Honor commemorating the Nazi dead of the failed 1923 *putsch*. The ominous power of this complex was such that after the war the Americans destroyed it and reburied the dead elsewhere. Aiding in Hitler's plan to build a new imperial Berlin as a monument to Nazi power was Albert Speer. In the official hierarchy of Nazi building types, stripped classicism was reserved for the most important government structures such as the new Reich Chancellery building by Speer and the Air Ministry buildings. Included in the repertoire of Nazi building types was a rustic medievalist style, or *Heimatstil*, which was deemed suitable for such edifices as youth hostels, clubs, training centers and homes. This

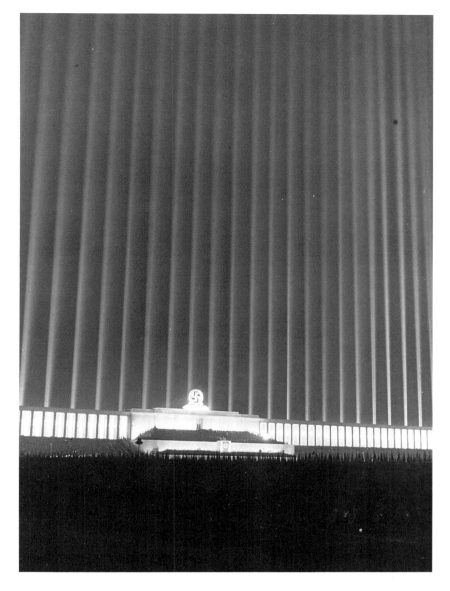

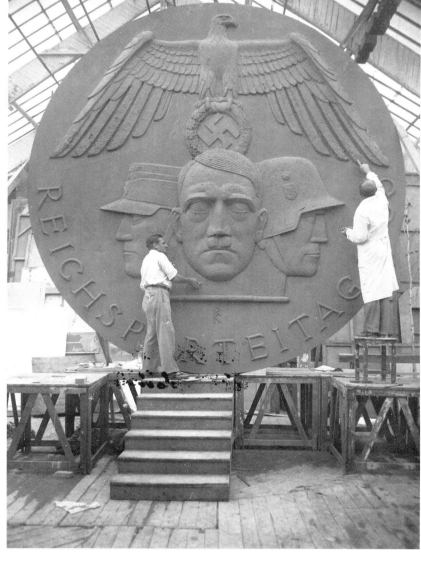

essentially nostalgic regionalist style was seen as indigenous to the Germanic region of Europe.

Functionalist architecture was a special case. On the one hand, according to Nazi doctrine, the flat roofs of functionalist buildings were not native to Germany but rather came from the Mediterranean area; hence functionalist architecture was associated with decadent orientalism and the Jews. On the other hand, Nazi power depended on rapid mechanization, and the quick and cost-efficient erection of new industrial buildings. Modernist functionalism, therefore, was permitted for ideologically less significant structures such as factories and office buildings.

The use of classical moderne intentionally drew on Teutonic roots such as architect Karl Schinkel's splendid neoclassicism, while emphasizing the supposed parallels between Hitler's regime and the classical civilizations of the ancient world. In its intimidatingly colossal scale and the banal repetitiveness of its elements, Nazi classical

ABOVE: *Albert Speer's choreography of searchlights at the 1934 Nuremberg rally.*

ABOVE RIGHT: *After the Nazis came to power, the sole purpose of art became to create propaganda for the state.*

RIGHT: *A triumphal arch dreamed up by Hitler and rendered by Albert Speer. The monument was never erected.*

moderne architecture forcefully promoted the legitimacy, power, permanence and regimental discipline of the authoritatian state. Austere in comparison with the more ornamented Soviet and Italian versions, the Nazi style projected an aggressive masculinity.

The Nazis also attempted to co-opt ancient Greek ideals in their promotion of physical fitness and the concomitant construction of children's camps, mountain resorts, swimming pools, gymnasiums and stadiums. Foremost among these was the complex built for the 1936 Berlin Olympics; an underlying theme of this event was the intention to impress the world with German efficiency and might. The ideal of physical perfection and Aryan racial purity, allied closely with that of the Nietzschean superman, was further promoted by the placement of bronze statues of idealized male nudes in public settings throughout Germany.

Ritualistic mass events were a Nazi speciality and Nuremberg, with its new classical moderne party congress buildings and Speer's Zeppelinfeld, was their most characteristic setting. The sheer monumentality of the Nazi architecture was due in large part to Speer's 'theory of ruin value,' which held that in terms of materials and construction techniques, Nazi architecture was built to last and that, at the end of the thousand year Reich, their ruins would be as visually evocative and psychologically resonant as those of ancient Greece and Rome. Ironically, Speer later considered one of his greatest achievements to have been an ephemeral one – the dramatic night time effects created by a choreography of searchlights for the 1934 Nuremberg party rally.

In actuality, such ceremonial spectacles combining stone and 'human architecture' could be viewed in full only by the Nazi leadership on their raised podium. Essentially then, these events were crafted for the lenses of still, newsreel and film cameras. By such means was the Nazi propaganda message conveyed to the public at large, a primary example being Leni Riefenstahl's film *Triumph of the Will*. The official Nazi architecture, seen by some as a synthesis of fortress and tomb, was in fact a grandiose stage setting for a heroic drama of compelling power and imperial ambition.

During these same years, the United States initiated an unprecedented and vast experiment in governmental patronage of the arts as President Roosevelt's New Deal administration established a number of agencies to keep thousands of artists, designers and architects at work during the ever worsening economic Depression. The key aim of the New Deal programme was stability; economic stability through the achievement of full employment, and political stability by allowing would-be revolutionaries to function as productive citizens in a communal effort to forge a better society. The classical moderne style, with its inspiring links to the American revolutionary era and to the golden age of Greece and Rome, combined weighty permanence, conservative traditionalism and optimistic modernism in a way which was aptly symbolic of this desired stability.

Of all the New Deal programs, by far the most ambitious were the building projects. By the end of the decade, the New Deal programs had been responsible for hundreds of post offices, libraries, schools, city halls, court houses and other civic structures from coast to coast. Characteristic of these edifices was the new Oregon State Capitol building, partially paid for by Public Works Administration (PWA) funds. When the old capitol burned down in 1935, New York architect Francis Keally's design won the competition for the new structure. Keally projected a flat-topped central cylinder, symmetrical massing and simplified wall surfaces relieved by flat piers. His design also incorporated a historically appropriate program of sculpture and mural painting.

The Wall Street crash of October 1929 did not immediately affect the construction of new buildings; there was a time lag before the Depression began to be felt. Those commercial projects already in the process of construction were generally completed, although many were to remain at least partially empty for want of tenants. But as unemployment spread into the building trades as well, the Public Works Administration was established in 1933 in order to increase employment and to improve the economy through the construction of needed civic buildings and other public works projects. Often the PWA provided only part of the building costs; the rest had to be raised by local taxes.

The architectural style of the PWA buildings was not dictated as a matter of official policy. The uniformity of many of these buildings was, rather, a result of the frequent shortages of specific materials and other restrictions that arose out of the Depression. The massiveness and ornamental restraint of the classical moderne style, which was already in use, was regarded as functionally and symbolically ideal for many of the PWA projects, although colonial revival styles

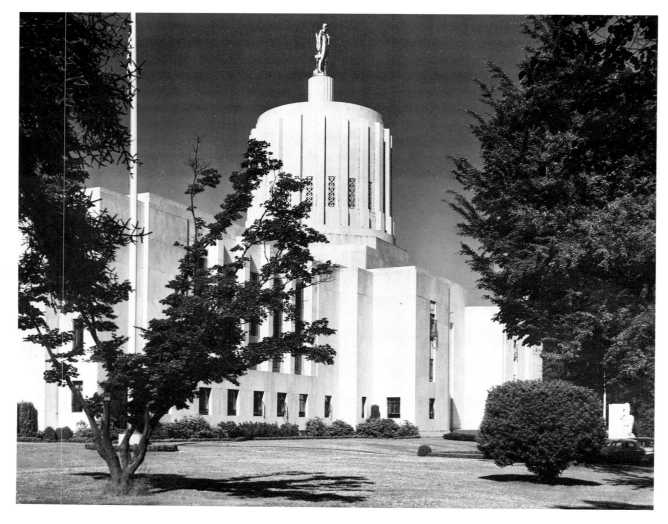

LEFT: *Francis Keally's Oregon State Capitol building (1936-38).*

RIGHT: *A more traditional classical revival was applied to the design of the new United States Supreme Court building.*

BELOW: *The more ambitious New Deal projects, such as the system of dams for the Tennessee Valley Authority, were utilitarian in nature.*

were also a frequent choice. And in Washington a more traditional classicism was chosen for such buildings as the new Supreme Court, the Jefferson Memorial, the National Gallery of Art and units of the bureaucratic complex known as the Federal Triangle.

The plans for individual buildings originated or had to be approved in Washington, and the projects were supervised by PWA personnel. The on-site construction could be supervised by the architects. Essentially the PWA projects were intended to put experienced construction workers back on the job. A second New Deal agency, the Works Progress administration (WPA), was established in 1935 to carry out federally sponsored construction projects which would not only employ skilled workers but also train unskilled workers for new trades. Many of the WPA projects involved renovations or repairs to already existing facilities. The requirement that most of the construction budget had to be spent on labor resulted in part in the massive handcrafted appearance of many New Deal classical moderne buildings.

Among the most impressive examples of monumental New Deal classical moderne were public works projects such as dams and bridges. Foremost among these was the prototype New Deal project, Gordon Kaufmann's modernist structures, accompanied by Oscar Hansen's heroic sculptures, at Hoover Dam. This complex was equaled by the dams and related structures of the Tennessee Valley Authority constructed under the supervision of architect Roland Anthony Wank. These awe-inspiring projects were the democratic counterpart to the grandiose monuments of the totalitarians.

Sculpture, in the form of reliefs and freestanding pieces, was an integral element of New Deal classical moderne architecture. That the Art Deco influence remained strong in New Deal art could be seen from Waylande Gregory's sculptures for a terracotta fountain group,

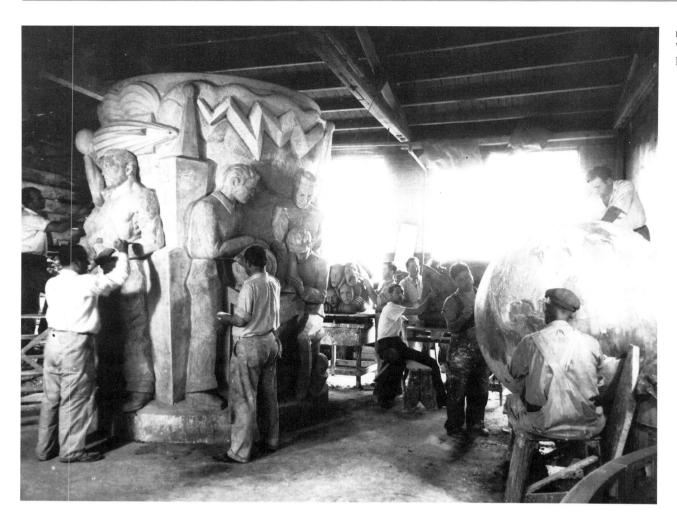

Light Dispelling Darkness, intended for hospital grounds in New Jersey. The stylized motifs of jagged lightning, clouds, skyscraper and dirigible were meant as a symbolic tribute to Thomas Edison, who had invented the electric light not far from the fountain's intended site. Heroic laborers and classical idealizations were another popular motif of American Depression-era scupture. And the interiors of these buildings were usually adorned with historically relevant or socially conscious murals by painters inspired by Diego Rivera and other artists of the Mexican muralist movement. A frequent part of

the New Deal mural and sculptural programme were such Art Deco motifs as transportation, communications, dynamic energy and heroic allegorical figures, all contributing to the optimistic theme of traditional values and technological progress working together to achieve victory over Depression-era woes.

This propagandist quality of American New Deal art and architecture resembled that of totalitarian Europe in both concept and imagery. Not only were there parallels in the symbolic use of monumental classical moderne architecture, the portrayal of superman-

RIGHT: *As seen in Gregory's sculptural group, Art Deco motifs such as lightning bolts, skyscrapers and transportation themes persisted in the more conservative works of the New Deal era.*

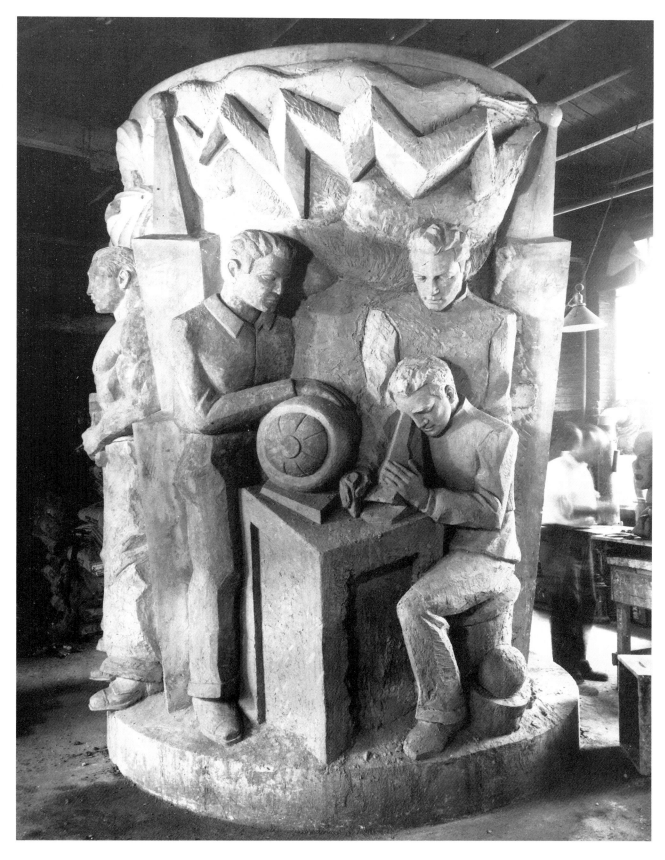

like figures in painting and sculpture, the massive government building programs and the romanticization of labor; but links also existed between such specific symbols as the Nazi and New Deal eagles, and the lightning bolt, representing on the one hand the storm troopers and on the other, dynamic energy.

At the end of the decade, the New York World of Tomorrow Fair reiterated the themes and trends of the era. The preoccupation of the fair's planners with behavioral control and psychological conditioning techniques underlined certain features that the fair, and Art Deco style as a whole, had in common with the art, architecture, social goals and propaganda of the totalitarian governments. Perhaps emblematic of these connections were the robots that were such a popular feature of the New York, as well as Paris 1925 expositions. As machines in human form they echoed the persistent machine aesthetic motif in sculpture and painting, the idealization of the human figure until it shed all individuality and finally came to resemble a gleaming and perfect machine. With their low tolerance for individualism, the totalitarians also preferred, in art as in life, idealized people in the heroic mode, repetitive cogs in a vast social machine,

who functioned in perfect synchrony and caused no friction. Similarly, the totalitarian predilection for mass athletic displays of calisthenics conducted in mechanical unison had an American counterpart in the synchronized dance choreography in the Busby Berkeley films of the era.

It is ironic that the Art Deco style and classical moderne architecture served concurrently as a vehicle for democratic aspirations and for totalitarian dreams of world conquest. And it is that protean quality which quite possibly hastened its demise. Whether Hitler's most enduring architectural heritage was the swift spread and subsequent dominance of the International Style is a matter for conjecture. It is true, certainly, that his repressive regime sent such pioneers of functionalism as Walter Gropius, Marcel Breuer and Mies Van der Rohe into exile and eventually into positions of influence in leading American architecture and design schools. It is undeniable, too, that the totalitarian use of classical moderne as an official building style made the style – with its connotations of authoritarianism, regimentation, and technologically efficient genocide – anathema to the generations that followed.

Art Deco Revival

World War II effectively put an end to Art Deco architecture and design as, in the late 1930s, industry shifted to the massive production of armaments and other military materiel. After the war, the austere International Style came to reign supreme in architecture and design; over the following decades Le Corbusier, Mies Van der Rohe, Walter Gropius, Marcel Breuer and their acolytes transformed the skyline with their virtually indistinguishable glass, steel and ferroconcrete boxes. The most pressing need was the reconstruction of the war-ravaged urban landscape, followed by socially and economically motivated efforts in the name of slum clearance and urban renewal. The ideological functionalists, who resolutely resisted the historicist allures of ornament, often designed buildings for the sites of razed 'outmoded' structures, a number of them Art Deco.

According to architectural historian Charles Jencks, the tyranny of the International Style was symbolically broken in 1972 – on July 15 at 3.32 to be exact – when the 17-year-old Pruitt-Igoe public housing project was dynamited. An ideal of rational utopian planning in the tradition of Le Corbusier and the Bauhaus, this high-density St Louis block ignored such humane considerations as a need for privacy, individuality and a sense of place. The result was such rampant crime, vandalism and squalor that demolition became the only solution.

Ironically, in the same year the project's architect Minoru Yamasaki completed his New York World Trade Center – the essential glass box monolithically duplicated.

A renewed interest in Art Deco design had arisen some years earlier. In the late 1960s collectors, art historians and designers began to focus nostalgic attention on the Art Deco artifacts, furniture, ornamental motifs and architecture of the 1920s and 1930s. A key event was the landmark exhibition at the Musée des Arts Decoratifs in Paris in 1966, *Les Anneés 25, Art Deco/Bauhaus/Stijl/Esprit Nouveau*. The title of the exhibition placed Art Deco on an equal footing with other long-esteemed design movements of the twentieth century, according it a new respectability. Numerous exhibitions, some devoted to specific artists, others to the period as a whole, followed in Europe and America. The revival was accompanied by a profusion of exhibition catalogues, magazine and newspaper articles, and books.

The respectful re-examination of Art Deco buildings by the academic and professional architectural establishment received impetus from yet another source. This was architect Robert Venturi's 1966 book, *Complexity and Contradiction in Architecture*, which created a theoretical justification for the adaptation of a variety of historical and vernacular styles in contemporary design. The book con-

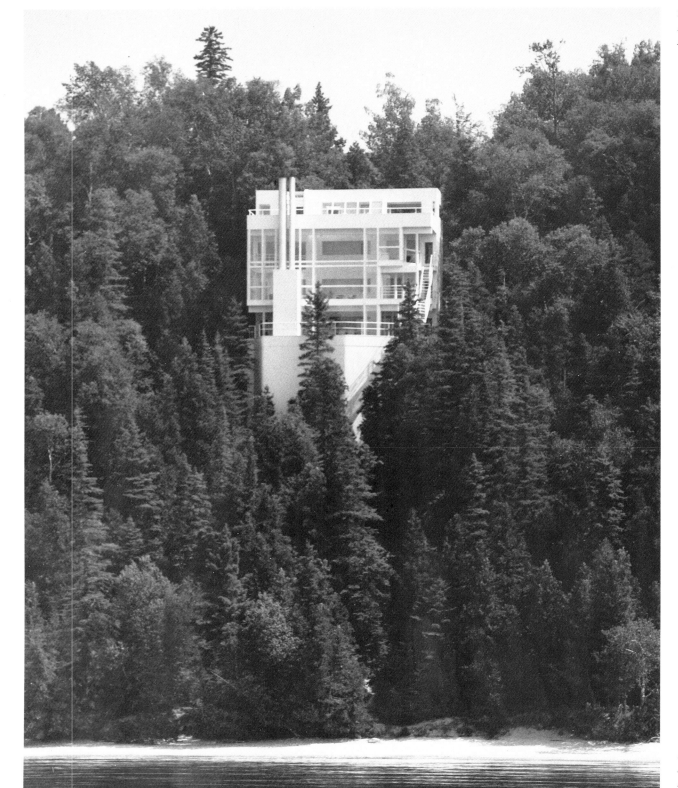

LEFT: *Douglas House, designed by Richard Meier in 1971-3, echoes Art Deco themes.*

ABOVE RIGHT: *Atlanta's High Museum of Art (1985) by Richard Meier. The exterior is reminiscent of* le style paquebot.

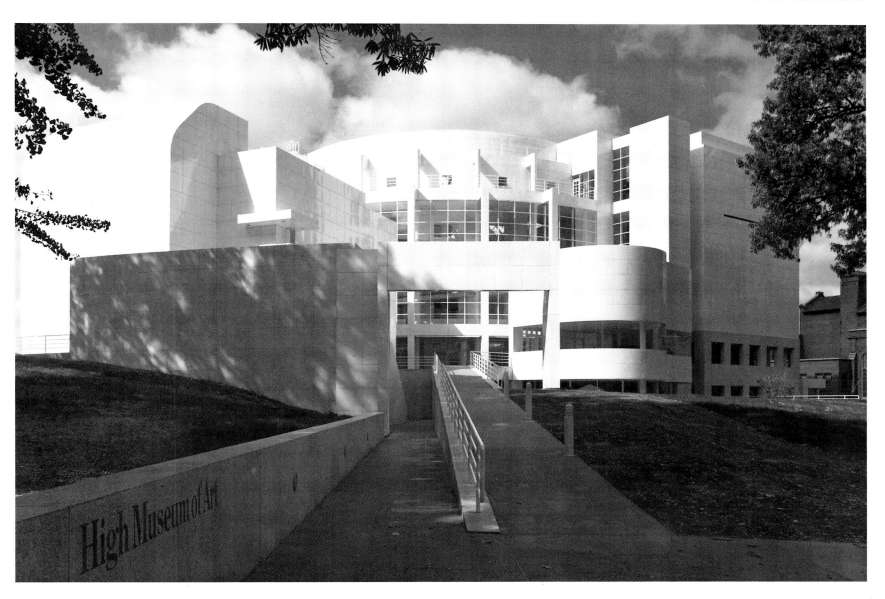

stituted a revolutionary assault on the functionalist views long held and promulgated by the theorists and practitioners of the International Style. Venturi wittily transformed the functionalist battle cry of 'less is more' into one for the postmodernists, 'less is a bore.' Implicit in Venturi's discussion was a renewed attention to the cultural context and symbolic meanings of architecture. Art Deco, a style based on eclectic and historically derived ornament, and one that valued the symbolic meaning of a building and its decoration, gained a new validity and vitality from this re-evaluation.

The fact that the rejection of functionalism and the accompanying revival of Art Deco occurred in the late 1960s owes a great deal to the nature of the era. The 1960s were a tumultuous decade marked by assassinations, the civil rights struggle and race riots, the Cuban missile crisis, the Berlin wall, the Eichmann trial, the Vietnam war, the British spy scandals, the Soviet invasion of Czechoslovakia following an earlier and bloodier invasion of Hungary, the cultural revolution in China, and the space race ending with the landing of men on the moon. The failure of rationalist technology led to the rise of the environmental movement, and the energy crisis of the 1970s made sealed glass buildings hostage to rapidly increasing heating and cooling expenses. The simplistic utopianism of the functionalist International Style no longer seemed relevant in a world so complicated and unpredictable.

From the resulting collective crisis in modern architecture arose the movement known as postmodernism which was characterized by eclecticism and the use of color, ornament and historicist motifs in symbolic ways or ironic combinations. Art Deco came to be one among the many historical styles drawn upon by postmodern architects. Contemporary adaptations of Art Deco included such elements as an abstracted monumentality; the use of bright colors, unusual materials and horizontal banding; decorative glass and lighting fixtures; skyscraper-style setbacks; cubistic columns and capitals; geometric ornament; and stylized architectural sculpture and bas reliefs. In these sophisticated stylistic allusions, the postmodernists share not just the forms of Art Deco, but something of its spirit.

A forerunner of postmodernism in England was Norman Foster's Willis Faber Dumas building in Ipswich (1974), which resembled during daylight a black vitrolite grand piano with flowing curves reminiscent of the 1930s streamline style. James Stirling's addition to Stuttgart's *Neue Staatsgalerie* (1977-84), clad with masonry in contrasting bands, was strongly reminiscent of the monumentalism of classical moderne. (A public outcry over Stirling's design demonstrated how persistent and traumatic the style's associations with 1930s totalitarianism still were.) When he accepted his 1980 gold medal from the Royal Institute of British Architects, Stirling cited Art Deco as one of the influences on his work. Significant too was the re-introduction of sculptural ornament into architecture. A student of Eric Gill, British sculptor Walter Ritchie began to receive numerous commissions from architects to execute architectural sculpture for such clients as the National Westminster Bank.

In France, Spanish architect Ricardo Bofill designed a number of buildings drawing on the classical moderne style. One of his most spectacular designs was the Theater of Abraxas (1978-82) outside Paris, part of a 584-apartment complex in the form of an abstracted Roman colosseum. Despite his postmodern stylization of historical ornament, Bofill echoed the idealism of the functionalists in that he believed in the civilizing power of classical forms.

In the United States, a pioneer in the introduction of Art Deco design elements into the contemporary architectural vocabulary was Michael Graves. Prime examples of his lively reinterpretations included the Plocek House and the city office building of Portland, Oregon. With his High Museum of Art in Atlanta (1985), Richard Meier made reference to the 1930s ocean liner-type streamline style, with its gleaming white curved surfaces and tubular metal railings. A powerful example of Art Deco readapted was the Cincinnati world headquarters of the Procter & Gamble company by Kohn Pedersen Fox Associates (1982-85), with its twin setback towers and interiors with decorative metal banding, cubistic column capitals and modernistic lighting fixtures. And the dramatically lit 1920s skyscraper renderings of Hugh Ferriss were echoed in such Helmut Jahn drawings

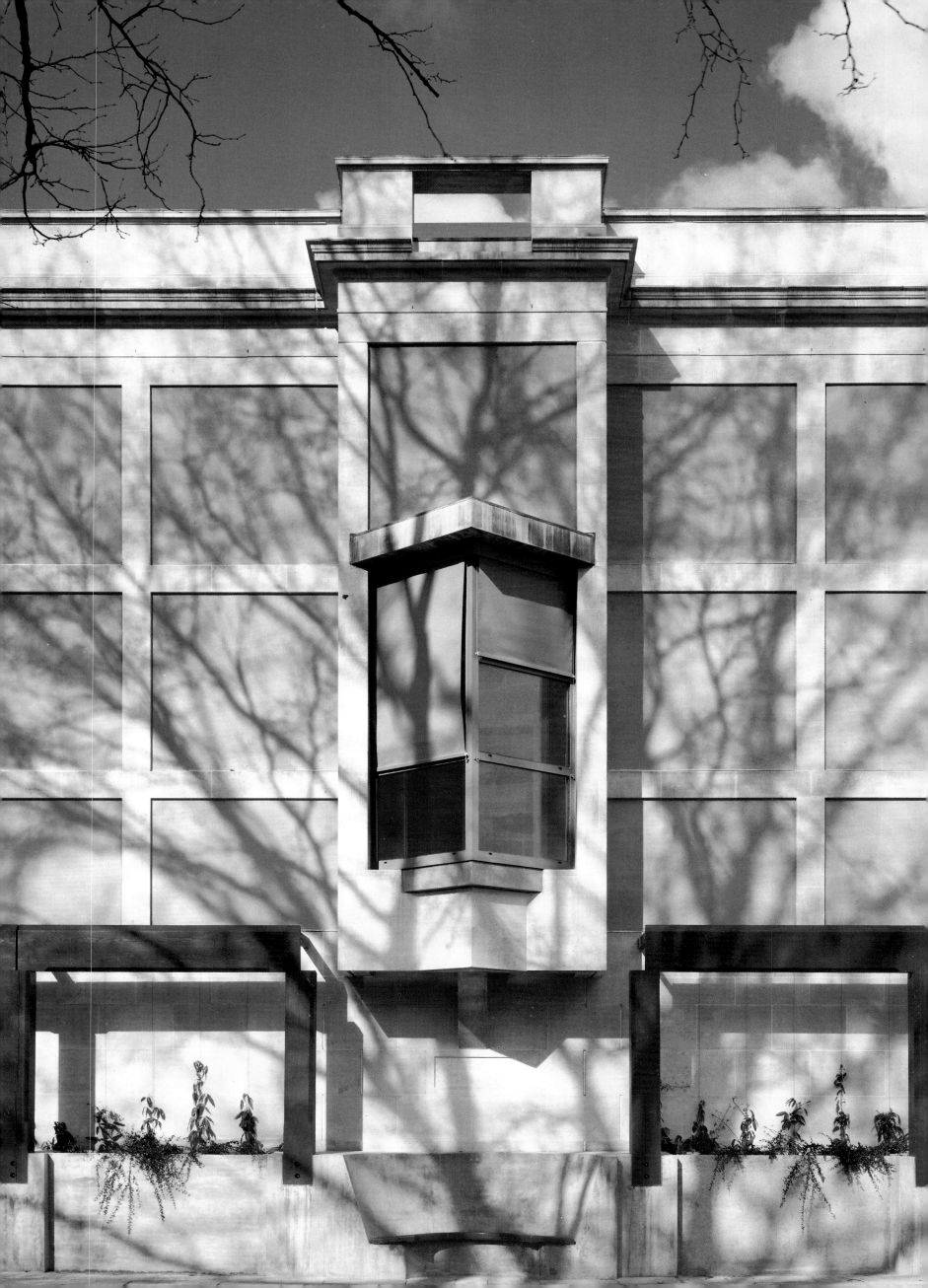

LEFT: *James Stirling's Tate Gallery extension (1980-84) displays his debt to Art Deco in general and classical moderne in particular.*

RIGHT: *In the Art Deco historic district of Old Miami Beach, the Collins Park hotel underwent renovation.*

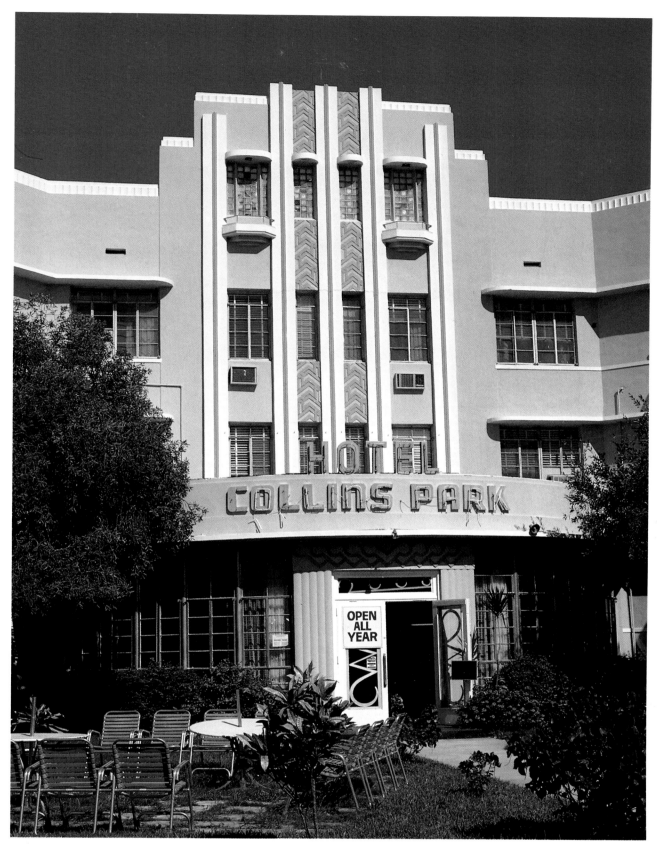

as that of his design for Houston's Bank of the Southwest tower. Many other commercial and civic structures erected throughout the United States from the late 1970s drew on Art Deco motifs.

Fortunately the Art Deco revival in architecture did not restrict itself to postmodernist adaptations and aesthetic scholarly appreciation. Too many original Art Deco buildings had already been razed, among them such treasures as Joseph Urban's Ziegfeld Theater in New York, Cincinnati's Union Terminal, and the Atlantic Richfield building in Los Angeles. Countless other buildings lay in similar danger. The recognition of Art Deco as a valid and unique twentieth-century style lent support to historical preservation efforts.

In London the demolition of the old Lloyd's building led to the formation of the Thirties Society in order to research and protect the best architecture of the 1920s and 1930s – and not just those in the Art Deco style, but also neoclassical and International Style buildings. As a result, many post 1914 buildings were listed, among them Battersea Power Station, the Peter Jones department store, Simpson's of Piccadilly, four Underground stations by Charles Holden and the London Zoo Gorilla House and Penguin Pool. In 1973 the Derry & Toms store

of 1933 reopened with most of the original Art Deco work intact. Once famous for its Rainbow Room, bronze paneling and carved reliefs, the new Biba store was redecorated in a mixture of Art Nouveau and Art Deco styles.

In the United States the strategy of gaining historical landmark status for threatened buildings saved the magnificent Oakland Paramount Theater by Timothy Pflueger. The building was painstakingly and authentically renovated after its purchase by the Oakland Symphony in 1973. New York's Radio City Music Hall, a monument of Art Deco interior design, also came into danger and was saved only after vociferous public protest.

American preservationists scored another major success when, in 1979, one square mile of Old Miami Beach was officially declared a historic district by the National Registry of Historic Places. The site contained some 400 buildings, most of them in the tropical deco style, and was the first such district with structures erected less than 50 years ago. The Preservation League there also supervised the renovation of such Art Deco hotels as the Abbey, the Adams, the Collins Park, the Delano, the Greystone, the Plymouth and the Versailles.

After the initial Art Deco enthusiasm had crested, the style remained in the commercial art vocabulary. In annual selections of top graphic designs during the 1980s, Art Deco continued as a strong contender among the various design options. But now there was less interest in its geometric patterns and more in reinterpretations of nostalgic imagery such as looming ocean liners like those by Cassandre, dramatically silhouetted skyscraper skylines, speeding streamlined locomotives and elegantly stylized human and animal figures. Advertising illustrations commissioned by stores alluded to that more glamorous era by including stylized palm trees, flamingos, DC-8 propeller planes and skyscraper skylines, sometimes all in one design.

Craftspeople also saw Art Deco as an inspiration for lively and attractively contemporary designs. Textile works such as pieced quilts were a particularly amenable medium for the geometric and Cubist motifs of the style. Art Deco was also widely used as a design source for jewelry designers and the makers of metalware and household accessories. Ceramists adapted Art Deco's geometric designs and Cubist shapes, as well as its stylized floral and figural motifs. A number of craftspeople even gave their works titles that specifically alluded to the historical Art Deco era.

The Art Deco style also provided inspiration for contemporary furniture design, resulting in such mass-produced pieces as a white lacquered streamlined bedroom ensemble complete with speed stripes, skyscraper-style brass beds, and black lacquered 'post moderne' skyscraper style dressing tables. Hong Kong's Tai Ping carpet company commissioned British designer Nadia Boyer to create 'Art Deco,' a design incorporating segmented arcs. Smaller mass-produced accessories included such items as clocks encased in miniature ceramic or metal DC-8 planes, figurines of languorous sylphs and photograph frames of black glass silkscreened with white 'deco geometrics.'

LEFT: *The graphic arts were widely affected by the Art Deco revival: Penguin Books' reissue of Evelyn Waugh's novels stylishly re-created the spirit of the era in which they were written.*

BELOW: *A lacquered adaptation of Saarinen's side chair, shown with the Grid writing desk (1983) by Kenneth F Smith, Jr.*

Another significant aspect of the preservation movement was the attempt to survey and document, in the form of articles, pamphlets, catalogs and books, specific Art Deco buildings. The result, in the United States, were publications on New York City, the Bronx, Washington, Baltimore, Seattle, Los Angeles, Tulsa, Pittsburgh, Miami Beach, Vermont and the Southwest, as well as on individual Art Deco landmark buildings such as the Louisiana State Capitol, the Oakland Paramount, the Atlantic Richfield building and Rockefeller Center. The preservation effort was also aided by the formation of Art Deco societies which published newsletters and offered symposia and walking tours.

The Art Deco revival also extended to the visual arts, where its impact became apparent in the era of Pop Art. In the spirit of nostalgia and of appropriation of popular imagery, American Roy Lichtenstein included Art Deco motifs in paintings, graphic works and even sculpture. He and other Pop artists of the 1960s initiated a cross-fertilization of the serious arts and popular forms that opened the way for a re-examination of Art Deco.

Commercial artists were also quick to exploit Art Deco motifs for their lively elegance, and thus helped to create a new trend in the graphic arts. Of particular interest were Art Deco's vividly colored abstract geometric patterns which were adapted by such prominent American designers as Milton Glaser, Seymour Chwast and Norman Green for use in posters, book covers, record album covers, new Art Deco typefaces and environmental graphics. Art Deco imagery also became popular once again in fashion advertisements and commercial illustration. Some designers borrowed geometric borders directly from the interiors of landmark Art Deco buildings. Others worked more innovatively, creating playful contemporary paraphrases. British designers also adapted the style inventively; Penguin Books commissioned new covers in the Art Deco spirit for its reissue of Evelyn Waugh's novels.

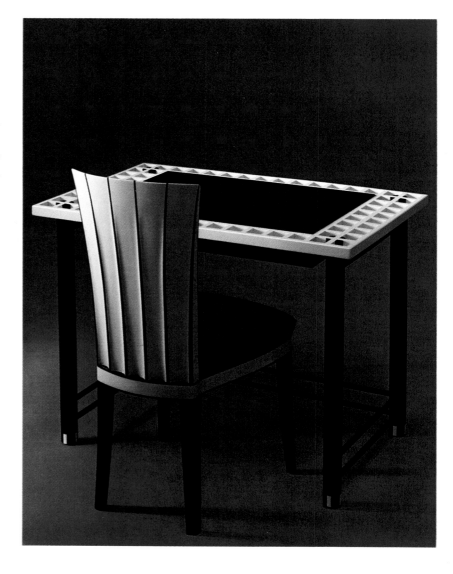

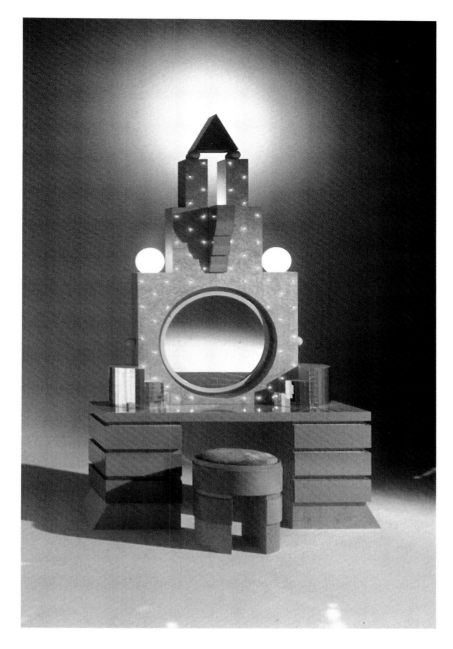

The mass production of Art Deco revival furniture was followed in the 1980s by the reissue of selected historical Art Deco furniture. Among the chosen pieces were Eliel Saarinen's 1919 White Chair, his 1929 Blue Chair and his elaborately veneered and inlaid armchair and round table designed in 1929-30 for his Cranbrook residence. Related furniture, similarly reissued, included Josef Hoffmann's 1913 Via Gallia armchair and sofa, and various tables, chairs and stools by Alvar Aalto. The Paris-based design company Ecart International reissued such classics from the 1920s and 1930s as René Herbst's and Robert Mallet-Stevens's functionalist furniture, and Eileen Gray's carpets, mirrors and chairs. Also reproduced were pieces by Pierre Chareau and Ruhlmann, as well as the far less exclusive British Lloyd Loom chairs in a range of pink, green and blue, with the original silver or gold underpainting. And the new respect accorded to the

ABOVE: *Michael Graves, 'Plaza' dressing table (1981), Memphis.*

ABOVE RIGHT: *This 'Diva' mirror (1986), by Ettore Sottsass for the design group Memphis, successfully reinterpreted Art Deco style for the postmodernist age.*

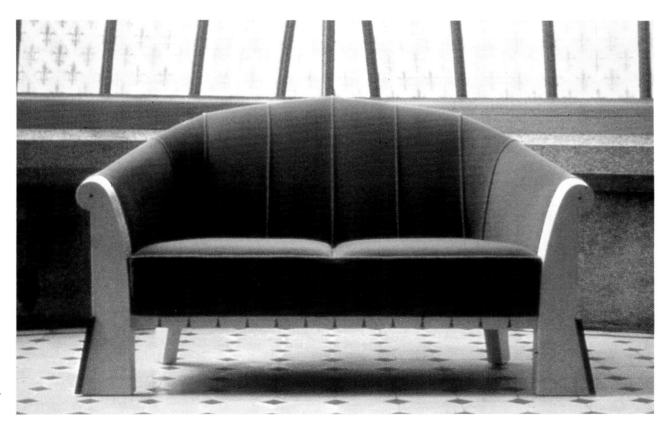

RIGHT: *Couch by Michael Graves for Sunar Hauserman.*

original Art Deco furniture and accessories was paralleled in the marketplace by ever rising prices whenever fine authenticated pieces were auctioned, a trend which reached a new high with the 1988 sale of the Andy Warhol estate.

The work of a number of fine furniture artisans of the late 1970s and 1980s was either inspired by Art Deco or bore close affinities to it. The hand made, one of a kind pieces of American Judy Kensley McKie, although not overtly based on Art Deco motifs, were designed in a spirit similar to that which informed the luxurious French Art Deco furniture of the 1920s. A sympathetic study of African art, as well as of pre-Columbian, Eskimo, American Indian, early Egyptian and archaic Greek artifacts provided sources for McKie's elegantly stylized animal and floral forms, and the repetitive geometric patterning of her Leopard Couch, Fish Chest and Frog Cabinet. In a similar spirit were various pieces by Wendell Castle, notably his 1982 Egyptian Desk with decorative veneers of ebony, maple and leather.

Further Art Deco inventions came from the Italian design group Memphis, founded in 1980-81 by Ettore Sottsass. Some colorful modernistic Memphis pieces were Constructivist in inspiration, while others drew on motifs from American popular culture of the 1950s. In a tribute to Art Deco, Sottsass produced his Park Lane coffee table and Diva Mirror. Other Memphis designs evoked Art Deco in their use of luxurious materials, setbacks and geometric forms.

The architects of the postmodern era followed their 1920s and 1930s predecessors in designing furniture and other accessories appropriate to their architectural interiors. Two leading American architects openly appreciative of Art Deco, Robert Venturi and Michael Graves, broadened their design ideas to include furniture in the Art Deco mode. Both designed chairs that playfully adapted Art Deco features. In his 1984 collection for Knoll International, Venturi created chairs of cut-out laminated molded plywood representing Art Deco and other historical styles. The Art Deco-influenced furniture of Graves – such as his armchair for Sunar Hauserman, with its exaggerated profile and angles, and its geometric ornament – did not refer to specific historical prototypes; it was, rather, a whimsical reinterpretation. Much more lively in its vibrant colors, references to skyscraper style and theatrical use of glass and dramatic lighting was the Plaza dressing table that Graves designed for Memphis. In a 1984 line of furniture for Georg Kovacs, American graphic designer Seymour Chwast created a series of 'retrograde modern' chairs, some of

The 1984 china designs commissioned by Swid Powell include 'Sunshine' by Stanley Tigerman (far left), 'Miami' by Laurinda Spear (left), and 'Grandmother' by Robert Venturi (right).

which were also reminiscent of Art Deco in their bold geometric shapes and vivid colors. British designer Charles Jencks created furniture in a similar spirit for his Thematic House in London; his Sun Chair, reproduced by Aram in fiberboard, employed the classic Art Deco sunburst motif. Austrian architect Hans Hollein also created witty and elegant pieces in the Art Deco spirit, including an astonishing 1984 dressing table for Möbel Industrie Design/Anwerk, and his 1985 Marilyn chaise longue and Mitzi couch for the Italian manufacturer Poltronova.

The renewed interest in Art Deco on the part of enlightened manufacturers was emphasized by a 1984 project sponsored by the Formica Corporation in which 19 furniture designers created impressive handmade furniture pieces incorporating Colorcore, a new Formica laminate. These striking cabinets, tables, desks, chairs, and screens contained many references to Art Deco as the vividly-hued new material was innovatively exploited for the graphic and ornamental effects to which it lent itself, and for its ability to accommodate a seamless volumetric form.

In the 1980s the design and architectural establishment indicated a new interest in other household accessories in the Art Deco style. Not

only did Noritake resume production of Frank Lloyd Wright's china pattern for the Tokyo Imperial Hotel, but the New York firm of Swid Powell commissioned such leading designers and architects as Venturi, Graves, Laurinda Spear, Stanley Tigerman, Robert Stern, Richard Meier and others to design china, crystal and silver. A number of these items, with their geometric patterning, Cubist-influenced designs and vivid colors bore a close affinity to the Art Deco style. The Italian firm of Alessi introduced limited edition coffee and tea services by 11 leading designers. Among these designs there were unmistakeable references to Art Deco in both its Cubist-influenced and streamline phases. Striking among the Alessi silver was Michael Graves's tea service which, with its exaggerated contours, evoked Art Deco in an idiosyncratic and architectonic way. In Hans Hollein's set, aerodynamic vessels were poised to take off from a tray resembling an aircraft carrier.

Following its escape from demolition, Radio City Music Hall became the source of 20 textile designs including fabrics, wall coverings, and carpets, all adapted from the original archives by F Schumacher and Company and issued under the title Radio City Music Hall Collection. The designs ranged from a Rockettes Border and a

LEFT: *The 'Big Dripper' coffee set by Michael Graves for Swid Powell.*

RIGHT: *Tea and coffee set by Michael Graves for Alessi.*

skyscraper pattern fabric to Musical Instruments, a carpet originally created in 1931 for use in the Music Hall's grand foyer.

Steuben Glass had continued to produce its 1930s Art Deco designs by Sidney Waugh and others, but a recent design by Paul Schulze, entitled *New York, New York,* reiterated basic Art Deco themes and interests. The block of solid crystal, whose corners were carved out in the shapes of the Woolworth, Chrysler, Empire State and World Trade Center buildings, referred not only to the popular skyscraper style of the 1920s, but also exploited the prismatic, refractive quality of crystal to achieve a Cubist fragmentation of light and images. The use of light as an expressive design element echoed the historical Art Deco interest in innovative lighting effects.

The jazzy use of glass was also explored by contemporary interior designers. An important project was the 1988 renovation of Rockefeller Center's fabled Rainbow Room restaurant. The club was sympathetically updated, with such new elements as cabinetry designed in homage to Donald Deskey by Hugh Hardy. The ambitious collaborative effort created a theatrical interplay of light, glass and mirror, in a sumptuous setting of terrazzo, cast glass, and mahogany. An aerodynamic boat model by Norman Bel Geddes was installed over the

LEFT: *Many original Art Deco features in the Savoy Hotel, London, such as this stylish staircase, have been carefully preserved.*

RIGHT: *The Penguin Pool, in Regent's Park Zoo, London, has now been listed and will be preserved.*

The molded glass panels by Lalique (left) and the original marquetry panels (right) were preserved in the recent renovation of the Venice-Simplon Orient Express.

South Bar. A similarly sophisticated reinterpretation of the Art Deco era was Robert Stern's redesign of the Mexx International store in Amsterdam, with its polygonal stainless steel columns and ziggurat-shaped capitals, geometrically ornamental glass and rich combination of materials.

Other interior designers also drew on Art Deco to recreate glamorous and nostalgic settings for fashionable restaurants, bars, hotels and even buildings undergoing conversion to condominiums. This effect was frequently achieved by incorporating authentic historical Art Deco architectural elements, such as sculpture, doors, stained glass windows, etched glass, signs and even entire rooms, which had been saved from destroyed buildings. Thus it is not surprising, for example, to find a recycled Art Deco Loew's Theater marquee over a bar, or to see the two Art Deco stone eagles from New York's demolished Airlines Terminal building flanking the main entrance of a corporate headquarters in Virginia.

An interior design that depended on murals for its effect was painter Richard Haas's recreation of a *trompe l'oeil* Art Deco interior for a New York gallery. A convincing illusionistic evocation of a luxurious 1920s zigzag-style interior, the room was intended as a homage to the past as well as a plea for the preservation of the rich heritage of Art Deco. For other illusionistic mural projects, the eclectic Haas drew on a diversity of historical styles ranging from classicism to the work of Louis Sullivan.

In the field of contemporary industrial design, the Art Deco revival also had an impact. In 1984 the Sharp corporation introduced a stereo cassette recorder in streamlined molded plastic, complete with speed stripes; it was a available in white, recalling 1930s Hollywood design, and in pink and aqua, echoing the hues of tropical deco. And the Airstream company, which has continued to produce its silvery streamlined caravans or trailers during the postwar decades, introduced in the 1980s a similarly streamlined motor home, whose aerodynamic shape paralleled that of both the DC-8 airplanes and streamlined locomotives emblematic of the 1930s.

Nor did the travel industry remain immune to the allures of the Art Deco revival. The archetypal train of the Art Deco era, the Venice-Simplon Orient Express, inaugurated in 1906 and closed down in 1976, was rescued by British entrepreneur James Sherwood. The 1920s sleeping cars he purchased were painstakingly restored, preserving their Lalique glass panels, ornate deco marquetry panels and Florentine upholstery. In 1982 the train resumed its historic route from London. Would-be ocean travelers also were offered the opportunity to enjoy a glamorous Art Deco recreation of the decades between the wars when the Royal Cruise Line's new ship, the West German-built *Crown Odyssey*, set out on its maiden voyages in 1988. For sheer elegance and sophistication, a transatlantic voyage on a floating palace such as the *Ile de France*, *Queen Mary* or *Normandie* was surely the ultimate experience of the Art Deco era.

Chronology

World Events	Art	Science/Technology
1901 President McKinley assassinated Queen Victoria dies	Wright's Chicago speech on the art and craft of the machine	First mass-produced automobile
1902	Perret's Rue Franklin building	Marconi's first transatlantic radio signal
1903	Wright's Larkin building Bernhard's 'Priester' poster Hoffmann and Moser found *Wiener Werkstätte* Metzner begins Leipzig memorial	Wright brothers make first flights
1904 Election of Theodore Roosevelt	Munich designers at St Louis Fair Saarinen begins Helsinki station Wright's Unity Temple	
1905	Hoffmann begins *Palais Stoclet*	Einstein develops special relativity theory
1906 San Francisco earthquake		Launching of HMS *Dreadnought*, first battleship in modern style
1907	*Deutscher Werkbund* founded Cubism begins	
1908	Iribe's book of Poiret's dress designs published Isadora Duncan's modern dance a sensation in Europe	
1909	Ballets Russes arrive in Paris Marinetti publishes first Futurist manifesto in *Le Figaro*	Blériot flies English Channel
1910 Halley's Comet	Munich designers at Paris Salon Wright's designs issued in Berlin Ruhlmann starts company Kahn's Detroit Hudson building	Curies isolate radium
1911 Amundsen became first man to reach South Pole	Perret begins Elysées theater Poiret starts Atelier Martine Epstein begins Wilde tomb	
1912 Bust of Nefertiti found *Titanic* sinks	Cabaret Theatre Club opens in London Doucet sells off antiques to make way for modern design Sauvage's pyramidal building	
1913	Omega Workshops begin Bourdelle's Elysées theater reliefs Taut's steel pavilion at Leipzig Armory Show in New York	Stainless steel first produced
1914 World War I begins	Taut's glass pavilion at Cologne	
1915		Panama Canal opened
1916	New York zoning calls for building setbacks, leading to zigzag style	
1917 United States enters World War I Mata Hari shot as spy Russian revolution begins	First jazz recording by original Dixieland Jazz Band	
1918 Woolley begins Assyrian dig Czar and family assassinated World War I ends		USA inaugurated first regular airmail service
1919	Atelier Primavera and Süe et Mare design studios founded Mendelsohn's Einstein observatory design Bauhaus begins in Weimar	Alcock and Brown made first non-stop transatlantic flight
1920 League of Nations founded Prohibition introduced in USA	Goodhue's Nebraska state capitol design	
1921		First Austin 7s produced
1922 Tutankhamen's tomb opened in Egypt Mussolini and fascists rise to power in Italy	Chicago Tribune tower competition Eliot's *The Wasteland* and Joyce's *Ulysses* published	
1923 Hitler imprisoned where he writes *Mein Kampf*, after Munich Putsch fails	Le Corbusier's *Vers une architecture*	Demonstration in New York of sound films (talkies)
1924 Lenin dies	Asplund's Stockholm library Breuer's Wassily chair Gershwin's *Rhapsody in Blue*	
1925	Lang's film *Metropolis* released Paris *arts décoratifs* exposition Colin's *Revue Nègre* poster Fitzgerald's *The Great Gatsby* published	
1926 Stalin gains power in Soviet Union	Mallet-Stevens' Cubist houses Hemingway's *The Sun Also Rises* published, a lost generation classic	John Logie Baird's first television transmission in Britain Goddard fires first liquid-fuel rocket
1927 Lindbergh's New York-Paris flight	Cassandre's *L'Étoile du Nord* poster Syrie Maugham designs her 'all white room' *The Jazz Singer*, the first sound film, released	

World Events	Art	Science/Technology
1928 English women receive vote on same terms as men	Chareau's glass house Dudok's Hilversum town hall Waugh's *Decline and Fall* published Brecht and Weill's *The Threepenny Opera* published	Discovery of penicillin
1929 Work begins on Maginot line Wall Street Crash starts worldwide depression	New York's Chrysler building erected	Airship *Graf Zeppelin* circumnavigated the earth in 21 days, 7 hours
1930		Airship *R101* destroyed during flight to India
1931	Paris colonial exposition Empire State building ends zigzag era	Electric razor invented
1933 Hitler elected Chancellor of Germany	Bauhaus closes Chicago Century of Progress Fair	
1935	USA's New Deal programs for artists and architects begin	Hayden Planetarium opened in New York City *Normandie* begins transatlantic route as luxury ocean liner *Queen Mary* gains Blue Riband on maiden voyage
1936 Berlin Olympics are Nazi showcase Edward VIII abdicates to marry Mrs Simpson Spanish Civil War begins		
1937 Amelia Earhart lost in Pacific Guernica air raid in Spain	Paris art and technology exhibition	Zeppelin *Hindenberg* destroyed by fire when landing at Lakehurst, USA
1938 Nazis occupy Austria, Czechoslovakia Welles' *War of Worlds* radio broadcast causes panic in USA	First Superman comic book published	Discovery of coelacanth, primitive fish, off South AFrica
1939 Outbreak of World War II	New York World of Tomorrow fair San Francisco Golden Gate Fair	First computer

Bibliography

Arwas, Victor *Art Deco* New York, Harry N Abrams, 1980
 Art Deco Sculpture New York, St Martin's Press, 1975
Battersby, Martin *The Decorative Thirties* New York, Walker and Co, 1971, rev and ed Philippe Garner, 1988
 The Decorative Twenties New York, Walker and Co, 1969, rev and ed Philippe Garner, 1988
Bouillon, Jean-Paul *Art Deco 1900-1940* New York, Rizzoli, 1988
Broadbent, Geoffrey, *et al Neoclassicism* London, *Architectural Design*, Profile 23, 1979
Brunhammer, Yvonne *The Nineteen Twenties Style* London, The Hamlyn Publishing Group Ltd, 1969
Cooper Hewitt Museum *The Oceanliner – Speed, Style, Symbol* New York, 1980
Dean, David *Architecture of the 1930s: Recalling the English Scene* New York; Rizzoli, 1983
Delhaye, Jean *Art Deco Posters and Graphics* New York, Rizzoli, 1977
Duncan, Alastair *American Art Deco* New York, Harry N Abrams, 1986
 Art Deco Furniture New York, Holt, Rinehart and Winston, 1984
 The Encyclopedia of Art Deco New York, Dutton, 1988
 Art Deco New York, Thames and Hudson, 1988
Forsyth, Alastair *Buildings for the Age, 1900-1939* London, Her Majesty's Stationery Office, 1982
Garner, Philippe (ed) *The Encyclopedia of Decorative Arts, 1890-1940*
New York, Van Nostrand Reinhold Co, 1978
Hillier, Bevis *Art Deco* London, Studio Vista Ltd, 1968
 The World of Art Deco New York, Dutton, 1971
Kery, Patricia Frantz *Art Deco Graphics* London, Thames & Hudson, 1986
Klein, Dan *Art Deco* London: Octopus Books, 1974
Lesieutre, Alain *The Spirit and Splendour of Art Deco* New York, Paddington Press Ltd, 1973
Mandelbaum, Howard and Myers, Eric *Screen Deco: A Celebration of High Style in Hollywood* New York, St Martin's Press, 1985
Neret, Gilles *The Arts of the Twenties* New York, Rizzoli, 1986
Robinson, Julian *The Golden Age of Style* London, Orbis Books, 1976
Rogers, J C *Modern English Furniture* London, Country Life, 1930
Scarlett, Frank and Townley, Marjorie *Arts Decoratifs 1925: A Personal Recollection of the Paris Exhibition* London, Academy Editions, 1975
Spours, Judy *Art Deco Tableware* New York, Rizzoli, 1988
Stamp, Gavin *et al Britain in the Thirties* London, *Architectural Design* Profile 24, 1979
Stern, Robert, *et al New York 1930: Architecture and Urbanism Between the Two World Wars* New York, Rizzoli, 1987
Weber, Eva *Art Deco in America* New York, Exeter Books, 1985
Wilson, Richard Guy, *et al The Machine Age in America 1918-1941* New York, Harry N Abrams, 1986

Index

Acknowledgments

The publisher would like to thank Martin Bristow the designer, Chris Schüler the editor, Mandy Little the picture researcher, and Pat Coward for preparing the index.

Picture Credits

Alessi: page 183(bottom)
Ampas: page 96(bottom left)
Archiv Gerstenberg: page 169(bottom)
Art Institute of Chicago: Gift of Fred and Harvey Goldberg: page 97(top), 139
Architectural Press: page 47(both)
Arkitekura: page 180(bottom)
Association of American Railroads: page 15(top)
Backnumbers: pages 114(bottom), 123(top right), 127(top), 120(top two and bottom right)
Baltimore & Ohio Railroad Museum: page 26(top)
Bauhaus Archive: pages 150, 151(all three)
Cecil Beaton Archive/Sotheby's, London: page 108(bottom)
Bildarchiv Foto Marburg: page 169(top left)
Alan & Sylvia Blanc: page 23(left), 24(top), 32(top, 33(both), 38(both)
British Architectural Library, RIBA: pages 9(top), 23(right), 39(top), 41(both), 51, 52(bottom), 55(both), 164, 166(bottom), 167(top)
Broadfield House Glass Museum: page 135(top)
The Brooklyn Museum: pages 148 Purchased with funds donated by the Walter Foundation; 125(bottom), 157(bottom)/Randolph Lever Fund; 159(bottom)/Gift of Fifty – 50
Richard Bryant/ARCAID: pages 22, 32(bottom), 49(top and bottom left), 73, 178, 184(top)
Martin Charles: pages 43, 45(both), 47(both), 48, 54
Chicago Historical Society: pages 12(bottom), 13(both), 14(bottom), 16(top), 76
Christies Colour Library: pages 58, 60(both), 61(both), 62(top), 65(bottom), 72(both), 86, 90, 91, 98(both), 133(top), 134(both), 136(both), 157(top right), 123(bottom)
Cincinnati Art Museum, Gift of the

Estate of Mrs James M Hutton II: page 75
Cleveland Museum of Art: pages 138(bottom)/Hinman B Hurlbut Collection, 142(top right)
Cooper Hewitt Museum, Smithsonian Institution/Art Resource, NY: page 104(bottom left)/Gift of Charles Payson; 141(top)/purchased in memory of Mrs Richard Irwin, Mrs Talbot J Talbot, R H Hunt, James Hazen Hyde, William Hindley and Miss Mary A Hearn; 141(bottom right)/Gift of Mrs Homer D Kripke
Corning Glass Museum: pages 130(both), 131(bottom), 138(top), 141(bottom left)
Cranbrook Academy of Art/Photo Dirk Bakker: page 80(top left), 81(both), 82(bottom), 146(bottom)
Cowan Pottery, Museum of the Rocky River: page 142(left)
Design Council: pages 64(both), 66, 155(both)
Design Museum: page 162(bottom)
Detroit Institute of Arts, Founders Society Purchase, Edsel B Ford Fund and Gift of Edsel B Ford: page 107(bottom)
Eastman Kodak Company: page 159(bottom)
Everson Museum of Art, Syracuse: pages 30, 143(top left)
Courtesy of Barry Friedman Ltd, NY: pages 99, 120(bottom left)
Joel Finler Collection: page 172(bottom)
Philippe Garner: page 104(top)
General Electric Company: page 14(top)
Giraudon: page 116(left)
Greater London Photograph Library: pages 50, 71(top both)
Haymarket Motoring Library: pages 152(bottom), 153(top)/Classic & Sportscar 162(top), 163
Lucien Herve: pages 39(bottom), 40, 42(top)
Angelo Hornak: pages 2, 11(bottom), 20, 28(all four), 29(all four), 44, 49(bottom right), 53(bottom), 65(top), 68(top), 69, 83, 85(all three), 96(top), 105(bottom right), 105(bottom), 106(all three), 128, 132(bottom), 133(bottom), 137(both)
International Museum of Photography at George Eastman House: page 110
Johnson Wax Company: page 35(top)
Keystone Collection: page 46, 67(top),

88(top), 161(top), 166(top), 168(bottom), 169(top right), 170, 171(both)
Howard Kottler Collection, Courtesy *Noritake Art Deco Porcelains* Photography Joshua Schreier: pages 144(both), 145(both)
Lauros – Giraudon, © ADAGP 1989: page 88
Leeds City Art Gallery: page 101
London Transport Museum: page 42(bottom)
Lords Gallery, London: pages 1, 117, 18(all three), 119(all three), 122(top right), 124(top left and bottom), 126 Photograph Courtesy of the Lefevre Gallery: page 102
John Margolies/ESTO: pages 35(bottom), 36(both), 37(both), 179
Peter Mauss/ESTO: page 25
© Norman McGrath: page 27
Memphis: page 181(top two)
The Metropolitan Museum of Art: pages 24(bottom)/purchase, 1967 Edward C Moore, Jr Gift & Edgar J Kaufmann Charitable Foundation Gift; 78(top), 79(both)/Emil Blasberg Memorial Fund, 1978; 100(bottom)/Gift of Mrs Soloman R Guggenheim, 1950; 143(top right)/Edward C Moore Jr Gift; 143(bottom)/Gift of Mrs Hunt Slater; 147(top), 160(top)/Gift of Mr & Mrs Herbert J Isenburger, 1978
Mitchell Wolfson Jnr, Collection of Decorative & Propaganda Arts: page 77(top)
Andrew Morland: page 153(bottom)
Musée des Arts Decoratifs Paris/Photo Sully Iaulmes: page 61(bottom), 62(bottom), 63(top)
Musée de la Publicité: page 116(right)
Museum of City of New York: pages 16(bottom), 19
Museum of London: page 52(top)
Collection, The Museum of Modern Art: pages 108(top), 109/courtesy Vanity Fair © 1927 (renewed 1955) by The Condé Nast Publications inc page; 113/Gift of Universum Film Aktiengesellschaft
National Museum of American Art, Smithsonian Institute, Gift of Paul Manship: page 96(bottom)
National Railway Museum York: page 122(top left)
National Park Service, USA: page 97(bottom)
Novosti Press Agency: page 168(top)
Pilkington's Glass Museum: page

131(top)
Rheinisches Bildarchiv: page 8
© Roger-Viollet: pages 9(bottom), 10(both), 11(top), 12(top)
Royal Pavilion Museum, Brighton: pages 59, 71(bottom), 100(top), 154(bottom left)
Santa Fe Industries: page 160(bottom)
Savoy Hotel Public Relations: page 56, 123(top left), 124(top right), 184(bottom)
Scala: page 167(bottom)
Shell UK Ltd: pages 121, 156(bottom)
Alex Siodmak: pages 6, 15(bottom)
Sinel Papers, California College of Arts & Crafts, Oakland: page 158
Steuben Glass: pages 140, 174
Jessica Strang: page 53(top)
Sunar: page 181(bottom)
Syracuse University Library: page 125(top)
Swid Powell: pages 182(all three), 183
Tate Gallery, London: pages 89, 92, 103
Ezra Stoller/ESTO: pages 17, 34(both), 74, 84, 95(both), 107(top), 176, 177
Topham Picture Library: page 93(top)
University Archives, University of Liverpool: page 67(bottom)
University of California at Santa Barbara: page 78(bottom)
University Museum, Southern Illinois University, Carbondale: page 94(top)
University of Texas at Austin: page 161(bottom)
Venice-Simplon-Orient Express: pages 186, 187
Victoria & Albert Museum, London: pages 63(bottom), 68(bottom), 70(both), 82(top), 135(bottom), 154(top and bottom right), 121, 122(bottom), end papers
Virginia Museum of Fine Arts, Richmond, Gift of Sydney Francis Lewis Foundation/Katherine Wetzel: pages 105(top), 132(top), 156(top)
George Waterman III: page 77(bottom)
The Wheatley Press: page 127(bottom both)
Westinghouse Historical Collection: page 18
Stuart Windsor: page 93(bottom)
Weidenfeld Archive: pages 115(top), 115/V&A
WPA Photograph Collection: pages 172(top), 173
Yale University Art Gallery/Enoch Vine Stoddard and Marie Antoinette Slade Funds: page 80(top right)
Zoological Society, London: page 185